FIGHTING ON ALL FRONTS

John Rothenstein in the art world

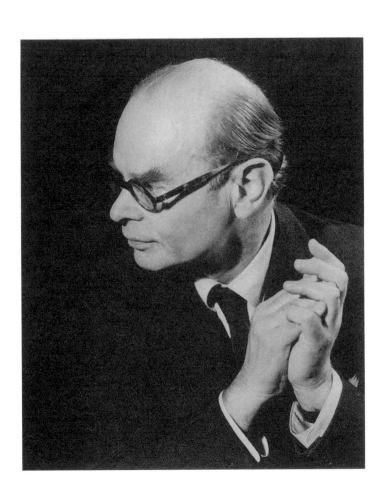

FIGHTING ON ALL FRONTS

John Rothenstein in the art world

Adrian Clark

Unicorn Press

IN MEMORIAM

CHRISTOPHER CLARK
1948–2015

VIRI VERE SINGULARIS

First published 2018 by
Unicorn Press
60 Bracondale
Norwich NR1 2BE

www.unicornpublishing.org

ISBN 978 1 910787 82 3

Designed by Nick Newton Design
Printed in the United Kingdom by TJ International Ltd, Padstow, Cornwall

Frontispiece: John Rothenstein. Photograph by Archie Parker, March 1963

Contents

Acknowledgements 6
Preface 8

PART 1 John Rothenstein before the Tate (1901–1938) 11
CHAPTER 1 William Rothenstein's Influence on his Son 12
CHAPTER 2 London and America, 1923–32 26
CHAPTER 3 Leeds and Sheffield, 1932–38 39
CHAPTER 4 The Books, 1926–38 56

PART 2 The Tate before John Rothenstein (1897–1938) 71
CHAPTER 5 The Status of the Tate 72
CHAPTER 6 The Four Previous Directors and Keepers 82

PART 3 Making History: Director of the Tate (1938–1964) 97
CHAPTER 7 Early Days and North American Tour, 1938–40 98
CHAPTER 8 War and Post-War, 1940–46 110
CHAPTER 9 Straws in the Wind, 1947–51 127
CHAPTER 10 Tate War: First Phase, 1952–53 145
CHAPTER 11 Tate War: Second Phase, 1953–54 159
CHAPTER 12 Last Years at the Tate, 1955–64 175

PART 4 Writing History 191
CHAPTER 13 The Autobiography 192
CHAPTER 14 Modern English Painters 205

Conclusion 218

Notes 223
Sources 246
Picture Credits 251
Index 252

Acknowledgements

This book could not have been written without the co-operation of the Rothenstein family, who have generously supported me throughout. Particular thanks go to John Rothenstein's daughter, Lucy Carter, who readily allowed me access to papers and photographs and made herself available to answer questions about her father. The end result does not necessarily match her own understanding of her father in every respect and I remain responsible for the facts and opinions contained in the book. I undertook at the outset that I would endeavour to be balanced in approaching John Rothenstein's career and this has been my primary objective.

Other people have helped in many ways and the following deserve special mention and thanks:

Charlotte Alexander, Howard de Walden Archives, London
Mary Allen, Jesuits in Britain Archives
Sally, Lady Ashburton
Emily Bourne, Parliamentary Archives
Sir Alan Bowness
Natalie Brooke
Martin Butlin
Judith Curthoys, Christ Church, Oxford
Professor Peter Davidson, Campion Hall, Oxford
Claire Devine, Perth & Kinross Council Archives
David Fraser-Jenkins
Ivana Frlan, Cadbury Research Library, Birmingham University
Jonathan Gibbs
Samantha Gilchrist, Special Collections Department, University of Glasgow
Adrian Glew and Colleagues, Tate Gallery Archives
Emma Goodrum, Worcester College, Oxford
Dr Neil Hopkinson, Trinity College, Cambridge
Virginia Ironside
Justine Mann, University of East Anglia Archives
Frieda Midgley, Kettle's Yard Archives, Cambridge
Steven Miller, Art Gallery of New South Wales
Ilaria della Monica, Villa I Tatti
Richard Morphet

Vanessa Nicolson
William O'Neill and Joe Kitchen, Henry Moore Foundation
Sarah Playfair
Mark Pomeroy, Royal Academy of Arts
Miriam Power, Westminster Cathedral Archives
David Pryce-Jones
Julian Reid, Merton College, Oxford
Charles Rickett
Sir Adam Ridley
Max Rutherston
Sir Nicholas Serota
Thomas Seymour
Samuel Shaw
Curtis Small, University of Delaware Library Special Collections
Chris Stephens, formerly Tate Gallery
Susannah Stone
The Hon. James Stourton
Hugh Tempest-Radford
Nicholas Thornton, National Museum Wales
David Ward
Catriona Williams

Preface

When John Rothenstein was born in July 1901 the Tate Gallery was coming up to its fourth birthday. By the time he took over as only its third Director (fifth Keeper), in 1938, it was in a sorry state. Conceived as the national gallery of British art, its remit had been uncomfortably extended in 1917 to require it also to be the national collection of modern foreign art. This confused dual purpose[1] placed an intolerable burden on those required to manage an institution which was still partly controlled by the National Gallery in Trafalgar Square, had no purchasing budget from the Government and which was bound to accept the often shockingly inappropriate pictures imposed upon it by the Royal Academy (RA) through the operation of the infamous Chantrey Bequest.[2]

A long twenty-six years later, when Rothenstein retired as Director in 1964, the Tate Gallery had under his guidance leapt into the modern world. It had escaped from the grasp of the National Gallery in 1955[3] and had, following a campaign launched by Rothenstein, regularised its relationship with the RA in respect of the selection of the Chantrey pictures. It had also been awarded a Government grant and had firmly established its place as the principal collection of modern art in the United Kingdom. The Tate was undoubtedly the best collection of British art in the world. Life for Rothenstein's successors as Directors was in many respects much easier after 1964 than it had been for him in 1938, when he took over from a disgraced alcoholic predecessor and then almost immediately had to shepherd the poor, dispirited Gallery and its collection through the Blitz and the extensive destruction and rebuilding which followed.

On this long journey through the querulous and challenging British art world, it is not surprising that John Rothenstein's reputation took some collateral damage. The art world then was no easier than it is now: no senior figure could hope to keep all parts of it happy for long. It was all but impossible to hold any major public position in that world without experiencing some degree of controversy, often to an extreme extent.

James Bolivar Manson (1879–1945), who was Rothenstein's predecessor at the Tate, is a fine example.[4] Director since 1930, he sank without trace in 1938 after a drunken outburst at an official function in Paris caused him to be fired. Over at Burlington House (the Royal Academy's home), drink also caused irreparable damage – at least in the eyes of the art critics of the day if not in popular opinion – to the reputation of its President, Sir Alfred Munnings, when, in the presence of

Sir Winston Churchill, he made a drunken speech at an RA dinner in 1949, attacking modern art in general and Picasso in particular.[5] Meanwhile, at the Victoria and Albert Museum (V&A), Leigh Ashton (1897–1983)[6] as Director suffered regular sniping from critics about his methods of displaying the museum's great variety of riches and he at some point became an alcoholic as well, such that for the last few years of his Directorship the running of the museum was necessarily in the hands of his assistant.

It was no easier at the National Gallery. Although Kenneth Clark (1903–1983)[7] was to have a good war as Director, successfully shielding the collection from harm and using the empty gallery for a variety of inspirational purposes, his reputation had already been seriously damaged. After tolerating internal jibes from his own curators about his alleged lack of scholarship, as the youngest ever Director, he had stumbled painfully (and publicly) in 1937 by causing the Gallery, in reliance on his personal attribution, to buy at considerable expense four pictures by what he hoped was Giorgione, only to have it pointed out by his colleagues shortly after the pictures had arrived at the Gallery that they were in fact by the rather lesser regarded Andrea Previtali and were relatively worthless;[8] they were certainly worth only a tiny fraction of what the gallery had just paid for them. To show that such things are rarely forgiven or forgotten in the art world, the National Gallery's website currently states, eighty years after the event, 'acquiring these panels as works by Giorgione caused one of the National Gallery's greatest scandals'. Clark's less flamboyant successor, Philip Hendy (1900–1980),[9] who arrived, like Rothenstein, with a background as Director of the Leeds City Art Gallery, provoked criticism by his hanging of the collection, to such an extent that it was discussed in a debate in the House of Lords in 1954.[10] It is said that Hendy also managed to lose for the nation the great collection of pictures belonging to Calouste Gulbenkian (1869–1955),[11] which Clark thought he had secured for the National Gallery; Hendy spent a great part of his Directorship arguing with critics about the wisdom of his policy and methods of cleaning the pictures in the collection.

Rothenstein's version of these public controversies was at least as painful as everyone else's. During the early 1950s it gathered to itself the term 'the Tate Affair' and it nearly finished him as Director of the Tate. It was remarkable that he was able to withstand the co-ordinated and violent public assault on his reputation led by that most acerbic of collectors, Douglas Cooper (1911–1984),[12] by the occasionally histrionic Graham Sutherland (1903–1980), who was a Tate Trustee, and by Le Roux Smith le Roux (1914–1963).[13] But survive Rothenstein did, even though he was prevented as a Civil Servant from defending himself in public, continuing until 1964 to preside over the building up of the national collections, ably assisted by his successor, Norman Reid (1915–2007).[14] Rothenstein also found the time – and the composure amidst the maelstrom of the Tate Affair – to write and publish in the 1950s the first two volumes of his great work, *Modern English Painters*.[15]

This study is not a biography of John Rothenstein. Rather, it is an analysis of his life in the art world. As such it will not fill in the details of his happy and secure home life with his wife and daughter, or explore the extensive network of close friends he had throughout his life, except insofar as they were part of his career in the art world. Many contemporary painters, of which the most significant were Francis Bacon, Wyndham Lewis and Stanley Spencer, were his friends, for example, and owed him gratitude for his long and practical support of their careers. Instead, the book will first sketch out the influences on Rothenstein which helped to make him the Director he became at the Tate from 1938 to 1964, through years when the whole British art world was transformed around him, and it will encompass the books on art which he published in the period up to and including the autobiography and *Modern English Painters*. It will then focus on his Directorship and on his achievements and failings. He had two fundamental tasks as Director: to improve the British art collection and to develop the modern foreign art collection. By the end of this book readers may judge for themselves the extent to which they think John Rothenstein succeeded.

PART 1
John Rothenstein before the Tate
(1901–1938)

CHAPTER 1
William Rothenstein's Influence on his Son

Just as this is not a biography of John Rothenstein, so it must not become a biography of his extraordinarily interesting father. Details of William's life are included to give flavour to John's background, so what follows will be only the briefest paraphrase of William's long and varied life. There can be no proper understanding of John's position on art without some knowledge of how his ideas were influenced by his father's life and thoughts.

John Rothenstein, oldest of his parents' children, barely makes an appearance in the three volumes of his father's autobiography. His birth on 11 July 1901 is mentioned in passing, but there is little or nothing about his life in a story which concludes just before John was appointed to the Tate. A reader of the three substantial volumes – *Men and Memories: Recollections of William Rothenstein, 1872–1900* (published in 1931), *Men and Memories: Recollections of William Rothenstein, 1900–1922* (1932) and *Since Fifty: Men and Memories, 1922–1938* (1939) – would be forgiven for thinking that there was no love lost between father and son. For an autobiography stretching over three volumes, consisting of 108 chapters, to contain almost no references to the author's eldest child must indicate something about the lack of importance of the child to the father. The uninformed reader might also assume that the poor son had, in the thirty-seven years he had been alive in the period covered by the books, achieved nothing worth recording.

Such a reader would be wrong on both counts. William was extremely interested in his son and his achievements, at least once he entered the art world, and he was proud of his son's career. In the long series of letters which William and John exchanged when they were apart, right up to William's death in 1945, the overwhelming emotion expressed is one of love.[1] William loved his son and John adored his father. When John became Director of the Tate in 1938, William said that it was the happiest day of his life.[2]

Far from being distant or uninterested, William's interest in and influence on his son, certainly from some time in the 1920s, was extensive. William did not simply love and have an influence on his developing son: he dominated him. John's approach to art, and his attitude to British and to modern art in particular, as well as some of his other characteristics, may be attributed to his father's relentless influence on him. A good example of this is the nature of the books which John published between 1926 and 1938. John's first book, published in 1926, when he was only twenty-five, was a catalogue of his father's portrait drawings.[3]

The Rothensteins have written much about their family and its origins; in what may be unique in publishing history in relation to the same family, between 1931 and 1970 not only did the father publish a three-volume autobiography but so did his son.[4] Both describe William's German Jewish parents coming to Bradford from Germany in the mid-nineteenth century to set themselves up in the prosperous textile trade which flourished in Bradford in those days. These people were not refugees from religious persecution; they were motivated by business, wanting to take advantage of better trading conditions. The Rothensteins flourished moderately in Bradford. They did not join the ranks of the most successful representatives of the late Victorian merchant class, who built the enormous houses which sometimes remain on the outskirts of industrial cities as monuments to their astonishing wealth, if not always taste, but they were prosperous enough to live comfortably and to raise six children all born in England. Somewhere in the gene pool which they brought with them from Germany must have been an artistic gene.[5] William, the fifth child, went on to become a considerable artist. His older brother, Charles (1866–1928),[6] was to inherit the family business and built up a significant art collection which might have come to the Tate (or indeed to Bradford) but which ended

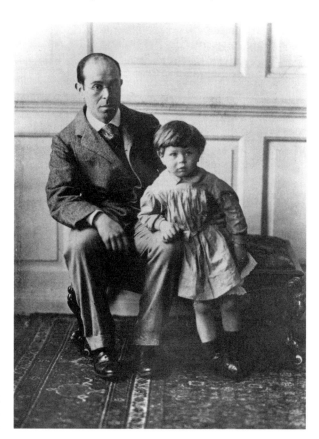

Father and son: William with John Rothenstein, Hampstead, 1903.

Albert Rutherston, c.1911.

up in the Manchester City Art Gallery.[7] The youngest son, Albert (1881–1953), was also a successful artist, as later was John's younger brother, Michael (1908–1993).[8] John's sister Betty (1905–1988) was a serious and promising young sculptor, until illness forced her to abandon that part of her life.

William, born in Bradford in 1872, was not destined to join the family firm or to remain in the North.[9] At the age of sixteen, after Bradford Grammar School, his precocious artistic talent was recognised and his parents were far-sighted and generous enough to pay for him to go to the Slade in London to develop his skills as an artist. There he started to mix with the London artistic and cultural world of which he was to become a significant part.[10] Within a year the young man had tired of the Slade's teaching methods and moved to Paris, to study at the famous Académie Julian,[11] and it was there that he was launched on his art-world career. Even at this early age, William's ambition and determination to get what he wanted, in the sense of fashioning his own training, is notable. One of his lifelong characteristics was a determination to succeed in everything he set out to achieve.

William Rothenstein became a successful artist, but his style of painting was superseded by changing taste and fashion in the British art world, of which he had been in the early years of the twentieth century an important part and, long before his death, it was painfully apparent that his star had waned. John describes 'the recurrent bitterness that seared his later years, arising from the precipitous decline in his own reputation as an artist'.[12] Of more significance to John's story was the way in which William was a part of the core group, not only of the artists who were at the heart of developments in British and French art in the early years of

The Princess Badroulbadour (John Rothenstein with siblings) painted by William Rothenstein, 1908.

the century, but also of many of the writers with significant reputations. Through determination and circumstance, William became one of the most important figures in the wider British cultural scene, astonishingly well-connected and widely influential. This was the environment into which John was born and in which he grew up.

By the time William returned to London, he knew many of the most exciting names from the Parisian cultural scene: Edgar Degas, Roger Fry (1866–1934),[13] Henry James, Stéphane Mallarmé, James McNeill Whistler, Camille and Lucien Pissarro, Walter Sickert, Henri de Toulouse-Lautrec, Paul Verlaine and Oscar Wilde.[14] With his German Jewish family background and experience in Paris, William was Continental in a way which distinguished him from his artistic contemporaries in England.

William had his first exhibition in Paris, in April 1892, jointly with the Australian artist Charles Conder, with whom he was especially friendly. Many years later John wrote a book about Conder.[15] William's experience was consolidated after his

return to England. In his first year back he worked in London and Oxford, meeting people like Max Beerbohm, who was to be a lifelong friend (and who also became John's friend), Aubrey Beardsley and D. S. MacColl,[16] who also was a long-term friend and supporter (and friend of John's).

Two years after his first Paris exhibition, William was having his first London show and living in Chelsea in the heart of the London artistic community, meeting people like George Bernard Shaw, Edward Burne-Jones and William Holman Hunt. A connection with Auguste Rodin followed in 1898 and, through his brother Albert, who arrived that year at the Slade, he met the young artists Augustus John and William Orpen (who later married the sister of William's wife). William was supportive of Augustus John and his work for many years; he was never as close to Orpen.

William went to great effort to make and to maintain all these connections and his son pursued a similar policy of connecting with, in his case, many of the major artists working in England. The father's personality led him to make more and more friends of all different types, particularly if they were in some way important, and he also, in the case of young artists, wanted to have an influence on their lives. This appetite for trying to exert influence was to lead him into difficulties: not everyone appreciated it.

Marriage to the pretty and vivacious actress, Alice Knewstub (1867–1957), a daughter of a minor Pre-Raphaelite artist, Walter Knewstub, led to the establishment of a Rothenstein salon, with a regular gathering of friends on Sunday evenings. Shortly after the birth of their first child, John, they moved from Chelsea to Hampstead, to a beautiful row of early eighteenth-century houses called Church Row, at number 26.[17] Two doors along, at number 28, lived Charles Aitken, who became the third Keeper of the Tate in 1917 and who also became a friend.[18] The Rothensteins began to entertain as a family.[19] Connections with people who were in some way significant in the world of culture, such as Joseph Conrad, Jacob Epstein, Eric Gill and A. E. Housman, continued to accrue; many people noted that, when his powers were at their height in the early years of the century, William's personality could be irresistibly magnetic. In 1907, he went to stay with and paint the art historian Bernard Berenson (1865–1959)[20] at the Villa I Tatti in Settignano outside Florence.[21] Berenson was later directly relevant to the turn which John's career took after Oxford.

William naturally got to know many artists, such as Paul Nash, whom John also came to know. When the young Mark Gertler knocked on the door of the house in Church Row to introduce himself to William, John answered the door: it is a good example of the extraordinary experience it must have been for a boy to find himself repeatedly exposed in his own house both to well-known, established painters and writers, and to new, young talents such as Gertler, before they became famous. John's father was generous with his time and advice and, although not particularly well-off, with his money where it was needed in the case of impecunious young

artists. He even carried on enclosing money with his letters to John almost up to his death, by which time John was forty-three and well-set as Director of the Tate.

During the first decade of the century, William, restless for new artistic experiences,[22] sought inspiration from his Jewish heritage by visiting a synagogue in Brick Lane in London's East End and producing a number of striking pictures of Jewish subjects. One of these, *Jews mourning in a Synagogue* (1906), was presented to the Tate as early as 1907.[23] In 1910 he travelled to India and met the poet Rabindranath Tagore (1861–1941).[24] Whilst William was there, Roger Fry, by then at the heart of the Bloomsbury Group, which included Virginia Woolf and Clive and Vanessa Bell, organised the first of the two legendary Post-Impressionist shows, which were to have a great impact on British art. They were held at the Grafton Galleries in London, the first being *Manet and the Post-Impressionists*; the other, the *Second Post-Impressionist Exhibition*, was held in 1912. The first included work by Cézanne, Gauguin, Matisse, Monet, Picasso, Seurat and van Gogh, and their pictures were met with astonishment by some art critics and the public. Its significance, revealed subsequently, was that it took a large step in the direction of prioritising Paris as the focus of the modern British art world. In future, British artists who wanted to impress a significant part of the critical establishment would have to demonstrate the influence of the French School on their work. They would also have to accept the likely critical treatment of their work as being inferior to that produced in Paris. Fry's failure to include Rothenstein in these shows, exacerbated by his belief in the superiority of art produced in Paris and later by his development of the idea of 'significant form' in conjunction with Clive Bell (1881–1964),[25] was the basis of a falling-out between Fry and Bell on the one hand and the Rothenstein family on the other which would never be reconciled. Prior to the exhibition, Fry had been supportive of William Rothenstein's work.

As William got older, other rifts developed in his life. Young artists may enjoy the idea of receiving money from older, wealthier men in the art world, not to mention unsolicited advice on their work, but that does not prevent them from biting the hand that feeds them in this way. This happened in a number of cases which William must have found particularly distressing, where he had made great efforts to try to cement friendships and develop the careers of artists who then turned against him. Gill, for example, had been a friend of William's but had drifted away from him as Gill had immersed himself in religious beliefs which William could not follow. The younger artist developed an almost savage hostility towards William, which he expressed in writing following the publication of the second volume of *Men and Memories* in 1932. In a letter dated 4 May 1932, Gill wrote:

> you will not expect me to say I like it for, as I told you long ago, I detest all this dishing up, curried, of personalities; and you know that, even if I am as grateful as I ought to be for the friendship you bestowed on me when I was young, I have long ceased to agree with your opinions.[26]

Later attempts by William to restore what had once been a close friendship were sharply rebuffed by Gill. John, in contrast, was to find that, by becoming a Catholic himself, he maintained good connections with Gill, which outlasted those of his father (see Chapter 2).

Another unpleasant experience for William came in the case of his relationship with Augustus John, whom he had helped extensively in the early years of his career in London. Augustus John's biographer noted that Augustus could not feel the gratitude which he was expected to feel. The artist simply resented being helped by someone whose personality he increasingly disliked.[27]

These are trenchant views. Augustus John held strong views on people; he was notorious for it. His views on Rothenstein do not need to be accepted as universal truths. Again, John Rothenstein later published a book about Augustus John, despite the deterioration of relations between his father and Augustus.[28] John had no concerns about maintaining friendly relations with people who had fallen out with his father; whether he deliberately encouraged such connections is another matter. In the complex bundle of features which characterised John's

Augustus John
by Sir William
Orpen, 1900.

relationship with William, there were occasional strands of resistance to what might otherwise have been an all-consuming paternal influence. John sometimes took decisions which went against what his father might have prescribed – becoming a Roman Catholic and going to America were examples; maintaining friendships with people who had fallen out with his father might have been another.[29]

The sculptor Jacob Epstein was another case in which relations between William and a young artist who had benefitted from his help turned irretrievably sour. At one time, although William was paying Epstein a monthly sum which he could ill afford, Epstein resented William's attempts to influence him.[30] The charmless response which William's generosity eventually elicited from Epstein came in a letter in 1911: 'I want no more of your damned insincere invitations. The pretence of friendship has gone on far enough.'[31]

Yet, for all the prickly outbursts of some of the young artists who reacted badly to what could be the cloying embrace of Rothenstein's friendship, there were many others who felt the opposite. Henry Moore (1898–1986), a student at the Royal College of Art (RCA) when William was its Principal, was always grateful to him. In 1972, in the catalogue for William's centenary exhibition at the Bradford City Art Gallery and Museum, Moore commented on how supportive William had been to him. He thought Rothenstein an idealist and a unique man.[32]

Paul Nash and Wyndham Lewis were not necessarily easy men to get on with, but they remained grateful to William for his support when they were young. (John became notably friendly in turn with Lewis as well). When William died, two other artists expressed their heartfelt and genuine thanks to him for his help: Allan Gwynne-Jones (1892–1982; by 1945 a friend of John's as well)[33] wrote to Lady Rothenstein on 15 February 1945 referring to 'so many of us who owe Will so unpayable a debt for all his friendship and help and encouragement'. Alan Sorrell (1904–1974)[34] wrote on the 19th: 'without affectation I can say that I have owed more to Sir William than to any other man'.[35]

There is a need for balance when looking at William Rothenstein's pattern of behaviour towards those developing artists whom he wished to support; all were favoured; as has been noted, some appreciated his help and some did not.[36] William did not enjoy falling out with people and was capable of moulding his views and principles to accommodate those of his more trenchant friends and acquaintances. In the case of the adult John Rothenstein, there were times when he courted fights, although sometimes his clashes were due to no more than naivety; if so, a tendency to pick fights deliberately was not a characteristic which he inherited from his father.

In the background to this paternal socialising and excitement, the eleven-year-old John had in September 1912 been sent off to boarding school.[37] Bedales in the village of Steep in Hampshire, founded in 1893 and established on its site in 1900, was for the time an unusual public school, in that it was non-denominational,

co-educational and sought to be 'modern' in its teaching practices. This combination appealed to wealthy liberal parents, especially from non-conformist backgrounds, whose aspirations for the social status bestowed by a public-school education meant that they could not trust the grammar school system, but who also wanted to salve their consciences by avoiding the rigid, often highly military and Church of England atmosphere of the traditional boys' public schools. Various pupils who went on to become professional artists studied there including Stephen Bone, Gwynne-Jones, Ivon Hitchens, Julian Trevelyan and Michael Wishart. Whatever the extent of its modernity and liberality, John did not enjoy Bedales as it practised its controversial and unproven modernist theories on its boys and girls. His early letters home were similar to those of many lonely children sent away from home to public school, begging his parents to write, to visit and to send food. In a letter to his mother he wrote: 'I am not extra happy here a visit would cheer me up a great deal.'[38]

He nevertheless was not one of those public schoolboys from the early years of the century who was forever scarred by his formative years in dormitories and cold showers, so it is unnecessary to dwell on his experience there. One aspect of his physical surroundings at Bedales may be important for the way his aesthetic interests developed. In 1911 the school had opened an interesting building called the Lupton Hall. Built in the latest Arts and Crafts style to the designs of Ernest Gimson, instead of the normal elements of a school hall it had simple white-painted brickwork, oak benches and a quarry-tiled floor. To use this building every day of his school life may have been an early practical exposure to the Arts and Crafts movement for John. He noted it in *Summer's Lease* as a 'fine place'.[39] William Rothenstein was also keen on the Arts and Crafts movement, particularly on William Morris, and John would have been influenced by this at home as well. Their home in Gloucestershire was filled with furniture designed by Gimson and the Barnsley brothers and John was impressed by the creation of the contents of a large nearby house, Rodmarton Manor, by local craftsmen.[40] This presages John's later development of the idea that modern artists had unfortunately become disconnected from the societies in which they lived, their efforts irrelevant to the people around them. The men supplying furniture and tapestries to the local patron were, by contrast, doing what John thought artists traditionally did: producing work with a purpose, which people needed and for which they were prepared to pay.

Generally in the chapter on Bedales in his autobiography, John can find nothing worthy of mention, characterising the seven years he spent there as largely meaningless: 'It would be wrong to suggest that my years at Bedales were wretched, but I was vaguely oppressed by a sense of something being fundamentally amiss – I had not the wit to see that the want of application on my own part and of critical firm direction on that of my teachers was making nonsense of my presence there.'[41] Instead of the usual public schoolboy stories of homosexual crushes and

so on, John fills what might otherwise have been a thin chapter with an account of his burgeoning interest in the beliefs of the Roman Catholic Church. Noting that his mother had been brought up as a Catholic, he denied that this had had any influence on his own conversion, which he ascribed to his own independent analysis of what, in the absence of any particular religious environment at home, he regarded as the religious options open to him. Reverting to the faith of his paternal grandparents did not appear to be an option.[42] Instead, writing when he was in his sixties about his distant recall of the developing religious feelings of a teenager, John describes how the boy Rothenstein worked out from his own careful scriptural analysis that, among the options he chose to consider (becoming a Quaker, a member of the Church of England or a Roman Catholic), it was the last which would suit him.

Moving away from the Church of England into Roman Catholicism was not unknown among young middle-class English men at this time. Well-known examples, such as those of Graham Greene (converted in 1926 aged twenty-three) and Evelyn Waugh (converted in 1930 aged twenty-seven) represent a typical pattern of rebelling against the rigid and frequently uninspiring and unimaginative State Christianity of their upbringing, which they experienced in their family lives and particularly at their public schools, which John, by contrast, never experienced. In John's case, he was moving towards Roman Catholicism on his own volition and without leaving any other religious belief, however formal. It was to be a few more years before the move to Catholicism was confirmed, but the old man writing his autobiography fifty years later was keen to demonstrate that the development of his serious religious beliefs began and were settled on early in his life. He wanted to make it clear that Roman Catholicism was fundamental to his adult personality and not simply a fashionable lifestyle choice.

In the meantime his father's attitude to him as a schoolboy is glimpsed in occasional letters. To modern eyes the tenor of William's letter dated 2 January 1911 to his son aged nine, before John had gone to Bedales and when his father was away on his Indian trip, strikes a harsh, hectoring, note. After lecturing him about the deficiencies of his juvenile writing style, the letter goes on:

> But you must get into the habit of taking pains over some things, or else you will find everything so difficult when you grow up that you won't be able to do things at all. You will be ten years old soon, dear boy, and I do want to feel that you are getting more of a man. That is why I want you to learn to catch a ball and to hit one with a bat … Make up your mind to take a little more trouble, dear boy, because I want you to grow up into a capable person. Remember that you are the eldest of the children and that you ought to be a real captain.[43]

Allowing for the different basis on which fathers operated as regards their eldest sons in those Kiplingesque days, the letter captures something of William's style

in his dealings with John: he was a loving, caring father, but he was stern. He also demonstrated that he felt that his position as the boy's father entitled (and obliged) him to tell John what he had to do. This attitude continued when John became a man; it never really changed.

John was not the only person to have theories about the rightful position of artists in society, based on Arts and Crafts ideas. In his case, as with Eric Gill, for example, such ideas were to become fused with those of Roman Catholicism, whose status as the ancient religion of pre-Reformation England he emphasised. In John's view, all was well in the arts in England either before the Reformation of the sixteenth century, when Henry VIII broke with Rome and the Church of England came into existence as a State church independent of Rome, or in a wider sense before industrialisation some time in the late eighteenth century changed the traditional operation of English society. These ideas, their loose historical precision varying according to John's whim, emerged in his artistic thoughts with the publication of his book on Gill in 1927 and in the books on nineteenth-century art that followed. They emerged again at Leeds in 1933 when he put on a show of copies of medieval wall paintings. These artistic curiosities satisfied him on two levels: the original paintings had been hand-made for a specific purpose by artists integrated into the requirements of their societies; and they were made for decorating and glorifying the Roman Catholic Church.

The year 1920 was a key time in the fortunes of the family. After several failed attempts, John, badly prepared by the educational experiments performed on him at Bedales, eventually managed to pass the necessary – and, by all accounts, not difficult – examinations called Responsions required to get into Oxford, where he arrived at Worcester College in October to read Modern History.[44] His father wrote a description of him at this stage of his life, in a letter to Max Beerbohm: 'He is an ardent Royalist, a strong Conservative, wears spats and hard linen collars and shirts'.[45] It is hard to tell if William's tone was mildly sarcastic or paternally impressed. This may not have been a description of a typical product of Bedales, especially when combined with Catholicism.

By then the family had moved their base back to London (to Airlie Gardens, Kensington), as William had been appointed to the most significant external post of his artistic career: Principal of the Royal College of Art in Kensington. John now regularly met a wide range of students at the RCA who were favoured by his father's support and encouragement. One of the core foundations of John Rothenstein's later life, in terms of his connections with the British art world and, ultimately, his writing about artists in *Modern English Painters*, was the extent of his personal friendships with artists of his generation. These connections began through his father. When John was home during university vacations in the early 1920s and later when he had come down from Oxford and was back at home before leaving for America, he was living in a milieu in which it was natural (and easy) to make friends with RCA students who were close to his father and benefitting in

some way from his encouragement. Thus, for example, John got to know Edward Ardizzone, Edward Bawden, Raymond Coxon, Barnett Freedman, Percy Horton, Albert Houthuesen, Charles Mahoney, Henry Moore, Eric Ravilious and Alan Sorrell.

At Oxford, John was a failure academically, getting a third-class degree in 1923; he was relieved not to have done even worse.[46] He had come across interesting people there, in the fortuitous way that university life generates random opportunities for unforeseen friendships. For example, he shared college rooms in his first year with William Gerhardie, the novelist, who was some years older than him. John's autobiography mentions his relationship with Lawrence of Arabia, who was a Fellow of All Souls from 1920 to 1922, before he sought to vanish from public life. From among contemporaries who went on to greater things, John also knew Anthony Eden (1897–1977) (later Prime Minister), Philip Hendy (later Director of the National Gallery), the Hon. Eddy Sackville-West (1901–1965) (later a well-known music critic), Lord David Cecil (1902–1986) (later writer and academic), Lord Balniel (1900–1975) (a Trustee of the Tate in 1932–37), Adrian Stokes (1902–1972)[47] and Richard Hughes (1900–1976).[48] Of these, Eden, Cecil and Balniel were members of the Uffizi Society, where undergraduates could meet artists and critics like Roger Fry. Eden gave a lecture on Cézanne, which would have been an early exposure for most of those listening to the artist fêted by the Bloomsbury critics. John was present at Eden's lecture, which he described as causing a sensation.[49]

Worcester was not home to the more prominent undergraduates, who tended to be members of Christ Church, Magdalen or New College; but that did not mean that John escaped the hedonistic, dandyish side of early 1920's Oxford.[50] The fact that he received letters from the Hon. Elizabeth Ponsonby (1900–1940),[51] brightest of the Bright Young Things, shows that he was part of her wider circle, at least.[52] In his autobiography he describes how he got to know her and how much he liked her.[53] Similarly, in 1924 the writer Peter Quennell (1905–1993) wrote to him from Balliol chiding him for having stirred up trouble with Brian Howard (1905–1958),[54] a legendary dandy at Oxford and the model for Anthony Blanche, the aesthete memorably described in Waugh's *Brideshead Revisited* (1945). If John was in Howard's circle, as well as Elizabeth Ponsonby's, it is not hard to imagine that his work ethic might have been correspondingly diminished. Photographs of him as an undergraduate show him in his panelled rooms in Worcester; as he remarks in his autobiography, after he had found his feet in his first year and passed his first examinations, his second year was spent getting to know people and amusing himself.[55]

John later explained why he had developed little interest in the visual arts by this point in his life.[56] His *ex post facto* rationalisation of this may provide a key to his early years. Writing more than forty years after the event, he describes his lack of interest as being due to

the character and experience of my father. He was a man of preternatural dynamism who had been intimate with many of the masters active in his time, and a multitude of lesser artists; he had seen so high a proportion of their significant works in so many countries; he had formed an opinion on each and every one of them, and he constantly voiced these opinions. So much experience, such passionate and continuous didacticism, combined to make it difficult for me to enjoy the visual arts, for it left me with so little hope for personal exploration. I was at once brought up short in head-on collision with some fully formed opinion about it which my father ardently desired to impart, even to impose.[57]

There is a ring of truth to this retrospective analysis. William Rothenstein must have been in certain respects a stultifying father, as men who have enjoyed success-ful public careers tend to be towards their sons. Such a large personality cast a large shadow over his family, from which John struggled to emerge. Failing to develop an interest in the visual arts may be seen either as a feature of a larger suppression of his personality by the dominance of his father in that area, at least within the Rothenstein family, or as an unconscious act of rebellion against his father.

As with many other young men, then and now, John Rothenstein came down from Oxford, in his case in the summer of 1923, just before his twenty-second birthday, with no idea what he was going to do next and no real qualifications for doing anything, but with high expectations as to what type of work would be suitable for him. In common with others in his position, his idle and unformed thoughts

At Garsington 1922: Edward Sackville-West, John Rothenstein, Julian Vinogradoff, Helen Anrep, John Strachey, Leslie Hartley and William Stead.

could, after three academic years of writing history essays, manage nothing more specific than the possibility of being a writer. Many books and articles did indeed flow from John's pen over the coming years, and he became a good writer, but writing was not to be his principal career: fifteen years later he became the Director of the Tate Gallery.

CHAPTER 2
London and America, 1923–32

Put simply, for four years after coming down from Oxford in the summer of 1923, John messed about in London. He lived with his parents, did a bit of journalism for the *Daily Express* and others, socialised a great deal and published two small books: one about his father's work and one about his father's friend, Eric Gill. With almost no earned income, John nevertheless became an active member of the Savile Club,[1] of which his uncle Albert and father had been members since 1907 and 1908 respectively. John's upbringing and his experience of Oxford had given him a taste for a vigorous social life, which was to be lifelong. He mixed with people like the three Sitwells and Alec Waugh (1898–1981),[2] brother of Evelyn and member of the Savile, and occasionally met Evelyn himself, meriting references in Evelyn's diaries: 'I went to the Savile in search of Alec and found Johnny Rothenstein. We

Eric Gill; Alice Mary (née Knewstub), Lady Rothenstein, by Sir William Rothenstein, c.1913.

drank together and then bought some bottles of champagne which, after going to the Alhambra for a few minutes to see Layton and Johnstone, we took to tea at Olivia's.'[3] Although John himself makes no mention of this incident, he does record walking along Notting Hill Gate with Waugh around this time 'discussing the bleakness of our prospects'.[4]

Overall, John knew slightly many of the people whose lives have been recorded as part of the whirligig of 1920s Oxford and London decadence; but he makes no material appearance in any of the general studies of this particular (and well-recorded) group.[5] On the one hand, although he knew some of those involved in the world that would later be characterised as 'Brideshead', or those who made up the Bright Young Things, he was nowhere near the heart of any such group, however one defines it – he was fundamentally too much his father's son for that, with a serious and ambitious streak in his character, which emerged before too long, as with his father. On the other hand, his experience of Oxford and London in the 1920s makes his violent antipathy to what he regarded as the social deserts of Leeds and Sheffield in the depressed 1930s understandable.

In his more serious mode, as his father had when young made a point of taking every opportunity to extend his art-world connections, John also got to know many of the students at the RCA who enjoyed his parents' hospitality at their house on Sunday evenings. He also mentions talking to his father almost daily.[6] This combination of meetings with artists, talking about their work and what they were trying to achieve, and regular discussions with his father shaped the tastes and, more subtly, the inclinations of John Rothenstein's artistic character. The books he wrote before the war were all heavily influenced by his father's life and friendships and views on art. Eventually, when John came to write about twentieth-century British art, he was able to do so from a unique viewpoint, based on the personal relationships he had built up with artists over many years and based on the artistic background represented by his father and his generation of artists from which the sort of modern artists John liked had developed.

In June 1926 John Rothenstein, after long maturation, formally joined the Roman Catholic Church. The way in which John describes his religious beliefs in his autobiography and the emphasis he puts on them, culminating in his conversion, suggests that he wanted his readers to regard his Catholicism as a matter of great importance to him. Later occasional snipings about John's Catholicism affecting his judgements of artists (it was said that he had too much respect for Gill, Tristram Hillier and Roy de Maistre, supposedly because of their Catholicism rather than their artistic merits, for example) can largely be ignored as partisan comments from hostile critics. Yet, his religious beliefs did make him open to the achievements of the more spiritually inclined artists of his generation, such as Cecil Collins, David Jones and Stanley Spencer. Although John believed in the importance of his conversion, the motivations for it may not have been those he chose to express.

There were at least two unspoken reasons for his conversion (and for the considerable emphasis he gave it in his autobiography). In the first case, it was all part of his escape, conscious or otherwise, from the cloying influence of his father: becoming a Catholic would give him a characteristic different from those of his father. John said that going to America in 1927 was in part a wish to escape the influence of his father, and being received into the Roman Catholic Church is likely to have been partly driven by the same motive. When John told his father about his decision to join the church, William asked him to reconsider, as he himself had done when being led in the same direction by such Catholic friends as Gill. Indeed, in William's case the failure to become a Catholic was part of the cause of the breakdown of his relationship with Gill.

Another deeper and unspoken possible reason for John's conversion and the emphatic way he chose to describe it may have been his flight from what he regarded as the taint of Jewishness in his family. John never dealt happily with his paternal family's Jewishness. Particularly before the exposure of Jewish suffering at the hands of the Germans before and during the war, the attitude of the Roman Catholic Church towards Judaism was not always benign and he would have picked up occasionally strong feelings of anti-Semitism from his Catholic friends, his Oxford friends and more widely in the sort of society in which he mixed in London. Osbert Sitwell, for example, was a friend and later a Trustee of the Tate. Here is his biographer on Sitwell's attitude to Jews: 'Though by the standards of the time Osbert was in no way exceptional, his writings and recorded speeches are filled with examples of anti-Semitism. He insisted always that the Jews were members of a separate race, not merely of a separate faith, and regretted that they had been allowed "to adopt European dress and ape European manners. Their life is one round of pretence, of pretending to be Europeans, Christians, Englishmen, English Gentlemen, Peers and Viceroys".'[7] So far as Sitwell was concerned, John Rothenstein was Jewish, whatever faith he professed. When speaking of him Sitwell was later quoted as saying 'Some of my best friends are Jews: I just can't stand a Japanese Jew.'[8] (This last remark was a reminder of a line of personal insult towards John's appearance, which certainly clouded the Tate Affair, in which his features were said to resemble those of a Japanese person).

Then there was John's other Oxford acquaintance, Evelyn Waugh, whose anti-Semitism was openly and repeatedly expressed and long-lasting. The same applied for some time to John's friend Wyndham Lewis. Casual anti-Semitism in the English cultural world was widespread in the 1930s and it can be imagined how keen John would have been while moving in these circles to deny that his family was Jewish in any substantive sense. Even after the Second World War, English society had its anti-Semitic moments which would have ensured that John could never be completely off his guard insofar as those around him regarded him as Jewish. There was an instance in the late 1940s when Alfred Munnings, then President of the Royal Academy, who also regarded John as Jewish, was at the Garrick Club and

Sir Alfred James Munnings. Self portrait, c.1950.

'loudly called John Rothenstein a bloody Jew and said that was why he staged an exhibition of the work of Chagall, another Jew.'[9] This reflects badly on Munnings but it shows what Rothenstein had to put up with. When John was appointed as the London buyer for the Art Gallery of New South Wales in 1945, one of the gallery's trustees in Australia, probably assuming that John was Jewish, wrote to the director of the gallery: 'I fear that our money will be thrown, if not into the gutter, at least to the Ghetto.'[10] As late as 1960, when John was taken for lunch at the City Club by Anthony Lousada (1907–1994),[11] whose family had Jewish origins, John was warned by his host that the club was 'very anti-Semitic'.[12]

In the light of these sorts of remarks, it is no surprise that the autobiography plays down the Jewish background of the Rothenstein family. John treats his father's mother as the only seriously Jewish member of the family, as if his paternal grandfather's and father's Jewishness could be discounted (his father, as an adult, was never a practising Jew) and he speaks instead a great deal about the old English (and occasionally Catholic) family of his mother, the Knewstubs. There is evidence that John actively disliked his family being regarded as Jewish. It comes not from his own published writing, but from other sources, including a letter he wrote to the editor of the *Jewish Chronicle* in May 1933.[13] This letter affirms how keen he was not to be regarded as Jewish:

Dear Sir, I have just been shown a cutting from your issue dated 5.5.33 in which a bronze head of my wife by my sister, Mrs. Ensor Holiday ('Betty Rothenstein'), exhibited at the Royal Academy, is alluded to as a matter of Jewish interest. I hope that you will not consider me pedantic if I draw your attention to the fact that neither artist nor sitter, nor indeed any member of the Rothenstein family, are members of the Jewish community, but belong definitely to another faith. Unless my memory is at fault a contributor to your paper fully recognized this fact in as far as my father is concerned, in a review of one of the volumes of his 'Men and Memories'. I might also add that his father was closely associated with the Unitarian movement. I understand furthermore that a member of our family in London has recently made similar representations to your art critic, whose rather frequent (although I believe most sympathetic) references to members of our family are felt to be rather misleading. Yours very truly …[14]

At the heart of John Rothenstein's character was there a discomfort about his identity, which he sought to subdue and which may not have been helped by his taking on the beliefs of the Catholic Church?[15] He did not want to acknowledge the Jewish upbringing of his father or his father's parents; nor that his paternal grandparents were German; nor that their home was in the North of England.[16] None of these facts suited John's desired self-image. David Pryce-Jones, writing about Bernard Berenson (a Roman Catholic) and Pryce-Jones's own grandmother (Mitzi [Mary Fould-Springer]), both of whom had Jewish origins, put his finger on the issue which John may have faced: 'He and Mitzi had a similar psychological evolution. Both wanted to believe they had adopted a new identity so that other people no longer thought of them as Jews but they couldn't be completely sure of success.'[17]

Suppressing concerns of the kind John so passionately expressed takes its toll on a character; it creates a tension which may manifest itself somehow. As John started to move onto the public stage with the publication of his books, and particularly after his appointment to the Leeds City Art Gallery in 1932, after which he was always to be under scrutiny, moments of aggression began to appear towards those who in some way crossed him, which are not seen in the character of his father. For whatever reason, there was a fault-line in his personality and it caused him much trouble in the coming years.[18] Becoming an active Roman Catholic did not subdue this. Lousada, who met John only in the early 1960s but had quite a few dealings with him at that stage, thought he could see what John was trying to do, noting that John's '… constant struggle to establish himself as a Roman Catholic and not a Jew eventually brought him to very nearly a grinding halt'.[19]

One of the people with whom John had extensively discussed his nascent religious beliefs had been his father's friend Eric Gill. He had been talking to Gill about becoming a Roman Catholic long before he actually did so and Gill's association with the Rothenstein family gradually transferred itself from William to

John; the father had disappointed Gill by making it clear that, ultimately, his mind and outlook on life were determined by secular (or artistic) rather than religious thoughts and he refused to become a Catholic despite Gill's encouragement. John, by contrast, had a stronger streak of religious belief than his father. From as early as 1919 through to John's conversion in 1926, correspondence with Gill had continued, gently sharing issues relating to the Catholic faith. At the conversion, Gill agreed to be John's Catholic godfather. John claimed that he only realised that his friendship with Gill had outlasted that of his father after both men had died.[20]

Another person John became friendly with from 1920 onwards was Wyndham Lewis, again originally a friend of William's. John had many meetings and discussions with Lewis, crediting him with helping him to dismiss abstract art: 'He clarified my vague comprehension that abstract art – however natural and beautiful a means of expression for certain temperaments – was wholly inadequate as a means of expressing the full content of the vision of others.'[21] It is unclear how John accommodated the fact that Lewis's novels contain many anti-Semitic passages and that it was only with the war that Lewis started to reverse his earlier opinions on the subject. His attack on John's friends the Sitwells, in his 1930 novel *Tarr*, may also have caused a moment of awkwardness for John. Friendship with Lewis also reinforced John's enmity towards Roger Fry. Lewis had fallen out with Fry years earlier and he gave John another reason to dislike the Bloomsbury critics.

Wyndham Lewis. Photograph by George Charles Beresford, 1913.

John always gave practical help to artists he particularly liked. In Lewis's case, there were to be at least two major works purchased by the Tate in John's early years there: the portrait of Ezra Pound in 1939 (Tate, 5042) and the *Surrender of Barcelona* in 1947 (Tate, 5768), and other pictures by Lewis also entered the Gallery's collection during John's directorship. The practical help culminated shortly before the artist's death with the major show put on by the Tate in 1956, *Wyndham Lewis and Vorticism*.

In 1923, John made the acquaintance of Stanley Spencer, the third of his father's old friends whose spiritual approach to painting struck a chord with John. Again, there were to be many meetings and discussions over the years and both John and his wife, Elizabeth, became close to the artist, tirelessly putting up with him and his eccentricities.[22] When opportunity arose, John did his best to promote Spencer's career by putting forward his pictures for acquisition (see following chapters). Later, John would guide the Tate Friends to acquire another important picture for the Gallery and in 1955 the Tate organised a retrospective of Spencer's work. The relationship between John and his wife on one side and Spencer on the other is an excellent example of how practically helpful and supportive the Rothensteins were to artists who needed their help.

John's connections with Lewis and Spencer made for fruitful material for their respective chapters in *Modern English Painters*, though Gill, having a book to himself in 1927, did not appear. In these otherwise fallow years before going to America, John gathered material for his book *The Artists of the 1890's* (1928), meeting those artists who survived from the group he had chosen to cover, namely Walter Greaves, Philip Wilson Steer, Charles Ricketts and Charles Shannon.

By 1927 his parents knew that, while he was developing and honing his skills as a writer, he was going to have to do better; if he was ever going to be independent they suggested that he could no longer live cosily at their expense in his attic apartment at their home in Kensington. John knew that his parents were right; that something had to give. His writing career was developing slowly, but was desultory and unfocused and was never going to earn him any serious money to live on or form the basis of a viable career. His parents were not wealthy enough to maintain him while he amused himself in the Savile Club, even if they had wanted to. He had to find something else to do. One short sentence in his autobiography hints at the direction in which his mind was travelling at this time: 'I failed an interview for a junior post in the Victoria and Albert Museum.'[23] Other failures of this kind awaited him after he came back from America.

What he in the end found to do has the feeling of a direction which he had not necessarily planned to take, although he later said that he had been considering some such move for several years.[24] It may have been a suggestion made to him by his father. John's version was that, in talking over the choices for his future with Bernard Berenson, his father's friend, the latter suggested to him that he might be able to get him a position in the art history department at Harvard and wrote a

Bernard Berenson, c.1950. Photograph possibly
by Barbara Strachey.

suitably supportive letter intended to facilitate this. In the meantime, apparently coincidentally, an offer arrived from a Professor Sax that John might wish to join, not the highly prestigious faculty at Harvard, but the less well-known art history department at the University of Kentucky in Lexington. The invitation came not to John but in a letter to his father, dated 18 August 1927, in which it was made clear that one of the reasons for inviting John to take the job was his father's reputation (together with the fact that Geoffrey Holme, the editor of *The Studio*, had recommended John).[25] If the idea of John's going to work in an American university art history department originated with William, this would explain the intervention of Professor Sax. John presented the decision as one he reached himself, with the help of Berenson. Certainly, he was only offered a job of any kind because he was William's son: it is difficult to see what other qualifications he had in 1927 for such a job. When the Berenson-inspired approach to Harvard did not materialise, the Kentucky offer was accepted.

In 1927 John became a lecturer in the department of art history at Lexington for the academic year 1927/8; the following academic year he moved on to a similar position at the University of Pittsburgh. These were not prestigious jobs in the international art world of the 1920s, but they were at least regular and paid after the arid years in London. As they were in the lecturing and teaching side of that world, they were not directly relevant to a career which later lurched off into gallery administration; nevertheless, they opened John's eyes to a life that was not directly under the influence of his father and which might lead him to something resembling a career.

The ability to lecture and teach, often in subjects about which John knew nothing, was good training, both for his later professional life back in England and also for his self-confidence. Professor Sax, writing to William on 5 October 1927, shortly after the start of John's first term, reported that John was doing well in his lecturing: 'He seems to be a born teacher'.[26] John was to lecture on a wide variety of subjects throughout his life and his American training helped him to contemplate and achieve this.

In an undated printed letter noting its annual meeting on 29 March (which must have been 1928), the Kentucky branch of the English-Speaking Union tempts its members by saying that, at the conclusion of routine business, Professor Rothenstein would speak on 'Great Britain's World Policy and the United States'.[27] (One of the features of American university positions at this time was that people like John Rothenstein, with his poor academic record, were rapidly elevated to the level of professor.) This and other recorded lecture topics[28] suggest no lack of self-confidence for a young man who had scraped a third-class degree from Oxford. They suggest a man with a strong belief in the importance of his thoughts on any given subject; others in his position might have declined an invitation to speak on a subject which they had no qualifications to cover, but not John. Merely being aware that he agreed to give such a speech – without knowing what he said or how it was

John in his twenties by unknown photographer.

received – slots in a piece of the jigsaw of John's personality which will need to be recalled concerning his later years: too much self-confidence. He acknowledged another shortcoming in his character a little later when writing to MacColl from Pittsburgh to praise one of his books: 'I have to guard myself constantly against absorbing your point of view entirely at times, which is the highest praise any person as obstinately opinionated as myself can give.'[29]

John's lectures were sometimes reported in local American newspapers, which described his background: these descriptions must represent the young Rothenstein's self-image, as the coverage can only have come from information provided by him. An unidentified Kentucky paper says this, under the heading 'Authority on art will teach here this year':

John K. M. Rothenstein, member of an English family of famous artists, has been added to the faculty of the art department of the University of Kentucky. The new professor is the eldest son of Prof. William Rothenstein a celebrated English artist, who has made more portraits of his great contemporaries than any other living painter. He is the principal of the Royal College of Art, London and trustee of the National Gallery of British Art. John Rothenstein also has artistic connections on his mother's side, she was formerly Miss Alice Mary Knewstub oldest daughter of the late Walter John Knewstub, a well-known pre-Raphaelite painter and an intimate friend of Rossetti. He was also a direct descendant of John Knewstub, the celebrated preacher leader of the Puritan party in the reign of Queen Elizabeth. Mrs. Rothenstein's mother was formerly Miss Emily Renshaw, a noted beauty several times painted by Rossetti. Among John Rothenstein's other relatives of artistic interest are Sir William Orpen an uncle, and Albert his father's youngest brother, who designed scenery for various ballets and Mrs. Pavlova and Karsavina. Another brother, Charles recently gave his magnificent art collection to the City of Manchester. Mr Rothenstein was born in Edward's Square, Kensington, London and educated at Bedales School, Petersfield and Worcester College, Oxford. He was graduated from Oxford in 1923 taking honors in modern history. At the university he was joint editor of the undergraduate conservative magazine, the Oxford Fortnight. After graduating he became lead writer on The Daily Ex, Times Literary Supplement, contributor to the Spectator, National Studio, Apollo and other organs of the London Press. In 1926 he published a monumental work, the Portrait-Drawings of William Rothenstein 1889–1925: the American edition of which has just been issued by the Viking Press. Last year he published a short critical biography of Eric Gill, his god-father, whose best known works are the carved Stations of the Cross in Westminster Catholic Cathedral, London. He has been commissioned recently to write a section on printing in the new Harmsworth's History of the World. Mr Rothenstein has been privileged in having from his earliest days entry into

the innermost circle of the artistic and literary world of London, and enjoying the friendship of such men as Joseph Conrad, Arnold Bennett, Max Beerbohm and W. H Hudson. His recreation is traveling, and it is his intense interest in America that has been, more than anything else, instrumental in bringing him to Lexington.[30]

Encouraged by making progress in his life away from the influence of his father, John began to flourish in America. He wrote to his mother on 11 October 1927: 'I am enjoying life here immensely. The work is very arduous, but it happens that I can manage it alright.'[31] Describing the work as 'arduous' is the sort of thing young people say to their parents when in their first job, to encourage relief in their parents' minds that all the years of sacrifice they have made have been worthwhile. It may have seemed arduous compared to loafing about at home or in Oxford, but in reality it was not; John knew, though, that it was what his mother would want to hear. He enjoyed what provincial American middle-class society had to offer in the 1920s, where he was treated with deference as a rare visitor from another world, and soon discovered love, meeting Elizabeth Smith, from a prominent local family, whom he married within a few years and who remained a loving and supportive wife throughout their long life together. John's mother would have been delighted had she lived to see how John's marriage worked out. On 25 May 1929 she wrote to John regarding his wedding to Elizabeth: 'together you will be strong to fight the battles of life and withstand the disappointments.'[32]

Any life viewed backwards, with full knowledge of the future, gives hints as to themes or characteristics which only later became apparent. In John's case some of these hints, these touches of colour, had been building up and in 1927 there was another one: John arranged for the University of Kentucky to put on an exhibition of his father's portrait drawings.[33] These had been the subject of John's first book, in 1926, and now he arranged a matching exhibition. The book and the exhibition demonstrate how John's formative years as an active member of the art world were influenced by using his father's reputation.

John's experience in the history of art department of the University of Pittsburgh for the year 1928/9 was more of the same sort he had had in Kentucky. He was listed as lecturing on introductory topics, such as 'The Architecture of the Italian Renaissance' and 'Modern Art'. Where he acquired the qualifications to lecture on the former is not recorded; it was probably at a basic level and perhaps no one in the audience knew any better. As time passed, John sensed that, in the career-planning which was then beginning to mould the way he considered his life, there was nothing more to be gained from hanging around in America, lecturing to uninterested students at provincial universities; his life, and whatever career he was going to have, would have to be made in the more culturally sophisticated and challenging milieu of England. Certainly, no career which John would have wanted could be made in Pittsburgh:

John Rothenstein and Elizabeth by William Rothenstain, 1939.

in the autumn [of 1928] I plunged into the murk of Pittsburgh. Natives of this city and visitors of later years speak of it as a place transformed, but in 1928 and 1929 it was not an agreeable place, for an outsider at all events, to live in. … Pittsburgh University seemed to me to be an inhuman place, an institution like an office which students attended for the sole purpose of securing the degrees necessary for their several careers.[34]

On 12 January 1929 John wrote from Pittsburgh to MacColl, thanking him for his advice: 'I should like too to follow the rest of your advice and come to London and do art criticism. If I saw any chance of regular work of that kind I should be more than happy to do it, partly for its own sake, partly because I find this city so odious.'[35]

John's later descriptions of Leeds and Sheffield show how uncomfortable he was in industrial cities like the one from which his paternal family came. The refinement

of some part of his upbringing, no doubt while enjoying the superficial sophistica-
tion of life among the smarter undergraduates at Oxford and in the Savile Club,
had made such places insufferable to him. His earlier books demonstrate that he
disliked the effects of industrialisation generally and blamed it for what he saw as
some of the shortcomings of the world-view of many modern artists. This idea
probably came from Gill.[36]

In the summer of 1929, after teaching for one academic year, John could stand
academic life in America no longer. He left Pittsburgh, returned to Lexington to
marry Elizabeth and then set sail for England. For the two and a half years which
followed, John and Elizabeth lived with John's parents in London, in the same
rooms which John had vacated a few years earlier to go to Kentucky. With a view
to making promotion in the art world more likely by equipping himself with an
appropriate qualification, or because his ignorance of much about the history of art
had become apparent to the young professor, John took a doctorate in art history at
University College London.[37]

There were times during this period, as he explored opportunities for a paid
job in the English art world, when John and Elizabeth contemplated returning to
America to live and work. One of the reasons for John coming back in the first
place had been the possibility of applying for a position at the National Gallery,
for which purpose he had managed to secure another letter of support from Ber-
enson.[38] But John seems not to have applied. In 1930 Randolph Schwabe wrote
to John regarding 'backing for the Edinburgh chair'.[39] Later that year he was put
forward, at the instigation of W. G. Constable (1887–1976), the first director of
the Courtauld Institute,[40] and despite John asserting that he had no interest 'in the
field of provincial art gallery direction', for the job of director of the Walker Art
Gallery in Liverpool, which he also failed to get after a hopeless performance at
the interview.[41] On 31 March 1931, MacColl wrote to support John's application
to become Keeper of the Ashmolean Museum in Oxford.[42] It is not known if John
did not apply or applied and failed. Schwabe noted that he was at a committee
meeting of the New English Art Club in July 1931 when John's application to be
Gallery Secretary[43] was considered and rejected.[44] The artist George Clausen wrote
to John on 4 February 1932 noting that he thought John had the 'qualities essential
in such a responsible post as that you are seeking' (it is not known which applica-
tion Clausen was referring to).[45] This somewhat depressing pattern of failure to get
the sort of job he was seeking, or indeed any job, is not described in these terms in
the autobiography; the Liverpool experience is the only one he mentions. When
writing in 1965, John must have felt that a recently retired Director of the Tate
Gallery could admit to a certain amount of youthful failure, but not what might
amount to a catalogue.

Then, early in 1932, John was encouraged to apply for the position of Director
of the City Art Gallery in Leeds, which was vacant.[46] The stars in the firmament of
John Rothenstein's career in the art world were at last beginning to align.

CHAPTER 3
Leeds and Sheffield, 1932–38

In early 1932, John Rothenstein defeated twenty-one other candidates to get the job of Director of Leeds City Art Gallery. Despite what sounds like a considerable achievement he was not enthusiastic about his new position when he arrived in July of that year: 'The large size and the utter dereliction of the place, my total inexperience of administration and my ignorance of provincial museums, heightened my misgivings; had I found myself captain of an unseaworthy ship instead, they would hardly have been more serious.'[1] This description, written thirty years after the event, may be compared to the positive comments he gave to a local paper almost as soon as he arrived. On 7 July 1932 he was reported in the *Yorkshire Evening Post* as saying that he was 'much impressed by what I have seen of the collection here'. He had noted with approval works by Thomas Gainsborough, Richard Wilson, John Sell Cotman and Thomas Girtin and a few days later he loaned the gallery his Blanche portrait of Walter Sickert. He was quoted in the *Yorkshire Evening News* of 3 August as saying: 'by purchasing the work of younger contemporary British Artists … Leeds will be participating in the artistic life of the country'. This was an early statement of John's noble ambition at Leeds, and later at Sheffield, which was to instil into the artistic community in which he found himself an appreciation of modern British (and where possible foreign) art. In September 1932, under John's influence, Blanche's *The Saville Clark Girls* entered the collection through the Leeds Art Collection Fund.[2] He also arranged the acquisition of a picture by Barnett Freedman called *Sicilian Puppets*, Spencer Gore's *Standing Nude*, Gilbert Spencer's *Girls gathering Flowers* and Wyndham Lewis's portrait drawing of Wing Commander Orlebar.[3]

John also encouraged the acquisition of work by earlier artists. By October 1932, a portrait by William Orpen had been donated, as had a painting by George Morland. John had got the gallery to acquire a Girtin watercolour and a Canaletto of 10 Downing Street had been lent. By December, there had been further loans, of works by Augustus and Gwen John, Matthew Smith and Stanley Spencer and a picture by Rossetti had been bought. In November, John wrote to the art historian Tancred Borenius (1885–1948) to say: 'I am enjoying the work here immensely and making very dramatic changes'.[4]

Whatever his view of its art collection, he was not enthusiastic about the city of Leeds. Here he is writing to MacColl on 28 July (probably 1932): 'A brief note to tell you how I am faring in these strange surroundings. Contrary to my expectations,

Leeds is a dead city: there seems to be no life, no interest in anything but sport, no society at all.'[5] In a letter dated 27 July 1932 to his mother he had said: 'we have no life here, and therefore no real news. We hardly know anyone, no-one seems to go out or to entertain; Leeds is in fact a dirty, dreary and utterly dead city.'[6] It seems to have been Pittsburgh all over again. A few months later he wrote to his father (on 7 October): 'I need not tell you how I long to be back in London. As a matter of fact I rather dread my visit by reason of the inevitable departure.'[7] Christmas 1932 was spent at home with his parents and, whatever the impression given elsewhere, it is interesting to read William's comment about the visit in a letter to Max Beerbohm on New Year's Eve: 'We have John and Elizabeth with us over the holidays: John seems to have made great changes at Leeds, and Elizabeth to have gained many friends.'[8] John took the opportunity over the holidays to keep himself abreast of what young British artists were doing by visiting the studios of Barnett Freedman, Percy Horton and Eric Ravilious.

William, who was an ambitious man, and ambitious for his family, and far more experienced and balanced in his understanding of how a career could be developed, was indeed taking the longer view of John's career and was quite pleased with John's appointment. On 31 March 1932 he had written to Elizabeth: 'You know how delighted we all are over John's success. The more I think of the prospect, the greater the chances I see for John. He can raise the whole standard of the provincial museum in England if he throws himself into the work.'[9] Nor did William share John's dislike of the industrial cities of the North: 'In Sheffield, as in Bradford, he was impressed by the sense of power common to all the large industrial cities of the North. This was the West Riding and he felt at home.'[10] Jim Ede (1895–1990),[11] working at the Tate and Modernist in outlook, also wrote to John with great (if not entirely diplomatic) enthusiasm to congratulate him on his appointment: 'It's a great thing for these provincial towns to get intelligent people to the gallery, they don't deserve it'.[12]

What is particularly striking about John's description in his autobiography of his journey to the North, and his expressed dislike of the Yorkshire scenery which he encountered on the way, is his failure to connect his experience with the fact that his father's family came from the great industrial city of Bradford, a few miles down the road. As a boy John had visited his German grandparents there and later his uncle Charles, after the latter had taken over the running of the family business following his father's death in 1914. (Charles himself died on 1 January 1928.) William had been brought up in Bradford and later became the first Professor of Civic Art at the University of Sheffield in 1917 (until 1926), and yet John describes his journey to Leeds as if he were visiting another planet. Something psychologically odd is going on here in the way that John, many years later and after his long metropolitan career at the centre of the British art world, again sought to shape the narrative of his life. By the 1960s when he was writing the first volume of his autobiography, it suited him to paint a picture in which arriving in the North was

utterly alien to him; it did not suit him to connect the history of his family in the area with his own circumstances. Leeds was in a way a natural place for someone with his family background to go, but there is no sense of that in the authorised version of his life.[13]

This first experience of managing a public gallery was a trial run for the Tate not many years later. Helped by the excellent Secretary, Ernest Musgrave (1901–1957), who was John's age and went on to have his own distinguished career as Director first of Wakefield and then of Leeds City art galleries (in 1945),[14] John set about re-ordering the dilapidated and disorganised gallery completely; he eventually persuaded the authorities in 1933 that it had to be closed down for two months so that it could be repaired and repainted and the collection rearranged and rehung without interference from visitors. This was preparation for the revivification of the Tate after the Second World War. Musgrave ('a reassuring figure, resourceful, imperturbable, conscientious, courteous, and above all dedicated', as John described him in *Summer's Lease*) taught him to understand the administrative side of running an art gallery: 'It was he to whom I owe my initiation into art gallery administration, for I had no notion how pictures were packed, transported or insured, or how the staff entrusted with their custody were recruited and organised.'[15]

John also experienced for the first time the need to try to accommodate the wishes and interests of a governing body – in this case the Art Gallery Sub-Committee of the Libraries, Art Gallery and Museum Committee of Leeds City Council, of which Alderman Leigh[16] was the chairman – whose attitude to the promotion of modern art was not necessarily sympathetic to that of the director. This was preparation of sorts for dealing with the more formidable body of the Tate Trustees in later years, although the issues facing those local worthies seeking to guide provincial art galleries into the modern world in the 1930s were different. There was a strain on demands on local funding for an art gallery (as against a hospital or school, for example) and a suspicion amongst those holding the purse-strings of the benefits of spending council funds on modern art. 'They often showed prejudice both [sic] against what was unfamiliar and a strong disposition to accept gifts proffered by influential citizens, but, as far as my own experience went, they otherwise received the Director's proposals in an open-minded and friendly fashion.'[17]

The reorganisation of the gallery was done well and John deserves great credit for deciding that it had to be done, persuading the authorities to let him do it and then actually achieving it. The place ('disgusting to enter')[18] was reconstituted: pictures cleaned, rehung, brought from and sent to storage; new works acquired, some of them from artists who were John's friends, and the work of the best local artists brought to the fore in their own room; the roof repaired and the galleries redecorated. John was able to impose on the gallery his vision of what an acceptable collection of largely British art across a wide period should look like. He carried on using his and his father's connections with young British artists to acquire pictures from them. A small work by Allan Gwynne-Jones was acquired, but the highlight

was the acquisition in July 1933 of *Separating fighting Swans*, a major work by Stanley Spencer.

For many of the young artists concerned, not only was the financial benefit of selling a picture to a public gallery helpful in alleviating their often atrocious financial circumstances, but it was also, in many cases, an extraordinary opportunity which John was giving them to get their works into a public collection, at a relatively early stage in their careers. The ways in which twentieth-century British artists were able to develop wider reputations as artists is not always clear, but it must be the case that publicity about their work going into a public collection helped them. The response to all the changes, from the national and local press coverage of the reopening, which was effected by John's friend W. G. Constable at the end of June 1933 and which his proud parents attended, was encouraging. The art critic of *The Times* had a piece on 3 July under the heading 'Leeds Art Gallery. A transformation', which concluded: 'It is not easy to recall such a good account of one year's stewardship as the reopened gallery affords, and it is to be hoped that Dr Rothenstein will receive from his committee the encouragement and support that he clearly deserves.'

John achieved a similar transformation after the war with the Tate. His Leeds experience showed how effective he could be at galvanising action and resolving practical challenges which might have overwhelmed directors from the more scholarly end of the art-world spectrum. Visitors to an art gallery will judge their experience more by the physical environment they encounter than by the extent of the director's academic achievements.

An exhibition which John arranged at this time – *Copies of English Mediaeval Mural Paintings by E. W. Tristram*, 1933 – illustrates the way in which his religious

Percival T. Leigh by Edwin Crosse.

beliefs could colour his directorial activities. The point of the show, so far as John was concerned, was that the originals pre-dated the Reformation. They were, in other words, Roman Catholic in conception and context. Nestling in amongst more normal sources of reviews of shows at art galleries in John's press-cuttings book is a small piece from the *Catholic Herald*. Their attention must have been drawn to this obscure show in the North by the director; it is difficult to imagine that they would otherwise have been on the mailing list of an art gallery in Leeds for all its normal shows. They drew the conclusion which John would have wanted, seeing the exhibition as of 'unique Catholic as well as artistic interest.'[19]

If the overall task of negotiating improvements in the set-up of the gallery was only loosely speaking similar to what John was to face at the Tate, there was an ominous foretaste of his later experiences in the deterioration of his personal relationship with an important local figure.

Alderman Leigh was a key member of the small Leeds art community of the 1930s, effectively controlling the appointment and activities of the director of the art gallery through his chairmanship of the relevant committee. It was essential for his own well-being that the director work out a suitable modus operandi with the Alderman. He had encouraged John to apply for the post in the first instance and this may have led John to assume that his support was unconditional. John did not always read people correctly when confronted with views which were not those he held. Photographs in the local newspapers show how an alderman of the 1930s might feature in a caricature. Not especially tall, he was balding with at times a short, military-style, moustache. He wore a wing collar, a dark three-piece suit appropriate to a man of his office, with a watch-chain visible across his stomach and a decidedly steely glint in his eye. Although John indulges himself in his autobiography with an insulting description of the Alderman's local accent and ignorance of art, in a passage which cannot have amused Yorkshire readers of his book, in the confined space of Leeds local politics in which he operated in the 1930s, Alderman Leigh was a man not lightly to be crossed, especially by a young man from the South of England of a type far different from an alderman.

By contrast, the published photographs of John at this point (often in the same photograph as the Alderman when something was being opened at the gallery or a particularly fascinating item was being pointed out to an enthralled visiting dignitary), show a formally suited, serious, scholarly looking youngish man. With the young director being slightly built, hair thinning, wearing spectacles and unsmiling in every photograph, there was perhaps a suspicion among those observing and forming judgements of him that he was a serious man indeed: might his expression, so relentlessly stern and unbending and indeed blank, intimate that he was supercilious about the situation in which he found himself?

Alderman Leigh was not, by John's account of matters, entirely straightforward with him regarding his salary. In the way in which John tells the story, choosing to emphasise what he portrayed as naivety, he had understood that his annual salary

was to be the same as his predecessor, namely £650, even though this had not been confirmed at the time of his application or interview. John claimed that he was persuaded to accept the post for the tiny sum of £360 on condition that, according to his understanding, it would rise to £650 at the end of his first year. No written record was made of any such agreement. When the anniversary came and no salary rise was forthcoming, John handed in his notice at the end of October 1933.[20]

From this point onwards John's account of events cannot be trusted; there is a degree of manipulation of the record. According to John, his resignation, done privately by formal letter to the chairman of his committee in the appropriate manner, was followed to his astonishment by Alderman Leigh wrong-footing him by giving a statement to the press about the resignation, which John did not think accurately represented the facts. This unexpected turn of events forced him reluctantly to abandon proper procedures and turn in self-defence to the gentlemen of the press himself.[21] In fact, following the story through the press cuttings which John retained (and which he might have consulted when writing his autobiography), it did not happen like that at all. John first submitted his letter of resignation and then immediately made a statement to the press about it, before the possibility of any comment from the Alderman to the press. This is known because many newspapers reported the statement verbatim on Friday 27 October without comment from the Alderman. Repeated in identical terms across a number of papers (here the *Bradford Telegraph*), it was clearly a written statement and not just a verbal response to different journalists' enquiries:

> The Chairman of the Libraries and Arts Committee has been aware for many months of the circumstances which have compelled me to resign, with the utmost respect, my position as Director of the Art Gallery.
>
> These circumstances are outlined in a letter recently addressed by me to the Chairman, informing him of my decision, and if it is considered desirable that the contents be made known, I am perfectly willing that it should be published.

What is more, his resignation was announced simultaneously with that of Loris Rey (1903–1962),[22] who was the head of the Sculpture Department at the Leeds College of Art and whom John knew well, having recently published an article about him in the *Yorkshire Post* on 22 June 1933. The conjunction of statements cannot have been a coincidence. This was a deliberately concerted act by John and his friend, designed to cause the maximum amount of public discomfort to his employers and specifically to Alderman Leigh, especially because John's statement made it clear that, if the press wanted to know the real reasons behind his resignation, they simply had to ask the Alderman, whereas John himself, apparently with firm adherence to the proprieties of the situation, could not comment further.

It is not clear what John hoped to gain from all this. He may have imagined that the publication of his story in local newspapers would pressurise the committee

into begging him to withdraw his resignation and offering him a higher salary; possibly it was a simple act of spite against one who was not going to be allowed to think that he could get the better of 'the Professor'. The initial newspaper stories contained no comment from the Alderman, who was said to have been away from home but who may perhaps have been gathering his thoughts on how best to deal with the young man. If he was discommoded in any way by John's presentation of the circumstances surrounding his resignation, it was only for the briefest moment, for by the time the weekend was over the Alderman had loaded up his ammunition and the papers were telling a different story.

On Monday 30 October, the ongoing newspaper coverage of this exciting local event suggested that the Alderman's press machine had opened up with its first salvo; one can assume that the Alderman had at least as many friends in the local press as the director. *The Evening News*, for example, said this about the Alderman's reaction to the resignation: 'It has come as a great surprise. We have backed Dr Rothenstein up in everything and any suggestion that we have not seen eye to eye on some matters is groundless. The question of salary was to come before us shortly'. This statement appeared in a number of papers. At the same time, Mrs Leigh, also a member of the Libraries, Art Gallery and Museum Committee of which her husband was chairman, was making statements to the press, presumably with her husband's knowledge. She focused on John's salary, acknowledging that it was an issue, praising her husband for wanting to increase it but finding his hands tied in the dire economic circumstances in which in 1933 everyone found themselves. The final Leigh family quotation which then did the rounds, all on the same day, appeared for example in the main local newspaper, the *Yorkshire Post* on 30 October: 'The reason Dr Rothenstein is leaving is that he wants more salary. That is the only point.'

The Alderman knew his man. This statement annoyed Dr Rothenstein considerably, as his autobiography makes clear. It annoyed him so much that he felt that he had to have another word with the journalists, who were enjoying this tit-for-tat rather more than the daily fare they were used to writing about when covering the municipal life of Leeds. That John's rejoinder began to appear in the press on the same day as the Alderman's last shot shows how keenly he was conducting his campaign, making himself available to the press whenever they needed a quotation. His brief experience at the *Daily Express* after Oxford had not been wasted. For example, the *Yorkshire Evening News* on 30 October quoted John's response to the effect that he had resigned not simply because he wanted more salary, but as a matter of principle, namely that he had been promised a salary increase by Alderman Leigh on which he had relied and which had not been forthcoming.

It appears that, following these rapidly delivered on-the-record exchanges, honours were at least equal in terms of how the people of Yorkshire were likely to be thinking about the principles of their young and soon-to-be-departed director. If this is how John saw things as the press developed the story, it may have caused him

to play his final card. The next day, the 31st, stories appeared in the press saying that John might be appointed to an exciting new post in Sheffield. A few days later this was confirmed and the vigorous press campaign about the resignation from Leeds subsided. All that is left at this point is to tuck away the thought that John occasionally relished a public scrap, which he preferred not to be seen to have lost, and that he used his autobiography to publish his account of key events in his life, putting himself in the best possible light on all occasions.

After the lively phase of newspaper coverage, the *Yorkshire Post* reported on 10 November that Alderman Davies had said that he was: 'informed that within 12 minutes of Dr Rothenstein's letter of resignation being delivered to the proper officer both newspapers in Leeds were informed by telephone of its contents, and I consider it is a very improper procedure for Dr Rothenstein to have adopted. If he wanted to attract publicity to himself, he certainly succeeded.' This mildly defamatory comment was not met by Dr Rothenstein with a writ claiming damages for his injured reputation. The paper published a quiet letter from him on 13 November denying the truth of the story and saying that he had merely responded to the press when they approached him. It often helps, in working out the source of a leak, to identify who stood to benefit most from the leak. In this case it is not obvious why it might have suited John's employer to leak his letter of resignation as soon as it was received and before he was ready to comment on it.

There was an aldermanic theme to John's life at this time. He had been approached during 1933 by another one from Sheffield, asking whether he would come to Sheffield to run the art gallery he was building there.[23] The offer from Sheffield was formalised and accepted on 10 November 1933, some time after it had suited someone to provide the local press with the story during John's altercations with Alderman Leigh. John may only have felt confident enough to stir up the hornet's nest in Leeds because he knew that the better-paid position in Sheffield was his and he thought he would have some sport. Before moving the short distance from Leeds to Sheffield, however, other things need to be considered which are not recorded in the autobiography but which are relevant to an understanding of John's career.

It has been a theme of this work that William influenced his son. During August and September 1933 he wrote him a series of letters that illustrate how he involved himself with John's career.[24] On 25 August, William wrote in relation to John's draft letter of resignation from the Leeds post, which he must have sent his father for comment two months before deploying it. This shows how long John had been mulling over his resignation strategy.[25] He would also have needed time to get Loris Rey's resignation aligned with his own. It is also a sure indication of the closeness of their relationship and the respect John had for his father and his views that John, aged thirty-two, felt it necessary to do this. William duly gave his advice, although it is not known if John took it. It was, in the circumstances, good advice, showing the pragmatic subtlety of William's mind:

There is a slight note of personal resentment against Leigh: to my mind your letter would gain were this omitted. The fact remains that you were keen to get the job and that Leigh did strongly support your candidature. Any hint of failure to keep his word must offend the recipient of a letter of the kind you intend. Such a letter is read again and again, is put before the committee and carefully scrutinised and discussed.

A committee may justly say that the Chairman exceeded his duties if he made promises he was not in a position to make or keep. That you and others put in for the post knowing what the salary was – and that, if you are not satisfied you are perfectly within your rights in going elsewhere. Letters always *read* more strongly than they are meant to; and there is quite enough criticism in your leaving without forcing the point too much … I do think it important that you should leave under the pleasantest conditions. For Leeds has been your first step up the ladder and, in its crude way, has shown appreciation of your work.

One suspects that, although John shared the draft of his resignation letter, he did not discuss his press campaign with his father before he launched it and that William would not have approved.

Kenneth Clark, whose formidable career achievements in the art world were, at every stage, to overshadow those of his contemporary John and every other

Kenneth Clark. Photograph by
Howard Coster, 1934.

participant in that world, had been Keeper of the Department of Fine Art at the Ashmolean in Oxford, but in the second half of 1933 it was known that he would be leaving to take up his new position as Director of the National Gallery, which was to begin on 1 January 1934. In a letter dated 4 September, William suggested that John apply for the job at the Ashmolean. He knew that John was on the brink of resigning from Leeds. William confirmed that he had consulted his brother Albert, who had since 1929 been Ruskin Master of Drawing at Oxford and who was a Fellow of New College. Albert's position required him to work in the Ashmolean most days, so he was well placed to advise his older brother whether the position there might suit John. Here is what William said that Albert thought at this stage: 'Albert was here last night and is warmly in favour of your putting in for Clark's post'. Over the next few days, William reflected upon his advice about Oxford as he mulled the matter over in his mind. He had asked his brother whether his position in Oxford would help John's application or hinder it. The answer from Albert, whose thinking had also evolved since he was first consulted by William on the evening of 3 September, was that he now felt that his own position definitely would not help and might even hinder John, because of the potential for an allegation of nepotism. Nothing if not pragmatic, and turning his focus to the potential advantages of the Sheffield offer, William began to trim his advice to John, to the extent that by 12 September he was writing:

> My dear John, I have been thinking of your future. There is much to be said for trying for the Ashmolean [John's autobiography does not reveal that this was in his mind again at this time]; but 'the bird in hand'. I am fearful lest you prejudice your chance for Sheffield. For one must remember that you have done little in the way of actual scholarship and the rivalry of men who have specialised in Italian and classical art would be formidable. There is also this to be said – you have special claims where contemporary art is concerned. You care for it, and have won your spurs over it; and were such a place as the Tate in question, I would have no doubts. But to lose Sheffield would be a disaster. Perhaps I am wrong in having any misgivings but there it is – I have moments of anxiety. I shall be glad to hear from you on the subject. I gather that the Oxford post is one that many will apply for – and I doubt whether in this case you would have Constable's backing – I rather think he would have one of his own special cronies in mind.
>
> If my advice be worth anything – my feeling is for you to keep to a gallery which allows for growth, in the direction of contemporary art especially. The Ashmolean is a scholarly gallery, is it not? But I can see the attraction of Oxford, and of the salary.

The next day, another letter exposed William's long-term plans for John's career even more sharply: 'The Sheffield job, coming after the Leeds one, will strengthen your chances when such an appointment as the Tate, for instance, becomes vacant.'

Mention of John ending up in charge of the Tate is remarkably perspicacious of William in 1933. He had been a Trustee of the Tate since 1927 and could have seen its workings under two directors of contrasting styles (Aitken and Manson). His resignation letter from the Tate to Lord d'Abernon was dated 20 June 1933: 'I have no reason for retiring other than my belief that one more in touch with present continental tendencies should serve on the Board'. When the Chairman pushed him to reconsider, William replied in different terms: 'I have for some time been out of sympathy with decisions for which, as a Trustee, I share the responsibility. Further, I have a growing dislike to sitting in judgment on my contemporaries'.[26] The real reason for his retirement may have been obscure, but the stern, hard-working William Rothenstein would not have appreciated the environment being created at the Tate by the somewhat desperate combination of Manson and Fincham (Assistant Keeper when John arrived at the Tate).

William had been friendly with all the Directors of the Tate preceding his son's appointment; their qualities will be considered in Part 2. He may have formed the impression during his time as a Trustee that his son could do the job as well as the others and, with his guidance, probably better. William returned to the theme in a letter to John of 18 March 1936: 'I gathered from Constable that Manson doesn't like his job and that he would be giving it up before long. Though there would obviously be other applicants, there is no doubt you would be one to be seriously considered when the time comes. I am always hearing praise of what you have achieved.'[27]

John's presentation in his autobiography of the Tate opportunity, when it arose following Manson's disgrace in 1938, as a surprise and his decision to apply being little more than an accident, must be viewed with some doubts in the light of these letters.[28] Father and son had been thinking about John's career in these terms since 1933 and it may be that William's resignation as a Trustee had been intended, at least in part, to facilitate just such a development by avoiding any problem about nepotism if the opportunity arose for John to apply.

On 22 September 1933, John replied to his father agreeing not to apply for the job in Oxford and instead to accept the position in Sheffield. John subsequently showed that he was trying to learn from his experience of dealing with the Leeds governing body in that, before accepting the job in Sheffield, he wrote 'a long letter to Alderman Graves giving in some detail my ideas as to how the new gallery should be run and emphasising my ambition to build up a representative collection of modern British painting, and I urged him not to consider my appointment unless our views were truly in harmony.'[29]

Mr Graves's response, if any, is not recorded. If John had been more experienced in the ways of the world, the need to write such a letter and the impossibility of ever enforcing his conditions on the wealthy man who was funding the new gallery should have alerted him to the perils of the course on which he was embarking. Throughout his working life John Rothenstein was not always as astute

as he needed to be when confronting the motivation of powerful men operating in pursuit of their interests in the art world; he could be naive. He often failed to discern that their interests, perhaps initially disguised or hidden, were never going to fall into line with his own, however logical he thought his own position was, and that the power they were used to wielding meant that they would not give way. By the time this had dawned on him, disaster had often struck. In the case of Alderman Graves, there was to be a honeymoon period, then one of disillusionment before the move to the Tate in 1938 effectively rescued John from experiencing the full consequences of his poor judgement in 1933.

Although John's tenure at Leeds did not expire until his notice period ended in 1934, John and Elizabeth quickly moved their things from Leeds to Sheffield in November 1933. The excitement in the press about his resignation cannot have made it easy for him to remain physically at the gallery in Leeds, which was still under the control of Alderman Leigh.[30] There is no public record of the Alderman's mood during the early weeks of November, but it would be a remarkably unusual example of the finer aspects of human nature if it was entirely charitable towards Dr Rothenstein. The new gallery in Sheffield was due to open in July 1934 (John also had to look after the Mappin Art Gallery there) and John wisely preferred to finish various tasks in Leeds and to plan the decoration of the new gallery,

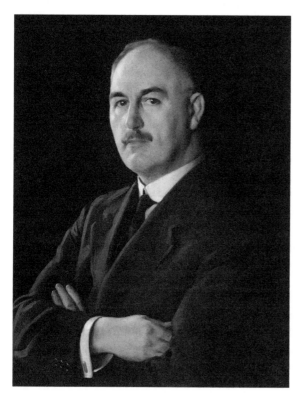

John George Graves (1866–1945)
by David Jagger (1891–1958).
Museums Sheffield

together with deciding on the contents of its new permanent collection, from the safety of Sheffield rather than Leeds.[31]

John was no more taken with the city of Sheffield than he had been with Leeds but he was right to regard this as an exciting opportunity for a man of thirty-two with a potentially fascinating career in the senior levels of gallery administration opening up ahead of him. At Sheffield, John had what he needed to be effective in his various jobs in charge of art galleries: efficient (and preferably loyal) administrative assistants. In this case he had George Constantine (1878–1967),[32] who replaced him as director in 1938, and Betty Dunster, and their time 'was divided between recruiting and training attendant staff, the multifarious problems connected with the equipment and decoration of the gallery, the establishment of an office, and the assembly of loans and the formation of a collection.'[33] A wry smile may have passed John's lips when he was writing these words in the early 1960s. His experience of the disloyalty of one of his assistants at the Tate just over ten years earlier got extensive coverage in the second volume of his autobiography (see Chapter 13).

Armed with the new lessons he had at least partially learnt in the arts of diplomacy, John agreed to hang as many of the Alderman's collection of pictures as he could stomach, but there were limits to the extent to which he was prepared to moderate the purity of his choice in the interests of diplomacy, and many works from Mr Graves's collection were not chosen to grace the walls of the gallery which would bear his name. To make up the gaps, in an attempt to create a widely representative collection for the new gallery, John drew in loans from the National Gallery, the Courtauld Institute (who lent Cézanne's *Card Players* and van Gogh's *La Haie*), the Tate (which lent a Degas, three Gainsboroughs and a Turner), the Victoria and Albert Museum (Chinese porcelain and Persian pottery) and the Royal Academy (six Constables and a Reynolds). The relative ease with which John secured loans from these places was indicative of the extensive connections which he and his father had with the art world. Those running the institutions were often friends and happy to assist.

Private collectors, such as Hugh Walpole (who lent a Sickert) and Eddie Marsh (who lent a Stanley Spencer self-portrait), were also persuaded to lend. In his effort to bring the collection up to date, John included works by living British artists (Sickert, Steer, Cedric Morris, Gilbert Spencer, Wadsworth, Roberts, Augustus John and Paul and John Nash), whom he thought the locals (and Mr Graves) could tolerate, but he shied away from those artists whose work might antagonise Graves, such as Henry Moore and Matthew Smith. He included works by relatively modern foreign artists, such as Boudin, Cézanne, Degas, Fantin-Latour, Legros, Pissarro and van Gogh, but nothing too daring. There were also many works from artists of earlier centuries. The resulting collection, the choice of which was entirely John's, was well-balanced, fresh and full of interesting pictures from a wide range of periods and styles, and reflected well on John's taste and practical abilities in putting together an exhibition. He had really done Sheffield proud in

setting up the new gallery with a collection which could legitimately generate civic pride. The cloud on the horizon was Mr Graves and what was going to happen to the large rump of his collection.

The new gallery opened in July 1934 to widespread public acclaim, but John remained a restless soul. As he tried to develop a local appreciation of modern British art, he soon discovered that Sheffield did not have an active tradition of supporting the arts, even less than Leeds, and that it was not going to become receptive to the sort of modern art which John thought they should see. It soon became clear that it was not the place where he wanted to put down either professional or personal roots; there are occasional background indications that he had no intention of remaining in Sheffield. On 9 July 1934 W. G. Constable, whose idea it had been for John to go to Leeds in the first place, wrote to him to say that he agreed that John should not pursue 'the Toronto idea' – from the context, an academic post rather than a museum one.[34] On 16 October his father wrote to him to say that he had bumped into Constable, who had told William that John was applying for a post in Birmingham.[35] This may well have been the post of the first director of the Barber Institute, which had recently been formed as part of Birmingham University; in fact, its first Director was Thomas Bodkin (1887–1961),[36] who started in 1935.

Either John did not apply or did not get the job[37] and in September 1934 he decided it was time to take a risk on the response of the Sheffield art-going public, not to mention the members of the Council, to some more strident modern art: he arranged through Tom Honeyman of the dealers Reid and Lefevre[38] for the gallery to borrow a major early work by Picasso called *La Vie*.[39] Dating from 1903 (the Blue Period) and showing a naked woman and a near-naked man, it joined a Matisse in bringing to Sheffield the sort of modern art which had never been seen there before. It came on top of a loan exhibition which John had procured from the Leicester Galleries in London for September and October 1934 of *Drawings by Contemporary Artists*, which also included work by Matisse and Picasso. Around this time an important picture by Frances Hodgkins, *Enchanted Garden*, which would have seemed modern in Sheffield, was given to the gallery by Lefevre. In March 1935, John achieved something of a coup by securing a loan exhibition of a collection of nineteenth- and twentieth-century French works on paper, which was on its way from New York to Paris and which was shown nowhere else in England. This included work by Cézanne, Degas, Delacroix, Géricault, Manet, Picasso, Seurat, Toulouse-Lautrec and van Gogh. The combination of all these events in 1934–35 made it clear to Mr Graves and to the people of Sheffield what the Director's priorities were.

Whether or not the Picasso had any part in it John does not say, but the sense of a honeymoon in Sheffield began to sour in July 1935, a year after the gallery had opened.[40] Alderman Graves suggested that the time had come to return all the loans and to replace them with works from his own collection, hundreds of which

John Rothenstain by Sylvia Baker, c.1935.

were still adorning the walls of his home, which had not been his intention when founding the new gallery. John must have been horrified at the thought of dismantling his carefully conceived group of pictures:

> From this moment there began a long conflict of wills between Alderman Graves and myself – in the course of which I was subject to heavy and continuous pressure: between his determination to impose the remainder of his collection upon the city and my determination, made painful to maintain by my deep sense of gratitude, to resist. Slowly but surely the close cooperation that had existed hitherto between us diminished.[41]

A partial solution was found when the Alderman funded an extension to the other Sheffield city art gallery, the Mappin, and dumped three hundred of his spare pictures in it.

Set on acquiring the best modern art he could find, John continued to try to develop the Graves Art Gallery and the appreciation of art by the people of Sheffield, with lectures, loans and visits from important members of the wider art world. Kenneth Clark, for example, lent more pictures from the National Gallery and even visited Sheffield himself at John's invitation.[42] One idea of John's, which indicates what a good gallery director he could be from the public's point of view, with his intuitive grasp of what might appeal, was to organise groups of local schoolchildren, up to two hundred at a time, to visit the gallery. To encourage this

he again used his London connections to persuade the Leicester Galleries to lend a collection of Walt Disney's working drawings, which he put on display in Sheffield in March 1935. This was a novel concept, particularly for a provincial art gallery in 1935. John's successful idea in promoting such visits was to foster a new attitude towards art appreciation amongst local people, starting with their children. When he was not plagued by political issues arising from within whichever art establishment he was in, John was daring and experimental and often highly effective as a director.

John also took an active part in creating the Sheffield Art Collections Fund in 1936, which acquired and gave a number of pictures to the gallery over the years, thereby bypassing the purchasing restrictions set by the local authorities. He was inspired to promote the Sheffield fund by his experience of dealing with the Leeds Art Collections Fund, of which he was the honorary secretary when Director at Leeds. This had been founded in 1912 by Frank Rutter (Director of the Leeds City Art Gallery in 1912–17) and the important local collector, Michael Sadler, with the intention of purchasing pictures independently of the local authority so as to circumvent their disapproval of modern work. John was also aware of the work done in this direction by MacColl, who had helped to establish the National Art Collections Fund in 1903. However he was going to achieve it, John was impressively determined to ensure that Sheffield would acquire good works by modern British artists.

Members of the family from time to time came up to stay with John and Elizabeth in Sheffield. Indeed, the couple introduced John's sister Rachel to a local bookseller, Alan Ward, who later became her husband. (The Wards carried on living in Sheffield after John had returned to London.) Whenever possible, John took the opportunity to escape from Sheffield, particularly to visit artists. For example, he went to see Stanley Spencer in Cookham in Berkshire in 1935, and he became friendly with Paul Nash.

By 1936, John was becoming increasingly frustrated. Having established the new gallery, he knew that he was never going to win a long attritional war with Alderman Graves which would enable him to develop the gallery further along the lines he wanted. He had also seen how difficult it was to persuade the people of Sheffield to approach with an open mind the sort of modern art he wanted them to like. In March 1936, a show called *Twentieth Century British Painting* was attacked in the *Sheffield Telegraph*. In January 1938 he put on an eclectic exhibition, *Contemporary British Painting*, which included the work of a wide variety of artists, including his own father's and uncle's. More challenging to the local public would have been pictures by Wyndham Lewis, Paul Nash, Matthew Smith and Stanley Spencer and particularly some abstract pieces by Edward Wadsworth. There were several prominent (and favourable) national reviews (for example, T. W. Earp in *The Times* of 15 January and Eric Newton in the *Sunday Times* of 16 January 1938), but the local reaction was not as favourable and various rude letters were published in the

John, Elizabeth and Lucy at Far Oakridge, 1935.

local press, making it painfully apparent what John was up against in his campaign to broaden local tastes. On 21 February, the *Yorkshire Telegraph* published a letter which began: 'Sir, does anybody in Sheffield want a good laugh? Then let him go to the Graves Art Gallery'. They also published a piece of their own criticism under the unpromising headline 'A Philistine views Modern Art in Sheffield'. The author was predictably hard on Wadsworth's abstracts.

John's understandable restlessness as he fought to promote modern art was not helped by his awareness of the increasing tensions in the wider world: Sheffield seemed a long way from where things were happening. All was to change in March 1938, when he received a telephone call telling him about the disgraceful activities in Paris of Manson, Director of the Tate Gallery. The door to John Rothenstein's fame and future creaked open.

CHAPTER 4
The Books, 1926–38

John Rothenstein's early books display the weight of his father's influence on him when he was young.[1] *The Portrait Drawings of William Rothenstein, 1889–1925* came out in 1926 when John was twenty-five. This was during that fallow period of his life after Oxford when it must have seemed irresistible, with no job in sight, to borrow his father's reputation. It was a loyally filial production. With virtually no editorial contribution from John, he just chose which pictures to reproduce and then annotated the entries for each work in a formulaic way. This required some considerable administrative effort but none at all in the nature of writing and no attempt was made to explain why the pictures had been chosen, why they were worth publishing or, indeed, who the artist was. The only literary contribution was Max Beerbohm's preface, which accurately, if somewhat portentously, described the book as 'a monumental iconography composed in filial piety by a grown-up son.'

The only personal touch from the author in this austere first work were the dedications, to the Hon. Mrs Claud Biddulph and to John's sister Rachel. Margaret Biddulph was the wife of a rich Gloucestershire landowner, living in Rodmarton Manor.[2] John loved the fact that the Biddulphs had filled their large house with Arts and Crafts contents commissioned from local craftsmen. There was an extra factor in his approval: Mrs Biddulph was 'drawn towards the Catholic Church'.[3] Sometimes unexpectedly and incongruously, the Catholic Church would make an appearance in several of John's early books. This dedication in 1926 was a harbinger of things to come.[4]

Having satisfied the need or wish to publish something openly respectful of his father, and one which had been relatively easy to accomplish, John next studied an artist who had been one of his father's closest friends, Eric Gill.[5] In 1927 his anonymous short book on Gill appeared. As noted earlier, Gill had a strong influence on John's conversion to Catholicism but this did not mean that he was prepared to overlook the factual errors which John made. In a letter of 1 May 1927, Gill wrote to say that he had got 'a lot of minor facts wrong and the journalese seems to me … a pity'.[6] On 5 June he wrote again to John to say how disappointed he was with the book. In his autobiography, John admitted to the book's defects ('my monograph is a faulty thing'), blaming them on the fact that he had been abroad when the proofs had arrived and had therefore been unable to check them.[7] He does not mention the tweak about 'journalese'. In any case, in the twenty-nine pages of text, John

aired some of the thoughts which characterise his early writing. He felt that people for the first time appeared 'to be dependent upon two fundamental beliefs. The first in some form of industrialism. The second in the relativity of truth':

> Hardly had the marriage of Science and business been consummated when a new world came into being and two great tendencies were immediately discernible. The population began to increase at a rate hitherto undreamed of, and science started that attack upon established belief which has, after a century and a half, left great multitudes without faith in any fixed and unalterable truths.[8]

Eric Gill was seen as 'essentially a believer in absolute values and absolute truths … He does not believe in absolute values because he became a Catholic; he became one rather because he believed in their existence and the Church supplied them.' Gill's becoming a Catholic in 1913 was seen by John as 'the culminating event of his life', by implication reflecting his own experience.[9]

Gill's views, as expressed in his own autobiography, overlapped with John's.[10] It appears that, at least as regards the views which John was expressing in these early books, the influence of Gill on his thinking about art was as great as the influence of William. Gill, for example, says this about science and industry:

> The application of science to industry … became simply the instrument for the complete degradation of men and the destruction of all the trades by which normally men serve one another – that is to say all the trades which were patient of mechanisation, all the so-called 'useful' arts. But the others, not so patient, the 'fine' arts, were thus isolated. They became 'hot-house' arts; and as one of the most conspicuous effects of mechanisation was to reduce the workman to an impersonal instrumentality, an exaggerated importance came to be attached to the exhibition of personality fostered in the hot house. Personal, all too personal, and eventually only to be judged by irrational and even anti-rational standards of aestheticism.[11]

Gill was also influenced by his attitude towards religion and specifically by the Roman Catholic Church, whose beliefs he had come to espouse. Indeed, at one point he explains that a reason for the parting of ways between his outlook on life and the outlook typified by William Rothenstein and other artists was his distress at their attitude towards religion. Gill could never allow himself to put art above religion in the way they did – 'they seemed to regard religion as being essentially nonsense but valuable as a spur to aesthetic experience and activity'.[12]

With no more than an essay, John's book on Gill contained some of the seeds of John's way of analysing the history of art which he developed in succeeding books. The centrality of his view of Catholicism lay at the heart of his thinking and Gill was in many ways the perfect person for the new convert to write about. Whether a Catholic-based analysis of the wider contemporary British art world would take

him far or enable him to discern the qualities of other artists was going to be a challenge which John would face as he expanded his repertoire in the coming years.

His first substantive work, *The Artists of the 1890's* (1928), was dedicated to the French artist Jacques-Emile Blanche (another friend of his father's from his days in Paris)[13] and to Bernard Berenson. The book's full length gave him scope to develop the theories he had started to adumbrate in the volume on Gill and which ran through a number of his pre-war works. They may reflect or include those of Gill and of his father, gleaned from all those conversations with William in London in the 1920s;[14] they may simply be the ideas of a relatively young and not fully developed mind, grappling with the challenge of reducing the complexities of the developments of the art world to a coherent formula. Some reviewers identified the influence of William. The anonymous reviewer in *Apollo*'s September 1928 issue, for example, had this insightful comment: 'The relationship of father and son is nearly always characterised by an antagonism often open, more often perhaps latent; yet this antagonism is frequently accompanied by a mutual if unconfessed admiration. … It is obvious that the book could not have been written by Rothenstein fils without the help of Rothenstein père.'[15] Wherever they came from, the themes were clear: the impact on artists of society's loss of religious faith, the effect on artistic output of the industrialisation of society and the identification of a proper purpose in producing art.

John alighted on the artists of the period because he knew about their work, as a result of his exposure to them and their work through his father, who knew all the artists covered in the book. This was, in other words, a study of some of his father's closest artistic friends: it was a work steeped in the influence of his father. Moreover, it was favourably disposed towards these artists, including to the work of his father, which was covered in its own chapter. This book was another example of filial piety.[16]

Whether John was sufficiently equipped to write about these artists from the point of view of actual knowledge rather than paraphrasing what his father had told him is another matter. In September 1924 he had been to stay with Max Beerbohm, who wrote to his wife about the extent of John's historical and artistic knowledge: 'about the 19th [century] his mind appears to be a complete blank. The first decade of the 20th also finds him at a loss. As to the 19th, by the way, I must except the 'nineties: about them he is not indeed very knowledgeful [sic], but is (or was till I rather threw cold water on them) extremely enthusiastic.'[17]

Around the material with which his father's generation of artists provided him, John wove his ideas, beginning by noting that the work of the 1890s was 'highly unfashionable'. Given that his father was one of the artists concerned, it feels that the son was seeking to remedy any failure to understand the significance of his chosen period. He described his first aim as being to show 'how naturally, how logically the movement of the nineties, with all its challenging affectation and extravagance, takes its place in the tradition of art in England; to show that the very

'On the Threshold of Life'.
John Rothenstein by Max Beerbohm, 1923.

qualities with which we find it difficult to sympathise were rendered inevitable and necessary by circumstances.'[18]

Fortunately for the writer's theories, he quickly established in the first chapter of the book, titled 'The Artist and the Industrial World', that the painters he had selected to represent the 1890s reacted against both industrialisation and classicism. Their work served a purpose, namely: 'to help the age towards self-realisation, towards a truer sense of values by which to judge the present and mould the future'. John felt that current artists did not do this: there had been a 'loss of contact between art and the rest of human activities'.[19] Whereas traditionally society had regarded artists as a practical necessity, making their own particular and natural contribution to life's daily requirements, now instead society placed greater value on the work of engineers and scientists. Artists, their work no longer serving a purpose, had become independent of patrons, such as the Roman Catholic Church, and become instead 'servants only to their own moods, theories and conceits ... The worst became not so much servants as slaves, not so much slaves as prostitutes, to the new industrial-commercial society'. The nineteenth-century artist became either a parasite or a pariah: 'occupied with expressing themselves or filling their pockets, the artists now looked with unseeing eyes upon the outer world'.[20] If only the men of the sixteenth century who had promoted the Reformation had realised 'that they were in fact destroying the unity of Christendom,

cutting themselves away from that Catholic Church to which the great majority of them were devotedly attached – and substituting for the successor of St Peter the successor of William the Conqueror'. For indeed, 'until the renaissance and the reformation there had been an almost exclusive subject for all art, the Catholic religion'.[21]

It is possible that some of these ideas about the rightful place of the artist in society had by this time been developed during conversation between John and Wyndham Lewis (whom he had met in 1920), as well as between John and Eric Gill. As late as 1954, Lewis was writing that strange art was being produced because art had become almost totally disconnected from society, with no direct function and only existing as the plaything of the intellect.[22]

Whatever the extent of John's discussions with others, this was an unusual way for a young art historian to found a criticism of the qualities of artists of a relatively recent vintage. There were artists whose active religious sensibilities were intact, and those in society who contemplated such things in 19th century Britain had been riven by ecclesiastical controversy. It is a trap to judge John's chosen critical apparatus only by the often godless standards of those writing about art in the twenty-first century. Nevertheless, his early and repeated emphasis on such themes overshadows his critical acumen as an art historian. It feels in these early books as if he was displaying his youthful theories and choosing facts to fit them, using a teleological agenda, like other historians now and then. The result in the first two general chapters of *Artists of the 1890's* resembles an extended essay by a clever student: a broad sweep of human history, crushing and remoulding from its high all-seeing vantage point the hills and valleys making up the historical landscape into the smooth contours of a seamless narrative, heading inexorably towards the author's pre-selected conclusions. Many generalities about art and life were required to achieve this and the prose sweeps on relentlessly towards its predetermined targets.

John later acknowledged the shortcomings of his method in this book, just as he criticised his book on Gill, admitting that it had 'many and serious faults: the historical introduction was too long' and the whole was 'a very amateurish affair'. It 'largely deserved the savage unsigned review contributed by Clive Bell to the *Nation and Athenaeum*'.[23] He might have added that it was also simplified to an extent which rendered its status as history nugatory, if intended as serious analysis rather than promoting his own agenda.

About the artists themselves, in their individual chapters, John began the method which he was to use effectively in *Modern English Painters*. Each piece on an artist was well-written, to the point and informative, using personal details of the artists and their lives to create credible and arresting images of them as people. For Greaves, for example, who by that time was over eighty, John tracked the old artist down to his room in Charterhouse, where he was living as a Poor Brother, and extracted from him over a number of conversations the fascinating insights which

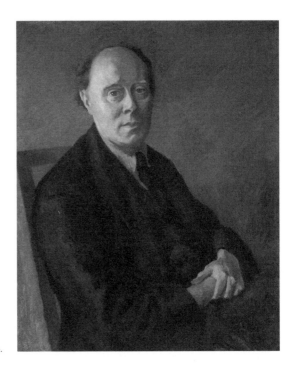

Clive Bell by Roger Fry, c.1924.

characterise this part of the book. John's comment on the satisfaction he felt at this process could be used as a summary of what *Modern English Painters* would achieve and what his intentions would be in writing it: 'The consequence of my coming to know Greaves was to make me feel it both a privilege and a duty to preserve against oblivion some memorials, however slight, of artists whom I have known – especially those whom fashionable opinion passes by'.[24] Elegiac passages in the short chapter on Greaves would later be echoed by the style of *Modern English Painters*: 'He is a man for whom the world, with its controversies, its admirations, its hatreds, has no meaning. His world, which is dead, did not extend beyond the river banks of Old Chelsea and Old Battersea, or his life beyond the feverish activity of the inhabitants of the water-fronts, mostly long quiet in their graves'.[25]

Only occasional aberrations mar this section of *Artists of the 1890's*, for instance in the chapter on Beardsley, whose conversion to Catholicism is given prominence and congratulation ('That he already loved the externals of the Catholic Church, and one of his closest friends was a member of her priesthood, predisposed him in her favour').[26] Worse is the following irrelevant passage:

Of those who can be termed 'of the 'nineties' the proportion who either maintained their Catholicism intact or afterwards entered the Roman Communion is surprisingly large. Francis Thompson and Lionel Johnson both remained devoted to the religion of their birth, while besides Beardsley were converted his friend John Gray, who entered the priesthood, Ernest Dowson,

Alice Meynell, the Michael Fields, Lord Alfred Douglas, André Raffalovitch, and Frederick Rolfe, better known as Baron Corvo.[27]

No one writing today would think it would strengthen their case to mention in support Lord Alfred Douglas or Baron Corvo.

As the first substantive book by an unknown young writer, it received an extraordinary amount of coverage in the press, again presumably due to the Rothenstein name. It was reviewed largely favourably, if sometimes in patronising terms, by older writers who had experienced the period John was writing about, which they knew he had not. The reviewer in *The Times* of 25 May 1928, for example, said:

> What always strikes most of us who lived through the period and came in contact with some of its literary and artistic leaders is that they were not so very different from similar talents at the present day. They had a different idiom, that is all. The plain truth of the matter, and Mr Rothenstein sees it, is that most of the artists of the nineties were minor artists.

As for John's attempt to identify the principled hostility to the industrial world of the artists he was studying, the reviewer squashes its significance: 'The minor artist of the nineties could not digest a mechanical civilisation, and so he elaborated a squeamish evasion and called it a revolt.'

The *Daily Telegraph* of 5 June saw it, on the one hand, as a 'well-written, critical and entertaining little book'. The writer in the *Saturday Review* of 30 June, on the other, could have crushed a sensitive author: 'Undoubtedly there are the makings of a writer and an art critic in Mr John Rothenstein; but he would be wise to cling, for the next ten years, to the simple truth that a picture is just a picture, not the inevitable outcome of antecedent economic and social revolutions or to be valued as an illustration of extraneous theory.'

The *Observer* eventually got round to reviewing the book, on 30 December 1928, fully six months after everyone else, alighting on a characteristic of Rothenstein's which rings true:

> Right or wrong, he leaves the reader with but little doubt that he is not prepared, merely for the sake of it, to meet anyone half way on any point on which he has made up his mind. The only doubt, in fact, which persists is exactly how much of it is Mr John Rothenstein's own conviction, or whether he has sat at the feet of his distinguished father.

The next book on art which John published, *British Artists and the War*, appeared late in 1931.[28] The author again gave himself a long introductory section in order to develop some of his favourite themes without hurrying to address the subject matter of the book. The introduction, running to seventeen pages, was almost entirely taken up with attacking abstract art without troubling to mention war artists. The build-up to this attack will seem familiar:

The ever-growing separation between the artist and society that has characterised the post-renaissance and post-reformation world allowed the Greek impulse to create beauty for its own sake gradually to reassert itself; and the growth of a purely aesthetic impulse and the gradual dwindling of art patronage by Church, king and aristocracy in turn has ultimately given rise, and for the first time in history, to an art that serves no utilitarian purpose whatever, but exists for itself alone.[29]

It might have been thought that the last book had run this particular hare to ground, but apparently not. There were those who thought that

painters should content themselves with exploring the possibilities of paint and by no means attempt to do what could be done better by other means; and, since accurate representation, for example, could best be obtained by photography, movement by the cinematograph, and drama by the written word, these objectives should be outside the sphere of painting. Such a line of argument leads inevitably to the conclusion that the only proper subject for the painter is abstract form.[30]

He goes on:

The phenomenon with which I am concerned is rather the attempt, on the part of an intelligent and influential body of critics and artists and scholars who are not satisfied merely to assert their belief that the art of pure form is a supreme manifestation of the creative spirit, to discredit all contemporary works in which expression plays an important part, and, moreover, to propagate the belief that expression not only is, but always has been, detrimental to art. This latter belief is continually voiced and still more often implied.[31]

John can see how abstract art may be appropriate for the modern artist, who now 'specialises in the creation of formal harmonies instead of making works of art which also serve to inspire piety or terror, to instruct or to awe'.[32]

With these sentiments, John had in his sights the approach to art criticism taken by Clive Bell and Roger Fry, for example, with their focus on form and the doctrine of 'significant form' which they had been developing in print since 1914. He quotes disparagingly from Bell's *Landmarks in Nineteenth Century Painting* (1927) and writes that 'very significant of a certain trend in contemporary thought is his attempt to divorce art utterly from life and to make of it, instead of the finest distillation of the creative spirit of Man, a mere matter of catering for highly-specialised connoisseurship'. In contrast, 'For myself, I believe on the contrary that art is an integral part of life … It is the part of the great artists to speak, as it were, for all men, to utter that which all men half-know yet cannot recognise unaided and to reconcile them, in some measure, to the strange world in which they have their being.'[33]

Eventually the author explains how this build-up in his Introduction relates to the supposed subject matter of the book. On page 21 it is said that the First World War restored the union between art and life so painfully severed, in John's eyes, in the course of British history (whether the Reformation, the Renaissance or the Industrial Revolution, he was not clear):

> While the War lasted, in short, and for the few years afterwards while the memory of it lingered, the gulf between life and art, which had widened steadily for more than a century, momentarily disappeared. Thus it came to pass that artists who had been treating trivial subjects or else had been studiously avoiding subjects of any kind, and artists who believed that the language they used was a self-sufficient end, suddenly found themselves voicing the terror, the awe, the scepticism, the disgust and the humour of vast numbers of their fellow-men.

Yet, once the War was over, 'art has returned once more into the circle of the Elect, and become in consequence complacent, esoteric and almost wholly abstract'.

Although John did not publish a book about art in the Second World War, he did express similar views about the effect of that war on artists:

> Many artists who might have seemed, before the war, to have cultivated an esoteric vision, have found, in their reactions to the war a common ground of contact with the public, thus narrowing the lamentable rift which had tended in the years between the wars to place the artist, increasingly immersed in theory or the curiosity of his personality, in a position of unprecedented isolation.[34]

This book attracted less press coverage than *The Artists of the 1890's*, reviewers probably feeling that they had already given enough coverage to the views of the young Rothenstein and this product needed no further analysis. They may have felt that the subject matter, especially when wrapped in the introduction's theoretical padding, was of little interest to their readers so many years after the events it described.

Rothenstein enjoyed writing polemically at this stage in his literary career. He largely grew out of it as the years passed. In 1931 it suited him to engage in the Modernist art critical debate by developing a unique position and then exaggerating its characteristics; by the time of *Modern English Painters* in 1952 his views had matured.

During the early 1930s books came out in rapid succession. He must have been writing these in the period between returning from America and starting at Leeds. *Nineteenth Century Painting: A Study in Conflict* (1932) was based on his doctoral thesis and was dedicated to his parents. The first forty-five pages (out of a total of 180) were devoted to the historical distinction between classical and romantic (or Gothic) art. The turgid writing of this first section bore the hallmarks of

a doctoral thesis which should not have been published. It set up a proposition and then brought to bear the supporting evidence: 'An important aspect of the history of nineteenth century painting may therefore not inaptly be stated as an acute conflict between the classical temperament, seeking to impose itself by linear design, and the romantic, by revolutionary developments of colour and light.'[35] There were long quotations from his friend MacColl's work on the same subject[36] and the Catholic Church got mentioned: 'It is interesting to note, in passing, the affinity between Roman Christianity and classical art, and Protestant Christianity and romantic art, respectively. The objectivity of classical art is parallelled by the objectivity of Catholic doctrine, whereas in both romantic art and Protestantism the subjective element predominates.'[37]

The rest of the book followed the pattern of *Artists of the 1890's*, with chapters on individual artists, more than half of whom were French. This was his first, tentative step into writing about non-British artists and it is unclear how sure he was in seeking to cover them. There is a final chapter on Impressionism: 'Broadly speaking, Impressionism was the culmination of a movement originating with the Dutch landscape painters, the early English water-colourists, Constable and Delacroix, which had as its principal aim the replacement of tradition by the direct action of nature upon the individual temperament'. Unfortunately, in John's view, the loss of technical classical painting skills meant that, after the Impressionists, those painters seeking to achieve 'a profound pictorial view of the universe' were unable to do so as they had lost 'the elaborate technical equipment' needed.[38]

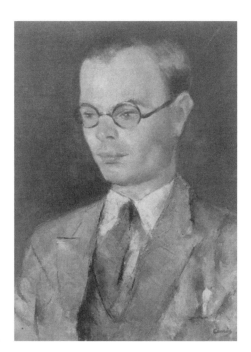

John Rothenstein by unknown artist, c.1930.

Rothenstein's *An Introduction to English Painting* came out late in 1933. For the period which John knew least about – up to the eighteenth century – the book proceeded uncontroversially. Since the whole book was an introduction, no introductory chapter was needed and the subjects were dealt with straightforwardly. When he started on artists with whose work he was more familiar the author began to flex his polemical muscles. John Constable was made to bear a cross whose significance some readers may not have divined: he is said to have 'opened the way to the art of pure design, wholly unrealistic in character, which began to dominate Europe towards the close of the nineteenth century'.[39] Whether or not this is true of Constable is beside the point; what John intended was to fire a shot at the shortcomings of 'modern art', with its focus at the hands of various art critics on pure form.

In devoting a chapter to the work of Stevens and Watts, the book deviated from the way a modern writer would cover this period. For a book of thirteen chapters purporting to encompass the entirety of British art, to have a chapter on these artists would now feel unbalanced. The old Rothenstein bursts out: 'Prior to the Reformation the dominant power in Europe was the Church … Her success was rendered possible by the co-operation of the artist, who evolved a symbolism more or less intelligible to all Christians'.[40] Unfortunately, monarchs replaced the Church as patrons, then the aristocracy replaced the monarchs and, finally, that most terrible of events in the early Rothenstein canon, the Industrial Revolution 'went far towards completing what the Reformation had begun'. 'The artist, denied a patron, was for the first time in history thrown entirely upon his own resources'.[41] Nevertheless, whilst that chapter is made to bear many favourite themes, the book as a whole is excellent.

There were widespread reviews, reflected in a popularity which has seen many later editions of this book. Most reviews were favourable, recognising that the author had wrestled well with the limitations imposed on him by having to squeeze a vast topic into a book of less than two hundred pages: no author could give equal or even adequate emphasis to all the many artists with a claim to be included.

Sir John Squire, writing in *The Sunday Times* on 3 December 1933, said that 'within his limits he has done extremely well, providing a mass of facts laconically.' Rebecca West in *The Daily Telegraph* (on 1 December) said that the 'work is really a miracle of industry and conciseness and good sense.' The anonymous writer in *The Observer* (10 December) felt that 'his history is well arranged, lucid and critical.' Dissenting voices, still acknowledging the achievement in the context of the format, came from the academic reviewers who were notoriously hard to please. It was easy to get on the wrong side of John Pope-Hennessy, who wrote in *The New Statesman* on 30 December: 'Mr Rothenstein clings too closely to Mr Borenius's coat-tails to make his first sixty pages anything more than an unimpressive and not very well synthesized parade of second-hand scholarship, which the excellence of much of the later part of his book … renders all the more regrettable.' Anthony Blunt, in *The Spectator* on 5 January 1934, although again generally favourable towards a

book which he appreciated had to be superficial, nevertheless felt that Rothenstein was 'rarely diving far below the surface, and on these occasions getting entangled a little, as in his analysis of the vision of Constable, a confusion of abstraction and ambiguities'.

In themselves these academic tweaks were unimportant and insignificant at the time, in the context of the mass of favourable reviews which John's book received. They were, however, premonitions of what came later when, as part of the variety of criticisms which John had to endure during the Tate Affair, his alleged lack of intellectual substance as an art historian was aired.

The last book published before John went to the Tate was *The Life and Death of Conder* (1938), which had been written in Sheffield.[42] This full biography represented the first time that John had written in this manner. It was a curious artist to have chosen. By the 1930s, Conder's reputation as an important Romantic artist was declining (though the Tate had held a retrospective in 1927) and one might think that John's focus on this artist was yet again driven by the influence of his father. In the index, for example, the largest number of page references were against the name of William Rothenstein. It may be significant that John's autobiography barely mentions the book.

John describes on page 55 the relationship between Conder and his father after they met in Paris in 1890: 'there grew up between them the most lasting and intimate friendship of Conder's life'. William had written extensively about his friendship with Conder in his autobiography, describing him as 'one of the rare lyrical painters, singing now with the morning innocence of the lark, now with the more sinister note of the nightjar'.[43] The book contained many quotations from the correspondence between Conder and his father, and the world described, of MacColl, Beardsley and Wilde, was that inhabited by his father in the 1890s. Commenting on a proof, on 18 February 1938, William wrote to John to say that he thought it excellent but 'I have made a good many suggestions – your writing, dear John, is careless. I could have made more'.[44]

John had already applied himself to Conder in *The Artists of the 1890's*; the question was whether Conder merited a whole book to himself.[45] Whilst the introduction contains no polemical attacks, still the author says that it is the post-Cézanne focus on form rather than atmosphere which has caused a Romantic vision such as Conder's to fall from grace. He ends by saying that, just as the art world had eventually recovered an appreciation of the Romantic world of Watteau, Boucher and Fragonard, so it would for Conder's delicate productions.

It is easy now to dismiss this approach as tendentious and unlikely to be correct, but the author has a point.[46] Astute contemporaries, such as MacColl, regarded Conder's work as skilful and, in its own way, significant. Those writing later about earlier art which does not coincide with their sensibilities are not better or more intelligent art critics than their predecessors who approved of such work; they are just constrained by the tenets of their own age. Such dismissals may, in the longer

scheme of things, be mistaken. Rothenstein was right to remind his readers of this, even if Conder may not have been the best choice of artist to illustrate the theory.

Alan Clutton-Brock reviewed the book in the *Times Literary Supplement* of 17 December 1938, remarking that 'Conder once enjoyed a high reputation which at the present time it is rather difficult to understand'. Harold Nicolson in *The Daily Telegraph* of 18 November was complimentary. According to Clive Bell's important review in the *New Statesman* of 26 November, Conder was 'a feeble artist', in a set of which William Rothenstein was 'a small figure'.[47] Bell drew out the heavy dependence of the book on information supplied by the author's father and remarked that 'the noblest act of piety [Conder's] executors could have performed would have been to destroy nine-tenths of what was left in his studio'. Having dealt with the artist, Bell had no compunction in dealing with the author, 'not a very good writer', although he tells the story 'feelingly and well'. He finished by finding John a touch 'provincial', which was undoubtedly a dig in view of John's recent departure from Sheffield. John bore a long grudge against Bell, on account of this and other comments he made in his journalistic career.

To conclude, by the time he arrived at the Tate, John had published a number of books in which he had tried out his youthful theories about the art world. Some of his topics had been unfashionable and different from those of modern art which were generally of more interest to art historians of John's age. It was as if the influence of the late nineteenth-century environment of his father's art had turned his focus backwards, towards topics and artists which had little resonance for modern art historians. Moreover, the way he chose to write about his unfashionable topics was also knowingly out of line with the approach of critics such as Fry and Bell. As has been seen in, for example, the introduction to *British Artists and the War*, John was prepared to disagree openly with what he saw as mistaken art criticism. This independence of thought and approach showed how secure his background had made him feel in his own artistic knowledge. He had grown up living with and talking to artists, not merely reading about them; insofar as he had ideas about art, they were largely based on conversations with those artists, rather than on theories. This pragmatic, non-academic approach lay behind the later belittling of him as a non-intellectual; such attacks may have been true but were largely irrelevant to his life.

John later came to have some misgivings about his early written work. On 18 September 1951 he noted that he had been given the proofs of the fourth edition of *An Introduction to English Painting* for updating. 'A sickening experience it was. Have a loathing for my old writings (with not much of a compensating sense of improvement) but correcting them involves me in what would be better forgotten'.[48] An example of how he had changed by the time of the mature writing of *Modern English Painters* is that Eric Gill did not feature. The artist whose thoughts and words had seemed important enough to address in a monograph in 1927 was not considered relevant in 1952. Equally telling was that in *Modern English Painters*

and thereafter, the long list of publications by Rothenstein cited in the front did not mention the book on Gill.

More to the point, John had honed his descriptive skills so that he was able to describe artists' lives and work with considerable insight. He wrote well and, once he abandoned polemics and concentrated on description and creating impressions of artists and their lives which were rounded and insightful, he would take his place high up in the scale of those able credibly to write about art and artists. The pre-war books were understandable experiments; they were essays addressing issues which he needed to get off his chest. They left the way clear for him to move to a more mature style which he could make his own in relation to more mainstream and contemporary artists. The author of *Modern English Painters* had created and sharpened his tools.

PART 2
The Tate before John Rothenstein
(1897–1938)

CHAPTER 5
The Status of the Tate

Before John Rothenstein, the third Director and fifth Keeper, walked up the steps from the Embankment and through the front door of the Tate, his future, glittering or otherwise, stretching before him, what he was walking into needs to be seen. What sort of institution was this, a mere forty-one years after its foundation? It is only with some context about the background of the Tate as seen from 1938 onwards that what the new Director did – or could – achieve there can be fairly judged.[1]

The creation of the Tate in 1897 had marked an evolution of the concept of the purpose of a British national art collection. The National Gallery, founded in 1824, had opened in Trafalgar Square in 1838. For some years there had been no formal collection policy regarding the sort of art which could be acquired, as the Trustees, in keeping with the more laissez-faire attitudes of the time, accumulated what they liked and what happened to be received by way of gift or bequest. Much of what was acquired at this stage were Italian pictures of the High Renaissance. British art was inevitably part of this random accumulation, although, because of the traditional attitudes at the time towards the history of art, it was not regarded as being as important for the development of the national collection as work by a recognised and finite group of Old Masters.

As more British pictures arrived, more by gift than purchase, there was no room to house them in the main building, which was then much smaller than it is now and which also housed the RA until 1869; part of the Vernon bequest in 1847, for example, which consisted of a large group of British pictures and sculpture, had to be kept initially at the donor's house in Pall Mall and was later accommodated at nearby Marlborough House rather than in Trafalgar Square; in 1856 the enormous Turner bequest of 282 oil paintings and more than 19,000 watercolours had to go to a building next door to the South Kensington Museum (later renamed the Victoria and Albert Museum) when it came under the control of the National Gallery in the 1850s.[2] The Chantrey Bequest, set up in 1840, with the purpose of enabling the purchase of British art, came into effect in 1876 after the death of Lady Chantrey, and the British pictures acquired under its terms also began their life at the South Kensington Museum. Only in 1876 did relatively large holdings of British art from various sources reach Trafalgar Square when the building was enlarged by seven new galleries.[3]

If the locations of the national collection of British art were to an extent explained by the limitations of space in Trafalgar Square, there was also a feeling amongst the

Trustees that the main galleries were primarily for great works by Old Masters, who were usually foreign, and that most British art was of a separate and subordinate category. Accumulating examples of British art because it was by native artists did not fit into what the National Gallery Trustees thought their collection was for. The sugar industrialist Henry Tate (1819–1899) was typical of Victorian self-made men in his artistic tastes. He preferred to accumulate the more easily understood British art of the time rather than the Old Masters favoured by the aristocracy. Therefore, when he offered in the 1890s to fund the creation of a separate gallery just for British art, including sixty-five of his own pictures, the logic of splitting off that part of the national collection was readily accepted by the Trustees. After complicated manoeuvring over some years about the new gallery's location and architecture, a site on Millbank was acquired and the new National Gallery of British Art opened in 1897, legally constituted as an annexe of the National Gallery. It soon acquired the informal name of "the Tate Gallery". For the first twenty years of its existence, those running the Tate were called Keepers rather than Directors, under the supervision of the Director of the National Gallery. Here the terms Keeper and Director are used interchangeably for all those running the Tate from 1897 onwards.

The building on Millbank initially consisted of a vestibule, seven galleries flanking the river and a sculpture hall. On a site of three acres there was ample room for expansion as funds permitted. Its architecture, designed by Henry Tate's favourite architect, Sidney Smith,[4] made a grandiloquent statement on a part of the Embankment which was not smart and which had formerly been graced by a large prison. As a result, it was not universally admired and it was soon discovered that the river front in Pimlico was difficult for the general public to get to, long before underground trains reached it. Another issue which marred its start, at least in the eyes of the art world, whose taste tended towards the more obviously modern than that of the general public, was that the sixty-five pictures given by Henry Tate, which formed the core of the new collection of 245 pictures, were, in a word, 'rubbish'.[5] This was a little harsh but, inevitably, many were typical of the academic production of the RA at the time and were not artistically modern. In addition, the new Gallery was given the Chantrey pictures from the South Kensington Museum, 18 pictures by G. F. Watts, donated by the artist (and 3 more in 1900) and 96 British pictures from various other sources. Lumped together, the initial national collection of British art was bewilderingly incoherent. There was no way to explain it as a matter of cultural or curatorial logic. If it had any theme, it was the heavily academic taste of the second half of the nineteenth century. As John said in 1947, looking back over the formation of the collection, the worry was that 'a "British Luxembourg" founded by Tate would be nothing but an annex of the Royal Academy'. Using an amusing turn of phrase which he had developed by this time, he went on to say that 'the prospects for independent art were dark; a national Valhalla for shaggy cattle and rollicking monks … would make them darker yet'.[6]

Henry Tate died in 1899, but not before he had provided funds to extend the Gallery and in that year nine further rooms and a larger sculpture hall effectively doubled its size. The donor's young widow, Lady Tate, in seeking to fill the new rooms, exacerbated its problems by acquiring work in her late husband's taste, sometimes at vast cost, and donating it to the Gallery. In 1900, for example, she spent the huge sum of £5250 on Millais's *The Boyhood of Raleigh* (N01691)[7] and handed it over to the Tate.

Despite the purity of the theory lying behind its creation, from the beginning there was confusion as to which British art was sufficiently modern to go to the Tate and which was sufficiently grand to remain in Trafalgar Square. The Trustees, responsible for both galleries, quickly realised that it might not be in their interests to release to the junior gallery at Millbank all the works of Turner and Constable, for example, as these were rare examples of English paintings which were considered grand enough to hold their own amongst the Old Masters in the main collection. The Trustees had no intention of denuding the main gallery of such pictures for the benefit of the Tate: they invented an artificial cut-off date for transferring to the new gallery pictures by British artists born after 1790 (Turner having been born in 1775 and Constable in 1776). Even then, the Trustees were not averse to ignoring their own rules and keeping in Trafalgar Square British pictures which they particularly liked by artists born after 1790, such as Landseer (born in 1802); and they decided to break their own rules by letting Millbank have a few lesser works by Constable. Causing even more confusion was that the Trustees, constantly faced with the lack of space at the National Gallery, decided from time to time that there were pictures by foreign artists, particularly relatively modern ones such as Henri Fantin-Latour (1836–1904), which they could spare as they were not Old Masters. These were transferred to the less crowded galleries at Millbank, notwithstanding its intended purpose as a home solely for British art.

Since there was no Government grant dedicated to buying British art, considerable significance was given to the operation of the Chantrey Bequest, which generated sufficient income every year (around £2000) to buy a considerable number of British works of art. Unfortunately for those running the Tate insofar as they wanted to bring any element of coherence to the collection, the choice of these pictures was not in their hands but in those of representatives of the RA, with no influence from the National Gallery or the Tate, even though the Chantrey pictures, falling into the category of modern British art, were passed on there. As a result, most of the money was spent by the Royal Academicians on buying work from living Academicians, which meant that pictures poured into the Tate of a type which the Tate would not necessarily have chosen. The endless bad blood which this arrangement generated between the Tate and the RA will come up from time to time in these pages, until eventually it fell to John Rothenstein to sort it all out, which he largely did.

Space at the Tate for its ever-growing collection of pictures rapidly diminished and new galleries were regularly required in these early years. An additional nine

new rooms were announced in 1908, built through the generosity of J. J. (later Sir Joseph) Duveen (1843–1908). They opened as the Turner Wing in 1910, to house most of the Turner pictures and drawings transferred from the National Gallery. Duveen, operating as part of the firm called Duveen Brothers, had a successful career as an art dealer. His son (also Joseph, 1869–1939) in particular made a great deal of money for himself, some of which he gave away with extraordinary philanthropic largesse to promote various artistic enterprises. Apart from the work he funded at the Tate, he also paid for building works at the Wallace Collection, the National Gallery, the National Portrait Gallery and the British Museum (where the Duveen Gallery was built to house the Elgin Marbles) and he helped to endow the Courtauld Institute. In his art-dealing practice, he worked closely with the ubiquitous Bernard Berenson, who advised him in relation to Italian pictures. The closeness of his connections to the Tate, and the importance which he attached to them as against his other philanthropic projects, is well illustrated by the titles he chose as his status progressed. Created a knight in 1919, he became a baronet in 1927 as Sir Joseph Duveen of Millbank and in 1933 he became Baron Duveen of Millbank.[8] Apart from money, he also gave the Tate various modern pictures, such as Stanley Spencer's *The Resurrection, Cookham* (Tate, 4239), which he gave in 1927, Sargent' s *Study of Mme Gautreau* (Tate, 4102) in 1925 and Augustus John' s *Madame Suggia*, (Tate, 4093) also in 1925.

The other main source of structural friction which the administration of the Tate experienced in its early years was the clash of interests between the National Gallery's collection and its own. The Trustees until 1917 were the same body of people and they could decide to move back to the National Gallery any pictures which had found their way to Millbank but which they thought would be more appropriate in Trafalgar Square, just as they could frustrate Millbank by refusing to transfer to it all their British pictures or by sending them second-rate or modern foreign pictures. This became a particular problem when the Tate started to take in modern pictures by foreign artists after 1917. Some of the more significant works acquired in that way, such as those by the Impressionists, began to attract the attention of successive Directors of the National Gallery, as they gradually entered the canon, ceasing to be regarded as merely controversial in their modernity and therefore better left at the Tate. The fact that the Director of the National Gallery retained the right to call for pictures at the Tate to be moved to the National Gallery, whatever the wishes of the Director of the Tate, highlighted the subservient nature of the junior gallery to the senior; it also meant that the Tate's Director, increasingly as the definition of 'modern' foreign pictures adopted in 1897 or in 1917 became outmoded, was likely to be frustrated in trying to build and maintain a coherent collection. What had been a modern foreign picture, and therefore released to the Tate or allowed initially to be held by the Tate, ceased to be modern, especially if developing taste in the art world encouraged the Director of the National Gallery, backed by his Trustees, to

think that particular pictures would enhance the senior collection and should be moved.

In practice, the resolution of this tension, especially after the creation of a separate Board of Trustees for the Tate in 1917, depended firstly on the personalities of the Directors of the galleries and their working relationship; they were on the front line of this confrontation, loaded as it was in favour of the National Gallery, at least until the statutory separation of the galleries in 1955. Sir Charles Holmes, who was the Director of the National Gallery from 1916 to 1928, after holding the Directorship of the National Portrait Gallery, disliked the Tate under Aitken trying to claim all the modern foreign pictures from the National Gallery after 1917; he particularly resisted letting them have work by Goya (who had died in 1828) and Ingres (who died in 1867). Kenneth Clark touched on the delicate subject of the relationship of the galleries in his letter of congratulation to John on 7 May 1938: 'It will be a great relief for me to have a reasonable being at the Tate who does not envisage the relations of the Tate and National Gallery as a continual guerrilla warfare'.[9] This was a reference to Clark's recent experience of dealing with Manson. Later, although John found that he and his old Oxford friend could work together where the operations of the galleries overlapped, it was not so easy with another Oxford acquaintance, Philip Hendy, after he replaced Clark in 1945. Hendy and Rothenstein, backed by their respective Trustees, occasionally disagreed about Hendy's wish to move pictures to Trafalgar Square. This was another fundamental constitutional problem which John later helped to resolve, at least as regards the transfer of British pictures. The implementation in 1955 of the National Gallery and Tate Gallery Act 1954 forced the galleries to work out an allocation of pictures between them at that moment, but the matter could never be completely settled because the collections continued to evolve. John had to do battle with Hendy on this issue for the rest of his time at the Tate.

The malign operation of the Chantrey Bequest, whereunder by 1903 only five out of 110 works in the collection had been purchased from sources other than Royal Academicians,[10] widely noted in the press, had led in 1904 to the establishment by the House of Lords of a Select Committee 'to enquire into the administration of the Chantrey Trust and if necessary make recommendations'.[11] This committee, chaired by a Liberal politician, the Earl of Crewe, recommended that those administering the trust should pay more attention to the work of artists outside the RA but, without legislation, nothing changed in the way that the Bequest was administered and the Tate's frustration continued. The Tate had at least publicly demonstrated that it regarded itself as independent of the RA.

Over the years which followed the Tate stumbled along. It was hamstrung by its constitutional position and the jumble of its original pictures; without a purchase grant, its collection could not grow logically or methodically, whatever the efforts and ambitions of its successive Keepers or Directors. It did grow physically, as adjacent land was acquired and more galleries were erected, but, looked at as a

whole, the collection was misshapen and highly unsatisfactory as a representative collection of modern British art. Each Director could manage to achieve only a little progress by focusing on a discrete aspect of the range of challenges, preferably avoiding confrontation with the National Gallery. Charles Aitken, who arrived at the Tate in 1911, for example, started to hold loan exhibitions at the Gallery (even then, the first such show was of work by the beloved Alfred Stevens, who was given a further exhibition in 1915). This in theory enabled the Gallery to exhibit art not currently well represented in its collections and to discourage the visiting public's possible conclusion that, with its plethora of Chantrey pictures, the Tate was just an adjunct of the RA. Loan exhibitions reflected the tastes of Directors but they were an opportunity to experiment if the Director was able to gain the Trustees' support.

The Trustees recognised the muddle in which the Tate was operating and in 1912 another committee (under the chairmanship of the famous and eminent first Marquis Curzon of Kedleston) considered various issues relating to the national collections, including what to do about modern foreign pictures, which were not suitable for the Tate with its focus on British art, or easy to accommodate amongst the Old Masters in Trafalgar Square, which were largely foreign but not modern. The Committee recommended in 1915 that the Tate should house the national collections of all British art and also modern foreign art. As noted earlier, this structure was adopted in 1917 and the Tate was given a degree of independence; financial matters, however, remained the responsibility of the National Gallery, which would always be the senior gallery. In 1919 more than two hundred British pictures were transferred from the National Gallery to the Tate. It became clear that the Tate's function extended to forming a collection representative of the whole of British art. This sounded more straightforward, but was no easier to achieve in practice.

Initially, in order to damp down any urge the Gallery might have to operate too independently, the new Tate Board was heavily laden with representatives of the National, which was given three seats, together with ex-officio positions for its Director and Keeper. The RA, ever keen to make the sort of points which would be made by the type of artists' union it believed itself to be, argued that professional artists should be represented on the Tate Board and in 1920 the new constitution was amended to include practising artists (or architects) on the Board.[12] In the early years, these tended to be members of the RA: of the first four to be appointed under the new regime, Muirhead Bone, David Cameron, Charles Sims and the architect Aston Webb, only Bone was not a Royal Academician.

Whatever their independence from the National Gallery, those who were solely Tate Trustees were still men of the same artistic tastes as their counterparts on the National Gallery's Board. They were conservative in their acquisition policy (in particular any Trustees who were also members of the RA, whose loyalties were always split whenever Chantrey business came up) and this caution prevailed at

least throughout the 1920s and 30s. As regards modern art it was matched by all the Directors until Rothenstein. The likelihood that the Tate would focus its exiguous resources on acquiring exciting new works by artists like Picasso, Matisse and Braque must have been virtually zero.

Given the Tate's constitution, with a full-time executive Director and a Board of Trustees representing a mixture of interests, responsibility for the nature of the Gallery's collection caused tension. The Director could seek to promote various artists by proposing that the Tate acquire their work. He could also ignore work he did not like or which he thought the Board would not accept: it was unlikely that the Trustees would themselves propose an acquisition without the Director's support. However, his influence was restricted. Acquisition decisions were taken collectively by the Trustees; the Director could not propose a work of art and insist on its acquisition against the wishes of the Board.

This limitation on the Director's powers once pictures were in front of the Board needs to be borne in mind, when later the question of the responsibility for the Tate's acquisition policy became highly controversial, culminating in the public-relations disaster of the Tate Affair. Critics who failed to understand the Tate's constitution picked solely on the perceived shortcomings of the Director, and the supposed timidity or limitations of his taste, when criticising gaps in the collection. Indeed, sometimes a Director could be faulted for not proposing certain artists' work but both legally and in practice any shortcomings were the responsibility of the Trustees. There were many instances before Rothenstein arrived of offers of gifts of modern pictures being declined, including works by Cézanne. Those critical of the Tate's appetite for modernity tended to use Cézanne as the touchstone for gauging the Tate's attitudes. Nothing by Cézanne, who had died as long ago as 1906, came into the Gallery's collection until the gift of the Stoop Collection in 1933, ironically whilst one of the most conservative Directors, Manson, was in charge.

There were no Government funds and no funds via the Chantrey Bequest to buy modern foreign works of art after 1917. Nor, before Rothenstein, was there much appetite amongst Directors or Trustees to acquire such things. In 1923 Samuel Courtauld (who became a Trustee in 1927), partially inspired by some of the foreign pictures he had seen in the Hugh Lane Bequest, sought to improve the Tate's collection of foreign pictures by setting up a £50,000 fund (the 'Courtauld Fund') to acquire paintings from a selection of French artists of the second half of the nineteenth century; important examples by artists such as Degas, Manet, Renoir, Seurat and van Gogh began to be acquired as a result, the choice being decided by a knowledgeable independent committee, on the advice of Roger Fry, outside the control of the Trustees.[13] The twenty-three pictures thus acquired, some of them major works by the artists concerned, thereby started off in the Tate, as the holder of the modern foreign collection, but were transferred to the National Gallery when they were deemed by the National Gallery to have fallen out of the

definition of 'modern'. Even this scattering of good new pictures was a modest contribution to the long, slow task of trying to bring the national collection of modern foreign pictures anywhere near up to date. Twentieth-century foreign pictures in the first three decades of the century were hardly being acquired at all. It was only too apparent with the benefit of hindsight that this was the very period when many of the great works of art of the century were being created and when they might realistically have been acquired at reasonable prices. By the time that was realised, it was far too late for the Tate to try to catch up once market values had soared.

The question of where any foreign pictures could be shown in the Gallery, which was fairly full of British art, was alleviated by the generosity of Joseph Duveen, as noted earlier. New galleries funded by Duveen opened in 1926 as the Sargent Gallery, at the time that another House of Lords committee reported its findings on the proper home of the controversial Hugh Lane Bequest.

An Irish art dealer and collector, Hugh Lane (1875–1915) had bequeathed in his will of 1913 a fine group of thirty-nine pictures to the National Gallery in London.[14] Appointed Director of the National Gallery of Ireland in 1914, he executed a codicil to his will, intending to leave the pictures to the City of Dublin. But he was drowned when the *Lusitania* was sunk in May 1915. Once it was established that the codicil had been signed but not witnessed, it was undoubtedly invalid, as a normal matter of probate law; the pictures therefore followed the intention of the original will and arrived in London, causing political if not legal controversy between London and Dublin, both of whose art establishments wanted them. Over the years, especially following Irish independence, the pictures became an unlikely pawn in wider politics between the two nations. Whatever the politicians' fascination with their symbolic significance, major works by, among others, Daumier, Degas, Monet, Morisot, Pissarro and Renoir were initially put into the new Sargent Gallery at the Tate.

Apart from through the Courtauld Fund, which was quickly exhausted, or by trying to influence those administering the Chantrey Bequest, the Tate could buy pictures via the National Gallery's Clarke Fund, which could be used for buying British pictures. This consisted of a capital sum of £23,104, donated by Francis Clarke, which at this time was generating interest of approximately £500 per annum. It was supplemented in 1938 by the National Gallery allowing the Tate to use the income from the larger Knapping Fund, which was not restricted to the acquisition of British pictures. It contained conditions on its use which the Tate would have been well advised to observe. Other smaller funds were available from specific bequests, but there was still no funding from Government. Many pictures therefore arrived in the Tate's collection randomly as a result of bequests or gifts from individuals or from the Contemporary Art Society (CAS); some came via the National Art Collections Fund. Occasionally, as with the acquisition in 1919 of the important illustrations by William Blake of Dante's *Divine Comedy*, a group of institutions and people could come together informally, on an ad hoc basis, to

use their own funds to make a particular purchase for the Tate. This was not a technique which could be used often and certainly could not be relied upon to supplement the collection.

One of the small but, in practice, significant changes recommended by the Curzon Report of 1915 had been to permit the Tate Trustees to withdraw from display pictures which they regarded as inappropriate; as a result, many Chantrey purchases quickly vanished into storage, rarely, if ever, to go on display again. Nevertheless, more inappropriate Chantrey pictures continued to arrive at the doors of the Gallery before continuing what in many cases became their final journey to their resting place in the cavernous basement rooms. This was particularly disappointing given that the RA had representatives on the Tate Board, who might have seen things from the Tate's point of view. Whether they did or not, they did not materially influence those making the buying decisions.

Prior to Rothenstein's arrival, the Director and the Trustees did not help the situation by continuing to turn down modern pictures which they did not like, including works by Monet and Renoir; gifts sometimes overcame the Trustees' reluctance to acquire modern art. Larger sculpture galleries were built in 1937, courtesy again of Lord Duveen, but there was not much sculpture of sufficient size and quality to put in the large new halls, apart from a group of bronzes by Rodin, which had been transferred to the Tate from the V&A, and a few pieces by Dobson, Epstein, Maillol, Stevens and Watts.

Kenneth Clark, Director of the National Gallery from 1934, tried to regularise the decision process as to which pictures should be left in the Tate and which should be in the National Gallery, but this was difficult whilst Manson was Director.[15] In effect, when Rothenstein arrived in 1938 time was standing still as regards the constitutional structure of the Tate and any coherent evolution of its collections. There were many pressing constitutional issues which would need to be resolved to enable the Tate to move forwards as a great national collection, or to gather coherence in the shape of its various malformed collections, but there was no serious engagement with these until Rothenstein came to the Tate.

When Rothenstein did arrive, one of the members of the small and dysfunctional executive staff whom he inherited was Robin Ironside (1912–1965), who was called an Assistant Keeper but had no specific duties around the Gallery.[16] Ironside was under no illusion about the deficiencies of the Tate in the 1930s. What he wrote to Rothenstein in 1964 to congratulate him upon his retirement gives a flavour of what state the Gallery had been in: 'I was glad to note that you were given full credit for having raised from the dead an institution which (though at the time I was professionally employed in promoting the fiction that it still breathed) had, in my private opinion, been buried unnoticed years ago'.[17]

Similar comments were made by Jim Ede, who had worked at the Tate under Aitken and Manson since 1921 and who had left as recently as 1936. He had endeavoured to promote modern art from within the moribund institution, but to

little avail in the face of the hostility of Manson and the Trustees. On 4 April 1964 he wrote to John: 'I was touched by the great passage of years and the immense amount you have done to the Tate. It makes me laugh to think what a hole in the corner concern it was when I was there'.[18]

CHAPTER 6
The Four Previous Directors and Keepers

There were only four Keepers or Directors of the Tate before Rothenstein: Charles Holroyd (1897–1906), D. S. MacColl (1906–11), Charles Aitken (1911–30) and J. B. Manson (1930–38). All were, to a greater or lesser extent, friends of William Rothenstein.[1] This chapter will sketch out their characters, achievements and failings while they were in charge of the Tate, to put some context into the choice of John Rothenstein and how he may be compared to his predecessors, since one of the allegations made during the Tate Affair was that he was unfitted for the job. It will be seen that this was not the case and that he was well able to hold his own in comparison to his predecessors. It could easily be argued that he was more successful as Director than any of them. The others on the shortlist to succeed Manson in 1938 will also be noted and again, as Kenneth Clark saw, Rothenstein came out head and shoulders above them.

Just as the purpose of a national art collection had been fluid during the nineteenth century, so the role of a full-time professional executive running a national art gallery, especially one including modern art, was not well-defined in England at the beginning of the twentieth century. The appropriate balance of past experience as a gallery director, knowledge of the art and administrative or academic track record was not settled, with the result that the experience of the four Keepers by 1938 had come in all shapes and sizes.

Charles Holroyd (1861–1917) was appointed the first Keeper in September 1897. Born in Leeds, he had initially studied mining engineering at the Yorkshire College of Science. He then sharply changed academic direction, came down to London and took up a place at the Slade under the French artist Alphonse Legros, who had been at the Slade since 1876 and who later became the teacher in charge of the young William Rothenstein when he was there for a year in 1888. In fact, when William arrived aged sixteen, he was looked after by his fellow Yorkshireman, who had by this time become an assistant master at the Slade. Legros taught Holroyd etching, in which medium he enjoyed some esteem as an artist, later becoming a Fellow of the Royal Society of Painter-Etchers. He had pictures accepted at the Royal Academy Summer Exhibitions from 1885 to 1895 and joined the Art Workers' Guild in 1898, becoming its Master in 1905 when still the Director of the Tate. The Guild had been established in 1884 by a group of architects associated with William Morris and the Arts and Crafts Movement. It had expanded to incorporate a wide variety of artistic practitioners and its activities gave rise to the Arts

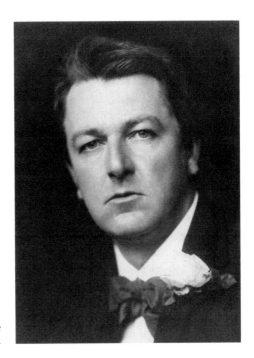

Sir Charles Holroyd. Photograph by George
Charles Beresford, 1907.

and Crafts Exhibition Society in 1887. Holroyd's prominence in the Guild suggests his strong bias towards Arts and Crafts ideas. In this vein, he was for example adept at medal design. He was not widely noted as an author, apart from a well-regarded biography of Michelangelo (1903).

At the Tate, Holroyd collected designs for sculptural or architectural projects and also portraits by the painter and sculptor, Alfred Stevens (1817–1875), whose best-known work was the Wellington Monument in St Paul's Cathedral. Stevens was regarded as a genius by some but overlooked by others. His supporters thought he had been hard done by as he struggled for many years to accomplish the Wellington commission. Championing him rather than attempting the Herculean task of assembling a broader, more representative collection of British art was Holroyd's individual initiative and took the new Tate away from critical thinking as to who were the leading recent artists. Holroyd may have felt that it was better to concentrate the Tate's limited resources on a small number of artists than to spread the collection thinly in a forlorn attempt to make it representative.

In 1906 Holroyd, who had been knighted in 1903, moved on to the Directorship of the National Gallery, from which he resigned ten years later due to ill health. The transfer between the galleries is symptomatic of the attitude of the Trustees; with the supervision of both galleries they would have seen the promotion of a Keeper from one to Director at the other as a natural career progression. As Keeper of the Tate Holroyd was regarded as a good administrator, but hampered in all larger decisions by the faults of the Tate's constitution. Although it is thought

that he made a number of achievements, particularly in building up the Tate's collection of works by Turner,[2] he left the Tate with many unresolved and perhaps insoluble problems.

D. S. MacColl (1859–1948) was a close friend of William Rothenstein's, as has been seen, and different in many ways from Holroyd. He was also a controversial choice for the Tate job, because he had used his regular column in the *Saturday Review* in 1903 to attack the Royal Academy's administration of the Chantrey Bequest.[3] He had then re-published these articles in pamphlet form in 1904, making himself even more unpopular with the RA. MacColl asserted that the original Chantrey will had 'been ignored, its intention perverted, and the funds … grotesquely maladministered'.[4] He was a man of considerable personal integrity; the word 'formidable' seems to suit what is known about his character and he is the only Tate Keeper prior to this book to have been the subject of a published biography.[5]

Son of a Scots Free Church minister, MacColl was born in Glasgow and studied first at University College London and then at Lincoln College, Oxford, whose Rector at the time was the eminent author Mark Pattison. At UCL he spent three years studying for ordination to the Church of England, developing an interest

D. S. MacColl by Donald Maclaren, c.1906.

in art in his spare time. He won many academic prizes but decided that he did not want to be a priest. At Oxford he was also successful, winning the prestigious Newdigate Prize for poetry in 1882 and helping to found the *Oxford Magazine* in 1883. After Oxford he spent a number of years lecturing and travelling and by February 1890 had become the art critic of the *Spectator*, thus launching his art world career.[6]

To develop his skills as an artist MacColl enrolled as a part-time student under Frederick Brown at the Westminster College of Art, joining the New English Art Club (NEAC), which Brown had recently helped to found. On a visit to Paris in 1890, MacColl met William Rothenstein and his circle; thus began a lifelong connection with the Rothenstein family. A respectable watercolourist, MacColl has six works in the Tate. One, *Crock and Cottage Loaf no. 2*, of 1931 (Tate, 5103), was presented in 1940 by none other than the Chantrey Bequest. One suspects that William Rothenstein, who was a Tate representative on the Chantrey Recommending Committee, had a hand in that decision. At the *Spectator* MacColl flirted with controversy, promoting artists such as Monet and Degas, still regarded by some as dangerous revolutionaries, and also Impressionism. He began the attacks on the RA which were to make him notorious in the 1890s, as did his promotion of Degas. A long print battle developed between him and the art critic of the *Westminster Gazette*.

MacColl moved from the *Spectator* to the *Saturday Review* in late 1896, in time to comment negatively the following year on the Tate's new building.[7] Then, as previously noted, MacColl's agitation against the operation of the Chantrey Bequest led to Parliament recommending changes in the administration of the Trust. Against this background, it was controversial when, in June 1906, MacColl was appointed to be the second Keeper of the Tate. As MacColl's biographer says, the Royal Academicians must have thought the Government had gone mad.[8] The appointment of such a vocal critic of the RA could not help to resolve the tensions between the two bodies. Moreover, MacColl was a candidate with no experience of running a public institution.

Now, bizarrely, MacColl was responsible for the hated Chantrey pictures at the Tate and, moreover, the building that he had readily criticised. He was also responsible for building an extension to the gallery to house the Turner Bequest in 1907 and he continued Holroyd's policy of acquiring work by Alfred Stevens. The latter is a good example of how difficult it is for even sensible and experienced people to guess which artists' reputations are likely to survive. Suffice it to say that Stevens's work is not much better regarded now than many of the despised works by Academicians bought through the Chantrey Bequest.

Before and after his time at the Tate, MacColl was active in establishing funding outside the Government to support galleries labouring with non-funding or underfunding or with restrictions on what they could acquire. In 1903 he had been present at the inaugural meeting of the National Art Collections Fund (NACF),

which survives to this day as the Art Fund.[9] It aimed to raise money from subscribers in order to acquire works of art and to give them to public institutions. A particular objective was to prevent great works of art from being sold abroad. MacColl had been arguing for three years in the press for the establishment of such a body and he was elected to its first Executive Committee. One of his motivations for agitating for this sort of body was his despair at what he – and many others – perceived as the waste of the not insubstantial Chantrey Bequest.

By the time he got to the Tate, MacColl realised that, despite its funding in 1905 of the acquisition of Whistler's *Nocturne in Blue and Gold* (1872–5, Tate, 1959), the NACF was not effective in buying modern pictures for the national collection.[10] Its limited resources were being drained by purchases of major works of art which came onto the market in the early years of the century – members of the aristocracy were trying to boost their declining revenues from land by selling their Old Masters. The locus classicus of this dilemma, which left the NACF with no funds for modern works of art, was the need to support the purchase for the National Gallery in 1906 of the *Rokeby Venus* (*c.*1648, NG 2057) by Velázquez. In order to secure this, the large sum of £45,000 had to be raised in short order, a prodigious task for a voluntary organisation with a limited number of members.

So in 1909, MacColl in continuing despair at the Chantrey Bequest supported the establishment of another society, which became the Contemporary Art Society (CAS) (also still going today). Its funds were used to buy contemporary pictures for distribution to public galleries around the country. Its first annual report (1911) noted acquisitions of oils by Vanessa Bell, Duncan Grant, Augustus John, Henry Lamb, William Nicholson and others, together with drawings by Gauguin, Rothenstein and Sickert.[11] Initially the CAS used a committee to choose which new pictures to buy, but this was reminiscent of how the Chantrey Bequest was administered, with collective decisions tending to favour the lowest common denominator. Soon CAS purchasing decisions were devolved onto a single buyer, whose appointment rotated regularly, with the authority to select works for purchase. It will be seen later which works John Rothenstein chose when he was the CAS buyer.

With all these different demands on his time, MacColl got increasingly exhausted. In 1909 he wrote a critical memorandum to the National Gallery Trustees, grumbling in particular that he as Tate Keeper was unacceptably limited in acquiring pictures.[12] With no grant, he had had to resort to something not far short of begging when he wanted to acquire British art for the national collection. A good example had come in late 1906, when the Whitechapel Gallery held an exhibition of Jewish art. A major picture on display was *Jews mourning in a Synagogue* by MacColl's old friend William Rothenstein, and he informed the director of the Whitechapel, Charles Aitken (as noted, MacColl's successor at the Tate from 1911), that he would like this picture for the Tate.[13] The hint was taken and various private donors were informally approached: it duly entered the Tate collection (Tate, 2116)

at no cost to the nation. Such informal pressure, however, was no way to try to build up a coherent national collection.

By the time the new Turner Wing opened in July 1910, MacColl was utterly exhausted and when he attended Roger Fry's first Post-Impressionism exhibition in December he collapsed with what was described as heart strain. The Trustees considered that he needed a lighter workload.[14] By agreement he therefore stood down from the Tate and was appointed Keeper of the Wallace Collection in London in January 1911, a much less onerous role and less in the public eye than the Tate. MacColl returned to the Tate as a Trustee from 1917 to 1927: at the level of senior administrative positions, the British art world was a small place at this time.[15]

Charles Aitken's transfer to Millbank in 1911 is another illustration of this gallery-hopping among leading administrators. Aitken is regarded as having been a success at the Whitechapel which, like all public galleries, struggled with lack of funding from its opening in 1901. He had put on some interesting shows there. For example, modern British art was represented by *Artists in the British Isles at the Beginning of the Century* in 1901, *Contemporary British Artists* in 1908 and *Twenty Years of British Art* in 1910. The only exhibition dedicated to modern foreign art under Aitken was *French and Contemporary British Painting and Sculpture* in 1907.[16] Choosing him for the Tate job was not illogical. He knew about running a gallery and his experience suggested that he would not be hostile to all modern art at the Tate[17] although, like all Directors, he was to find 'modernity' a slippery thing. In fact, his reluctance as Keeper to engage constructively with acquiring modern foreign art during this

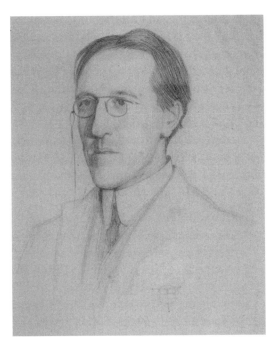

Drawing of Charles Aitken,
artist unknown.

crucial period of the Tate's development meant that the Gallery could never represent that key phase of modern European art.

In 1921 Aitken refused to accept even the loan of a Cézanne, offered to him by one of the Davies sisters from Gregynog.[18] For this he was attacked by the *Burlington Magazine* (from 1920 to 1933 under the editorship of a Scottish art historian, Robert Tatlock).[19] Aitken also turned down a chance to buy a Cézanne portrait in 1922, compounded by turning down four more Cézannes a few months later. A picture by Cézanne finally entered the collection, but only on loan, in 1929, just before Aitken retired. In that year Aitken and the Trustees rejected an offer from the CAS of Matisse's *Reading Woman with Parasol*, although it was eventually accepted in 1938 (1921, Tate, 4924). As regards modern British art, Aitken was responsible for the purchase of the Tate's first work by Matthew Smith (*Peonies*, 1928, Tate 4410).[20]

Aitken's choice of exhibitions of modern art was more conservative than it had been at the Whitechapel, when he was younger and free of the Tate's Trustees. In 1913 he put on a Pre-Raphaelite show and one on William Blake's work. Exhibitions of Turner, Cotman, early British watercolours, paintings from the 1860s, Richard Wilson and Thomas Rowlandson during Aitken's tenure were not controversial, but there were occasionally more modern subjects (although not up to date) – Whistler as early as 1912, Beardsley in 1923, Conder in 1927 and Philip Wilson Steer in 1929. To the conservative British art establishment, personified by the RA and the Tate and National Gallery Trustees, such shows were perhaps modern enough.

An important, and long-lasting, benefit which arrived under Aitken, gracing the Tate since 1927, is the Rex Whistler mural called *The Expedition in Pursuit of Rare Meats*, painted on the walls of the restaurant; again, it was Duveen's idea and money which made it possible. This quirky and unusual work could not be said, however, to be representative of modern art. No sooner was the mural finished than it was damaged by the flood which swept through the basement of the Tate when the Thames burst its banks in 1928.

By the time John Rothenstein came to write the second volume of his autobiography in the 1960s, he had perfected his extraordinary ability to summarise personalities in a balanced and credible fashion. This is what he said about MacColl and Aitken in *Brave Day, Hideous Night*:

> Aitken had a different kind of mind from MacColl: MacColl was a man
> of exceptional intellect, learned, incisive and elevated; one of the finest
> writers of his generation on the fine arts … And a most formidable advocate.
> In comparison Aitken seemed ordinary: his intelligence was relatively
> pedestrian; his powers of expression were limited; he was a dry, retiring, quite
> unimpressive person who, had he not been Director of the Tate, might have
> lived out his life without leaving any particular mark. But Director of the Tate

he was, and the opportunities the position offered and the responsibilities it imposed brought out qualities that made him a great director: clarity and liberality of mind, firmness of purpose, and a burning devotion.[21]

This illustrates the difficulties in selecting a new Director. What was the definition of a 'good director', let alone one interested in modern art? It was far from obvious. On paper, Aitken had been well qualified and John was able to see his qualities. The biographer of Manson had a similar view of Aitken's personal attributes but without John's modifying sentiment:

> Charles Aitken was in every way a contrast to Manson. Spinsterish in habits, a celibate and a bachelor, prim in manner, he might well have been mistaken for a churchwarden. … He didn't like anything that was contemporary or foreign, his taste was for the crucifixions and the annunciations of the early Italian painters, and the Pre-Raphaelites, and his firm belief was that art is nothing unless it contributes to the moral and social welfare of humanity.[22]

Aitken's friendship with Manson's wife was the link which got Manson a job at the Tate, starting on 9 December 1912 as Clerk and rising to Assistant Keeper in 1917.

The appointment of Manson as Director in 1930 marked the first occasion on which the Tate had promoted an insider.[23] Since the Gallery's foundation, its Directors had come from a variety of backgrounds. Holroyd had been a teacher at the Slade; MacColl had been an art critic of controversial opinions; Aitken had been translated from the Whitechapel; now an inside candidate who was himself an artist presented himself. It may be that, with the executive staff at the Gallery so tiny and the Gallery so young, there had not previously been any suitable internal candidates. Shortly after 1930, the Trustees must have wondered whether their choice of this particular internal candidate had been wise.

The 1930s before Rothenstein's arrival were a low point for the Tate. Manson's main assistant was David Fincham and, judging by some of the correspondence which passed between them, they were a cynical pair. When Robin Ironside joined the staff in 1937, he was put in a room with no allocated duties to perform and told by Fincham to keep out of the way. Manson himself, contrary to his later reputation as a reactionary anti-Modernist, had in his early years been a painter at the more adventurous end of the British art spectrum. If his own output never got much beyond competent flower paintings in a loosely Impressionist style and his attractive self-portrait (*c*.1912, Tate, 4929),[24] he had been one of the early members of the Camden Town Group and had been its secretary. When this evolved into the London Group, Manson remained its secretary (around 1913). Such groups were considered modern in contemporary Britain. Like William Rothenstein, Manson had trained at the Académie Julian in Paris, held his first solo exhibition in Cambridge in 1910 and went on to become a member of the New English Art Club in

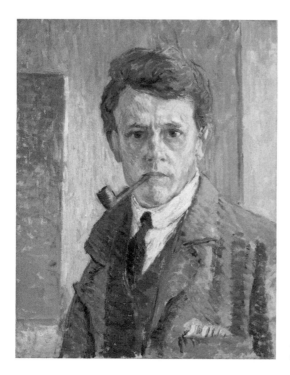

James Bolivar Manson. Self portrait, c.1912.

the 1920s. He also had something of a literary career, with books on Rembrandt, Degas, Sargent and Dutch painting and an introduction to the Tate called *Hours in the Tate Gallery* (1926).[25]

His problem, in terms of contemporary art once he became Director, was common in the art world: his tastes, having been relatively modern when young, solidified with age and stopped keeping pace with developments. The year 1913 marked high water in his modernity, when he put his name to this statement in the catalogue of an exhibition of the London Group:

> To conceive a limit to artistic development is an admission of one's own limitations. Nothing is finally right in art; the rightness is purely personal, and for the artist himself. So, in the London Group, which is to be the latest development of the original Fitzroy Street Group, all modern methods may find a home. Cubism meets Impressionism, Futurism and Sickertism join hands and are not ashamed, the motto of the Group being that sincerity of conviction has a right of expression.

A few months later, unable to tolerate the modernity of the work of artists such as Bomberg and Wyndham Lewis, Manson realised that he did not believe what he had written and resigned from the Group. By the time he was appointed as Director of the Tate in August 1930, the Trustees were probably aware (and comfortable) that his artistic tastes were stuck in an earlier age. The Director's personal

taste was highly relevant to what art managed to join the permanent collection and, in any event, the Director had to anticipate what the Trustees would tolerate; but their tastes were never likely to be more modern than his. There was also little sense that the Director should subordinate his own taste in order to build a representative collection: if the Director did not like a work of art, it tended not to be welcome. Manson could tolerate the work of leading British artists such as Duncan Grant, Augustus John, Sickert and Wilson Steer, and was fully supportive of what many still regarded as the modernity of the Impressionists, but more modern (not to mention abstract) practitioners were beyond his tolerance or comprehension, and the accession of work in those categories was actively resisted. Even work by Henry Moore was rejected while Manson was Director, as was work by Matisse. One exciting event during his Directorship for which Manson can take little credit was the arrival of modern works by foreign artists from a Dutch collector based in London, Frank Stoop. He presented a work by Braque in 1928 (*Guitare et pichet*, 1927, Tate, 4416), and when he died, the Stoop Bequest, which brought with it the Gallery's first examples of work by Cézanne and Matisse together with excellent works by Picasso. Manson was ambivalent about accepting this bequest of seventeen pictures, but the result was a marked improvement in the quality of the Gallery's holding of modern foreign art.

It is easy to think of Manson's Directorship as stalling the evolution of the Tate's collection, but the following artists' works were acquired, particularly as gifts and bequests, an indication that the collection was expanding in the right direction: Braque, Cézanne, Degas, Derain, Dufy, Ensor, Laurencin, Matisse, Modigliani, Picasso, Douanier Rousseau and van Gogh. English artists whose work was acquired included Bevan, Grant, Hodgkin, Augustus John, Nevinson, Philpot, Sickert, Smith, and Gilbert and Stanley Spencer. No doubt a long list of omissions and rejections could be compiled, particularly of modern foreign art, and the end result in terms of the balance and extent of its coverage of twentieth century art was poor.

Manson's choice of exhibitions should come as no surprise. The work of George Chinnery in 1932 and Sir Edward Burne-Jones in 1933 were acceptable; shows of cricket pictures and then of other sporting pictures, both in 1934, may have been popular with the wider public but were unlikely to have pleased connoisseurs. Such exhibitions contrast sharply with what John Rothenstein was achieving at the same time in Sheffield. The Museum of Modern Art in New York approached the Tate in 1936 offering to bring on to London their *American Art 1609–1938*, which they were planning to hold at the Jeu de Paume in Paris in 1938.[26] As a good example of the different tastes and attitudes of the two Directors, Manson was unresponsive to this proposal, whereas John later picked it up enthusiastically. William McTaggart (the elder), the Scottish artist who had died in 1910, got a show in 1935 and Professor Tonks from the Slade, who died in 1937 aged seventy-four, had the only show of 1936. Overall, however, neither Aitken nor Manson seriously tried to hold

an exhibition of work by any avowedly modern artist in the 1920s or 30s; again, it was Rothenstein, working in conjunction with the Arts Council, who remedied this during his long directorship.

As time passed, Manson seemed to get diminishing pleasure from a job which required much fairly relentless administration and external representation of the Gallery. Instead, he wanted to concentrate on his painting. Thomas Bodkin recorded an ominous instance of Manson's increasingly unpredictable behaviour as early as 1933, at an official event in Gothenburg. He noted that Manson 'enlivened the proceedings by making all sorts of queer noises at inopportune moments, particularly during the course of speeches which he thought were dull'. Manson's drinking became a problem which he made little attempt to conceal. Kenneth Clark noted that Manson used to appear drunk at Board meetings, on one occasion falling off his chair and having to be carried out.[27]

In 1937 Manson got embroiled in the tiresome process of defending a libel action received from the French artist Maurice Utrillo. This arose when Fincham, either mischievously or simply without checking his facts, published in an official Tate catalogue that Utrillo 'had been a drunk who had died in 1934'.[28] Utrillo at this time not only had many years ahead of him but also, not surprisingly, took offence at the implication that he was an alcoholic or worse. Manson had to deal with the consequences, which were stressful for him until the case was finally settled in February 1938. By this time he was also suffering difficulties in his marriage; the combination of all these problems put him under terrible strain.

The stage was now set for the final scene in Manson's short and somewhat desperate tenure as Director. On 4 March 1938 he attended a lunch in Paris to celebrate the opening of an exhibition of British art at the Louvre. The meal, in the grand surroundings of the Hôtel George V, was a formal occasion. Manson, perhaps maddened by the formalities, became increasingly drunk and out of control as the lunch wore on. Gothenburg turned out to have been a dry run for what followed in Paris. According to Kenneth Clark who was there as Director of the National Gallery (and was also a Trustee of the Tate), Manson interrupted events by making 'farmyard noises' and by haranguing those on the top table, beginning with Jean Zay, the French Minister of National Education and Fine Arts, and going on to Frances, Lady Phipps,[29] the wife of the British Ambassador to France, Sir Eric Phipps.[30] According to Clark, Manson's comment to Lady Phipps was to invite her to come and see him, so that he could show her something not in the Tate Gallery, whereupon those on the top table decided that the lunch was over and stood up and walked out, followed by the rest of the guests. Once outside, Clark had to lie down on a park bench because he was laughing so much but, clearly, those of a drier turn of mind were not so amused.[31]

Clive Bell was also at the lunch. His summary was that Manson arrived already drunk and 'punctuated the ceremony with cat-calls and cock-a-doodle-doos, and finally staggered to his feet, hurled obscene insults at the company in general, and

the minister in particular, and precipitated himself on the ambassadress'. Bell hoped that 'an example will be made, and that they will seize the opportunity for turning the sot out of the Tate, not because he is a sot, but because he has done nothing but harm to modern painting'.[32] His reaction to Manson's replacement is not recorded.

Manson's biographer, W. S. Meadmore, tracked down Lady Phipps some years later: 'Lady Phipps told me that the incident passed almost unnoticed', which makes one question the reliability of memoirs. Meadmore also noted that the initial interruptions from Manson came during Clark's speech, which Clark does not choose to mention. Randolph Schwabe recorded in his diary on 26 March that he had bumped into Ralph Edwards (sometime Keeper of Furniture and Woodwork at the V&A) who had also been present at the lunch. Edwards had heard that, following the lunch, there had been a tactful letter from the French Minister about the incident 'in which the demonstration was put down to natural enthusiasm and warmth of heart, or something to that effect. Edwards says Manson's cock crow was so realistic that people thought for a moment that some mechanical method of sound reproduction was being employed'.[33]

Whatever the detail, it was a dreadful incident in the eyes of the English present, who included the Hon. Sir Evan Charteris, the Chairman of the Tate Trustees.[34] Manson himself seemed initially oblivious. In a letter written at the time about the lunch he mentioned nothing untoward and simply remarked that he went back to his hotel afterwards and slept for five hours.[35] By contrast, the Tate Trustees and the Treasury regarded this as the final nail in Manson's coffin as Director and moved with astonishing alacrity: exactly two months after the fateful lunch, the Treasury passed a formal minute appointing John Rothenstein as his successor.[36]

To begin with, Manson had to be persuaded to resign on the grounds of ill health. In the letters which Charteris wrote to Manson there was no rancour but, rather, much warmth and affection, which suggests that Charteris had not regarded him as a terrible Director. An undated letter is representative:

> I am touched by your letter. I have been friends with you too long not to have felt to an uncommon degree this happening. But everything must be done to make the best of it – to me it has only the moral quality of an attack of measles – but you would be the first to realise that other reactions were involved.[37]

Manson, maybe fearing the effect on his income, suggested that he might be put on sick leave instead of resigning but Charteris remained firm: 'I'm afraid the suggestion about "sick leave" is not feasible and cannot be entertained by the authorities – I have discussed the matter with the Treasury and they take the view that the resignation should be operative as from April 15th'.[38]

Having dealt with Manson, and no doubt under the goad of the Treasury, the Trustees rapidly turned to the question of his replacement. John, alerted in Sheffield by telephone that Manson was on the way out, was excitedly wondering

whether he was going to be invited to apply, his father having told him that one waited for an invitation. It took a chat with the art critic Eric Newton to correct this impression and John duly sent in his application, dated 4 April.[39] In a measured way, John set out his career details, omitting any mention of his father. He ended with a statement which might have come back to haunt him during the Tate Affair had it ever been made public: 'British painting has always been my principal field of interest and study'.[40] He had perhaps forgotten that British painting was only half the Tate's remit in 1938. It was not a shortcoming likely to have any negative effect on the Trustees.

How many people applied is not known, but the final four candidates are known. On 13 April, Charteris wrote to the Earl of Sandwich, a fellow Trustee, about the fateful Paris lunch. It was an official, typed letter but at the bottom Charteris wrote by hand: 'Most unlucky your being away re Directorship. 4 names sent in. Rothenstein, Wellington, William Gibson and Leigh Ashton'.[41] By 'sent in', Charteris meant that the Trustees had referred these names to the Prime Minister's Appointments Office, which was to make the final choice, no doubt with their recommendations appended.[42] Of the names given, Rothenstein was by far the most obviously appropriate candidate. This needs to be emphasised in view of the later criticism about his unsuitability to be Director. A brief look at the qualifications of the other three should show why they were unsuccessful.

Hubert Wellington had been born in 1879, so he was nearly sixty in 1938. A minor painter, he had been a lecturer at the National Gallery and at the Royal College of Art, where he was William Rothenstein's Registrar (and published a book about him in 1923), and was in 1938 the principal of the Edinburgh College of Art. He had no experience of running a public gallery, even a provincial one, and it is unlikely that he would have driven the Tate forwards in contemporary art or otherwise.

William Gibson, educated at Westminster and Christ Church, Oxford, was about the same age as John Rothenstein. He had been Assistant Keeper at the Wallace Collection from 1927 to 1936 and was the deputy director of the Courtauld Institute. As an indication of his mind-set, his obituary in *The Times* on 23 April 1960 noted that he liked to live without a telephone or a wireless and, where possible, without electric light. This suggests an inappropriate approach to the Tate and the challenges of modern art. Shortly afterwards he was appointed by Kenneth Clark as Keeper of the National Gallery, where his taste in eighteenth-century French art was more suitable.

Leigh Ashton was a close friend of Clark's. Having joined the V&A in 1922 in the Department of Architecture and Sculpture, he had transferred to Ceramics via Textiles. He had become an expert in Chinese art and only later went on to run the V&A, developing a drink problem. In an undated letter to John before the announcement of the result, he tipped John off that he had heard 'from an impeccable source' (probably Clark) that the job was John's. 'I thought you had the best

Sir (Arthur) Leigh Bolland Ashton.
Photograph by Walter Stoneman, 1949.

chance, as I could not be regarded as a picture man.'[43] He was clearly a master of understatement.

So John got the job. His ground-breaking experience at Leeds and Sheffield had not been in vain. One could imagine that William might have had a hand in his son's appointment. He probably advised John not to mention him in his application.[44] On 25 March he wrote to John that he had tried to persuade his wife that he 'could, must, do nothing; that you have made your name and will be considered on your merits. There is nothing to be done save wait – and put the matter out of one's mind'. This sounds proper in the circumstances and would have answered any allegations of interference had it not been for the following sentence in the letter: 'I will let you know when I can get Evan C[harteris]'.[45] Doing nothing on the one hand and on the other telephoning the Chairman of the Trustees as they considered his son's candidacy made odd bedfellows.

In any event, the Treasury wrote to John on 1 May offering him the job at a salary of £1161 per annum. The Sheffield authorities agreed to release him from his contract with them, Alderman Graves writing John a generous letter on 5 May, which did him great credit. Other letters of congratulation arrived from friends and family. William's pleasure was uncontained; all his ambitions for his son's career had been fulfilled and he was proud of what John had achieved.[46] It is some relief to know that, by the time things turned sour for John at the Tate, William Rothenstein was long dead.

CHAPTER 7
Early Days and North American Tour, 1938–40

Arriving at the Tate on 2 June 1938, at the age of thirty-six, John was the first Director of the Tate to have a serious interest in and understanding of modern art. He faced two immediate challenges. Before he applied himself to developing the collection as he had at Leeds and Sheffield, it was essential to assess the qualities of the senior staff and develop a good working relationship with them, and quickly to build relations with the Trustees, particularly the Chairman, so that he could gauge their appetite for acquiring modern art. If he could reach an understanding with the two Assistant Keepers inherited from his predecessor and with the Chairman, much else involved in running the large gallery and modernising its collection could fall into place, and the blizzard of challenges in such a high-profile role and from the ominous world situation could be withstood.

John had learnt from his experience in Leeds and Sheffield that, with his relative lack of administrative and commercial skills, he needed to rely on staff who were both able and trustworthy. He quickly became friendly with Robin Ironside but the other and more senior Assistant Keeper was a different matter. David Fincham's character cannot now be recreated in detail; scraps of evidence from his letters and comments on his activities by others are all that are available. Appointed to the Tate

John with William Rothenstein, c.1938.

Robin Ironside.
Photograph by Harold White.

in 1930, the same year that Manson took over as Director, Fincham and Manson were close and shared an irreverent sense of humour which was occasionally pointed in the direction of the Trustees behind their backs. That closeness meant that he was not well disposed towards Manson's replacement, especially if the new man was not going to share Manson's capacity for frivolous behaviour and for tolerating similar behaviour on the part of his most senior assistant. Kenneth Clark recorded that, at the time of the incident described in Chapter 6, when Manson had to be carried out of a Board meeting, his place 'was then taken by a much less charming, but almost equally drunken subordinate named Fincham, who had no interest in art, but had married Lord d'Abernon's niece'.[1] Lord d'Abernon (1857–1941) had been Chairman of the Trustees at the time of Fincham's appointment. John too commented in his autobiography on Fincham's habitual drunkenness, apparently favouring long sessions in nearby pubs at lunchtime, which rendered his afternoon performances in the Gallery unpredictable and occasionally embarrassing in front of important visitors.[2] John's suspicions of Fincham were confirmed during the war when he was lunching with Manson, who told him that Fincham 'had repeatedly told him he intended to "teach me a lesson", "show me where I got off"(!) etc etc when I was appointed and boasted he intended to be as difficult as possible'.[3] This made for awkwardness in John's early days at the Tate, when he needed help from his colleagues to understand what the job required; it also meant that he was thrown into relying on Robin Ironside.

John's sometimes poor ability to judge the adequacy or appropriateness of staff at the Tate will be explored further but, from the beginning of his Directorship, his judgement on how to handle difficult employees was not one of the new Director's strengths. John considered the possibility of firing Fincham shortly after he arrived and realised what a problem he had inherited; but, in the interests of not being seen as too precipitate so soon, and probably to avoid a direct confrontation, he left Fincham in place, which turned out not to have been a wise decision.[4]

Apart from Fincham and Ironside, there was a group of gallery attendants and junior staff upon whose reliability and resourcefulness the Tate soon found itself highly dependent. Key amongst these was John Lee, a gifted craftsman, whose many tasks included repairing damaged pictures and frames but whose general abilities in sorting out problems were something of a Tate legend. Rothenstein developed considerable respect for many of the staff once the war started and they had to cope with the challenges caused by the widespread bomb damage to the building.

Just as relevant to the success of a Director was his ability to develop a good working relationship with the Trustees. Here John was fortunate in having for his first couple of years Evan Charteris as Chairman, whom he liked. In *Brave Day, Hideous Night* John emphasises how brilliant he found the early Chairmen whom he experienced at the Tate, in contrast to his less satisfactory experience with their successors. Whether the description of his relationship with Charteris (and, later, Jasper Ridley) is entirely reliable is a moot point. John expressed great admiration for the way Charteris handled the Board. He 'presided with style, getting his own way almost invariably, I noticed, by arguments presented with a casual elegance that masked their lawyer-like precision'.[5]

Among a largely reasonable group of Trustees were a number who were already friends of the new Director's or his father's. John started with a fund of goodwill, since the Trustees had just selected him and were likely to regard anyone as better than Manson. Even so, there were several strong characters and a mixture of types on the Board; for example, the aristocrats tended to approach their role in a different way from either the artists or the representatives with more professional backgrounds. In later years, corresponding to their changed status in English society, the prevalence of the aristocracy on the Board declined. John later claimed that, as Director, he subsequently found that, with the benefit of hindsight, he preferred to deal with aristocrat Trustees than with middle–class businessmen.[6]

Whatever the social status of the Trustees, it was not possible for any Director to please all of them all of the time. Apart from Kenneth Clark (representing the National Gallery), there was Augustus John (artist representative), the Earl of Crawford and Balcarres (representing the National Gallery) who, as David Balniel, was an old Oxford friend of John's, Sir William Reid Dick (a sculptor representing the RA), Sir Edward Marsh (a major collector of work by modern British artists), Sir William Nicholson (artist representative), Lord Howard de Walden, the Earl of

Sandwich, Viscount Bearsted (representing the National Gallery) and Sir Walter Russell (artist and Keeper of the RA Schools). Many had other representative positions in the art world and together they constituted a formidable body of influence in that small and incestuous world. Inevitably some were more attentive to the Gallery's business than others. When Lord Howard de Walden suggested he might resign in 1939, the Chairman wrote to John: 'What an astonishing thing that Lord Howard de Walden, after never coming to a meeting or apologising for his absence,' and so on.[7] The tenor of this letter suggests that the Chairman had developed a rapport with his Director. Nevertheless, relations were not able to develop properly between the pre-war Trustees as a whole and their new Director because of the lead-up to the outbreak of war in September 1939.

The conditions which John describes at the Gallery in June 1938 were not satisfactory, the rudimentary administrative system having virtually collapsed under Manson and Fincham and with the ineffectual involvement of Ironside.[8] This was bad for a large national institution. Files relating to the collection and administration could not be found and letters could not be properly answered; the staff were demoralised, some of them casually indifferent to and cynical about their tasks; the decoration of the galleries was tired and too many rooms were hung with the most wretched of the Chantrey pictures, which Manson had deliberately chosen to hang as a joke and as a taunt to the RA.[9] In *Brave Day, Hideous Night* John, who hated such pictures as much as Manson, amusingly described them as 'Alpine valleys, puppies in baskets, ladies in eighteenth-century dress standing on chairs, affrighted by mice, and the like'.[10] In other words, the new Director found himself in a similar situation to that in Leeds on arrival there in 1932 and, in the same way, set about rectifying what he could by the application of practical common sense.

John Rothenstein lost no time in beginning to turn the Tate Gallery into a source of national pride. Then he did it all again after the end of the war, when he was faced with the unprecedented challenges caused by the extensive physical destruction of the building. In 1938 he just needed to be efficient and imaginative and the contrast with Manson would do the rest. A group of forgotten works by Turner was discovered in the stores, cleaned, framed and hung in the Gallery; and the Chantrey pictures, hung with cynical pleasure by Manson and Fincham in three galleries, were banished to the basement, where a new storage and retrieval system was developed so that the Gallery's stock of unshown pictures could be properly monitored. In place of the embarrassing Victorian pictures representing RA taste, John followed the pattern which he had tried to establish at Sheffield and collected works by Burra, Gertler, Augustus and Gwen John, David Jones, Wyndham Lewis, Lawrence Lowry, Paul Nash, William Nicholson, Sickert, Matthew Smith, Stanley Spencer and Wadsworth, which all appeared on the walls, some for the first time. This rehanging was appreciated at least by those visitors with some tolerance for such work but, as at Sheffield, the taste of other visitors could veer dangerously towards the Chantrey end of the art spectrum.[11]

The new Director even managed to develop the collection of modern foreign pictures after lunching with Douglas Cooper, who was unique in England in amassing early Cubist works. Cooper was antagonistic by nature, especially to anyone who challenged the primacy of early Cubism in twentieth-century art or his own knowledge of it. No doubt enthused by the departure of Manson, he approached Rothenstein's appointment as an opportunity to influence what should be acquired for the Tate's modern foreign collection: after the lunch, he loaned a work by Braque, then three works by Gris, three by Picasso and two more by Braque. Given the later deterioration in Cooper and Rothenstein's relationship, this early demonstration of goodwill came to seem completely out of character.[12]

Almost the day he arrived at the Tate John received a letter encouraging him to reconsider Manson's refusal of the American art show currently on in Paris.[13] Although the idea was supported by the Foreign Office, as being beneficial to Anglo-American relations, the Trustees eventually decided not to proceed, partly because there was little time to organise it (the show was finishing in Paris in July), partly because a planned exhibition of Canadian art might have been overshadowed by the American show. John, however, strongly supported such a show, and it eventually reached the Tate after the war.

Outside the Tate, John and his wife reconnected socially with the artists they knew. John describes pre-war meetings with Wyndham Lewis, Henry Moore, Paul Nash, Ben Nicholson and Stanley Spencer, and made occasional proposals to the Trustees that work by them should be acquired. For example, in 1938 a Stanley Spencer picture, *Rickett's Farm, Cookham Dene* (1938, Tate, 4942) was purchased via the Clarke Fund, and in 1939 the famous Wyndham Lewis portrait of Ezra Pound (1939, Tate, 5042) was bought using the Knapping Fund, as were two oils by Paul Nash.[14]

All might have been well, had it not been for the habitual drunkenness of Fincham and the growing unrest in the world; Neville Chamberlain's Munich appeasement fooled no one for long. The impression among educated British people in late 1938 was that war with Germany had been delayed but was inevitable. Institutions such as the Tate, which had been warned by the Government since the early 1930s, were now required to decide how they would protect their collections in a war which was expected to include widespread bombing of capital cities.

John describes what happened at the Tate after Munich: 'We were mainly occupied with the vast and infinitely dispiriting task of completing the existing sketchy plans for removing the greater part of the collection to houses relatively remote from places likely to invite aerial attack.'[15] Whereas the National Gallery focused on moving its collections to Wales, the three houses which had already been selected for the Tate were Eastington Hall at Upton-on-Severn in Worcestershire, Hellens at Much Marcle in Herefordshire and Muncaster Castle in Cumberland, together with some disused tunnels in the London Underground system. The houses had to be visited and checked for their suitability. Similar preparations were going on

at the other national collections. The owners of great houses became keen to store these collections when the alternatives in the event of evacuating people from dangerous areas were for their houses to be requisitioned for nuns, students, schoolchildren or, worst of all, military personnel. The damage done by stacks of pictures was as nothing compared to what children or soldiers could do, as the owners of Castle Howard found in 1940 when a large part of the house burned down whilst occupied by a girls' school. Sir John Ramsden, the owner of Muncaster Castle, wrote to Fincham on 6 January 1939 to say that he welcomed the pictures coming to his castle in the event of war, since 'their presence here might help preserve us from, or reduce the number of, the threatened hordes of small children'.[16]

All this special preparation meant that the Gallery's normal business was affected. The three exhibitions held at the Tate before the war whilst John was Director had been planned by Manson. The first was of paintings and sculpture by the recently deceased Glyn Philpot in July 1938. For October 1938 the National Gallery of Canada, through Vincent Massey, organised the previously mentioned show, *A Century of Canadian Art*, and in May 1939 there opened the last pre-war show, *Mural Painting in Great Britain, 1919–1939*. This consisted of photographs of murals undertaken during the period, rather than the murals themselves, although the Tate had the Rex Whistler mural on the walls of its restaurant downstairs. When that exhibition closed on 30 June 1939, there were no further exhibitions in the Gallery until 11 April 1946.

The final signal to begin the removal from the Tate came with the announcement of the non-aggression pact between the Germans and the Russians in August 1939, which stunned the Western Allies and which indicated that war must be imminent. When he heard the news John was in Glasgow, with his friend the artist Tommy Lowinsky,[17] and promptly travelled back to London to supervise the activation of the plans. It was, above all, vital that all the important pictures had left the Gallery by the time any bombs fell on central London. On 24 August the Tate was therefore abruptly closed, its visitors shepherded out of the building which they would not be visiting again for a long time. A vast, almost military, operation then began to remove most of the pictures from the walls, many out of their frames, pack them for transport, load them onto lorries and send them off to the railway to travel into the placid English countryside or the dark tunnels under London.[18] By the time the war began, on 3 September, the Gallery was virtually empty and as prepared as it could be for the ordeal that followed. The initial phase of John's Directorship was over. In 1940 he commented to Evan Charteris that he regarded the time between his appointment and the outbreak of the war as 'enchanted days'.[19]

Not only was the Gallery empty of pictures but soon also of its Director: after setting up a small, dark office in a relatively safe part of the closed and shuttered Tate, with two typists and nothing to do, and taking his wife away for a few days to Brighton, John Rothenstein had boarded a ship to America on 1 October, not to return for seven months.[20] In the daily diary which he had started to keep on

22 August 1939, prompted by the realisation that war was imminent, there is no mention of this trip until 15 September and no explanation of why he was going.[21] The autobiography, which was often used in hindsight to create a preferred version of the record, is fuller.[22] It explains that he and Elizabeth were aghast at the anti-British attitude of American public opinion, which tended to blame Britain for wanting war, and John wanted to do something about it. He had tried to join the armed forces but had been prevented by the Treasury. However, he was given permission by the Treasury[23] and the Ministry of Information to go to America and Canada, where he had invitations to give lectures, and to report back on the state of North American public opinion.[24]

There is no reason to doubt this origin for the trip, although John may have been understandably influenced in wanting to get his wife and daughter out of London by photographs of children and mothers being hurriedly evacuated in what was officially called Operation Pied Piper. The issue is not so much why he went as whether it was wise of him to go; a secondary issue later became why he had not come back, as weeks away turned into months.

The details of the trip are of only passing interest. Day after day, John's diary records what he was doing – largely, enjoying himself.[25] Fêted everywhere as a British art world dignitary and wartime curiosity, he had ready access to those in charge of the leading art galleries wherever he went. Whatever public hostility there may have been towards Britain, there was none shown towards the visiting Director and it seems unlikely that John met many ordinary Americans outside the art world (although he was introduced to various senior individuals through his wife's family). Lunched and dined in his official capacity in New York, Washington, Baltimore, Buffalo, Boston, Cleveland, Lexington, Detroit, Chicago, Ottawa, Toronto and Montreal, John had to endure no hardships of any kind. He made many useful connections in the American art world, some of which were later helpful in arranging Tate shows. The CAS had authorised him to offer pictures from their collection to American and Canadian galleries, which led to pictures being given to MOMA (a Stanley Spencer), the Art Institute of Chicago (a David Jones), the Newark Museum of Art (a William Roberts) and the National Gallery of Canada (an Ethel Walker).[26] Otherwise there was much travelling around; there was even a handful of lectures, several on 'The Evacuation of the Tate', which was easy enough to be delivered impromptu as the occasion required. He had an article published in January 1940 in a Canadian magazine, *Queen's Quarterly*, on 'British Painting To-Day'. There was a long break from official duties over Christmas and the New Year, spent with his wife and daughter at his wife's family home in Lexington.

It is hard to resist the impression that there was little, if any, serious point to such a long trip. Had it lasted for a month, observers back in England who were comparing the lack of activities at the Tate with the makeshift events being quickly organised in support of public morale at other empty galleries might have noticed

nothing untoward. In a month John could have compiled a large dossier on American opinion for his masters in London. Instead, by the time he returned at the beginning of May 1940, trouble had been brewing about his absence.

Evidence of trouble started to reach John from a number of sources. Throughout his time in North America, he had been trying to keep in touch with Fincham and Ironside and they with him, but it was difficult for letters from London to find their moving target. John sometimes answered a letter which had already been superseded by others yet to reach him. It is tempting to think that Fincham, in particular, was endeavouring to keep his boss in the dark about what was going on at the Tate, but his letters do not necessarily support this. It seems, rather, that delegation in John's absence had not been made clear. Seven letters survive from Fincham to John dating between 19 October 1939 and 6 April 1940 and seven from Ironside. Six survive from John back to Fincham and three to Ironside.[27] Their dates show how haphazard the process was and the impossibility of receiving timely instructions from the Director.

The correspondence started shortly after John left. Fincham dutifully reported in his first letter various dull administrative matters,[28] together with a discussion about replacing the sick Charteris as Chairman (Charteris died in 1940). John may have thought that, if this was all that was going to happen at the Tate in his absence, he was better employed roaming about North America having a good time than sitting at his desk adjudicating on staff squabbles and waiting for the bombing to begin.

In fact, all the exchanges were friendly ('with warmest regards to Fincham and all of you') and routine until John's short letter to Fincham of 15 February 1940: 'I was a little puzzled today to receive a message from one of the trustees, suggesting that there were a certain number of important matters coming up at the Tate which really called for my decision. I had no idea that anything was being done except purely routine matters'. Fincham sent a letter on 19 February, but that was before he had received John's and it referred to an earlier letter of John's dated 26 January. Having received no reply by 2 March, John wrote to Ironside: 'I have been wondering what has been happening at the Tate having had no news whatever since Fincham's letter dated December 18th'. By the time John wrote this, Fincham had already written again.

Trying to make sense of the muddle, Fincham wrote a third letter, dated 6 March, in which he addressed John's letter of 15 February, explaining that the Trustees had held a Board meeting: 'The suggestion that a number of important matters are coming up at the Tate which really call for your decision quite frankly bewilders me. If you could give me a hint as to what they are, it would be easier to reply, and to judge whether I had in any particular way failed to forward you the necessary information.' He then itemised the routine issues which he and the Trustees had discussed in John's absence. Next, John on 15 March answered Fincham's earlier letter of 19 February, having only just received it. Many points had

already been answered in Fincham's three letters. John grumbled that he had not been told about the Board meeting or important decisions like purchases. Fincham had another attempt to answer John's concerns with the last letter in the series, dated 6 April.

It is hardly surprising that Fincham, unwisely left in post after John took over at the Tate and then criticised him, took the opportunity of John's prolonged absence to cause trouble for him. It seems that he enjoyed telling anyone who asked – especially the Trustees – that he had no idea where John was or when he was returning. This message, probably intended to put John in a poor light, had the misfortune of being true. It would have been difficult for Fincham, or indeed anyone, to have covered for their superior more convincingly for seven whole months of haphazard wartime communications and John's full schedule of travel. John occasionally mentions in his diary chancing on a batch of correspondence from England waiting for him, but it was invariably long out of date by the time it caught up with him.

One exchange of letters is not mentioned in John's diary. On 2 March 1940 he wrote to Tommy Lowinsky, asking whether he thought that he should return to England. Lowinsky received the letter on 25 March and immediately replied that it was imperative that John return as soon as possible, firstly because

> the worst construction has been put upon your prolonged stay in America, since no-one knows of a good reason why you are there. There has been a lot of talk, as people who would like to see another director at Millbank in your place are making the most of it … I have even heard some names suggested as your successor.

Lowinsky also told John that he had heard from New York that there was a view that John was job-hunting in America. But the other reason he gave for John's immediate return was that he was missing out on many activities in the London art world, much at the hands of Kenneth Clark. Lowinsky concluded, prophetically, that he was 'left with a deep feeling of anxiety for your future'.[29]

It was clear when John eventually got back that, whether through Fincham or otherwise, the Trustees were indeed unhappy about his prolonged absence. Reaching Liverpool on 3 May, after a frightening crossing (John's job at night on the relatively small boat he had managed to join being to scan the dark sea for the periscopes of German submarines), John made his way down to London. In order to get an objective briefing, he first met his brother Michael, who told him about the London art world over the last seven months. John noted that Michael had mentioned 'the gossip re my absence'.[30] This was partly a reference to comments made by Clive Bell in the *New Statesman and Nation* on 30 December 1939: as part of a hostile review of the third volume of William Rothenstein's autobiography, Bell had noted that it would not be easy to see pictures in the Tate at the moment, as it was closed and 'the director has withdrawn to America'.[31] When John had a

meeting on the following day with the Tate's acting chairman, Sir Edward Marsh, he was therefore not surprised to find that even this gentle ex-civil servant, not known for his stomach for a fight, 'had misgivings re my absence'.[32] Marsh's actual comments are not recorded, although it is known that while John had been away he had been in touch with the Treasury to say that he was 'rather embarrassed by the continued absence of Rothenstein'. The Treasury response, dated 10 April 1940, had reassured him that John had by then agreed to sail to England.[33] After his meeting with Marsh, John met Fincham and had a 'long and difficult discussion' with him.

Had Tate criticism been all that he had faced, behind closed doors, that would have been unsettling enough for John as a relatively new Director. He had not been in the post long enough to have established sufficient goodwill from the Trustees and staff to ride over that sort of criticism without denting his reputation. Unfortunately for him, the criticism went beyond the doors of the Tate.

Possibly more hurtful than these criticisms was that John's father had also asked him why he was staying away so long. Three such letters survive, the first from as early as 2 January 1940:

> I hope you may soon be thinking of returning – there is more going on in the artists [sic] world than I expected and you are really needed here. Several people, since the National Gallery is used daily for concerts, have regretted that the Tate cannot be used; Clark is getting together a show of younger men's work which is to be shown at the National Gallery. In fact there is a buzz of propaganda for artists at this moment.[34]

This letter pointed up one of the problems of Rothenstein's absence: the undamaged Tate's closure and emptiness was being shown up by activities at other public galleries. The Phoney War, between the start of the war on 3 September 1939 and the German invasion of France and the Low Countries on 10 May 1940, had thrown everyone into confusion as to a war which seemed to threaten the destruction of English cities but which for the moment was largely avoiding Western Europe. Bombs had not been falling on central London as expected and the nation's art treasures were slumbering peacefully in their country houses, tunnels and caves. Families who had evacuated their young children from London in September 1939 were in early 1940 bringing them back, just as things were about to change.

Kenneth Clark, having sent away the pictures in the National Gallery before the war started, in the same way as Rothenstein, had then stayed at his post in London and, in the absence of any bombs on London, had vigorously used the empty National as a venue for temporary events and concerts. As Lowinsky had pointed out to John, Clark had also busied himself with various committees, the most famous of which was the War Artists Advisory Committee, which aimed to secure the lives of British artists by keeping them away from the armed services. Clark chaired this committee, which held monthly meetings at the National

Gallery and of which John should have been a member. Clark had discussed with Rothenstein before he went away what might be appropriate for their respective galleries under war conditions. John's note of 11 September 1939, that they had 'agreed on the importance of doing everything possible to ensure the continuance of exhibitions of painting and sculpture throughout the War', rings hollow in the case of the Tate.[35]

The concert pianist Myra Hess began a series of lunchtime classical music concerts in the National Gallery as early as 10 October 1939, which proved to be popular with the London public, suffering from the fact that many normal venues were closed.[36] The result had been an increasing popularity for the National Gallery as a provider of much-needed cultural sustenance. Similarly, the Royal Academy, whose President at this time was the architect Sir Edwin Lutyens, had sent its permanent collection to country houses or down into the Underground system, but had decided that it must at least keep the annual Summer Exhibition going. When John returned in May 1940, that show was about to open at Burlington House. A large number of other shows, some from external bodies, were held there throughout the war, since the building suffered little serious bomb damage.[37]

In William's next letter to John, dated 19 January 1940, he said that he was frustrated that he had heard nothing in response to his earlier one: 'When I last wrote it was to say that I hoped you might be thinking of returning. I know nothing of your plans; but there is a move to open up the Museums. ... There has been some comment on the Tate being closed'. In contrast, William noted, the V&A, many of whose contents had been whisked off to Montacute House in Somerset or boarded up and left in situ, had reopened (on 13 November 1939) and Clark was arranging an exhibition of modern paintings at the National Gallery and 'his concerts have been signally successful'.[38]

Before William could write again, a question had been asked in Parliament about John's absence. On 23 January the Labour MP for Stoke-on-Trent, Andrew MacLaren, who was himself a painter and an expert on Renaissance art, asked whether John was still being paid and, as the Gallery was closed, what he was doing. The extraordinary answer was that he was being paid, bearing in mind that he was lecturing in North America 'under the auspices of the National Gallery of Canada, and arranging for the proper care of British pictures which have been on loan at the New York World Fair'.[39] Having indicated that he was going to ask further questions, Maclaren was dealt with in private by the Treasury, who wrote to John on 21 February that it was being asked how much longer he was going to be away.[40]

The third letter from William, of 21 March, was another example of the great common sense which characterised his advice to his obdurate son. Why John had not replied about this issue is not clear. He certainly received the letters, as they survive in his files. His diary for 22 March 1940 recorded the receipt of a letter from his father. Yet no answer did he give. That of 21 March spelt out the position quite starkly:

I am rather concerned at hearing nothing from you in response to my letters. Surely my hints as to opinion here, and the feeling about the Tate, were worth at least considering. I doubt whether you realise how much the need of providing both for artists and the public is being catered for. Apart from the important committees set up, with full powers for appointing artists for war work and for the portraying of England, besides the provision of opportunities for individual art, there is an unexpected impetus in the way of exhibitions and for acquiring paintings. … My own feeling is that you should be here: it is the feeling of others, less kindly disposed, also. I hope you will give consideration to what I am writing.[41]

What does the North America episode say about John? His daily diary entries record, until near the end of March, no substantive mention of the Tate, Britain, the progress of the war, the fate of his wider family left behind or that of any of his friends back home. The diary simply notes who he was having lunch or dinner with or which gallery he was visiting. Thoughts of home may have been passing through his mind but the diary does not reveal any. Suddenly, however, it does. On 27 March 1940 there is a unique entry in this period of its coverage: 'Thought much about geography and war. GB's position. Certain misgivings'. The penny must at last have dropped that the trip to a peaceful country with no shortages or daily concerns about the war had been pleasant but had gone on long enough. Once he had decided that he should return, it still took a long time to arrange his departure, but that was inevitable at this stage of the war, with transatlantic crossings difficult to come by because of the submarine menace.[42]

What the trip shows is John's lack of judgement when wrestling with an issue by himself. The only person who might have advised him, in the absence of him taking any notice of his father's letters, was his wife Elizabeth. Yet she was not with him for most of his travels, staying in Lexington with their child. She had little direct knowledge of what was going on in the London art world and perhaps could not imagine the reputational damage caused by John's prolonged absence. She could not in any event have wanted him to leave them and return voluntarily to dangerous and unpredictable wartime London. In the past it was John's father who had stepped in to guide his son around the more difficult decisions he had to make in his career; here in 1940 he was trying to do that and was frustrated not to be able to discuss the situation with his son. With his sophisticated understanding of the sensibilities of the art world, he could see only too well that John had been away too long for his own good.

As time passed, John was to make more mistakes as Director of the Tate. The death of his father in 1945 cut him off from the only person whose advice he would both listen to and follow when it came to the direction his career should take. Without his father there in the background, dispensing sound paternal advice whether asked for or not, John was to become dangerously isolated.

CHAPTER 8
War and Post-War, 1940–46

Chastened by the experience of trying to explain and justify his trip to America, John soon had something more serious to worry about. The diary records Fincham continuing to niggle him, but it also records the news of the war, which was getting increasingly dire from May 1940 onwards. Dunkirk made people in London extremely fidgety about the possibility of an invasion. It must have seemed to John that he had chosen a bad time to return to the country. Although he kept up his social life – lunches and dinners at the Athenaeum, the Ritz, the Café Royal, other London clubs, day after day – he also spent time travelling by train to the three country houses to check on the Tate's pictures.[1]

The war news got steadily worse, with Paris occupied in June and the complete surrender of the French following soon afterwards. German forces were now occupying the Channel coast of France staring across the water and deciding on their next objective. England was in a desperate state of anxiety over the summer of 1940 and on 7 September the London Blitz began. London was to find itself bombed for fifty-six out of the following fifty-seven days and nights. After their own house in Primrose Hill was rendered uninhabitable by bombing, John quixotically decided, probably partly out of guilt at his long absence but also because he urgently needed somewhere to live, that he and his wife would go to live in the Gallery as it awaited its fate. At the time there was little understanding of the penetrative power of high-explosive bombs.[2] A few days afterwards, on the night of 15/16 September, the Gallery, with John and Elizabeth inside, was hit by bombs for the first time. They were lucky to survive. As the next day dawned it was apparent that the Gallery had suffered considerable damage, which was only worsened over succeeding nights. There could be no question of the Director and his wife sleeping anywhere near the shattered glass roof.[3]

There was, indeed, no possibility of the Director or his staff doing any normal work in this environment. It is hard to know what they could have done. There are photographs of John and the forlorn gallery attendants wearing their tin helmets standing around among the debris wondering what they could do. The Gallery was soon virtually a ruin, flooded by torrential rain in the absence of a roof; it was the most bomb-damaged of all the major London galleries and museums, probably because it adjoined the Thames which the German bombers were following at night over the darkened city. The Gallery could certainly not now be reopened for temporary exhibitions, whatever the public appetite for them. John had no choice

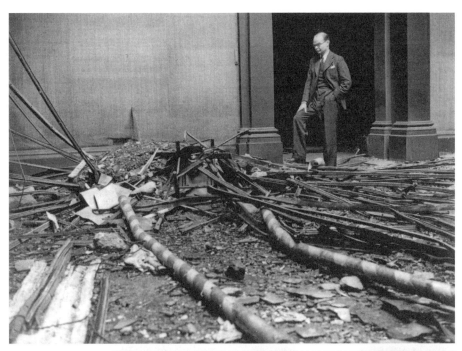

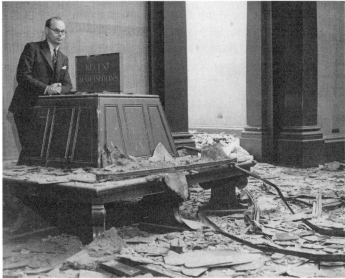

John Rothenstein, Tate Director, inspecting bomb damage to the Tate Gallery during World War II.

but to continue the life he loved, of lunches and dinners, trips to galleries, home to the country at weekends and to Oxford as a base to visit the two refuge houses in the Cotswolds, topping himself up with Jesuit debate at Campion Hall in Oxford in the meantime. Occasionally, he travelled up to the Lake District to see conditions at Muncaster Castle, where Fincham was spending time. He often went with

Ironside, whose company was highly congenial; there is no mention of him ever travelling anywhere with Fincham.

One thing John continued to do was to write. A chance meeting with the great art patron Peter Watson (1908–1956) led to John writing 'Painting in America' in June 1941 for *Horizon* (co-founded by Watson and Cyril Connolly).[4] The issue opened with Connolly's editorial encouraging closer cultural contacts between England and America, as the former faced isolation in Europe. John's article contributed to this theme and he used his knowledge of the subject from his time in America in 1927/8 and his recent stay. The article was written at a fascinating moment, noting that art had rapidly moved on in the decade between his visits (attributing this in part to the American Depression, which had forced some of its artists to return home from Paris, and in part to government patronage of the arts),[5] but did not name any of the artists associated later with the efflorescence of American art post-war. He mentions painters like Grant Wood, whose Realist images of gaunt rural people holding pitchforks (*American Gothic*, 1930, Art Institute of Chicago) are now familiar to a wider audience, but not others now highly regarded, such as Georgia O'Keeffe. Still, John was keen to promote American art where he could and other articles and lectures on it followed.[6]

One direct, later result of John's trip to America and his focus on American art was a 1946 exhibition called *American Painting, from the 18th Century to the Present Day*, which came on to the Tate from the National Gallery of Art in Washington, following discussions with the latter's Chief Curator, John Walker, in 1939 and with Alfred Barr during the war (though it had first been proposed ten years earlier).[7] It included the work of several contemporary American artists such as Milton Avery, Ben Shahn and Mark Tobey. John wrote a two-page introduction, 'A Note on American Painting', to the catalogue. At about the same time John also started discussions with Walker for a show of American designs, which ultimately came to the Tate in 1950 as *An Index of American Design*.[8]

Throughout the war John published many articles, sometimes on the Tate and its recent acquisitions.[9] This occasionally included contributions to slightly esoteric publications, such as the *Bedales Chronicle* (an article on the Gallery in 1944). Sometimes he wrote on religious art, particularly how damaged Catholic churches could best be restored after the war. For example, he wrote a long article, 'Church Decoration in England: The Coming Opportunity', in *The Tablet* on 26 July 1941 and a piece in *The Universe* on 6 February 1942. He was profiled (by his Jesuit friend Vincent Turner, on whom more shortly) in the *Catholic Herald* on 7 December 1945.

Once the Germans were able to send bombing raids deep into England from their bases in northern France, the war soon caught up with the Tate's supposedly safe houses. On 17 December 1940 the Tate Board minutes recorded that bombs had fallen near Hellens, breaking windows including, rather worryingly, those of the room where the Tate pictures were being kept.[10] Around the same time bombs

fell near enough to Eastington to cause concern. It was not being unduly alarmist to imagine the Tate's collection being damaged, so that it was time to find even more remote locations in which to store it. Finding safe enough houses, away from the routes the bombers were likely to take on their way to and from more strategic targets, took some research. Eventually, in March 1941, Hellens and Eastington were replaced by Sudeley Castle near Winchcombe and Old Quarries at Avening (both in Gloucestershire).[11] The latter was the property of Viscount Lee of Fareham, who had founded the Courtauld Institute, installed John's old friend W. G. Constable as its first director and been chairman of the National Gallery. Lee had also given Chequers to the nation as a retreat for the Prime Minister and had given pictures to the Graves Art Gallery when John was its director, so they probably knew each other. It may not have been a coincidence that, of all the country-house owners clamouring to store pictures, his should have been chosen.

As time passed, Fincham's star at the Tate waned, his influence having peaked during John's absence in North America. John wrote to Sir Edward Marsh on 6 December 1940 complaining about Fincham and in July 1941 he wrote to the Treasury complaining about Fincham's expenses claims.[12] By October 1941 Sir Jasper Ridley (1887–1951),[13] who had been appointed as the new Tate Chairman, was visiting the Treasury to discuss how best to get rid of Fincham. The Treasury official noted: 'While Ridley himself regards the Director as honourable and peaceloving … one or two members of the Board might side with Mr Fincham'.[14] Even by 1941, John's characteristic belligerence had caught the attention of his masters at the Treasury. This reflected negotiations between them about the extent to which

Sir Edward Howard Marsh. Snapshot by Lady Ottoline Morrell, c.1935.

Sir Jasper Nicholas Ridley. Photograph by Bassano Ltd, 1928.

the Treasury should pay John's own travelling expenses. His ruffled feathers on the subject may explain why he chose to pick on Fincham's expenses as a battleground. Ridley nevertheless persuaded the Treasury to find another Government department for Fincham, who left for the Ministry of Labour around the end of 1941. His new employer found no fault with its new recruit, reporting back to the Treasury in April 1942 that he had 'turned out to be a very good officer'. He was still at the Ministry of Labour when the war ended and never returned to work at the Tate.[15]

John found the new Chairman a sympathetic and supportive colleague. As with his description of Charteris, John's enthusiasm in the autobiography may be overstated, since throughout his account of dealing with Ridley runs his wish to put later Chairmen in a relatively bad light. John records how years later a Trustee who had served under Ridley, Allan Gwynne-Jones, told John that his

> belief in the happiness of all aspects of the Tate's life under Jasper's chairmanship was quite erroneous: the Trustees, he told me, had felt increasingly frustrated and restive, for the simple reason that so brilliant was Jasper as Chairman that they felt that somehow he and I always got our own way, and that they themselves were little more than pawns in the game.[16]

What John said he particularly liked was that Ridley told him what he wanted him to do, so John was 'always in a position to act decisively and promptly in the awareness that I could count on his full support'. Ridley then ensured that the Board behaved themselves: 'as long as he remained Chairman the Trustees shared fully, or seemed to share fully, his confidence in me'.[17] The truth may be that, with his wide business experience Ridley was an effective and strong Chairman, but his relationship with his Director was easier to manage at this early stage of John's career as Director than it would be for later Chairmen. John probably became harder to manage as he became more experienced in the job than later Chairmen after Ridley. Whatever Jowitt's abilities as a Chairman, for example, John would have been more challenging for him in 1951 than he had been for Ridley ten years earlier.[18]

John also had a good relationship with Manson, whom he encouraged to write a history of the Camden Town Group, but by this time Manson's life was too disorganised for serious writing. At lunch at the Savage Club at the end of 1941 Manson was 'very bitter' about Fincham, although it is not clear why.[19] Fincham continued to pop up in the diaries from time to time[20] and John relished the fact that he was discovered in 1946 to have purloined a portrait by the Victorian artist Richard Dadd which had been lent to the Tate and had sold it for his own profit. Unable to recover the picture, the Board demanded that Fincham repay its value to the Gallery.[21]

There seems to have been a tit-for-tat between Manson and Fincham, seeking to denigrate each other to John. In 1947 Fincham visited the Gallery to collect some pictures left there in storage and took the opportunity, now that Manson was

dead, to give John some 'facts' about him; that he had, when Director, spent a night in police cells for being drunk and disorderly but had got away with it by giving a false name; that Manson had made money by dealing in works of art in his own name in 1937; that he had been arrested for indecent exposure in Chatham; and so on. John noted: 'Attacked him, I surmise, to justify own delinquency'.[22] When John dined with the Pissarro family in September 1948, he recounted their view that Fincham had been Manson's 'evil genius', with an ascendancy over him which had 'contributed to his ruin'.[23]

The war raged on in the background. In London there was still an art world of which the Director of the Tate Gallery was an important part. John remained in contact with other leaders of this small world. He kept in close touch with Kenneth Clark at the National Gallery and there are tantalising references to their talks. At lunch at Buck's Club on 5 November 1942 they '[d]iscussed plans for division of TG after War into a modern gallery and one of Brit art'. Despite being recommended in the Massey Report a few years later, it took nearly sixty years before that logical idea bore fruit.[24]

Relations with the Royal Academy had to be maintained, but they were not as harmonious. On 14 January 1943 John said that he felt that Sir Walter Lamb, the Secretary of the RA from 1913 to 1951, was 'increasingly hostile to the TG'.[25] Lamb, an Australian, born in 1882, was the brother of the artist Henry Lamb. As Secretary, he was the main officer with whom John had to deal in relation to official matters,

Sir Philip Hendy. Photograph by Howard Coster.

for example the never-ending difficulties of administering the Chantrey Bequest. Lamb had alarmingly suggested to John that, under the terms of Chantrey's will, it was within the RA's power to compel the Tate to put the whole Bequest on display on a permanent basis.[26] This aggression eventually brought Chantrey matters to a head a few years later. The President of the RA, Sir Edwin Lutyens, was suffering from cancer by the early 1940s and gets few mentions in John's diaries;[27] he had no interest in either exacerbating or resolving the Chantrey problem. When he died on 1 January 1944 he was replaced by Alfred Munnings.

Also in January 1943, John bumped into Philip Hendy, who was soon to take over from Clark as Director of the National Gallery. Hendy was not always easy and John recorded (on 19 January) that Hendy had 'said more to me than in all the 20 years I've known him'.[28] The strength of their relationship became crucial once Hendy took over in Trafalgar Square, both because of the need for the two directors to agree on matters such as which pictures should come back to the National from the Tate when they got old enough, but also because the National Gallery's Director sat on the Tate Board. His supportive attitude towards Rothenstein during the Tate Affair was important but Hendy could be awkward on the Tate Board. In 1947, for example, he blocked the Gallery's acquisition of a Pre-Raphaelite picture which John wanted to buy, noting that he would on principle oppose any Pre-Raphaelite purchase.[29]

John had lunch on 9 June 1943 with John Pope-Hennessy (1913–1994), then aged twenty-nine.[30] This was long before this most formidable and intimidating of art historians had taken up his positions as, successively, Director of the V&A (1967), Director of the British Museum (1974) and Chairman of the Department of European Painting at the Metropolitan Museum in New York (1977). In 1943, attached to the Air Ministry, he was not as formidable to John, twelve years older, who noted Pope-Hennessy's 'strange eyes and manner, but I found him very agreeable and intelligent'.[31] Perhaps it helped that Pope-Hennessy was a Catholic.

Amongst many connections with the art scene, John was on the Art Panel of the Council for the Encouragement of Music and the Arts (CEMA), under the control, inevitably, of Kenneth Clark. CEMA existed for a relatively short time, 1942–45, but in that time its Art Panel was responsible for buying many pictures by British artists.[32] It also arranged tours of the Tate's wartime acquisitions (in 1942 and 1944), a memorial exhibition of the work of Philip Wilson Steer (organised by the Tate at the National Gallery in 1943), *Two Centuries of British Drawings from the Tate Gallery* (1944) and *British Narrative Paintings from the Tate Gallery* (1944). In 1945 CEMA was subsumed into the newly formed Arts Council, with whose Art Panel John was also involved from its beginning (again under the chairmanship of Clark). The first meeting of this panel took place on 16 August 1946 and it was to acquire many works by contemporary British artists.[33] The Arts Council inherited the touring programme of CEMA, showing the Paul Klee exhibition organised by the Tate at the National Gallery, which opened in December 1945.

John was at the centre of the small group of people who understood and liked contemporary British art and who could even do something to promote it. The other benefit of a close connection with the Arts Council was that, lacking suitable exhibition space of its own, it sponsored many of the exhibitions held at the Tate after the war. At lunch on 6 February 1947 with Philip James, Secretary of the Arts Council, he discussed future exhibitions such as that on van Gogh (which opened in December 1947), Chagall (February 1948) and Paul Nash (March 1948). John and Philip James became close friends, with the families sharing Boxing Day in 1947.[34]

Similarly, John had access to that other great source of institutional funding for acquiring contemporary British art, the Fine Arts Advisory Committee of the British Council. Here he also took part in arranging works for home and overseas shows which the Council organised during and after the war. For example, in 1943 the Council put on in London *Modern Paintings and Drawings by British Artists*. In the same year, it arranged a tour to three cities in neutral Sweden of *Contemporary English Watercolours*. Finally, that year, there was an ambitious tour to South America (Peru, Brazil, Uruguay and Chile) called *Exposicion de Arte Britanico Contemporaneo*, selected by Kenneth Clark. In 1946 John helped to organise a British Council touring exhibition to America and Canada, writing notes on the pictures in the catalogue. He also worked with the British Council to tour a large selection of pictures from the Tate's collection (as the Gallery was unable to accommodate them pending further repairs). Accompanied by the Director, who wrote an introduction on 'British Painting' to the catalogue, the show visited nine European cities, as *Tableaux Britanniques modernes appartenant à la Tate Gallery*, although it was not wholly successful in persuading audiences of the virtues of modern British art. In Paris, for example, it was poorly received.[35] Herbert Read (1893–1968)[36] was on the panel considering this show and had resisted it; in 1945 he wrote to Douglas Cooper about 'Rottenstone' wanting to 'hawk his mouldy collection round Europe, himself as itinerant showman'.[37] Either then or previously he was among the art critics treated as enemies by John. Read's combination of anarchism, pacifism and belief that aesthetics could lead to social harmony was unlikely to have met with John's sympathy and there came a vigorous attack on Read's theories in the chapter on Ben Nicholson in *Modern English Painters*.[38]

Major Alfred Longden, the Director of Fine Art at the British Council from 1940 to 1947 and a fellow member of the Art Panel at the Arts Council, accompanied John on part of his European tour; his comments on John's behaviour were recorded by Randolph Schwabe:

> He is not very fond of John Rothenstein. They travelled together in Holland. Longden complains that J.R. parades his Catholicism too much; also J.R. wrote an article in '*Time and Tide*' describing the trip … all in the first person and saying nothing of his companions. … Longden could not resist writing to Rothenstein congratulating him on the article, saying what an excellent official

Herbert Read. Photograph by Howard Coster, 1934.

report of the tour it would make if only the 39 'Is' in the course of it were replaced by 'we'.[39]

John got another opportunity to give effect to his tastes in modern British art when he was appointed the Supplementary Buyer for the Contemporary Art Society in 1940–41, with up to £300 to spend.[40] There were many connections between the Tate and the CAS. John was already on its Committee (as was Manson); the President at the time was Lord Howard de Walden (a Tate Trustee), the Chairman was Sir Edward Marsh (a Tate Trustee and Chairman in 1940–41), the Treasurer was Sir Jasper Ridley and the Assistant Secretary was none other than Robin Ironside. With its office in the Tate it was effectively an adjunct of the Gallery and a vital source of pictures for the national collection. In amongst some curiosities (such as works by little known artists like his friend Catherine Dean and C. E. Grunspan),[41] John bought several works which were later given by the CAS to the Tate, such as pictures by Piper and Stanley Spencer. One painting he was responsible for buying was *The Mantelpiece* (1939, Tate, 5262) by Allan Gwynne-Jones, another Tate Trustee and friend of the Rothensteins; this work passed from the CAS to the Tate in 1941.[42] There were similar cosy arrangements involving the Chantrey Bequest. As mentioned earlier, Sir Walter Russell was an RA representative Trustee at the Tate. In 1938 and 1940 two of the pictures which the Chantrey Bequest dumped on

the Tate were by him.[43] They joined several others by him which had already been acquired via the Chantrey Bequest.

As if all this were not enough to keep John busy, he voluntarily took on an informal role as the London buyer for the Art Gallery of New South Wales in Sydney in 1945.[44] He was allowed to spend at his own discretion up to £1000 per annum buying contemporary British art for the Australian gallery. This appointment came about because John knew Hal Missingham, who was appointed Director of the New South Wales Art Gallery in 1945 but who had worked in London in the 1930s. The art bought by John included in 1946 paintings by Beerbohm, Harold Gilman, Anthony Gross, Frances Hodgkins, Winifred Nicholson, Piper, William Rothenstein, Sickert, Sutherland, John Tunnard and Ethel Walker (earning John commission of more than £50); and in 1947 pictures by Leonard Appelbee, Burra, Gwynne-Jones, Tristram Hillier, Piper and James Pryde were bought (£25 in commission). The galleries bought from included the Zwemmer, Redfern, Lefevre, Leicester and Leger. This illustrates how John gave practical help to artists he knew personally and it also enabled him to curry favour with London dealers who could be helpful regarding pictures the Tate wanted to acquire. Adding together his influence at the Tate, the Arts Council, the British Council, the CAS and this Australian position, John's centrality in the British art world, in terms of works bought for official collections, was considerable.

John's social life had a strong Catholic tinge to it. He made friends with Vincent Turner, whose counsel proved comforting to him, especially later during the horrors of the Tate Affair. Staying at Campion Hall on his trips to visit the Tate's pictures in their safe houses, and while Charles Mahoney was preparing his large mural designs for the decoration of the Lady Chapel,[45] he got to know well-known Jesuits such as Father d'Arcy (1888–1976), who was a heavyweight intellectual in the English Roman Catholic world.[46] D'Arcy formed another link to other Catholic friends, such as Eric Gill (who died in 1940) and Evelyn Waugh. The day before he lunched with Pope-Hennessy, on 8 June 1943 John had lunched with Waugh, finding him 'more traditional than anyone I know'.[47] John also saw other Catholic converts like Graham Greene, but none of this had any material bearing on his role in the art world. His friendships did, however, take up much time. He frequently saw Catherine Walston (1916–1978),[48] for example, renting a room from September 1944 to late summer 1949 in her flat at 6 St James's Street, where he observed the growing connection between Walston and Graham Greene, which in early 1947 turned into a lasting affair. This was embarrassing for John, partly because he had introduced them,[49] but also because the Rothensteins were friendly with Greene's long-suffering wife, Vivien, who lived in Oxford. John records many conversations with Catherine throughout the war.[50]

Pure socialising sometimes blended into socialising with the art world: it was not always possible to distinguish the two. For example, he dined on 28 June 1943 with the artists Roland Ossory Dunlop, Edward le Bas and Matthew Smith. He

worked hard at the National Gallery to hang Tate-inspired exhibitions of work by Sickert in 1941 and by Steer in 1943, together with exhibitions of the Tate's war-time acquisitions in 1942 and 1945, and then recorded in his diary how much he enjoyed being introduced to the Queen when she visited the Steer exhibition and to Queen Maria of Yugoslavia and lunching (separately) with John Betjeman and T. S. Eliot.[51] He generally spent most of the week alone in London, available to lunch and dine to his heart's content, and then went to see Elizabeth (and often Vincent Turner) in the country for the weekend. This dialectic seemed to suit him. Having spent part of his childhood in the country, he was not bored by country life: he enjoyed being in the garden, in particular, and looking after their various animals. It was therapeutic for him to get out of the city. His wife, in contrast, at this time rarely came to London and they led largely separate lives during the week.

As the war receded from Western Europe following D-day on 6 June 1944, wider travel became possible. There was a trip to Paris with Kenneth Clark in October. They both assumed that, as Paris art dealers and collectors began to recover from their long occupation by the Germans, there would be easy, cheap pickings of art. But it turned out that no one was desperate to sell them anything. The Paris art market had been resilient during the Occupation, trading happily with the Germans as opportunities arose.[52] John saw an exhibition of French art produced during the Occupation but, apart from Picasso's, he found the work poor and derivative. Visiting Picasso at his studio at 8 rue des Grands Augustins, he was shown vast quantities of the artist's current output. John, who was keen on Picasso's work, unsuccessfully attempted to buy a large oil for the Tate.[53]

John continued writing throughout the war, contributing an introduction to a book by Max Beerbohm in 1943[54] and to a book about Manet in 1945.[55] In between came a book about Augustus John (a Tate Trustee from 1933 to 1940),[56] for which he again mined the vein of his father's contacts, like the books on Conder and Gill. This one formed an extended essay introducing many plates of the work, whose selection was debated by author and artist for about two years.[57] Augustus John was, at this twilight stage of his career, much in the public eye, because the war had thrown the attention of the art world back onto surviving older British artists, such as John and Walter Sickert. *Horizon* had taken on the task of publishing his 'Fragment of an Autobiography' in a series of issues, from August 1941 to April 1949, just before the magazine closed. Rothenstein's book went through a number of editions and followed a book on Augustus's drawings by the art dealer Lilian Browse, which itself followed a large show of his drawings at the National Gallery.

Co-operating with the artist, John probably had little choice but to portray Augustus as a genius, noting the irrelevance of judging his work against that of other modern British artists. Even so, John tweaks modern artists generally – their declining capacity to handle paint, compensating for diminished 'manual dexterity' by focusing on 'greater thoughtfulness'. Unspoken as contrasts with modern artists, but undoubtedly intended as such, are comments that Augustus does not

plan his work; he does not 'cultivate an esoteric taste' or 'protective aesthetic theories'.[58]

John was pleased enough with this text of 1944 to use large parts of it again in 1952 in his chapter on the artist in the first volume of *Modern English Painters*; he even concluded both with the identical paragraph.[59] His freedom when writing may have been restricted by the fact that the artist was alive when both texts were published. Notable is the quality of John's writing by 1944. He writes well, with an effective mixture of sufficient technical analysis for most readers of the book and a subtle and sympathetic representation of the artist's personality based on personal knowledge or friendship. The writing skills which came to the fore in *Modern English Painters* were already there by 1944.

In December 1945 John published a book which broke new ground for him in that it was about an artist who had not been a friend of his father's, Edward Burra.[60] In yet another example of Kenneth Clark's dominance of the British art world, during the war he promoted a series of small books under the generic heading of 'Penguin Modern Painters'.[61] Published in large cheap paperback editions, profusely illustrated, many in colour, these became deservedly popular. Priced at 2s 6d they were accessible to a large readership and helped to spread knowledge of young British artists. Clark had chosen his favourite artists to be covered by authors who were his friends and the series started with Henry Moore (written by Geoffrey Grigson) and Graham Sutherland (by Eddy Sackville-West, both April 1944). In John's case, Clark asked him to cover Augustus John but he had proposed Burra instead. The Burra book was the seventh in the series, with sixteen pages of text followed by thirty-two of illustrations, half in colour. While Burra was not from William Rothenstein's generation (being born in 1905), he had been at the RCA in 1923 when William had been its Principal and had been one of the young artists who had visited the Rothenstein home.[62]

Burra was an English artist whose reputation owed something to Rothenstein's support of him. In 1942, for example, John had contributed the foreword to the catalogue for a Burra show at the Redfern Gallery. The 1945 book was the first on Burra and its publication in the Penguin series put the young artist firmly into the company of leading British artists. John, who tended to remain loyal to his artist fiends, later wrote a long piece in the catalogue for Burra's large retrospective at the Tate in 1973 and then a favourable chapter in *Modern English Painters: Wood to Hockney* in 1974. John also acquired work from Burra in his own right, owning at least two major pictures.[63]

Of more note for Burra's nascent reputation was that John persuaded the Tate to acquire major pieces by the artist quite early in his career. *Harlem* (1934, Tate, 5004) and *Dancing Skeletons* (1934, Tate, 5005) were bought via the Knapping Fund in 1939, followed by three more in 1940.[64] In 1942 *The Studio* presented *Soldiers at Rye* (1941, Tate, 5377) and in 1955 another work was acquired.[65] Various pictures by Burra were also bought by the Walstons, presumably under John's influence.

Graham Sutherland. Photograph by Francis Goodman, 1946.

Edward Burra. Photograph by Neil Libbert, 1970.

The Tate had been acquiring art throughout the war, even if paintings were not hanging in the badly damaged galleries. In amongst the long lists of pictures acquired by gift or bequest are those the Gallery managed to buy with its small funds. A focus on these will say more about the taste of the Director and about what he was able to persuade the Trustees to accept. In 1939, for example, just looking at British art, which was relatively cheap in the case of living artists, funds were found to buy works by Burra, Wyndham Lewis, Lowry and Paul Nash; in 1940 works by Bawden, Jones, three sculptures by Moore, John Nash, Piper, Ravilious, Stanley Spencer and Sutherland; in 1941 work by Armstrong, Gertler, Hitchens, Paul Nash, Pasmore, Sickert and Smith; in 1942 work by Glyn Philpot and William Roberts; in 1943 Duncan Grant, Thomas Hennell, Frances Hodgkins and Smith again; in 1944 Graham Bell (who had been killed in the war) and Hodgkins again; and in 1945, two pictures by Ben Nicholson, Sickert, Spencer and Tunnard.[66] These were respectable acquisitions of work by some of the most modern British artists. CAS and Chantrey Bequest purchases which went to the Tate were also, to an extent, influenced by the Director.

Where the pattern breaks down is as regards the acquisition of modern foreign pictures, which tended to be more expensive. Only a few acquisitions were made, still fewer of note – an Utrillo in 1939, an Ernst in 1941, a Chagall in 1942.[67] Various reasons can be given for this disparity: there was less foreign work available to purchase in England during the war; the Tate had little money; and the taste of

the Director and his Trustees favoured British work, also needed to fill the large gaps in the British collection, which they regarded as their priority. Saying that Rothenstein should have focused the Board and the Tate's resources on foreign art is a viewpoint but not a truism.

The Board, in any event, was always conservative about acquisitions. Later criticism of John as Director, that he failed to acquire enough by the great twentieth-century foreign artists, needs to be seen in this light: much was misguided and tendentious. A good example of the Board's attitude comes from its meeting on 17 January 1945 when it considered what John described as a 'shaft' by Barbara Hepworth. This would have been a valuable acquisition just in terms of later market prices for Hepworth's work. But the Board rejected it. The comments John recorded from the Board's discussion are illuminating. Kenneth Clark, who had a huge personal collection of modern British art and was perhaps the most knowledgeable and forward-looking Trustee, said that abstract art was 'a heresy' and doubted whether the Gallery should have any abstract art at all (this in 1945). Henry Moore agreed that the Tate should not take the piece, saying that 'if sculpture [was] nothing more than that it wd be a poor affair'.[68] All seven pieces of sculpture bought by the Tate in 1945 were by Henry Moore.[69]

That year had many significant events. Before the war could end, William Rothenstein died after a long illness. John had been urgently summoned to his bedside a number of times over recent years but each time the old man had rallied.[70] On this occasion, 14 February, Elizabeth rang to tell John that his father had died and, while his diary simply recorded that he could not 'describe his grief',[71] he was devastated to lose his much-loved father. The autobiography contains a short, but very moving and loving, chapter reflecting on his father and his generous human qualities.[72] Their relationship had rarely faltered and towards the end William had freely expressed his own love for his son. On John's birthday in July 1942 William had written: 'you have, too, a considerable achievement behind you, and much that should be fruitful before you. ... with you and Bill I can leave things in good hands' (Bill being the family name for John's younger brother, Michael).[73] He wrote a particularly moving letter to John on 12 April 1943, in which he reflected on the successes of his own career: 'On the whole I have had a successful career. ... An official artist during the last war, head of the RCA, a Trustee of the Tate, member of the Fine Arts Committee and finally knighted', going on to praise John: 'Moreover I have reason to feel some pride in the important public positions offered to you, which you are filling with such ability.' As late as May 1944, the elderly William was still unable to resist volunteering commentary on John's writing ability, saying that it had improved in his book on Augustus John.[74]

Then the war did end, in May 1945, and shortly afterwards Manson died, on 3 July. Clark told John that he did not want to carry on at the National Gallery because he wanted to pursue his own interests as a writer; his resignation was announced in December 1945. John began to agitate to get some part of the Tate re-opened.

In one sense this was bad timing because there was great upheaval among the staff. On 4 February 1946, for example, he recorded 'everything wrong at Tate'; on 12 February, 'V worried about staff position at TG. Whole fabric collapsing'.[75] John's management style had nothing to do with the unrest. The social and economic fabric of British society had been traumatised by the war and many people were unsettled and unhappy at the idea of simply resuming their pre-war roles.

As John bustled about securing the necessary resources to enable some galleries at the Tate to be repaired and arranged loans for the exhibitions he planned for the re-opening, the small staff came under great pressure. Not enough were qualified in the immediate post-war period and the Treasury, labouring with the terrible financial state of the country, was strict on cost control at the Gallery. Young people joined on an unpaid basis as 'attachés' (who might now be called 'interns'). One of these was Roderic Thesiger, the younger brother of the famous traveller, Wilfred, who joined in summer 1945 at the age of thirty, after studying at the Courtauld. After a while, he could not afford to carry on and later became a significant art dealer. Another successful attaché was John Russell, who had joined the Gallery during the war and who went on to be a successful art critic. A more permanent hire in 1946 was Honor Frost, who set up a new Publications and Information Department.[76] She was the ward of a legendary collector of modern British art, the solicitor Wilfrid Evill, and ultimately inherited a vast collection of modern British art from him. John was, initially at least, pleased with her contributions to the Gallery's administration.

By April 1946 all the administrative barriers to the partial re-opening of the Tate had been overcome. John's commendable doggedness had largely achieved

Georges Braque at his London exhibition with John Rothenstein. Photograph by Kurt Hutton, 1946.

this, amid the general malaise of post-war shortages and the particular problems with staffing. Ernest Bevin, Secretary of State for Foreign Affairs, opened six galleries on 10 April. An eclectic collection had been put together. One gallery showed French nineteenth-century painting; another the work of such English Romantics as John Martin; there was an Arts Council show of Cézanne's watercolours; a British Council exhibition of Braque oils and Rouault aquatints; and British art from the collection of Vincent Massey, who was a Tate Trustee in 1942–46 and High Commissioner for Canada and was in the process of leading a review into the functions of the National and Tate galleries. It was a varied collection of pictures and not indicative of any bias on the part of the Director against works by foreign artists. Braque himself came to see the show in May and the King visited in June.[77]

The same year, however, saw the departure at the end of October of Robin Ironside. John was sorry to see him go.[78] They were fond of each other and each had learned to accommodate the personal foibles of the other. John was lucky to be able to replace him with Norman Reid, whose long career at the Tate began then, but theirs was more a professional than personal relationship.[79] Reid had trained as an artist before the war, during which he had served in the army. He had thereby acquired useful administrative skills and rose through the Tate hierarchy, eventually taking over from John as Director in 1964.

Norman Reid, following his appointment as Director of the Tate Gallery, 1964. Photograph by Chris Ware.

Ultimately the Treasury was persuaded to authorise hiring new staff. John's diary records a telephone call from the Treasury on 22 October 1946 regarding 'the staff crisis': the Gallery was permitted to hire an archivist and two assistants, pending a decision on whether to implement any of the recommendations of the Massey Report.[80] The Report, published in May 1946, in itself resolved nothing; it was supportive of the Tate's position and led to the 1954 National Gallery and Tate Gallery Act of Parliament to regularise their relationship. In the meantime, it noted that the separate characters of some of the national collections had become muddled together, especially between the National Gallery and the Tate. It recommended that the Tate should be divided into two separate collections, a National Gallery of British Art of all periods and a National Gallery of Modern Art; that the Tate Trustees should be independent of those of the National Gallery; that the Tate should have an official annual grant of £5000; and that it should receive the Chantrey money directly, so that it made the purchasing decisions on its own.[81] In 1946 the Tate did indeed receive its first official grant, of the princely sum of £2000 per annum. With this, as the Tate was then constituted, it was expected to buy British art of all periods, modern foreign painting and modern sculpture; any criticism of John Rothenstein's achievements at the Tate needs to bear this in mind.

CHAPTER 9
Straws in the Wind, 1947–51

John Rothenstein regarded the years between the partial re-opening of the Tate in 1946 and the Tate Affair in the early 1950s as a golden period.[1] His relationship with Jasper Ridley meant that he could get on with his job while shielded from the Trustees. The restoration of the Tate, culminating in its full re-opening in 1949, was complemented by a partial resolution of the Chantrey problem after John picked a public fight over it. An exceptional series of exhibitions was held, some on historic British artists, such as Blake in 1947 and a joint show of Hogarth, Constable and Turner in the same year, others on leading modern foreign artists.

Many of these shows under John's Directorship after the war were promoted by the Arts Council. Its secretary was John's friend Philip James, who initiated such exhibitions with a letter to John asking if he would support a proposal for a show which the Arts Council wanted to hold at the Tate. John almost always assented and would recommend the proposals to the Board. Once they were settled in the calendar, others at the Tate would make the often laborious practical arrangements for a large show, but the fact that the process worked seamlessly for many years was at least partly thanks to John's good relationship with Philip James. Occasionally, when it had the funds to mount its own show, without the Arts Council, the Tate was responsible for all the arrangements, including the preparation of the catalogue. Sometimes an exhibition was sponsored jointly by the Arts Council and the Tate or by other entities altogether.

A van Gogh show put on by the Arts Council in December 1947 was phenomenally popular with the public, newspaper pictures showing queues down Millbank in the pouring rain. Chagall followed in February 1948 and British artists who had recently died, such as Paul Nash (March 1948) and Edward Wadsworth (February 1951), were also covered. When John was discussing the possibility of the Nash show with his widow, Margaret, there came a reminder that his support had been appreciated: Margaret ended a letter to John with 'so I leave it to you who so sympathetically supported his work in his lifetime to take care of it now'.[2] In February 1950 Léger was shown jointly by the Arts Council and the Association Française d'Action Artistique, and in June *Modern Italian Art*. The eclectic selection of subjects catered for many tastes. A small show in 1948, *Pictures for Schools*, promoted by the Society for Education in Art with Arts Council support, picked up on John's readiness to encourage art gallery attendance as educational, as seen with his Disney show at the Graves Art Gallery in Sheffield: John was always

Marc Chagall with John Rothenstein in Vance, 1948. Photograph by K. Hutton.

looking for ways to broaden his audience and this exhibition enabled educational authorities to buy pictures for display in schools.

Once the worst of the disruption caused by the war was over, the many positive aspects of John's character as Director came into their own. He relished and was good at many parts of the job. He was enthusiastic and a great advocate and representative of the Gallery in the wider world. He encouraged many British artists, as had his father. When things were going well for him, when he felt unchallenged, he was charming and highly effective.

The permanent staff had been strengthened in 1949 by the arrival of Mary Chamot (1899–1993) as Assistant Keeper.[3] Born in Russia, she had after studying at the Slade worked at the National Gallery and the V&A and had published *English Medieval Enamels* (1930), *Modern Painting in England* (1937) and *Painting in England from Hogarth to Whistler* (1939). At the Tate, she worked with a growing band of well-trained colleagues – such as Ronald Alley (1926–1999), who joined in 1951 from the Courtauld as Assistant Keeper[4] – professionalising the Tate's approach to its collections. It was a distinctive feature of the Gallery in the early 1950s that, while the Director was in trouble in the media, serious research was being achieved, with John's full and active encouragement, such as Chamot's catalogue of the British School (1953).

Occasionally, the Organisation and Methods Division of the Treasury was asked to advise on the Tate's internal procedures. On 27 May 1949 John asked them to investigate the administration of the Publications Department, on which they reported in November. There were two further reports in 1950 and one in 1952.[5]

Despite later Treasury help given to John over the Tate Affair, the Treasury was aware that John was not always straightforward. In 1950 he asked them to review the whole administration of the Tate. John made many comments on their draft report, to which the Treasury reacted with some asperity. The Treasury realised that John had hoped that the report would say that the post of Deputy Keeper which he had given the newly arrived Le Roux Smith Le Roux was needed. In fact, as the Treasury thought Le Roux's and several other roles were not needed, John's comments (containing 'many mis-statements of fact')[6] were largely ignored.

The Gallery's collection continued to grow through gift, legacy or purchase, 1946 being a particularly rich year for gifts. The War Artists' Advisory Committee distributed the pictures it had commissioned, presenting to the Tate a large number by Armstrong, Bawden, Richard Eurich, Thomas Hennell, Moore, Nash, Piper, Stanley Spencer and Sutherland (nine works by him alone). Purchases in 1947 included work by Matthew Smith, Sutherland and Wyndham Lewis, together with works by earlier artists like John Linnell and Thomas Gainsborough. In 1950 the first picture by Francis Bacon entered the Tate when *Figure in the Landscape* of 1945 (Tate, 5941) was acquired using the Knapping Fund. Rothenstein was an early admirer of Bacon's and was instrumental in pushing through this purchase from Diana Watson, Bacon's cousin, via the Hanover Gallery. This was one of Bacon's seminal works, which had featured at the Lefevre Gallery in April 1945 when his mature work had first been noticed by an astonished public. The Bacon collection at the Tate grew in 1952 when his earliest significant supporter, Eric Hall, presented *Study of a Dog* (1952, Tate, 6131), followed by the major *Three Studies for Figures at the Base of a Crucifixion* (*c.*1944, Tate, 6171).

As regards foreign pictures, the Knapping Fund had also been used in 1946 to acquire three pictures by Klee and one by Gris, and three by Chagall had been

John Rothenstein
with Francis Bacon,
1957. Photograph by
Herbert K. Nolan.

Douglas Cooper in Argilliers, 1954. Photograph by Robert Doisneau.

presented in 1947 (and another in 1948). In 1949 what in hindsight looked like an unholy alliance of Rothenstein, Sutherland and Douglas Cooper made a great breakthrough. Sutherland, following his appointment as a Trustee in 1948, began agitating the Board, probably under Cooper's influence, to acquire more works by modern foreign artists, such as Picasso and Braque. Rothenstein, who relished any foreign travel, set off for Paris with Cooper. The latter had unrivalled connections among painters and dealers in France and between them the two identified a remarkable selection of pictures which were shipped to London for the Trustees to consider. John described the Board meeting of 18 August 1949 as the most exciting he could remember, with work before them by Braque, Dufy, Giacometti, Gris, Léger, Matisse, Picasso, Renoir, Rouault, Vlaminck and others. Of these, the Board, with the curious exception of Piper, agreed to acquire two Picassos, a Matisse, a Rouault, a Léger and two pieces by Giacometti.[7]

This illustrates how the modern foreign collection could be improved when the Board had some funds at its disposal, gave Cooper his head and followed his advice. Later suggestions that Rothenstein had any principled objection to work simply because it was contemporary or produced by a non-British artist were wrong. He was as excited as anyone at the Tate when prime foreign work could be acquired. Unfortunately, it was an isolated example during this period. Whilst there were several significant purchases of foreign art over the next few years (works by Gris and Dufy in 1950, de Chirico and Miró in 1951 and Lam in 1952), there were other instances of foreign works being sold cheaply in London without the Tate appearing to notice.[8] Sometimes Cooper drew the Tate's attention to pictures on

the market, knowing that they could not afford them, and then arranged for their sale to American museums.[9]

Not long after his appointment, Sutherland wrote to Cooper sharing his views of the Board's decisions regarding acquisitions. The insight which this gave Cooper fed his view of the incompetent leadership of the Tate, even if the decisions he complained of were those of the Trustees and not of Rothenstein.[10] The latter had, for example, put forward a picture by Soutine for purchase, but the ever-conservative Board rejected it. A Soutine did not enter the Tate's collection until one was given in 1959.[11] When Rothenstein proposed a Dufy on 20 April 1950, the Board rejected that as well, although a picture by Dufy was acquired that year.[12] Following a trip to Italy, John proposed various works by contemporary Italian artists, including the modernist sculptor Marino Marini: the Board initially rejected everything although, again, works by Manzù and Marini were acquired. John recited in his diary that he was 'v much distressed; oppressed by sense of failure and of possibility of more frustration.'[13]

In reality, all was far from well in Millbank in a number of respects. John, amidst the multitude of his engagements, was not aware that the growing problems and grievances developing around him were slowly coming together to cause him a single problem; in his mind, writing after the event, the Tate Affair burst on him like an unforeseen clap of thunder on 8 October 1952. In fact, a survey of the years from 1947 onwards shows the poison slowly spreading, and from a number of sources.

The first faint note of public disquiet at John's tenure had come through an editorial in the *Burlington Magazine* as early as September 1947.[14] Benedict Nicolson (1914–1978) had recently become the editor, with an appetite for shaking things up.[15] He had previously been Deputy Surveyor of the King's Pictures, initially under Kenneth Clark and, after the war, under Anthony Blunt, who had in 1947 become the Director of the Courtauld Institute (and was also a friend of Cooper's). Nicolson had worked with Bernard Berenson, like many in the international art world, and represented a type of serious art historian who did not appreciate the somewhat lighter academic qualifications of this Tate Director, who had no formal training in Old Masters. By the early 1950s the academic discipline of a group of well-trained art historians in England, some from the Courtauld, was a new departure for the British art world. Nicolson and Blunt were joined by Pope-Hennessy, Cooper, Herbert Read, Ellis Waterhouse (1905–1985),[16] Denis Mahon (1910–2011)[17] and, of course, Kenneth Clark. As John's father had pointed out all those years before, when John was contemplating a post at the Ashmolean in Oxford, John was not an art historian in the traditional sense; his academic knowledge was based on nineteenth- and twentieth-century British art. Many of these historians wrote regularly for the *Burlington Magazine* on a variety of academic subjects, often involving Old Masters. A number of them had no sympathy for Rothenstein when his problems reached the public domain.

Benedict Nicolson. Photograph by
Bernard Lee ('Bern') Schwarz, 1977.

The *Burlington* editorial, prompted by the Tate's fiftieth birthday, opened inauspiciously – 'The Tate Gallery has stumbled into its fiftieth year'– going on to note that 'white elephants in the form of academic painting of the late Victorian era, of interest chiefly to sociologists and Royal Academicians, occupy the wall-space that belongs by right to Redon, Chirico, Masson, Gris, Nolde and Miró'. Those running the Gallery would have agreed, as regards the Chantrey-type pictures, but most of these were not on display and, in any event, works by André Masson might not have been an improvement. Nicolson's list of preferred artists was strangely idiosyncratic. He also suggested what he saw as necessary improvements, which the Gallery might have supported, such as splitting it into its constituent collections and severing its connection with the Chantrey Bequest. Otherwise, there was nothing critical of John personally and the shows held at the Tate after the war were praised. John Russell nevertheless leapt to the Tate's defence, his letter being published in the November 1947 issue: 'you have radical amendments to propose – though it might have been more generous to acknowledge that every one of these projects originated within the walls of the Gallery itself.'[18]

Cooper gets many mentions in John's diaries in this period and quite a few letters between them survive. Cooper's partner, John Richardson, has said that, after the initially encouraging contacts between John and Cooper in 1938/9, Cooper's negative view of John first formed around the time of the Klee exhibition at the end of 1945.[19] His occasional charm and considerable expertise in

twentieth-century art history was mixed with unpredictable aggression and irritability, as if tormented by a physical problem like the gout which contributed to the irascibility of Munnings.[20] No physical excuse has ever been adduced to explain his demonic character.[21] He took against people (and things), rightly or wrongly, and then the chosen victim suffered. Irrationally generated grudges could persist for a long time. Resilient characters were able to laugh off his attacks – there is for example no suggestion that Kenneth Clark found him anything other than ridiculous. But John was not such a character and the ferocity of Cooper's attack, when it came to a head in the 1950s, was too much for him to bear.

Cooper could not resist having his say about the *Burlington* debate and his response to Russell appeared in a letter published in the January 1948 issue.[22] Around this time Cooper was agitating for the creation of the sort of gallery of modern art which he preferred, on the model of MOMA in New York, and had been unsatisfied by the development of the Institute of Contemporary Art under the guidance of Roland Penrose, Herbert Read and Peter Watson. For Cooper, the Tate had failed as a national gallery of modern art by comparison with MOMA. He alleged that it displayed pictures which were merely fashionable (his examples were work by Philip Wilson Steer, William Blake and John Martin), rather than the best of its traditional holdings. John's diaries noted what he described as 'a mendacious attack on the Tate in *Burlington*; fortunately Douglas Cooper's malevolence has made him overreach himself a long way'.[23] He then prepared a detailed response to Cooper, and his letter, the last on the subject, published in the March issue, sought to demonstrate that Cooper had been misguided.[24] For example, John rightly pointed out that, as a private rather than state enterprise, MOMA drew on huge funding from American benefactors to develop its collection, unlike the Tate with its muddled origins, tiny budget and remit to form different national collections.

It might be thought that John's letter would have left Cooper smarting but he tended to lurch from one topic to another without waiting for an issue which he had raised to be resolved. His pleasure came from making an impact with an outrageous comment, rather than entering a reasoned debate in which he might have to backtrack. So, even before John's letter was published, Cooper had picked another issue with John. On 23 January 1948, Cooper wrote to John[25] to say that he had been commissioned by Blunt to prepare the catalogue for the joint Tate and Courtauld exhibition at the Tate to celebrate the collection of Samuel Courtauld, who had set up the Courtauld Institute and had recently died.[26] Tongue in cheek, Cooper wrote that he hoped it would be possible to work together on a friendly and sensible basis and that he would try to make things go smoothly. He knew this was not true and John knew it as well. In light of the climate between Cooper and the Tate generated in the pages of the *Burlington Magazine*, this was a deliberate provocation, as it would inevitably involve close co-operation between Cooper and the Tate; John hurried off to meet Blunt to sort the matter out.

The diary entry for this meeting on 26 January 1948 reads: 'long talk with Anthony Blunt at Reform [Club] over lunch about Courtauld exhibition. Saw impossible for Douglas Cooper to do a Tate Gallery catalogue and proposed he should do a special one for the Courtauld Institute, and we should do another for our exhibition'.[27] Although it involved duplication, this was a sensible solution to what could have been awkward. Blunt's views on Rothenstein are unknown as he made no public comment on him. As a friend of Cooper's, Nicolson's and Proctor's, Blunt may not have been positive but he was characteristically discreet and took no overt part in the Tate Affair.[28]

Then, again before John's response had been published in the *Burlington*, it was reported to him on 2 February that Cooper had forced his way into the private viewing at the Tate for the Chagall exhibition and had made a scene which embarrassed Madame Chagall. On 11 February, Cooper telephoned again, this time to admit that he 'had no real criticism of Tate but felt resentful of our alleged failure to give full recognition to his help in Klee exhibition. I said regretted this but his conduct bestial, but that co-operation – which he suggested – would not pass unrecognised by us. Went together to lunch at French Embassy'.[29]

The small size of the British art world, and John's central part as Director of the Tate, meant that he had no option but to continue dealing and co-operating with Cooper in a variety of ways. Another week on and John found himself visiting Cooper to agree a selection of French Impressionist pictures to be used for the next Venice Biennale. John's diary noted on 17 February: 'his Picassos v fine; his library most workmanlike'.[30] No sooner had John's letter to the *Burlington* been published than he found himself having lunch with Cooper at the Reform, following

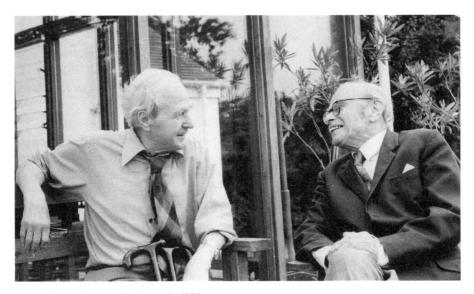

Henry Moore with John Rothenstein, 1979.

which they happily went off together to the Tate to re-measure some Courtauld pictures. John noted (4 March) that Cooper was 'v genial and informed'. After another lunch in March, John then heard in May that Cooper had violently 'attacked' work by Henry Moore (a Tate Trustee and friend of John's) at a sculpture exhibition in Battersea Park.[31] He then heard in July from Philip James that Cooper was offended because the Tate had asked MOMA to borrow work for their *Modern Italian Art* exhibition in summer 1950, but had not asked to borrow work from his collection.[32] In 1949 Cooper wrote offering to lend pictures for the forthcoming Léger show;[33] in 1950 he wrote to say that Léger was annoyed because one of his pictures had not been returned to him after the show. John calmly pointed out that the picture was not at the Tate.[34] Association with Cooper involved this endless roller-coaster ride of unpredictability. In July 1949, following another lunch between the two, the diary recorded that Cooper was 'always critical of Tate Gallery and me'.[35]

Whether John suggested to Cooper that he might help with a new Tate catalogue of their modern foreign paintings or Cooper himself suggested it is not clear, but the idea started to germinate in late 1949. On 19 October John concluded a letter to Cooper with this paragraph: 'With regard to the other matter I wanted, quite tentatively, to ascertain your views, but let me say at once that it was never in my mind that you should, in any circumstances, undertake the work in question "purely for love and honour".'[36]

On 22 November more light is thrown on Cooper's plan by the record of a dinner at which Cooper said that he would like to become the Deputy Keeper in place of Humphrey Brooke (1914–1988).[37] Rothenstein must have been appalled at this thought, even if he simply noted that 'his personality would surely prevent his being appointed'.[38] By 5 January 1950 the two were yet again lunching to discuss this new catalogue and whether Cooper might do it: 'Seems to me he would do it only if given a staff post', John noted in his diary.[39] Cooper then sent John a four-page letter on 10 January setting out his terms to do the job, notably that he would need to be appointed to 'some sort of acting Keepership on a temporary basis'. John replied saying that he was not hopeful of the Board finding his suggestions acceptable.[40]

Whether through design or chance, John now had another problem on his hands. As noted, the Board were unlikely to accept Cooper's suggestion, even if he himself wanted it. Yet how to escape the problem without provoking another damaging breakdown in relations with Cooper? Given John's previous mismanagement of difficult people, it is possible that, in their discussions on the subject, John had backed away from making the situation clear and had misled Cooper into thinking that the role might be his.

Once the idea reached the Board, it died; it was left to John to tell Cooper, by letter on 19 May 1950, that the Tate would not be employing him to write the catalogue of modern foreign paintings.[41] Instead, showing some cunning

which enabled him to escape a roasting, by May 1950 John had proposed another co-operation with Cooper, this time more at arm's length. This was for the Gallery to put on a major show of European painting covering the seminal period from 1900 to 1914. With Cooper's unrivalled knowledge of Cubism, such a show could have been made for him. Cooper wrote another proposal for how he saw this working; another lunch ensued to discuss it. The Board were interested but, as John wrote to Cooper on 21 June, 'the organisation of such an Exhibition would be beyond the unaided resources of the Tate'.[42] John asked the Arts Council whether they would support such a show, and they said they would, but the idea petered out as Cooper lost interest in it. (The show eventually appeared at the Tate in 1983.)

As was Cooper's way, he had found something else to grumble about, this time the Léger show which had opened at the Tate in February 1950. More letters followed.[43] The ghastly charade of trying to deal with Cooper never seemed to end. On 15 February John went to a party which Cooper gave for Léger, at which the host made a point of praising Reid when speaking to John and saying he 'never saw enough' of John. John's diary comment was 'faux-bonhommerie? Impulsiveness? Deceit? For he dislikes us both'.[44] In a particularly interesting letter dated 16 May, John attempted to explain to Cooper why he found him so difficult. Cooper had written to suggest that the difficulties between them were caused by John. Accusing one's opponents of one's own failings is an unattractive but well-known psychological blemish: 'You describe your own attitude as entirely friendly, and indeed more than friendly; and you describe my own as dictated by personal resentment, and as being hostile, antagonistic and so forth'. There is no evidence that John had been any of these things to Cooper. As his letter went on to say, 'one simply has no idea where one stands with regard to you. A series of friendly meetings is liable to be followed by an outburst of rancour, which always seems to be without legitimate cause, and without any limits whatsoever'.[45]

The appointment of Sutherland as Trustee provided a platform for a man who became another enemy of the Director. John had sought out Sutherland to ask if he would like to be a Trustee.[46] There were a number of reasons why this became unfortunate, although John cannot be criticised for recommending one of the leading British artists of the day. Firstly, John would not have known that Sutherland was ruthlessly ambitious. He loved to have powerful friends in the art world and, if he felt they could further his career, would fawn on them (his correspondence with Kenneth Clark is an example, Sutherland coming across as a sort of lapdog of Clark's).[47] Around the time of joining the Board, Sutherland had started to come under the spell of Cooper, with dire consequences for Rothenstein.

The second feature of Sutherland's character, which did not help calm the Tate as troubles unfolded, was his inexhaustible capacity for publicity and self-promotion; he was not a team player or an adherent of the policy of cabinet responsibility. At first, nothing between him and the Director surfaced. But he was there for the Humphrey Brooke affair, to be described shortly, and Brooke had been a

close friend of his for some years. All the dissatisfactions which Brooke felt about John's treatment of him would have been shared with Sutherland.

Internally at the Tate, amongst the tiny group of permanent executive staff below the Director, trouble was also brewing. Honor Frost, a favourite of John's, was developing the Publications Department. Unfortunately, the basis on which she had been employed had not made it clear whether she was a Tate employee subject to Civil Service rules or an independent contractor employed to complete a specific project. Her methods were unorthodox if she was a Civil Servant and she was not a favourite of everyone else's, perhaps because she had the ear of the Director; in particular she had become the target of increasing criticism from one of the Deputy Keepers, Humphrey Brooke.[48] John's diary records his rising anxiety as these criticisms came to his attention. On 7 May 1948, for example, he noted that Brooke was worried about what he bluntly described as Frost's 'useless-ness'. By June, Brooke was sending memos on the subject to the Chairman and urging clarification of the legal status of what Frost was doing. In December 1948 John wrote a sharply critical letter to Frost, following a Board meeting in which there had been a report on the Publications Department, together with vociferous criticism by Brooke. By 1949 the situation had got out of hand and on 4 January John asked Frost to resign on the basis of her unpopularity with other staff. The ambiguity about her status meant that no one was sure if she could be sacked like an employee. Brooke sent a long note to the Board on 18 February 1949 setting out his views. By March John was extremely stressed about the situation, feeling particularly exposed because of the risk of the Board's criticism being focused on him personally as a result of his own close links to Frost: 'Feeling v acutely upset by difficulties with B [Brooke]: bitter taste in mouth and pressure on pit of stomach.

(Thomas) Humphrey Brooke. Photograph by Howard Coster, 1953.

Have experienced this momentarily in cases of fright, but never in this lasting way before.'[49]

Following Brooke's memo, John wrote a statement to the Chairman, putting his own view and requesting a Treasury enquiry into the Publications Department to attempt to clear the air.[50] This ploy of asking for Treasury involvement was one he used again when internal Tate matters became even more difficult. He regarded the Treasury as both an external safety valve to reduce tensions with the Board and as an entity which tended to give the benefit of the doubt to the Director when it was a simple matter of arbitrating on clashing views.

John's exposed position was slightly alleviated when it became clear that, whatever the substance of his accusations, Brooke was undergoing serious mental instability: he was given indefinite compassionate leave.[51] Although John was no doubt relieved that Brooke was out of the office, the stress continued. The Board on 28 April was 'unsettled' when they had a further discussion about the Brooke allegations.[52] In the background, far from resigning, Frost was still writing letters putting her side of the story and seeking to clear her name.[53] By the time she eventually resigned, in November 1949, the Treasury report having found her guilty of a number of Brooke's allegations, it was also clear that Brooke would not be returning to the Tate.[54] John's status with the Trustees was diminished by this episode, since his personal embroilment with an issue meant he could not help resolve it, forcing others to do so. He was protected on this occasion by his good relationship with Ridley and by the Chairman's strong hold over the mood of the Board; but Ridley's early death in 1951 was to leave John exposed to a Board whose freedom to express their concerns had been kept suppressed. Another lasting legacy of the saga was that Brooke, a friend of both Sutherland and Cooper, remained unsympathetic to his old boss at the Tate after his appointment in October 1951 as the Secretary of the RA,[55] a post he held from 1952 to 1968. An immediate consequence of Brooke's departure from the Tate was that it created a vacancy.

Around this time John's poor judgement also contributed to his later difficulties. In spring 1948 he had been on another foreign trip, to South Africa, in order to discuss a show of its art to be held at the Tate (*Contemporary South African Paintings, Drawings and Sculpture* opened in September 1948). His account of the trip contained this fateful note, for 15 April: 'In the evening the Le Roux' gave a big party and dinner in my honour'. The next day: 'Professor Le Roux and I set off by car for the Game Reserve'.[56] They had a lovely time there, but the die was cast: the charming Le Roux, in time, nearly destroyed John's career.

Many letters passed between the pair during 1948, and in 1949 Le Roux visited Rothenstein at the Tate and started to inveigle his way into John's social life, with the diary recording a number of meetings and dinners. Le Roux was finding life in South Africa not to his taste following the change of government to the Reunited National Party in May 1948, with their policy of apartheid. He had a useful supporter among the Tate Trustees in Lord Harlech, who had known him in South

Le Roux Smith Le Roux. Photograph by
Bassano Ltd, 1937.

Africa where Harlech had been British High Commissioner in 1941–44. By plead-
ing to John, with impassioned assertions of hatred of apartheid, and with the
support of Harlech, Le Roux persuaded John that he should be put forward as
Brooke's replacement, even without the normal interview process, because he said
he could not afford to come to London for interviews.[57] No check seems to have
been performed on his reputation in the South African art world. On 15 Decem-
ber 1949 John noted that, while the Board was 'cagey' about appointing Le Roux,
it did so on a temporary basis.[58] By March 1950 Le Roux had extricated himself
from Pretoria and had moved to London with his wife and taken up his post as
Temporary Deputy Keeper, with special responsibility for the vexed Publications
Department. Of all John's misguided decisions, this was undoubtedly the worst.

According to John's own account, alarm bells about Le Roux's behaviour began
to ring almost as soon as he was appointed. He seemed to be determined to control
whatever he could get within his grasp; he wanted all correspondence coming in
to the Gallery, for example, to go through his hands; he wanted to control the Gal-
lery's public relations, which John resisted as he regarded dealing with the press
as his prerogative; and he ensured that everything he did was shrouded in secrecy,
such that even John was not allowed to know.[59] Norman Reid did not like what he
saw of Le Roux either, and after observing the breakdown of trust and co-operation
caused by the Brooke affair, both Reid and Rothenstein were increasingly alarmed

Sir Philip Dennis Proctor.
Photograph by Elliott & Fry, 1958.

at the possibility that a large cuckoo had been introduced into the Tate's small nest.[60] Years later, Dennis Proctor (1905–1983) who became the Chairman of the Tate in 1953, commented that John had made the position worse by insisting that Le Roux be given precedence over Reid, which encouraged Le Roux to think that he was John's chosen deputy Director.[61]

During 1950 and 1951 Le Roux treated Rothenstein to his face as a friend, while 'systematically laying the foundations for an attempt to displace me as Director'.[62] Most extraordinary is that, having appointed this man who quickly revealed himself to be a serious problem, John did nothing about it. He was informed by concerned staff that Le Roux was acting in a peculiar manner and was causing unrest but did not challenge him. On 6 November 1950, for the first time he told Le Roux off for failing to do various tasks but still there were no consequences. Nothing illustrates better John's inability to address challenging personnel issues. He even had the perfect opportunity to get rid of Le Roux when the temporary appointment came up for renewal in 1951. The Civil Service Commissioners and the Trustees wished to terminate the appointment but John saved him: 'As my Treasury friends later said to me, there was a sense in which I deserved all I got'.[63] Le Roux went back to ransacking the Director's correspondence files for a reason which was not apparent at the time but was to become only too apparent shortly afterwards.

Amidst the various strands that coalesced to form the Tate Affair, John decided to try to force the issue of what the Tate regarded as the maladministration of the Chantrey Bequest. Its Recommending Committee, with three representatives of the RA and two of the Tate, did not always agree on what it should recommend – hence its use of only a small part of its £2000 annual income during the war – and sometimes the RA vetoed apparently innocuous purchases, such as a work by

Tristram Hillier to join the two others by him which the Tate already owned. With possibly mischievous intent, John and his Chairman had been encouraging the RA from as early as December 1947 to exhibit the whole 437 items in the Chantrey collection at Burlington House, a show which opened in January 1949. To make plain where the Tate stood, John arranged for the *Daily Telegraph* to print on its leader page a significant piece he had written called 'Why the Tate does not show its Chantrey Pictures'.[64]

This exhibition and the reaction of the art critics of most of the major newspapers and journals could be seen as an unmitigated disaster for the RA and a triumph for modern art against RA taste. In fact, the public seemed far less offended by the Chantrey pictures than the critics. A reviewer in the *Sunday Times* saw the exhibition as a 'nostalgic feast' for the public, remarking that his generation had grown up with reproductions of these pictures and they were likely to receive a much warmer welcome than a great deal of modern art. The critic, Eric Newton, in the same paper a week later, said that it was not so much an exhibition of British art as a commentary on British taste.[65]

The opposite views, supporting Rothenstein's, were well aired. Wyndham Lewis made the typically trenchant comment that 'it would have been better to leave the Tate completely empty, rather than hang any of the Chantrey pictures'.[66] Raymond Mortimer was more balanced, coming down on the side of the Tate but noting that some of the Tate-influenced purchases were not much better than those of the RA. Why, for example, had works by artists who were in no sense 'modern', such as Dame Laura Knight and Meredith Frampton, recently been bought by the

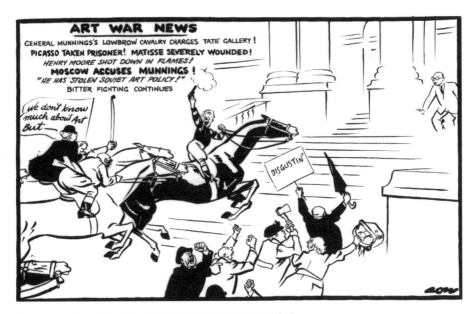

Cartoon by Sir David Low in the *Evening Standard*, 4 May 1949.

Chantrey Bequest at the behest of the Tate? He also noted 'amongst living painters the one on whose work it has been thought wise to spend most money is the present President of the Academy' – Munnings.[67]

There was other balanced comment. Charles Wheeler, himself later the RA's President (PRA) but at the time in the awkward position of being one of its representatives on the Tate Board, had a judicious piece in *The Times* in which he gently pointed out that both sides had shown a lack of 'the need to appreciate more fully the ephemeral nature of present values, as well as a slight over-confidence in our estimate of ultimate values'.[68] The great irony of the situation, in view of later events, was that John and the Tate were regarded by the RA as favouring modern art over the traditional styles, whereas Douglas Cooper and others thought the Tate was irredeemably out of touch with modern art and stuck in tastes which were insular and outmoded.

Whatever the comments, the exhibition was a financial success and the RA gloatingly sent the Tate £1000 as a share of the profits. From the Tate's point of view, the result of the exhibition came later in 1949, when its membership of the Chantrey Recommending Committee was equalised with the RA's and it was given the right to decline purchases. This brought to an end the worst of the Chantrey experiences which the Tate had spent much of its existence fighting and is to John Rothenstein's credit. Had he not been prepared to front a public attack on the status quo, the necessary pressure would not have been sufficient. Yet, John could not resist making mischief with the RA, even during 1949 when diplomacy might have been the order of the day. On 7 May 1949 *The Tablet* published his scathing review of the Summer Exhibition, which he described as 'one of the most dispiriting' he could remember. After a long paragraph praising the artistic abilities of his new friend, Winston Churchill, he concluded with: 'One thing, at least, is unambiguously apparent: towards academic standards the selection committees show – I should rather say parade – an indifference which makes nonsense of the insistent claim of the Academy to represent "Tradition".'[69] When the Tate and the RA were trying to settle their difference over the Chantrey Bequest, for the Director to publish such pugnacious remarks, whatever their truth, was unfortunate: it is revealing about John's judgement.

In 1949 Munnings was replaced as PRA by Sir Gerald Kelly (1879–1972),[70] who was another art world character with a savage temper. John did not have good relations with him either. On Kelly's appointment John wrote to him offering 'to do everything possible to make for goodwill' between the Tate and the RA, but Kelly ignored this letter until prompted to reply by Walter Lamb, the Secretary.[71] John recorded occasional threats over the Chantrey Bequest: on 30 April 1951 Kelly told him that he would 'break up whole Chantrey agreements' (sic) unless John sent only the artist Trustees to the joint committee, not other Trustees. Later in the year, John commented on the 'troubled atmosphere' at Burlington House, where he had picked up that Lamb had resigned rather than retired, as was being said publicly.[72]

The solitary year of 1951 could qualify as the golden period which John had in mind when writing his autobiography, coming after the skirmishes of the previous few years and before the onset of the Tate Affair.[73] He continued to record the ceaseless social events he enjoyed, in all their variety. After escorting the Queen around the Gallery on 4 July, he then spent a drunken evening in Soho with Francis Bacon and Matthew Smith on 30 July. In January there had been a trip to Paris to look at pictures by Braque, Robert Delaunay, Hartung, Léger and Villon. Revealing how challenging it was for the Tate to contemplate buying such pictures, he noted that the Braque alone was priced at £4000.[74] He found that he was getting on particularly well with Graham Sutherland, helping to decide at the Venice Biennale Committee that the artist should be the chief exhibitor in the British Pavilion in 1952 and that Sutherland was 'very pleased with rearrangement of Tate'. 'I like Graham Sutherland the more I see of him'.[75]

John slaved to finish the first volume of *Modern English Painters*, completing the preface and acknowledgements in June 1951. Le Roux caused no trouble, at least as far as John noticed or recorded, but caught the attention of Philip James in July, by broadcasting on the Third Programme a critical review of the two *Anthologies (British Painting 1925–1950)* shows put on by the Arts Council for the Festival of Britain (Le Roux's text was published in *The Listener*).[76] James was furious that a representative of the Tate should publicly criticise an Arts Council exhibition given its significant support of the Tate's exhibition programme. However undiplomatic, Le Roux's piece contained several reasonable points: arbitrary time limits had been chosen; some artists had up to nine works on show, where others had three; some suitable works had not been available; the split between the two 'anthologies' was artificial; and generally the selections were unduly timid.[77]

Otherwise John mentions occasional social events with Le Roux and an appearance by him in front of the Civil Service Commission,[78] in which he 'made a bad impression, seemingly flamboyant and interested in outside activities, T.V., radio etc'. Cooper was similarly quiet. He had bought the run-down Château de Castille at Argilliers in the South of France, which was taking him and John Richardson much time and effort to restore, and his normal eagle-eye for shortcomings at the Tate was momentarily elsewhere.

One event which at the time seemed to have little wider significance, but which Le Roux noted as it happened, was John's decision to fire an Assistant Keeper called Paul Hulton (1918–1990). He appealed to the Board against the Director's decision in January 1951. Two Trustees looked into the matter and reported back to the Board: Hulton's dismissal was confirmed at their meeting on 15 March. He went on to have a satisfactory career in the Department of Prints and Drawings at the British Museum but another enemy had been made.[79]

The Tate Board was quiet enough but evolving in a way which would contribute to John's later difficulties. Jasper Ridley's death in 1951 brought about some jockeying to replace him. Lord Harlech corralled support from Sutherland, Piper

and Moore but the appointment when it came down from the Prime Minister's Office was of Lord Jowitt (1885–1957), the former Labour Lord Chancellor.[80] Colin Anderson (1904–1980), who became a Trustee in 1952, later described Jowitt as being 'not a success' as Chairman:

> His vanity, and only superficial interest in the problems of the Gallery, showed all too clearly through the authoritative voice and the impressive presence. He had a habit of cutting short the Trustees' meetings for social reasons of his own, and of leaving the tail end of the Agenda to its fate. He never really got down to anything, so that the Director lacked even that atmosphere of unquestioning command from above, which had marked his relationship with Jasper Ridley.[81]

Jowitt's attitude towards his Director differed markedly from that of Jasper Ridley, ranging from severely critical to totally supportive; John experienced the former before the latter.

CHAPTER 10
Tate War: First Phase, 1952–53

In the 1952 New Year's Honours List, John Rothenstein was knighted. Congratulations poured in, the first telegram John received being from Le Roux.[1] Two months later a problem arose with Le Roux. John and Norman Reid had to have a 'difficult' discussion with him about his minute-taking.[2] They were concerned about his propensity for cornering aspects of the Gallery's administration and John's anxiety even over this mild interaction with his deputy was enough to give him a sleepless night.

Events now started slithering towards the disaster which was later called the Tate Affair. At the Board meeting in July 1952, according to John's diary, Le Roux pretended that he had not heard John ask Reid to take the formal minutes of the meeting and carried on preparing his own set. John noted that he was 'worried about Le Roux'[3] and a month later he was 'concerned by Le Roux's activities and attitude: always "Empire building" always playing politics'. Again, he 'hardly slept'.[4]

What John's diary did not record was that around this time he had suggested to Le Roux that he might look for another job, even pointing out an advertisement for a post elsewhere. Le Roux responded by letter dated 20 August that he had 'given a great deal of thought to your recent suggestion that I should consider seeking a post elsewhere', but that he was happy with his job and did not want to leave. His probation had been extended for a year in March, he had presumed that John was happy with him then and nothing material had changed in the meantime.[5] John eventually responded to Le Roux's letter (on 24 September) but he did not mention to the Board that this exchange of views had ever taken place. They learnt about it only when Le Roux told them.[6]

Meanwhile, Le Roux had himself committed an outrageous breach of normal employment practices, even by the standards of the 1950s. Mr Hockaday-Dawson, the Tate accountant, had had the temerity to tell Le Roux that the Tate could not reimburse some of his travelling expenses, which he felt clearly fell outside Tate guidelines.[7] Le Roux did not like to be challenged, especially by somebody whom he regarded as a subordinate. He had accordingly, on 30 June 1952, written to Mr Dawson a letter terrifying in its implications for a responsible employee: if Dawson was not prepared to work harmoniously with Le Roux, he should immediately resign. 'If not, I shall want a written undertaking that in future you will carry out my instructions, whether vocal or otherwise, without question'.[8] This was a formidable challenge to a man who was simply trying to do his job.

Through the summer Dawson had been fretting about the predicament he found himself in and in early September, with Le Roux safely away on holiday, he briefed John that Le Roux was making his life 'unbearable'. This conversation took place on the eve of a Board meeting and John, displaying his usual inability to deal effectively with staff problems, instead of agreeing quietly to take up the issue with Le Roux upon his return, briefed the Chairman that Dawson needed to talk to him about the expenses of the Publications Department.[9] John then absented himself from the ensuing discussion, thus enabling him to disclaim any responsibility for its outcome.[10] The Chairman listened to Dawson, discussed the matter at the Board and wrote to John after the meeting (telling him to copy the letter to Le Roux) setting out clear new guidelines as to what travelling expenses could and could not be reimbursed.[11] All this was done without hearing Le Roux's side of the story. When Le Roux came back from holiday, John himself was away and unable to explain to Le Roux how this unsatisfactory state of affairs had arisen. Le Roux was incensed, blaming John for challenging him behind his back, even though it appeared that it was Dawson and the Chairman who had done so. Le Roux wrote an angry letter to Philip Hendy on 30 September, saying that 'John's charges against me were baseless and irregular'. He had discussed matters with the Chairman who 'has told me to be completely outspoken at the next Board Meeting, which is on Wednesday 8 October, particularly about the way in which these charges were made quite needlessly in my absence. He agrees that I should clear away whatever discredit I consider to be under and will give me a chance to do so'.[12]

Such a small thing was the trigger for the horrors which followed. By the time John got back from his travels, the next Board meeting was imminent. He just had time, on the evening of 7 October, the night before the Board meeting, to have what his diary described as a chat with Le Roux 'about a variety of matters which have worried me', that is, he lectured Le Roux on many small grumbles.[13] It was another example of John's insensitivity in personnel matters and Jowitt later referred to it as 'unwise and tactless'.[14]

John dated the commencement of the Tate Affair to the Board meeting on 8 October 1952. His autobiography spends many pages analysing it from his point of view; various other accounts can be used to test what John wrote.[15] Events at the Tate had been drifting towards a crash for a long time: 8 October was when they burst to the surface. The meeting was attended by Lord Jowitt, William Coldstream, Lord Harlech, Philip Hendy, John Piper and Graham Sutherland, and with John, Reid and Le Roux in attendance and Colin Anderson, Edward Bawden, Dennis Proctor and Sir Osbert Sitwell absent. It is even known how those present placed themselves round the boardroom table because Coldstream drew a neat little plan in his journal.[16] Coldstream, who was also a Trustee of the National Gallery, described the meeting as 'very unpleasant'. He recorded that Le Roux asked to be allowed to make a statement in his defence against the charges made against him in his absence at the last Board meeting on 4 September. Bearing in mind Le Roux's

William Allen Jowitt, 1st Earl Jowitt. Photograph
by Bassano Ltd, c.1950.

note to Hendy of 30 September, at least the Chairman and Hendy knew this outburst was coming and other Trustees may also have been alerted.

Le Roux accused John of having used the incident between himself and Dawson as an excuse to try to get rid of him. The August exchange in which John had suggested he might find a new job was drawn to the Board's attention and acquired new significance in the light of John's handling of the Dawson episode. Le Roux focused on the fact that he had not been allowed to put forward his own view of events before being found guilty. He described John, according to Coldstream's note, as 'tyrannical and underhand in his dealings with staff'.

John's diary account was laconic: 'Bd, at wh. a most shocking event. LeR., evidently thinking I had brought expenses matters to Bd. in his absence & terribly angry & overwrought, read a long statement in a loud voice accusing me of every sort of crude and vulgar inhumanity to him for years & so forth, and created a shocking scene. Said almost nothing'.[17] (Coldstream noted that John had said in response to Le Roux's outburst that he felt Le Roux 'was in an abnormal and emotional condition'.) John's diary went on to say that 'Afterwards felt as though I'd seen a street accident been covered with filth & felt ill, shaky and despondent'. It was nearly three weeks before the matter merited another diary entry, during which he carried on recording his usual blizzard of social arrangements. However shocking he had found the experience, his immediate reaction, insofar as his diary reflected it, was that it held no longer-term significance; he may even have been pleased that the Board had seen Le Roux in his true colours.

One statement which Le Roux had made, which resonated loudly with the Trustees, was: 'People have long since ceased to believe that a procession of men

Sir Colin Skelton Anderson. Photograph by
Walter Stoneman.

come here with excellent reputations and then mysteriously turn into monsters of
inefficiency, or disloyalty, or whatever they are supposed to be, and then in spite of
the slurs cast upon them are able to continue their careers elsewhere with distinc-
tion'.[18] This was a thinly veiled reference to Humphrey Brooke, perhaps even to
David Fincham and to Paul Hulton.

Coldstream relates that, immediately after Le Roux's carefully scripted out-
burst, Sutherland suggested that Le Roux and John leave the room to enable the
Trustees to consider their response. Sutherland, Piper, Harlech and Coldstream
all then said they thought John 'probably behaved badly with his staff'. They all
agreed that the Chairman should look into the matter and report back to the next
Board meeting on 20 November – with John and Le Roux to continue working in
the meantime as if nothing had happened.

If the only issue which the Chairman was investigating had been the narrow
question of whether John had done wrong by raising Dawson's concerns with
the Chairman before the 4 September Board meeting, it would have been a short
inquiry from which John would have had little to fear. This may explain the silence
in John's diary after 8 October. He knew that Jowitt was happy with how he had
dealt with the expenses and accepted that Le Roux was wrong to blame John about
it. But events began to take a violent swing away from John between the October
and November Board meetings.

John had been persuaded by the agents of the actress Zsa Zsa Gabor to let
her visit the Tate in connection with a film she was making called *Moulin Rouge*.
Directed by John Huston, this was to be about the life of the French artist Henri
de Toulouse-Lautrec, and the actress allegedly wanted to visit the Tate to see

examples of his work.[19] In reality, the visit, which took place on 8 September 1952, can only have been a publicity stunt, as a normally cynical person would have spotted. A great time was had by all, many photographs being taken. John liked his photograph to appear in the press: it was noted how, at the Venice Biennale in 1948, when Henry Moore won a prize, 'Henry spent his time trying to avoid being photographed, while John Rothenstein spent his time trying not to avoid being photographed'.[20] John was also not averse to the charms of attractive women and enjoyed showing the actress round the Gallery, posing with her signing one of his books and looking together at works of art. When his back was turned, Gabor was photographed having cheekily raised one leg a long way from the floor to place it on a plinth supporting a sculpture by the contemporary Northern Irish artist, F. E. McWilliam.[21] In doing so she was emulating a dancing pose she adopted in the film. That and other photographs of her having a drink with John in his flat at the Tate then graced an article on the visit which appeared in *Illustrated* on 25 October. The text was not highbrow, its tenor not in keeping with the expected seriousness of a national art gallery and its Director.

In the event, all hell broke loose after the article appeared. Douglas Cooper attacked John in the *Times Literary Supplement* of 30 October, Viscountess Davidson, MP, put down a question in the House of Commons about 'why the Director of the Tate Gallery authorised the publication of the unsuitable article' and the MP Maurice Edelman prolonged John's discomfort by asking the Chancellor to explain the 'rules for determining the use of the Tate Gallery for publicity purposes'.[22] Lord Jowitt heard that the Court was upset about the article. Even John's friend Philip James was recorded by John as being 'very sour about Gabor article'.[23] For this to happen when the Chairman was preparing his report to the Board was unfortunate for the Director.

John's faulty judgement over this issue was soon compounded by another lapse. Sometime earlier he had written the script of a film which was intended to be made partly at the Tate.[24] It involved an American detective trying to solve the theft from the Tate of a priceless picture by Leonardo da Vinci, and was taken up by a production company.[25] The Board had been informed at the time but it seems had not focused on its implications for adverse publicity, and John may not have given the project much emphasis. His recollection was that they had also been informed that he was to be personally rewarded, to the tune of about £200, for the use of his script, although no Trustee remembered that.[26] With exquisite bad luck for John, filming was due to begin at the Tate in early November 1952. When this became clear to the Chairman,[27] who had just endured the adverse Gabor publicity and the supposed irritation at Court, he panicked, especially when it dawned on him that galleries might have to be closed to the public for filming to take place. He could easily visualise the bad publicity for the Gallery if that happened.[28] The Tate sought to back out of its contract with the film company, who promptly threatened to sue. By good fortune, John and Reid were able to allocate to the film company galleries

currently closed to the public and filming proceeded without disturbing the Gallery's normal operation. The Chairman was nevertheless incandescent.[29]

These trivial matters of publicity, though irksome, were superseded by a third matter: Le Roux was briefing the Chairman on the need to re-open the question of whether the Director had misled the Board as to the price it had agreed to pay the Marlborough Gallery for the Degas bronze of *The Little Dancer* (1880–81, Tate, 6076). In the guise of setting out a detailed account of the transaction, Le Roux was subtly suggesting that the Director had agreed to assist the Marlborough Gallery by getting the Tate to pay a price above market and that he had pocketed a handsome commission on the transaction as a result. John now understood the significance of a postcard he had recently received from Cooper, purporting to comment on John entertaining Gabor in his flat below the Tate: Cooper anticipated that John would soon be leaving his 'cellar' for a 'cell'.[30] Jowitt's report was now going to have to cover these serious allegations too, against the Director rather than Le Roux, with whom Jowitt had been having a number of conversations.[31]

At this stage, Jowitt had become relentlessly hostile towards Rothenstein, who was given little opportunity to provide his point of view on the issues under investigation. Consequently, the Chairman's report when presented to the Board on 20 November was highly antagonistic to John's position.[32]

What saved John from being summarily dismissed were two things. After the October Board meeting, the Treasury, partly at John's instigation, had begun to look into matters at the Tate in parallel with Lord Jowitt. John knew that the senior officials at the Treasury had considerable intellectual stature and independence: the way they approached gathering and evaluating evidence made the Trustees look like amateurs.[33] They also had a propensity, which suited John, to give more weight to a person they regarded as a senior Civil Servant than to his deputy. With their Civil Service mentality, they particularly distrusted the views of a disruptive subordinate. Jowitt had his own reasons to welcome Treasury involvement: there was legal ambivalence about who had responsibility for the Tate – the Trustees or the Treasury – and his position would be protected by getting the Treasury's views. If either of the high-profile defendants had to be sacked, Jowitt would probably also have preferred that to come from a Treasury report rather than his.

The other factor which helped John was the active support of Philip Hendy.[34] Having experienced difficulties with the National Gallery trustees, he pointed out to John that all trustees disliked the person who was their director, whoever he was, as there was an irreconcilable struggle between their view that they ran and were responsible for the institution and the reality that in fact the director took most of the decisions and represented the institution's public face.[35]

At the Board meeting on 20 November, Coldstream recorded, those present were Jowitt, Hendy, Moore, Sutherland, Piper, Bawden, Sitwell and himself. Anderson, Proctor and Harlech were absent and John, Reid and Le Roux were in attendance. They had three items before them: the Chairman's Report, a note from

John and a note from Le Roux. The latter spoke first and urged the Trustees to sack either him or John there and then. Le Roux was keen that the Trustees (over whom he had great influence) took the decision and not the Treasury (over whom he had no influence). After John and Le Roux had left the room, the Chairman reported that he had received a message from (Le Roux's friend) Harlech to say that he was 'disgusted' with Rothenstein and wished to have no more to do with him. The Chairman went on to say that he had interviewed the staff 'and his opinion of Rothenstein had sunk. He had no doubt that Rothenstein had behaved very badly on many occasions to his staff' and was in the habit of turning on them unexpectedly. The only member of the staff who had anything good to say about John was Reid. Hendy stemmed the tide against John by demanding that the matter be dealt with by the Treasury and, with the Chairman's support, the Trustees agreed.

The Treasury were well on the way in their assessment, and their reports and internal notes give an account which seems the most objective and reliable of all concerned. In the first place, the Treasury had little regard for the judgement of Jowitt. They saw him as being merely a barrister, not a judge, and easily swayed by the advocacy of whoever briefed him first, in this case Le Roux. They also saw that Jowitt had a tendency to panic. An internal note of 12 November remarks that, a few weeks before filming was due to begin at the Tate, 'Lord Jowitt took fright (being unable, among other things, to remember in the least what he had agreed to and what he hadn't).' However, they also had a low opinion of the Director's judgement. They thought that it had been foolish of him to entertain Gabor in the Gallery, to allow the film to be made at the Tate and to have found it acceptable to benefit financially from writing the script. One of the many perceptive people involved at the Treasury with Gallery matters was Edward Playfair (1909–1999).[36] John liked dealing with him.[37] Playfair's internal comment on the film was that 'this is a much more respectable story than that of Miss Gabor, though, like it, it rests in my view on a piece of bad judgement'.[38]

Some aspects of the saga were treated as a great joke within the Treasury. Focusing on the Dawson part, John had hoped that the outcome would be the sacking of Le Roux. He had therefore asked the Treasury about the process for sacking someone on probation, Le Roux's position: the Civil Servants patiently explained the internal rules, contained in a document called the ESTA code. One internal note read: 'At the risk of another rebuff we return this further piece of grandmotherly advice … Do you think Sir John Rothenstein and/or Zsa Zsa Gabor would like an autographed copy of the ESTA code?'

It took the Treasury no time to work out the rights and wrongs of the situation. Lord Jowitt sent them the papers after the Board meeting on Thursday 20 November and by Monday morning (the 24th) they noted internally that there was nothing to justify any formal investigation into Rothenstein. Le Roux, though, had shown 'gross disloyalty at all times' and there was no point in any enquiry into his behaviour as he should obviously be fired immediately.

Sir Edward Wilder Playfair. Photograph by
Elliott & Fry, 1956.

The Treasury files do not make clear what happened next but it can be sur-
mised that, when they reported their initial conclusions to Jowitt, he told them
that this would not satisfy the Trustees, who would accept a resolution only after
an official investigation. By early December a senior Civil Servant from the Inland
Revenue, Sir Edward Ritson (1892–1981), had been appointed to look into matters
on a formal basis. It took him no time to work it all out either; it was obvious to any
neutral person that Le Roux was the fundamental problem, not the accident-prone
Rothenstein.

Ritson started off with a short note to the Trustees explaining what he was going
to investigate. In sending a draft to Playfair for comment, the usual mandarin jokes
at the expense of the silly art world were evident: 'I hope the artists will appreciate
my contempt of detail and my admiration of Significant Form'. Ritson noted that
the one potentially serious task would be to ascertain whether the Director had
been 'guilty of any conspiracy with the Marlborough Galleries for his own benefit'
over the Degas bronze. That would not be a laughing matter.

As Ritson quickly worked his way through the evidence, trying for a resolution
before Christmas, notes on the Treasury files show what they were thinking:

> I find Mr Le Roux completely devoid of any sense of his proper place in a
> Government Department's hierarchy. In the first place, his conduct in the
> matter of expenses and his treatment of his Accountant were indefensible
> and even outrageous. … Secondly, his accusations against the Director as to
> the latter's share in bringing the expenses matter to the notice of the trustees

were unfounded, extravagant and irrational. Finally, and most importantly, he has during the last two months been conducting a campaign against the Director's probity and judgement behind the Director's back. ... To sum up, he has shown himself completely unaware of the sort of conduct required from a subordinate Civil Servant.

The Treasury were, in contrast, aware of John's failings. Whilst there was no evidence of impropriety on the Director's part regarding the Degas, beyond the usual administrative muddle which tended to surround him when he got involved in commercial activities, he somehow had to address the widespread feeling of insecurity which Ritson had picked up from speaking to the staff. 'I hazard the opinion that he is maladroit in personal relations, especially in disputes.'

Left to himself, Ritson's Report would have exonerated John from all serious criticism (whilst criticising his judgement) and would have recommended firing Le Roux. But Ritson had not heard the views of the Trustees and, when he did on 12 December, it checked the direction in which he was travelling. He saw Jowitt, Harlech, Anderson, Moore, Coldstream, Piper and Bawden and, while he was unimpressed with their ability to say anything logical or objective, all seemed to be determined to find fault with John rather than Le Roux. Coldstream came across as the most 'coherent' of them. To him, John 'was a disaster as the head of his staff and he wished they could get rid of him'. To the Chairman, John was 'unreliable, disloyal, dishonest and a bully and staff relations would never be happy so long as he stayed there'. To Moore, John was 'a thoroughly bad manager of his staff'. According to Playfair's long note of the meeting, 'all the Trustees without exception disliked and distrusted John Rothenstein.[39] Most of them regarded him as dishonest in his dealings with them and with his staff. Pressed a little, some or all of them admitted that this did not necessarily mean that he was deliberately and consciously dishonest: but he had a twisted and tortuous nature and tended to make the facts fit his thesis, probably persuading himself en route. He was jealous and secretive.'

The Trustees nevertheless accepted that the Tate had improved during his Directorship and that he was financially honest. None of them thought that he had made money himself out of the Degas transaction. Still, they all preferred Le Roux and discounted the fact that Reid had spoken up in John's favour since they considered that he always supported the Director, regarding him as 'excellent but an unhappy and weak man'. Playfair noted that the Trustees irrationally and unfairly applied standards which were lenient to Le Roux and harsh to Rothenstein.

Before finalising his Report, Ritson and Thomas Padmore (1909–1996)[40] interviewed Le Roux repeatedly and at great length on 15, 16, 17 and 18 December, to ensure that he could not complain that his points had not been fully considered or any decision had been taken behind his back. It can be assumed that Le Roux was not at his best when faced with dry senior Civil Servants, who had no part in the

art world and who were impervious to his charm: his tricks of persuasion were to no avail with them. However many times they went over the issues, they found it impossible to pin him down to any logical position. Padmore wrote to Playfair on 8 May 1953:

> Le Roux is a shifty, unstable, untrustworthy character of a degree of intellectual dishonesty which I do not remember having seen parallelled. The whole content of our conversations, taken together, led me to feel that everything that has been alleged against him from any quarter in the course of all this business is probably justified. And I would not tolerate him for five minutes in any organisation in which I had the responsibility for the appointment of staff. … I do not consider that anyone of that character is fit to hold Le Roux's present appointment.

Ritson's Report went to the Chairman in draft in December. Jowitt claimed that when he showed it to the Trustees, he had to work hard to persuade them, who all favoured Le Roux over John, not to resign en masse.[41] By way of brokering a compromise which would keep both Rothenstein and Le Roux in position, he forced them to shake hands in front of him and savaged John at a meeting on 22 December ('Lord Jowitt took the occasion to address me in a manner more hostile than any which even he has previously adopted towards me'). John was told that he would be receiving a letter 'of severe censure'.[42] After yet more haggling with the Trustees, the Ritson Report was formally released to the Trustees on 30 December. It noted:

> As a result of long conversations with Mr Le Roux I fear that he is a difficult man for any Director to cope with. Whereas I have found the Director agreeable to all the suggestions made to him, Mr Le Roux has been a most difficult man to bring to any agreement. He seems to ask for himself a freedom and independence inconsistent with his place in the organisation of the Tate.

In order to avoid sackings or resignations, the following were to be regarded as the basis of a settlement:

1. The Director was to be told that no Trustee thought him involved in dishonest financial dealings.
2. The Director was also to be told that he did not have the Trustees' confidence and was to be put on probation for a year.
3. Le Roux's probation was to be extended for a further year.
4. Treasury officials were to be made available to the Director to advise him on staff matters.
5. The Trustees were to give the Director their wholehearted support going forwards.
6. The Chairman was to take a greater interest in the day-to-day administration of the Gallery.[43]

Ritson and the Treasury knew the 'settlement' was unlikely to resolve the situation because of Le Roux's character, but it was the best they could do given Le Roux's duping of the Trustees. Soon enough John was reporting to his friends at the Treasury that Le Roux was still misbehaving, but now the Chairman at least was on John's side, it having finally dawned on him, after reading and discussing the Ritson Report with Treasury officials, that Le Roux was highly dangerous.[44] Rothenstein had many failings but he was the man to support in this situation.

In between all the drama, normal functions were continuing at the Gallery. Exhibitions promoted by the Arts Council closed 1951 (the work of Edvard Munch) and took place in 1952 (*Twentieth-Century Masterpieces*, Degas and Epstein, among others). Of British art, the Tate bought important works by Lucian Freud: a portrait of Francis Bacon (1952, Tate, 6040) and *Girl with a White Dog* (1950–51, Tate, 6039). The Chantrey Bequest brought in works by Rodrigo Moynihan and Matthew Smith. The death of the former Trustee Sir Edward Marsh, who owned a large number of twentieth-century British pictures, led to a few bequests coming to the Tate in 1953 (works by Duncan Grant, Stanley Spencer and Matthew Smith). Chagall gave the Gallery a couple of sketches but nothing of note was acquired on the foreign side.[45] Major exhibitions were mounted in 1953: in March the ICA promoted the notorious *International Sculpture Competition: The Unknown Political Prisoner*, which was won by Reg Butler. Graham Sutherland got his own show in May, sponsored by the Arts Council, and in September a full retrospective of

Selecting paintings for the John Moores Exhibition with Eric Newton, Lawrence Gowing, John Rothenstein and Hugh Scrutton, director of the Walker Gallery. Mid 1950s.

Matthew Smith opened. The last was promoted by the Tate and John was heavily involved, getting Francis Bacon to write a prefatory note to the catalogue, with Smith persuading the author Henry Green to write a foreword. John wrote the introduction. Renoir was the last main show of the year and again John found time to write the introductory text for the catalogue. Of the new Trustees who joined in 1953, John approved of two: the Hon. John Fremantle (1900–1994) and Lionel Robbins (1898–1984).[46] Lawrence Gowing (1918–1991)[47] replaced John Piper as an artist Trustee.

The year 1953 also saw the first stirrings of plans with which John was closely connected to hold a groundbreaking show of modern American art.[48] Before any decision could be finalised, there were the inevitable discussions about funding such an expensive show, with most of the work having to be shipped over from America. John promoted the idea internally and was eventually able to propose the show to the Board. This major exhibition – *Modern Art in the United States* – would eventually open in 1956.

Outside the Tate, John was appointed to the Art and Architecture Committee of Westminster Cathedral in 1953. He served on this until 1965 and was particularly involved in matters to do with the fabric of the Cathedral, such as the restoration of the column in front of the Blessed Sacrament Chapel and the removal of a mosaic of St Thérèse of Lisieux and its replacement by a bronze by Manzù.[49] Even in this capacity he tried to get his friend Henry Moore commissioned to design mosaics for the Baptistry, but he was thwarted by Thomas Bodkin.

After all the drama of 1952, there is a Phoney War feeling to much of 1953. John kept hearing that Le Roux was causing trouble, which he relayed to Playfair.[50] Reid was particularly annoyed because Le Roux put it about that he had lied to save Rothenstein's skin.[51] Playfair, who had a clear view of Le Roux's character, knew more trouble would come from him. The Treasury knew that the settlement was unstable and nothing would be resolved until Le Roux had gone. Under Jowitt's support for his Director, the Board creaked back into line and, albeit grudgingly, let John get on with his work. Jowitt told him after a Board meeting on 15 January 1953 that the Trustees were 'still unfriendly but beginning to swing'.[52] The one who was not swinging was Sutherland. The other person who was unreconciled in the background was Douglas Cooper. John received a typical letter from him in June, promising that Cooper would 'never weaken' in his attacks on John. 'There are still more than ten years in which to hound you out of Millbank – and it shall be done.'[53] This shamelessly venomous letter ended up helping John when the Trustees read it, as people began to see the level of vituperation which John had been up against.

In May 1953 Jowitt stood down as Chairman and was replaced by Dennis Proctor, who had been Deputy Secretary at the Department of Transport, having earlier been at the Treasury and involved in overseeing the national galleries and museums. Initially John thought he quite liked Proctor (at least in contrast to Jowitt)

but admitted to his diary that he did not quickly feel that he knew him.[54] This is hardly surprising as Proctor was indeed an enigma. As an undergraduate at King's College, Cambridge, in the 1920s he had been a member of the Cambridge club, the Apostles, and had become a close friend of Guy Burgess (who became secretary of the Apostles in June 1933) and Anthony Blunt.[55] Proctor joined the Treasury after Cambridge, and Burgess during his spying career had got good information from him which he had passed to the Russians.[56] Proctor was later able to satisfy MI5 that he had not appreciated why Burgess wanted the information.[57] By the time he was appointed to the Tate Board in May 1952, a year after the disappearance of Burgess and Maclean, Proctor had left the Civil Service and was working for the Danish company Maersk. This involved him in much foreign travel, which meant that, before becoming Chairman, he often missed Board meetings (he later re-joined the Civil Service in the Department of Transport). His role in the Tate Affair is not always transparent. With friendship with Blunt came friendship with Cooper which needs to be borne in mind when considering how he handled John, who was right to be wary of him.[58]

Some of John's time during 1953 was taken up with developing the National Art Collections Bill, promoted by the Treasury to implement aspects of the Massey Report of 1946 (as noted in Chapter 8).[59] It proposed legally to sever the connection between the Tate and the National Gallery, which would mean compromises as to who owned which pictures and who had the right, in what circumstances, to call for pictures to be transferred between the collections. There had to be many detailed discussions on this subject between John and his saviour, Philip Hendy.[60] The proposal which turned out to be the most incendiary was to give the Trustees of the National Gallery and the Tate the power to sell pictures which they did not require for their collections, subject to Treasury consent. This clause caught the attention of many interested parties, who began to focus on whether the Tate Trustees, in particular, could be trusted to exercise such a power.

Introduced in the Queen's Speech on 3 November 1953, the Bill was given its first hearing in the House of Lords by Lord Selkirk on the following day. Although the text of the Bill was short and seems uncontroversial, controversies were generated and a number of acrimonious debates, which John occasionally attended, developed in both Houses throughout the latter part of 1953 and the whole of 1954.[61]

Outside the Gallery, John's life reads like a newspaper's social diary. The King of Sweden paid him a visit at the Gallery and he had lunches with three duchesses. The funeral of George VI and the coronation of the new Queen came and went. John heard that Brooke was telling people that he was to be dismissed after the Coronation, but this was no more than Le Roux or Douglas Cooper amusing themselves.[62] Brooke was friendly with Cooper.

John had some fun with Francis Bacon. Getting him to write the promised note for the Matthew Smith catalogue was always going to be difficult. John, bravely, took him to dinner at the Athenaeum in June, claiming that he enjoyed

the experience 'immensely'. John loved the fact that Bacon liked to say what John regarded as shocking things, for instance about other artists. For Bacon, dining with Rothenstein must have been equivalent to dining with a teetotal maiden aunt compared to the company he usually kept in Soho and it must have been easy to indulge his fondness for shocking people when talking to the Director in his club. John noted in his diary that Bacon said: 'Henry Moore can't even imagine another contemporary artist being any good'. He also noted that Bacon was happy for him to make up the title of the seminal work in the Tate now known as *Three Studies for Figures at the Base of a Crucifixion* (*c.*1944, Tate, 6171). The title he jotted down was '3 studies for figs at foot of Cross'.[63] Having agreed to write the piece for the Smith catalogue, Bacon then decided that he was too busy and John accepted that all he would produce was some sort of note.[64]

The eruption of the hostilities which John and the Treasury had been antici-pating happened on 27 November 1953. John was in Oxford that day and there-fore not in his office to take a telephone call from an obscure Scottish peer called Lord Kinnaird (1880–1972).[65] He was calling about the Knapping Bequest, which belonged to the National Gallery, but which the Tate had used for many years when buying pictures and which the Bill proposed to transfer from the National Gallery to the Tate. When Kinnaird could not get hold of the Director, he was put through to Le Roux, who was only too happy to help him with his enquiry.

CHAPTER 11
Tate War: Second Phase, 1953–54

It has never been established whether Lord Kinnaird was acting in cahoots with Le Roux on 27 November 1953 or if it was an unhappy coincidence that started the second phase of the Tate Affair.[1] Kinnaird was not active in the art world and his involvement may have been an accident. Initially he sought to protect the interests of the Scottish national art galleries in the Bill which was before Parliament. He had seen that the Knapping Bequest had been made available by the National Gallery to the Tate and that it provided for art to be bought for the national collections of Scotland as well as for those of England and Wales, and he was curious to see whether this had been honoured. Kinnaird also thought that the administration of the fund was more likely to meet the testator's wishes if it reverted to the Trustees of the National Gallery. Little did he know what a can of worms he was opening.

Le Roux received the enquiry about what pictures had been bought with Knapping funds and, during the same working day, seems to have worked with phenomenal speed and efficiency to tabulate the information, check with the Treasury on the telephone that he was authorised to release it and sent it out to Lord Kinnaird. The hare was running. The speed with which Le Roux accomplished all this suggests that he had all the information available in advance of Kinnaird's call. He may have been alerted to Kinnaird's interest by the fact that, only a few days' earlier, on 24 November, the first substantive discussion of the Bill had taken place in the House of Lords at the Second Reading, in which Kinnaird had suggested that the administration of the Bequest be left to the Trustees of the National Gallery.

What Le Roux sent Lord Kinnaird was dynamite, in terms of its likely effect on the reputation of those administering the Gallery, particularly the Director. The list of Knapping acquisitions by the Tate over the years, going back to Manson's time but particularly under Rothenstein, showed many breaches of the terms of the Bequest, which required works of art to be by artists 'living at or within twenty-five years before the time of purchase'.[2]

Initially, under the calmer guidance of Proctor than Jowitt's, the Board did not panic. They seem to have taken the view that such things happen.[3] With the Tate's small permanent staff a few administrative errors were always going to happen, particularly in the art world of the 1950s. Their insouciance soon evaporated. John was also fairly relaxed about the issue at this point. He noted in his diary that Lord Kinnaird was making a nuisance of himself but he had not caught on to the fact that Le Roux was involved.[4] During the early days of December he bustled about in

Gallery records trying to find out the facts.[5] He wanted, naturally enough, to prove that it was not his fault, and seemed to recall briefing the Knapping Fund trustees about the Tate's purchasing policy as long ago as 1942. Unfortunately, those trustees had no recollection of this.[6]

By the time the House of Lords held another debate on the Bill, on 8 December 1953, Kinnaird had been discussing matters with Le Roux and was well briefed. He opened proceedings with a detailed account of the Knapping Funds and how they had been spent: the Tate had bought 191 pictures, of which 'a few dozen or so' did not comply with the Bequest. Kinnaird was followed by an even less likely peer to be found commenting on this particular Bill. Lord Amulree (1900–1983), was a doctor and expert on geriatric health.[7] Despite having no history of speaking in the Lords on cultural topics, he stood up after Kinnaird with a copy of the Knapping will in his hand and vigorously supported Kinnaird's points.[8] This brief intervention makes one thing clear: Douglas Cooper was behind this. He and Lord Amulree had lived together as a couple in London. That Amulree had a copy of the will also suggests that he had been briefed by Le Roux, who would circulate papers which put the Director in a poor light to anyone he thought suitable. Le Roux's direct links with Cooper and those close to him are not clear,[9] but it would not have required much detective work by Le Roux to see that any friend of Cooper's was unlikely to be a friend of Rothenstein's.

John still did not see what was coming: he was in the House of Lords for the debate on 8 December but recorded nothing significant about Kinnaird's speech.

Basil William Sholto Mackenzie, 2nd Baron Amulree.

Towards Christmas, he starts noting, without specifying details, that Le Roux was causing trouble in the Gallery.[10] Le Roux, who was no slouch in developing trouble for the Director, was by this time investigating whether other purchasing funds had been properly deployed, in particular the Courtauld Fund. He had realised that, if no one at the Gallery had been monitoring the conditions attached to one bequest, probably no one would have checked other funds. Whatever he was discovering was promptly told to the growing circle of John's enemies around Cooper, whose appetite for making public trouble for the Director was considerable, and whose ability to achieve it was greater than Le Roux's.[11]

On 21 December 1953, Le Roux rang the Director to ask him if he had seen Cooper's letter in that day's *Times*. This focused on the whereabouts of a picture by Renoir which the Tate used to own.[12] In fact there was nothing untoward about the Renoir and Proctor's letter answering Cooper's points was published in *The Times* the next day.[13] This did not stop the issue gathering momentum. The fact that the Trustees had sold the Renoir was notable in the light of the power of sale which the Bill proposed to give the Trustees. One of those genuinely alarmed by this proposal was Benedict Nicolson, not a stooge for Cooper but not well-disposed to the Tate or Rothenstein; he too wrote to *The Times* and the Chairman had to answer again, on 24 and 28 December 1953.

At this point the interconnectedness of people who were determined to cause trouble for the Gallery becomes clearer. Humphrey Brooke was a keen participant behind the scenes, still smarting from his treatment by the Tate over his legitimate concerns about Honor Frost and the Publications Department. He promptly wrote on 21 December 1953 to Cooper, who was keeping out of the way in France, obsequiously congratulating him on his letter in *The Times*. The wording Brooke used shows the slightly childish way this group egged each other on as they planned their little interventions in the public debate. Using his knowledge of the Gallery and particularly of the terms of the trust funds, Brooke supplied Cooper with questions to ask in any follow-up letters, particularly about the proper use of the Courtauld Fund.[14]

Thrilled to be a part, however insignificant, of this disparate alliance of protesters, Brooke wrote to Cooper again on the next day. In his letters (almost always using official Royal Academy notepaper), he regarded himself as his master Cooper's London eyes and ears, reporting that, following Proctor's letter in *The Times*, he had been to the Tate to check labels and correlate them to its catalogues. He had satisfied himself that Proctor's letter was misleading; Brooke seemed to imagine that he was helping to uncover the biggest scandal ever to affect the London art world.[15] In a long letter dated 6 January 1954, in the same vein, he mentions that he was in touch with the wealthy art historian Denis Mahon. It was clearly all a great game for him: he wondered whether they would not miss a great deal of fun if John were, in fact, replaced.

Mahon had had lunch with Le Roux and Rothenstein in 1950,[16] and his initial concern had been about the proposed power of sale. He published critical

letters in *The Spectator* on 1, 8 and 15 January 1954, followed by Cooper on 22 January. For a short time Mahon played quite a prominent role in the events which followed. He could, through his long career in the art world, pick fights for sometimes obscure academic reasons (for example, with Anthony Blunt in the 1960s). He was certainly independent enough to resist taking orders from Cooper. Cooper's files contain a group of seven letters and notes from Mahon, dating from 22 January to 7 February, written in highly excitable terms. His first congratulates Cooper on his 'masterly Spectator letter'. He records 'a number of peers who are taking an active interest in the matter' and another 'very strongly worded letter' from Ben Nicolson to *The Times*, which he fears they will not publish because 'no one appears to have the guts of a louse'. He has been to Somerset House to read the relevant wills himself; he has sent a four-page letter to the *Spectator* which, apart from a bit of the first page, 'they found too hot to publish'; he has discovered that Churchill himself was one of the 'seemingly countless dupes of our egregious charmer'. He describes the role of a Tate Trustee as akin to that of a 'cess-pool officer'. He requires vigorous action done 'with a thunder-clap'. He confirms that 'We are doing everything we can to keep things going here, and we have a good deal of high explosive up our sleeves'.[17] This was what John and the Trustees were up against.

Between Christmas and the New Year John and Reid tried to find out from Gallery records which works of art had been acquired using the wrong trust moneys. To do this task in a hurry, over the holiday period, grappling with the manual (and haphazard) filing systems which had to be consulted both at the Tate and at the National Gallery, forced errors.[18] By the beginning of 1954, the Board was keen to know exactly what it had done wrong, partly so that it could ratify errors, partly so that it could brief the Lords, who were trying to pilot the Bill through its Parliamentary stages and who needed accurate information to answer the queries they were getting. On 5 January 1954 the Board, armed with information from the Gallery on the trust funds, met to consider the issue without any staff present, and Proctor was not amused to receive during the meeting new information from Rothenstein and Reid which contradicted the information they had recently supplied to the Board. In the minutes the Board instructed the Director that they should be provided with details of the terms and conditions of the Trust funds, together with a statement certified by the accountants and countersigned by John, giving full details of all the purchases which had been made from those funds.[19] Proctor later commented that the Board was particularly angry that John made no effort to suggest any practical step by which the Board might address the problems that were coming to the surface: all the suggestions came from members of the Board.[20]

Another special Board meeting without staff on 22 January led to a statement by the Trustees being published on 26 January, listing the mistakes of which the Board was then aware. The minutes of this meeting were ominous from the

Director's point of view. He was to be asked for his comments on a draft note of the infringements and then warned that the Trustees took a grave view of the matter and would have to consider the question of taking action after receiving his comments. By this date it had become painfully apparent to the Trustees that there was nothing in the Gallery's files or in the minutes of those Board meetings which had approved the infringing purchases to show that anyone had ever checked what the funds could legally be used for.[21] Muddles over the Knapping funds were found to extend to all funds. John was mortified. He could see that the Board's attitude to the issue was not caused by the fuss in the press but by the substance of the matter they were investigating. In a note to the Board dated 30 January, he said 'may I express to the Board my most deeply felt dismay and regrets about all that has come to pass'. He concluded with 'I do wish to express to the Trustees my profound contrition and my sincere and earnest sorrow for the errors that have occurred under my administration'.[22] By this time Proctor had established that the Treasury had also lost faith in John's Directorship: he had been to see them privately in late January, to be told that they thought that John would have to go.[23] This time, it was the Board who saved John, not the Treasury.

Graham Sutherland had been missing the recent meetings of the Board. Since the beginning of 1954 he had been on holiday in France and visiting Douglas Cooper in his chateau. It can be assumed that he wanted nothing to do with helping to sort out the trust fund infringements: he had a different plan in mind. From France, Sutherland wrote to Proctor on 26 January resigning as a Trustee. He did this without prior discussion with anyone on the Board, because he feared that they would seek to change his mind as had happened previously when he had tried to resign to Jowitt. At the same time as he informed Proctor, he wrote to tell two of his principal patrons, Clark and Anderson, what he had done.[24]

Sutherland had, however, no intention of resigning quietly. He had discussed his resignation with Cooper and Mahon, who had both encouraged him and was gullible in allowing himself to be persuaded to resign in order to further their ambitions, not thinking through how his actions would be perceived by the Board who were battling to resolve the very problems he was concerned about.[25] Whether or not it was also Cooper and Mahon's advice that he should brief the papers before anyone at the Gallery could reply to his letter, the story of his resignation burst out in Lord Beaverbrook's *Evening Standard* on Friday 29 January and in the Sunday papers two days later. A letter from Denys Sutton (1917–1991)[26] in the *Daily Telegraph* on 29 January had called for a 'searching inquiry' into the Tate's administration and the call was repeated in Beaverbrook's *Sunday Express* following the resignation.[27] John may have reflected ruefully on the way Sutherland had used the press when compared to the way John himself had dealt with his own resignation from Leeds City Art Gallery; there were remarkable similarities.

Another feature of the Tate Affair which later became apparent was the involvement in the background of Lord Beaverbrook (1879–1964), the famous Canadian businessman and newspaper proprietor. He too had a house in the South of France (La Capponcina at Cap d'Ail) and Sutherland, who painted portraits of powerful people, was a friend of his, having painted his in 1951. Beaverbrook controlled the *Daily Express*, the *Sunday Express* and the *Evening Standard*, which became key outlets for the anti-Rothenstein and pro-Sutherland campaign which was rapidly developing.[28] He also knew Douglas Cooper and later invited him over to see him.[29] Beaverbrook was to make a serious error of judgement of his own by giving Le Roux a job after he eventually left the Tate.[30]

Proctor, who was himself outraged by the Director's failings over the trust funds and the attendant terrible publicity for the Gallery, understood Sutherland's concerns about administration of the Gallery, as did the Trustees (Gowing and Bawden wrote to Sutherland in support of his concerns),[31] but by the time of Sutherland's resignation, he and the Board had spent weeks trying to sort out the mess. He therefore had no sympathy for Sutherland, who had abandoned the other Trustees and even sought the most adverse publicity he could for the Gallery.[32] Sutherland's target may have simply been the Director personally but the publicity damaged the credibility of the whole Tate administration, including that of its Trustees. Proctor issued a statement (published in *The Times* on 1 February) pointing out the weaknesses in Sutherland's position. In particular, Proctor observed that, having missed the last three Board meetings and the preparation and publication of the list of misapplied funds, one of his principal reasons for resigning was manifestly being resolved appropriately by the Trustees. In any event, he should have sent his resignation letter to the Prime Minister, as the one who had appointed him, rather than to the Chairman.[33] Sutherland's standing amongst the Trustees declined further when it became clear that he was a closer friend of Cooper's than they had realised.[34] This cast a new light on Sutherland's resignation strategy. Colin Anderson, who had long been a friend and supporter of his, noted that 'from then onwards my friendship with him became, and remained, decidedly cool'.[35]

Sutherland, goaded by the negative publicity he was getting from Proctor and egged on by Cooper and Mahon, then wrote a short letter to the Prime Minister, dated 9 February.[36] The Prime Minister's Office, alert to the risk of Churchill getting sucked into this quagmire, passed what it described as 'a very curious letter' to Sir Alexander Johnston, HM Treasury, on 11 February for their advice on an appropriate response. Notes in the Treasury files show that the letter caused them some consternation. There was an initial concern that the Prime Minister might be inclined to take Sutherland's side, but in fact his reply (dated 15 February) to the artist was purely formal. One note, of 12 February, said:

> if the Director did in fact inherit a muddle, he has had nearly 16 years in which to set it right and I very much fear that the answer to all this may be that he is

not temperamentally suited for his job, at least in its administrative aspects. I know to my cost that he is also extremely difficult in his personal relationships with the staff.

Sir Alexander wrote back on 18 February to Mr Pitblado in the Prime Minister's Office offering the view that 'one of the troubles is that Graham Sutherland hates Rothenstein … this is a personal squabble between the Modernists'.

Sutherland then turned from Churchill to R. A. Butler, the Chancellor of the Exchequer, whose wife was Samuel Courtauld's daughter and therefore directly concerned about possible maladministration of the Courtauld Fund.[37] Following discussions with the rebellious gang round Cooper, twenty-three typed pages (dated 5 March) were hand-delivered by Sutherland to Butler himself at Number 11 Downing Street in a sealed envelope with a covering note asking the Chancellor not to show it to anyone. Sutherland said he had been advised by Counsel to present his memorandum in this way for fear of libel.[38] The long letter, which may have had Le Roux's input as it contained prodigious detail about the Tate's internal affairs which a Trustee was unlikely to have known, rehearsed everything, including the suggestion that the Ritson Report had been biased in favour of John as the senior Civil Servant against his junior. When he read Sutherland's letter (no doubt passed on in the usual way to the Treasury), Playfair commented on 8 March that there might have been bias against Le Roux because he was difficult to deal with and patently unreliable. The Treasury was, he accepted, also 'disgusted' at the prejudice shown by the Trustees against the Director. Sutherland's letter made some powerful points:

> What I came to learn about the Director, necessarily by a slow process, must be common knowledge to all the men and women who are constantly brought into contact with him in the course of their daily duties; the conclusion is inescapable that he must command the very minimum of respect, that he must be known to be incompetent and unreliable, but also that he must be feared for his powers of bluff and his ability to intimidate.

In the background Cooper explored whether he could mount a legal challenge to the Tate's administration of the trust funds. He consulted his friend Charles Fletcher-Cooke (a barrister and an MP whose later brief ministerial career ended after a scandal involving a Borstal boy aged eighteen) but he was discouraging, telling Cooper that, despite speaking to many people, 'most of whom seem to be called Dennis' (presumably referring to Proctor, Mahon and Sutton), together with Maurice Edelman (who had again asked questions in Parliament about the administration of the Tate), nobody had given him any evidence of 'something amounting to moral turpitude', rather than mere errors of judgement: therefore, a legal challenge would not succeed.[39] Cooper's pantomime role as the frustrated litigant continued.

Sir Charles Fletcher Fletcher-Cooke.
Photograph by Walter Bird, 1958.

From the beginning of 1954 the Tate Board had been operating in crisis mode, exacerbated after Sutherland's resignation announcement by a ferociously negative press campaign. The special Board meetings on 5 and 22 January were followed by four full Board meetings in February (on 4, 8, 13 and 18) and two meetings of a drafting sub-committee (on 6 and 7). Never in the history of the Gallery can the Trustees have worked so hard, with full attendance at all meetings save for the first two meetings missed by Sutherland when he was still a Trustee and the last one, which Lawrence Gowing had to miss (even then he wrote to the Chairman with his criticisms of the Director).[40] At the 4 February meeting the Board decided to prepare a report for the Chancellor, which the meetings of the drafting sub-committee achieved by 8 February (that meeting being held in the utmost privacy, at Anderson's house in Hampstead, well away from prying eyes and ears at the Gallery). The Board's next meeting (on the 13th) was held at the Gallery on a Saturday and all twelve available senior members of staff were interviewed, starting with the Director (who had not been called to any of the meetings that considered the trust funds). The interviews began at 10am and concluded at 9pm. Proctor recorded that only three of the twelve had a good word to say about the Director.[41]

On the Monday following Sutherland's resignation (1 February) the press barrage had begun. That day there were negative pieces in *The Times*, *Daily Telegraph*, *Daily Express*, *The Star* and *The Recorder*. The next day the *Daily Telegraph* published a letter from Lord Amulree and there were pieces in *The Sketch* and *Daily Mail*. On 3 February *The Times* carried a mildly supportive letter from John Piper, as a recently retired Trustee, and an extremely supportive one from John's friend

Robert Speaight.[42] (Benedict Nicolson sent *The Times* a response to Speaight but they did not publish it.)[43] On 4 February there were negative pieces in *The Times*, *Daily Telegraph* and *Daily Mail* and a long piece in *The Guardian*. *The Times*, *Daily Telegraph* and the *Evening Standard* continued the story on 5 February; the *New Statesman*, *Telegraph*, *Economist* and *Time and Tide* on 6 February and *The Observer* and *Sunday Express* on 7 February. Feverish notes passed from Mahon to Cooper recounting the press saga and noting such fascinating facts to them as that Rothenstein had been seen having lunch with the editor of the *Sunday Times* ('again') at the Athenaeum. In among these juvenile notes, Mahon gave at least one piece of excellent advice: Cooper 'had better keep out of it *publicly* as much as you can. J.R. is all set to pose as the victim of a personal vendetta. It is up to you not to allow him this valuable card'.[44] Nicolson had another shot with a letter in the *Daily Telegraph* on 9 February, after which there was a lull as the newspaper editors paused to see what official response would come out of the Tate. Mahon on 7 February had been urging Cooper to get Sutherland back from France: 'In my opinion (& it is the unanimous opinion of the inner circle of staff officers here) General G. S. should now return to be available at once when the real (Parliamentary) upset occurs. We have everything ready for him to take command.' Sutherland duly came back to England (on 13 February) to an immediate briefing from Humphrey Brooke.[45]

The key Board meeting was that on 18 February 1954, which drew the threads together and noted that there was a serious degree of maladministration in the Gallery for which the Director must be held largely responsible. Whilst they were not going to ask him to resign (the vote on this on 8 February at Anderson's house had been split equally, with Proctor deciding not to use the Chairman's casting vote for such a momentous decision), Rothenstein was to be severely admonished, and warned that, should they have cause for further dissatisfaction in the future, his handling of the matters dealt with in the recent inquiry would be taken into account. This assault on the Director was balanced by the long–overdue decision to sack Le Roux. That was communicated to Le Roux at a meeting with the Chairman and Fremantle on 5 March.[46] Shortly afterwards the Trustees received letters from five of the staff (Alley, Ryder, Butcher, Chamot and Crookshank) saying they were shocked by the treatment of Le Roux and hoping, naively, that the decision could be reconsidered. Ronald Alley even said: 'we shall miss Le Roux very much indeed'.[47]

Hostility from the Board towards the Director was not helped by the wave of attacks on the Tate in the press. The columns of the *Spectator* were being used against the Tate not only by Mahon but also by Ellis Waterhouse. Regular editorial broadsides and hostile letters had come from the *Evening Standard* (as noted earlier) and John was warned that, once Beaverbrook had a target in his sights, he was unlikely to relent until he had destroyed his objective.[48] Sutton continued to publish criticism of the Gallery wherever he could (for example, the *Daily Telegraph* on 29 January and *The Times* on 4 February). John viewed the pieces against

him in the *Sunday Times* and *The Observer* of 31 January, which Mahon found disappointingly mild, as defamatory.[49] Sutherland too supplemented the publicity with further outings in the friendly press (the *Daily Telegraph* on 3 February, *The Guardian* on 23 March and later in the year letters in the *Spectator* and the *New Statesman and Nation*). He was never to be satisfied. He even wrote to the Chairman, on 28 February, to reassure him that his resignation had not been 'influenced' by Cooper in any way, which Proctor circulated to the Trustees without comment.[50] John was ordered by the Board to make no public reply to any of the criticisms, as they thought this would exacerbate matters.[51] On 11 March 1954 the Board suffered the public humiliation of publishing its report on its own failings regarding the trust funds; another low point had been reached.[52]

Behind the scenes at the Tate, little work was being done by the Director, whose diary, not surprisingly, records his depression as he was battered publicly and at informal meetings with Dennis Proctor. On 25 January, he had 'the gravest interview imaginable' with Proctor. This came to a head in a hostile letter from Proctor on behalf of the Board. Dated 6 March, it said that the Trustees were faced with important issues and one of them was whether to terminate his appointment as Director. It went on to say that, whilst they appreciated that much of the public criticism had been unfairly focused on John, they could not indefinitely tolerate the consequences of his personal problems. Solely on the trust funds, they did not

John Rothenstein at the Tate c.1954. Photograph by Jorge Lewinski.

feel justified in firing him, but this did not mean that the Trustees were happy: they remained unimpressed by John's lack of leadership qualities.[53]

As if this terrible letter were not enough, on 10 March, at that scene of many Tate-related lunches and meetings, the Reform Club, he was told by the Chairman that, after things had, it was hoped, settled down, it would be wise to look for another job in a year or two, preferably in America. John was appalled but could hardly have been surprised.[54] He may not have appreciated the irony that this conversation mirrored his own with Le Roux when he had suggested he move on. Could John have seen his last ten years at the Tate he might have wished that he had taken Proctor's advice. Instead, after some deliberation he wrote Proctor a seven-page letter justifying all his actions and denying responsibility for the hostility towards him from the Gallery's critics. He claimed, for example, that he had never met Mahon (in fact, he had), had hardly ever met Amulree and was friendly with Sutton.[55]

Le Roux of course was not going quietly. He continued to attend Board meetings right up to May 1954.[56] To improve his chances of being employed elsewhere, he manoeuvred so that he was allowed to resign rather than being fired. The Board was happy to agree to anything by this stage so long as he left. They had realised that he was the source of all the damaging press briefings against the Gallery's administration: he was the only person who could have leaked, because no one else at the Tate stood to benefit from the hostility. Various duped supporters formed up and bizarrely demanded a meeting with the Chancellor of the Exchequer to plead for Le Roux's reinstatement. Lords Jowitt, Kinnaird, Methuen[57] and Harlech were joined by Sutherland, in this meeting at the Treasury on 13 May 1954. The Treasury itself now felt that Sutherland was defaming them, never mind the Director: a letter he had sent on 8 May as preparation for the meeting was described internally as a 'disgraceful document' and there was talk of referring it to the Treasury Solicitor to assess it for libel.

At the meeting, the professional advocate Lord Jowitt did much of the talking; the Treasury officials, by then well-briefed and holding clear and consistent views on Le Roux, listened largely silently and completely unsympathetically, and nothing happened. The Trustees knew the importance of keeping the Prime Minister on side and had sent John to see Winston Churchill to square him off, on 24 March.[58] Churchill urged John to stay in position and not to resign.[59] The result of this meeting was that Churchill ignored Sutherland, did not encourage the Treasury to take any action and almost certainly calmed down Lord Beaverbrook.[60] The worst of it seemed to be over by the end of May, when Le Roux finally left the Tate (after preposterously asking John to give him a reference).[61] When he heard some years later that Le Roux had died, John described him as 'the most evil person I've ever known'.[62]

In the hope that full disclosure would head off further criticism and allegations of cover-ups, the Trustees published on 5 October 1954 their *Report 1953–54:*

Review 1938–53, which contained all the facts and figures which a hostile world could possibly require. It listed all purchases, gifts, bequests, Chantrey bequests and acquisitions from the Contemporary Art Society and the National Art Collections Fund; it said which funds had been used for purchases; it listed all the Trustees and members of staff who had come and gone since 1938 (to allay fears that there had been undue staff turnover); and it commented in non-controversial detail on the collections. This avalanche of detail effectively put a lid on the Tate Affair, as was intended.[63] It did not stop press hostility, which was still being stirred up, particularly by Le Roux (now employed by Beaverbrook as his art adviser for his gallery at Fredericton, New Brunswick, in Canada) and by Sutherland.[64] But life was returning to something more normal at the beleaguered Gallery; in John's diary the flow of social engagements resumed.

Whatever the distracting publicity, 1954 saw a wide variety of exhibitions, including of the work of Dufy, Manet and Cézanne and the more domestic subjects of Charles Ginner, G. F. Watts, David Jones and George Morland. The only exhibition mounted by the Tate itself was the *Pleydell-Bouverie Collection of Impressionist and Other Paintings*, held 26 January–9 May 1954.

Meanwhile, the Bill was processing through Parliament. There was a short Commons debate on 18 February 1954 about the Tate's administration, in which a few hostile questions were batted away by the Government spokesman. One of the questioners was Cooper's favourite barrister, Fletcher-Cooke.[65] The Bill went back to the House of Lords on 30 March. Lord Selkirk began by graciously acceding to Kinnaird's request to drop from the Bill the clause transferring the Knapping Bequest to the Tate: Kinnaird was said to have 'carried out a notable public service' in pointing out the inappropriateness of this, which must have delighted him. Jowitt then owned up to being responsible, when Tate Chairman, for permitting the terms of the Carr (or Kerr) Fund to be breached; he described himself, quaintly, as standing 'in a whited sheet to tell this to the House'. Much of the rest of the debate was made up of Kinnaird suggesting and then withdrawing other amendments to the Bill, in an attempt to define the Tate's primary purpose more tightly. It is significant in view of the meeting at the Treasury in May that the other speakers in support of Kinnaird were Jowitt and Methuen.[66]

Months after another tetchy debate in the Lords on 8 April, with contributions from the same cast,[67] the process moved down to the Commons on 29 October. Henry Brooke, the Financial Secretary to the Treasury, who was responsible for guiding the Bill through the Commons, began by remarking on the 'unloving publicity and controversy' which the Tate had been experiencing. He nevertheless hoped 'that the greater part of our proceedings today may have the atmosphere of a christening rather than an inquest.' These forebodings were soon confirmed. The MP, G. R. Strauss[68] asked what was going on at the Tate and whether the Treasury was happy about it: 'It is said that some vendetta is being carried on by disgruntled people against the director of the gallery'. Strauss recited detail about

Elizabeth and John at their house in Newington, 1954.

Sutherland's resignation, including quoting from a letter from the artist in the *New Statesman*. He said that he was not going to comment on the Director's performance, because he was a Civil Servant unable to defend himself, but he thought that future Directors should be 'first-class' administrators rather than 'a luminary from the artistic world'. In congratulating Strauss for daring to venture 'into the lion's den of art controversy', Jo Grimond[69] remarked: 'It is sometimes difficult for politicians, living in the comparatively calm and impartial atmosphere of party politics, to realise the fierce passions which rage among the directors of museums and art galleries.' He then pointed out that Sutherland seemed happy to have remained a Trustee for many years but resigned when the problems he alleged were prevalent became public.[70]

Benedict Nicolson's brother, Nigel,[71] spoke (he must have been briefed by Ben, even getting in a mention of the *Burlington Magazine* as 'probably the chief organ of art historians and scholars') but restricted his comments to issues about the Bill of concern to him, not the controversial goings-on at the Gallery. Kenneth

Robinson[72] was a friend of John's and made a supportive speech which took twenty minutes. John was briefing his own friends, as had his opponents, and Woodrow Wyatt[73] also came out in his defence, making a similar comment to Grimond's:

> It is sometimes said that politicians intrigue against each other and are unkind and uncharitable to each other, but it seems from what artists and art critics say about each other in the columns of 'The Times', the 'New Statesman' and the 'Daily Telegraph' that we emerge in a very respectable and sober light, compared with a great deal of that.

Although John's supporters had canvassed Henry Brooke, he avoided any statement in support of the Director. John, who was in the Chamber for the debate and looking forward to hearing his reputation being restored in a public and high-profile fashion, was outraged that his position had not been publicly supported given the perfect opportunity.[74] Brooke instead gave his full support to the Trustees: 'It is not for me to complicate matters by expressing either praise or blame for those who are working in the galleries.' What John was unaware of was that Proctor had agreed with Brooke that he would take this line and that he would not give John any encouragement. That November, Proctor wrote Brooke a fulsome letter of thanks and congratulations for the way he had dealt with the issue.[75] After a couple of short debates in November, the Bill was passed, coming into force in February 1955.

Symbolically, the Tate Affair ended on 2 November 1954 at Forbes House just off Hyde Park Corner. There, at a reception celebrating the opening of a Diaghilev exhibition, in the heady atmosphere perfumed by Guerlain's *Mitsouko*, John punched Douglas Cooper in the face. He punched him hard enough to knock his glasses off. He had been driven to this because Cooper had been following him round the rooms insulting him in a loud voice, in spite of protestations from other guests.[76]

Despite John's terror about the likely press reaction (particularly given the presence at the party of the Queen's cousin, the Earl of Harewood) and about being charged with assault,[77] all that actually happened was that Cooper gave in. Proctor had lunch with him (of course, at the Reform) on 6 November, later making a detailed note of the discussion which took place.[78] Cooper denied personal malice towards the Director; he was simply concerned to remedy maladministration at the Gallery. Proctor noted that the Trustees had suffered as a result of John's incompetence and many Trustees would prefer a different Director. The problem with getting rid of him was that, whilst he was not a scholar, he had been a success as Director as far as the public was concerned, and therefore the Trustees were reluctant to fire him.

Perhaps encouraged by this indiscreet discussion, Cooper told Proctor that, provided the Director stopped saying that Cooper was conducting a personal campaign against him, he would withdraw his campaign against the Director and the Gallery for the next twelve months. Cooper said he was unable to control Le

From *The Daily Express*, 5 November 1954.

Roux but could control his 'associates' (probably Amulree, Brooke, Mahon, Nicolson, Richardson and Sutton and maybe Sutherland).[79] He wrote to or telephoned several at least; letters in reply survive from Denys Sutton and Benedict Nicolson.[80] In his letter, Sutton said that he had been thinking over their conversation and agreed that there should be 'a period of silence'. Even so, 'it would be wrong for me not to say that whatever explanations are now advanced by the Trustees to cover their behaviour it still seems to me to have been very improper'. He went on to remind Cooper that not all of those attacking the Tate had done so from the same angle. Sutton stated that he and Mahon had initially been motivated by how the Bill would affect the National Gallery and the Tate, and one thing had led to another: 'the suggestion that this was in the nature of a vendetta against the Director is wide of the mark.'

Nicolson had destroyed his letter from Cooper as instructed, describing it as 'a really terrifying document'. He was about to settle the editorial for the December edition of the *Burlington Magazine*, on 'The Tate Controversy', and after re-reading it, felt that it was sufficiently neutral not to offend Cooper's commitment to Proctor; he had taken the precaution of passing it by Anthony Blunt as well and he was happy with it.[81] The published article appeared to take the viewpoint of the more objective participants in the campaign 'in the service of the truth which has been conducted with dignity by a few well-disposed people wishing to sacrifice

"Incredible as it may seem, they've just discovered that someone's stolen Sir John Rothenstein"

Osbert Lancaster's pocket cartoon in *The Daily Express*.

their time to setting right what they believed to be wrong'.[82] This sentiment bears no scrutiny in relation to Le Roux and Cooper. In his reply to Cooper, Nicolson thought that Mahon and Sutton would not be prepared to relinquish their 'campaign' and would not be as prepared to support the Trustees as he was (he added that he was a great friend of Lawrence Gowing [a Trustee since 1953] and would support him).

To show Proctor his new goodwill, Cooper offered to secure for the Tate a fine picture by van Gogh as a loan and gave the Gallery £250 towards the purchase of a Matisse portrait of André Derain (1905, Tate, 6241). Proctor told John that Cooper was 'obviously defeated';[83] the long war was finally over.

CHAPTER 12
Last Years at the Tate, 1955–64

John might have known that the struggle was not in fact over. Whilst Le Roux was employed by Beaverbrook, there was always the chance that he might launch himself at the Tate through one of the Beaverbrook papers,[1] but the real menace to John's peace of mind remained Douglas Cooper. He was incapable of controlling himself, however much he might have been able to control his associates. Cooper was a psychologically damaged person, and his senseless personal attacks on the Director continued until John retired from the Tate.[2]

In these years, when the Tate Affair was supposedly over, John sometimes experienced Cooper's anger directly and sometimes obliquely, from unexpected sources. On 7 January 1955 he noted an example of the latter: an Australian journalist called Kisch[3] told him that he had written a piece on Cooper for an Australian newspaper, which had been met with a threat of libel. Kisch had shown John a letter from Cooper which had included an attack on the Director. John called it a 'disgusting letter'. He also noted its date, 27 November 1954, just a fortnight after Cooper had promised Proctor that he would lay off his campaign against John. Furthermore, Kisch told him that Lord Amulree had telephoned him to say, in a faint echo of the Degas bronze affair, that John accepted bribes. Kisch said that Amulree 'spoke so recklessly that he thought he wished to provoke an action [for libel?] involving me'.[4]

John recorded other incidents, which tended to follow a set pattern if he found himself in the same room as Cooper. In December 1955 Cooper made a scene at a hanging of an exhibition when John walked in;[5] in September 1957 Cooper launched a vulgar tirade against him in the Tate restaurant, including what John described as 'a somewhat disgusting gesture', which caused John to complain to Colin Anderson, then Vice-Chairman of the Trustees (he was Chairman in 1960–67);[6] again that September, at a private view of the Tate's Monet exhibition sponsored by the Arts Council, Cooper started screaming at John and had to be 'frogmarched' out of the room by John Richardson and Gabriel White (of the Arts Council).[7]

In between these absurd incidents, John also had to put up with petty insults. On 4 April 1956 the *Evening Standard* rang John to say that Cooper and Sutherland had stood down from a committee for a Nicolas de Staël exhibition at the Whitechapel Gallery because Rothenstein was on that committee. On this occasion John was able to brief one member of the press, which was now less inclined to take the side of Cooper and Sutherland.[8] Cooper's stated reason for the resignations was

that they could not tolerate being on the same committee as John, who had never supported de Staël or his work in all his years at the Tate when he was in a position to do so while the artist was alive.[9] John pointed out to the journalists that he had always liked de Staël's work and had personally put forward his work for the Tate to purchase on two or three occasions, but on each occasion the Trustees had turned them down.[10] On each occasion Sutherland had been a Trustee.[11]

Small provocations abounded. In 1955 John was working on an article for *Picture Post* on religious art.[12] He had suggested using as an illustration Sutherland's *Crucifixion* from St Matthew's, Northampton; when the paper sought Sutherland's permission it received a letter from his wife saying this would not be possible.[13] Also in 1955 John applied to be the Slade Professor of Fine Art at Oxford, only to find to his horror that the only other name put forward was Cooper's.[14] This cannot have been a coincidence. Denys Sutton rang John in March 1957 to tell him that Cooper had been appointed. Sutton's comment, a little odd given his co-operation with Cooper over the Tate Affair, was that he thought the appointment 'disgraceful on moral grounds'.[15] In contrast, Proctor mischievously congratulated Cooper on his appointment, suggesting that nearly everyone at the Tate was overjoyed at the news of the Slade Professorship.[16] Separately, John was told that Cooper had become openly and obnoxiously anti-Semitic and was making a nuisance of himself in New York.[17] He was also later told by Picasso's dealer, Daniel-Henry Kahnweiler, that Cooper was regarded as 'the buffoon of the Picasso court'.[18]

When John published *The Moderns and their World* in 1957, with an introduction which tried to analyse modern art in eleven pages, he might have known that Cooper would pick up the challenge, especially as John took the opportunity to make a few barbed comments about Cubism and abstract art. He saw them as having a place in the development of art, but they had been 'enveloped and almost smothered in a mass of ideological theorising and built into a philosophy of nature and of knowledge and indeed of the unconscious. In particular, they have both been treated as a sort of metaphysical painting that affords a superior insight into reality.'[19] Cooper rose to the bait. The *Times Literary Supplement* for 17 January 1958 published a heavily sarcastic review in which Cooper alleged that 'whole chapters of contemporary art history – and those the most important – have been left out'.

There was another incident in 1957 involving John's failure to attend a viewing at the premises of the framer Alfred Hecht.[20] Having accepted the invitation, John heard that the event had been cancelled so did not attend. It turned out that Cooper had wanted to go to the event. Hearing that John was due to be there, he had left an anonymous telephone message for the Director at the Tate that the event had been cancelled.[21] Also in 1957 Cooper tried to make it a condition of his involvement with an exhibition at the Marlborough Gallery that John would not attend any gallery event at which Cooper was present. Even Anthony Blunt thought this was too much and protested to Cooper about his behaviour.[22] Blunt was informed by

various parties about what was going on regarding the Tate, but did not participate openly. Proctor received a copy of a letter dated 15 October 1957 which John Richardson had written to Blunt about Cooper's behaviour: 'When he showed me your letter this morning he was behaving like a nasty little girl who had just stolen and eaten an enormous cake.' He went on to say that 'I think he is quite unbalanced in his feelings about Rothenstein, who has become a lightning conductor for the enormous resources of aggression that he is constantly generating'.[23] Sometimes John was able to observe Cooper's wrath being directed at others. On 5 July 1960, at the private view of the Tate's Picasso retrospective, 'D. Cooper arrived and screamed out at Roland Penrose in broken English he uses when excited "I am here to represent one Pablo Picasso to see that you don't mistreat his pictures"; Roland took no notice beyond distant nod of recognition'.[24]

In contrast to all the niggling to which he subjected the Director, Cooper tried to help the Gallery by working alongside Proctor as the Chairman to acquire important works by Picasso, Braque, Léger and de Stäel. They visited galleries together in Paris in 1957, which resulted in a long campaign by the Trustees to raise funds to buy those paintings. Ultimately, they bought everything except the Braque. The process demonstrated to the Treasury that the Tate's annual purchase grant was woefully inadequate in the modern art market, especially as the Tate was trying to fill in gaps in its modern foreign collection.

In the correspondence between Proctor and Cooper, which extends from 1954 to 1958, the Director gets few mentions and it is apparent that, to Proctor, John's role had been subordinated to that of the Trustees and even to Cooper himself as regards modern foreign pictures.[25] At one point John recorded with alarm that Proctor had invited Cooper to come to England for dinner with the Trustees; he had only mentioned this to John because Anderson had told him he must.[26] Nevertheless, the complex interplay of all the personalities at the Tate cannot be underestimated. Throughout 1955, for example, there are friendly letters on file from Proctor to John, often handwritten, thanking him for all sorts of things. When Proctor retired from the Tate in 1959 he wrote to John thanking him for all his support. He finished by noting that the Gallery had gone from strength to strength under John's Directorship.[27] Nothing is ever as it seems in the art world.

In 1961 Cooper published his monograph on Sutherland. Without naming Rothenstein, there were passages which were aimed at him. On the first page Cooper wrote about English artists of the twentieth century, picking out John's favourite artists:

When one thinks of the members of the New English Art Club [which included William Rothenstein] practising a debased impressionistic idiom ... of Nevinson and Wyndham Lewis aping the Futurists and Cubists, of Matthew Smith trying to be a Fauve, or of Paul Nash's flirtation with Surrealism, it becomes abundantly clear that these efforts were in vain. As strictly English painters some

of them had undoubted merits, but none forced his way into the main stream of European art and made there a significant individual contribution. In order to do so, they would have needed far more passion, concentration and technical ability, as well as insight into the sources of inspiration and motivating forces which had produced the various European styles.

This was Cooper's response to the rationale of *Modern English Painters*. The message was confirmed on the last page of Cooper's text: 'Today, Sutherland stands at the top of his profession in England and is recognised in European artistic circles as the only significant painter since Constable and Turner.'[28]

There was little doubt as to why the book had been written. Francis Bacon reported to John a conversation he had had with Richardson, who had confirmed that Cooper did not in fact like Sutherland's work but had written the book as a favour in return for his support over the Tate Affair.[29] Henry Moore repeated the same view to John, describing the book as 'payment for [Sutherland's] Tate resignation'; Moore said that he had heard Cooper 'despised' Sutherland's work.[30]

John also had to remain wary of Cooper's 'associates', who appeared to be untamed. Denis Mahon published a critical letter in the *Burlington Magazine* in January 1955.[31] John was told on 26 February 1955 that Ben Nicholson had reported being telephoned by Mahon to tell him some 'new revelations about the Tate Gallery' and that he responded: 'This is going too far; I'm really not prepared to listen', before hanging up.[32]

Battle-hardened, John handled all this with great dignity, maintaining a steady nerve. He reported any incidents of which he became aware and occasionally the Chairman remonstrated with Cooper.[33] For the rest of his Chairmanship, until 1959, Proctor encouraged Cooper to be remarkably helpful to the Tate. Cooper dealt directly with the Chairman about pictures in the market which might be of interest to the Tate, no doubt enjoying the likelihood that it would enrage John to find acquisition proposals coming to the Board without his involvement.[34]

From the beginning of 1955 John's working pattern at the Tate changed, with Monday off each week to do his own research, usually in the country, returning to London on Tuesday mornings.[35] This meant that his participation in Gallery matters diminished and he gradually spent less time there. He took the opportunity to make a number of overseas trips on Gallery business. In 1956, apart from three short European trips, he was in the States from 29 December 1955 to 22 February 1956 and from 30 September to 29 October. He sometimes came back from the trips recommending pictures for purchase. For example, in 1956 the Tate acquired from a New York gallery, on John's recommendation, a watercolour by the early American Modernist, John Marin.[36] In 1959 he was in Canada and the USA for more than a month. In 1960 he made work trips to Paris, New York, Helsinki and Italy; in 1961 he went to Paris, America, Canada and Madrid. The diary records visits by him to the Gallery as if they were unusual. On 14 June 1955 he noted that

he had been to see the Ben Nicholson exhibition, which had been hung by Norman Reid and the artist.[37] Undoubtedly, Reid, by then supported by excellent assistants such as Mary Chamot, Ronald Alley, Dennis Farr (1929–2006; who joined from the Courtauld)[38] and Martin Butlin (born 1929),[39] was being allowed to run all the day-to-day affairs of the Gallery, with John in more of a non-executive role. This structure was the only basis on which the Board would allow John to remain in post after the Tate Affair.

These were in effect shifts in the management of the Gallery, in favour of the Trustees in one direction and the staff below the Director in the other. Occasional plaintive tones in John's diary reflect the fact that his power in front of the Trustees was ebbing. On 19 January 1961 he noted the 'sense of smallness of my influence' at a Board meeting. A few months later, a Board meeting left him 'depressed finding I have so very little influence on Trustees', who decided on a purchase without seeking his views.[40] Nevertheless, he was not completely sidelined. He still came into the Gallery to prepare papers for Board meetings, at which he did his best to influence purchasing decisions. A number of the British pictures acquired in this period reflect his tastes. For example, in 1954 and 1955 the list includes work by Mark Gertler, Walter Greaves, Allan Gwynne-Jones, Frances Hodgkins, Augustus John, Wyndham Lewis, Roy de Maistre and Stanley Spencer. The following year included work by Edward Burra, Winston Churchill, Augustus John, Wyndham

Stanley Spencer with John Rothenstein, Newington, 1956.

Lewis, Roy de Maistre, Henry Moore and Stanley Spencer.[41] John's influence had clearly not totally disappeared.

The acquisition of foreign pictures was a different matter. It was easy enough for the Gallery to acquire pictures by lesser-known foreign artists whose work was cheap, but nearly impossible to buy major works. Even though the Government grant increased over the years, it was insufficient to fill the huge gaps in the collection which the Board had inherited, and many of the Gallery's Annual Reports at this time began with a prolonged grumbling on this subject. Occasionally an attempt was made to get a special Treasury grant for a particularly exciting opportunity, but these were normally declined in the case of modern foreign pictures.[42]

Sometimes gifts or bequests helped. A picture by Bernard Buffet came in this way in 1954/5; a Delvaux in 1957/8; an Arp, a Dubuffet, a Giacometti and a Soutine in 1959/60; a Gauguin in 1962/3; and an Ernst in 1963/4. But these were slim pickings. In terms of purchases of foreign pictures, works by Matisse, Picasso, de Staël, Giacometti, Kurt Schwitters, Ernst, Léger, Mark Rothko and Braque were the most notable over the ten years from 1954 to 1964. The Friends plugged a few of the gaps (particularly as regards American artists), for example producing a Balthus and a Philip Guston in 1959/60, a Jackson Pollock in 1960/61 and another in 1961/2, together with a Jasper Johns and an Ernst in 1962/3. They could occasionally be induced to buy important British pictures, such as a Stanley Spencer in 1962/3 and a picture by Hockney in 1963/4.

In these twilight years of his Directorship, his authority in front of the Board deliberately and severely diminished, it was difficult at times to know where the line should be drawn between his role and Reid's. John always had a high degree of amour propre, and his diary recorded sleepless nights over what he described as Reid's 'constant attempts to "takeover"'.[43] After a frank exchange with the long-suffering Reid the air was cleared.[44] Reid had demonstrated on many occasions over the years that he was not Le Roux; during this last phase of his Directorship, John would have to tolerate the age-old problem of an ambitious and effective deputy increasingly straining to do his superior's job towards the end of the latter's career.

Although it can easily appear that John was marginalised during his last ten years at the Tate, that is not the full picture. He remained the public face of the Gallery in the art world, at parties, private views, receptions, dinners and so on. He was still involved with major Gallery decisions, such as the exhibitions they (as distinct from the Arts Council) were responsible for (on Stanley Spencer and Klee in 1955, *Wyndham Lewis and Vorticism* in 1956, on Duncan Grant in 1959 and Bacon in 1962).[45] The Arts Council, still without a home of its own to put on large exhibitions, continued to use the Tate for exhibitions including *Gauguin* (1955), *Modern Art in the United States*, *Braque* and *Modern Italian Art* (all 1956), *Monet* (1957), *Kandinsky* (1958), *The New American Painting* (1959), *Sickert* and *Picasso* (both 1960), *Toulouse-Lautrec* and *Max Ernst* (both 1961), *Modern Spanish Painting* and

Ecole de Paris (both 1962) and *Modigliani* and *Soutine* (both 1963). A show which opened in 1964, called *Painting and Sculpture of a Decade, '54–'64*, promoted by the Calouste Gulbenkian Foundation, contained a remarkable range of modern work. The selections were made by Philip James, Alan Bowness and Lawrence Gowing and the idea was put to John by Gowing in a letter of 10 November 1961. John promptly took the idea to the Trustees and the show went ahead. There is no suggestion that John sought to prevent shows of work which may not have been to his taste and the show was a forerunner of how the Tate's offering would develop after his departure.

The shows of modern American art were groundbreaking in helping to introduce an English audience to Abstract Expressionism.[46] As has been seen, John was active in preparing the 1956 show. He had a long interest in modern American art and probably knew more about how it had developed during the twentieth century than many others in the British art world. He had been visiting the US since 1927 and was open towards and supportive of its art.[47] Early acquisitions of pictures by American artists (as distinct from examples received through the Friends) included Sam Francis' *Painting* (1957, Tate, T00148), which was bought in 1957 from Gimpel Fils in London, and Ben Shahn's *Lute and Molecules* (1958, Tate, T00314), which was bought from the Leicester Galleries in 1959.

The Director sometimes liked to exert his authority internally by involving himself with any hang going on in the Gallery and the staff learned to accommodate this.[48] He had formidable experience by this time in gallery presentation, in terms of hanging works and choosing wall colours to complement the pictures. Jack Yeats, for example, had thanked him personally in 1948 for hanging his pictures so well.[49] He was therefore particularly annoyed in 1961 when Reid discussed wholesale rehanging of the galleries directly with the Chairman, Colin Anderson, regarding it as a usurpation of his authority, rather than the reality of how the Gallery was being managed by this time.[50] Sometimes he recorded a nice comment. At the Canadian High Commission on 30 March 1955, after observing with fascination but no pleasure the drunken behaviour of Leigh Ashton of the V&A, he recorded that Gerald Kelly from the RA had been most generous in his comments to him, saying 'there is no doubt that you are a great director'.[51]

John was associated with the establishment of the Friends of the Tate Gallery in 1958. This led him to work closely with Robert Adeane (1905–1979), who was a wealthy businessman and landowner and a Trustee from 1955 to 1962.[52] Together they did much to develop the Friends, whose contribution to the Gallery's acquisitions (apart from those earlier mentioned) include Moore's *King and Queen* (1952–3, cast 1957, Tate, 00228) in 1959 and Matisse's *Snail* (1953, Tate, 00540) and Spencer's *Swan Upping at Cookham* (1915–19, Tate, 00525) in 1962. The acquisition of Spencer's major picture was promoted by John, who had spotted that it had become available from the Behrend Collection.[53] Anderson and Anthony Lousada were indifferent but John persuaded the rest and the purchase went ahead. The

Sir Robert Philip
Wyndham Adeane
with a painting by De
Chirico. Photograph by
Ida Kar, 1959.

Snail became one of the more famous and popular pictures of the Tate's modern foreign collection.

In its first five years the Friends contributed more than £85,000 towards acquisitions, which had a major impact on the Tate's buying ability. John went to New York with Adeane to set up an office for the American Friends of the Tate Gallery; as a result several significant purchases by the Friends for the Gallery were of modern works by American artists. The Friends was the final manifestation in John's long career in public galleries of his keenness to establish and work with external agencies able to supplement the buying powers of the underfunded galleries. Inspired by his friend MacColl's work with the National Art Collections Fund, he worked with the Leeds Art Collections Fund in his first post, set up a similar body at Sheffield and then worked closely with the Friends, the Contemporary Art Society and other bodies in London to make acquisitions for the Tate.

Outside the Tate John remained involved with the arrangements for the British Pavilion at the Venice Biennale, which resumed after the war in 1948 and was thereafter held every two years; he was on its Selection Committee from 1948 to 1964. In 1952 he was elevated to the event's International Committee of Experts

for one year. Here again he ensured wherever possible that artists he favoured got an opportunity to be involved. In 1948 Moore was one of the two artists to represent Britain and had won the International Sculpture Prize. In 1950 John promoted Matthew Smith's inclusion and also Sutherland's in 1952, before they fell out with each other. In 1954 Bacon was one of the British representatives, with Rothenstein's support. Thereafter John's influence on the choice of artists is not as apparent, since younger ones with whom he was not so familiar tended to be considered.[54]

John also kept up his connection with Winston Churchill. Apart from John's regard for Churchill's painting, there was now a stronger bond between them because Churchill had come to loathe Graham Sutherland, following the fiasco of the official portrait (1954) which Parliament had commissioned from the artist and which Lady Churchill, unbeknownst to the public at the time, had promptly destroyed. On 4 March 1955, John was with Churchill and gleefully recorded his comments on Sutherland:

> Before long Churchill began to speak most bitterly of G. Sutherland and the Portrait, saying it was deliberately malignant, that monstrous advantage had been taken of the situation, both to travesty the sitter (even the grossest caricature must have some resemblance or it would defeat its purpose) and to gain personal notoriety. It appears that it was done from photographs.[55]

This was all music to John's ears.[56] A year later, he noted a perceptive summary of Sutherland's character from his old friend, Eddy Sackville-West, whose portrait Sutherland had also painted: Sutherland was 'intent solely on his career, willing to throw over any friend once he had extracted what he could get from them'.[57] In similar vein, Alfred Barr described Sutherland to John as an 'arch-careerist'.[58]

By this time, within their limited connections to each other, John had a genuine friendship with Churchill. Many letters survive between them from 1949 to 1958.[59] John sent Churchill signed copies of his books and Churchill asked John for advice about which pictures he should submit to the Royal Academy Summer Exhibition. He would send his car over to the Gallery to collect John from time to time, especially after he ceased to be Prime Minister in 1955. The Trustees knew that encouraging Churchill would be wise and John was sent off to discuss with him which of his works might enter the national collection.[60] Churchill loved this. In the years following the Tate Affair John developed an idea for a book on Churchill the artist, which they debated in a number of letters but no such book was ever published.

Another important person whose orbit Rothenstein entered in 1955 was Lord Beaverbrook. John was far too innocent and naive, even by then, to see what was going on in the mind of this frighteningly powerful individual; he had never been good at divining the intentions of such people. When Beaverbrook asked him for lunch at his flat in Arlington House (behind the Ritz), on 12 July 1955, John asked why he had permitted or even encouraged his *Evening Standard* to be one of the

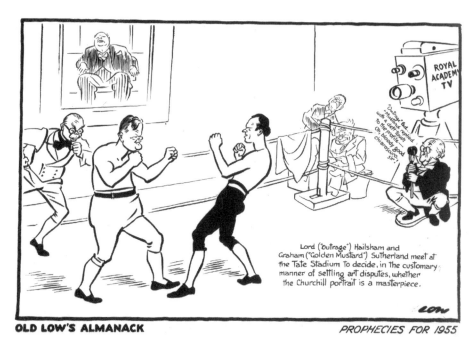

OLD LOW'S ALMANACK *PROPHECIES FOR 1955*

'Art Boxing' by Sir David Low. *Evening Standard*, 1955.

leaders of John's persecution during the Tate Affair. John was flummoxed to find him denying all knowledge of any anti-Rothenstein campaign, claiming that he was a great admirer of the Tate. The next day John mentioned this conversation to Vincent Massey, another Canadian, who said that, whatever Beaverbrook said, there was no doubt that he controlled every material aspect of his papers' output.[61]

Over the years John got a bit closer to Beaverbrook, who experienced the sort of difficulties with Le Roux which had been seen at the Tate, even asking John (at a lunch in 1956) whether Le Roux had ever stolen money from the Publications Department and whether he had in fact been dismissed from the Tate rather than resigning.[62] Le Roux had tried to take control of aspects of the Beaverbrook art collection at Fredericton and had also kept for himself some of his employer's vast fortune. Le Roux was unlikely to win a battle with Beaverbrook and he soon found himself (in 1956) working elsewhere.[63] Instead of seeking Le Roux's advice, Beaverbrook now shamelessly drew on John's advice over pictures in his collection or which he was thinking of acquiring. In what may have been intended as an apology to John for his treatment during the Tate Affair, John was invited to Fredericton for the official opening of the gallery in 1959. It was the sort of event he relished. Flown out to New Brunswick at Beaverbrook's expense, his hotel arranged and paid for, he was treated like visiting royalty. It was 1939–40 all over again.[64] He also enjoyed hearing from Beaverbrook that Sutherland had told him that he had been deceived by Le Roux over a picture he had given him, which Le Roux had

sold.[65] When John came across a slightly sour piece in the *Evening Standard* on 28 November 1960, he referred it to Beaverbrook personally, who promptly replied: 'The Evening Standard has no quarrel with the Tate and cannot have any animosity while I am alive. You have access to all the columns of this newspaper at any time, and you would always be given a good position in the paper for anything you wish to say'.[66]

John must have felt a shudder of *déja vu* on 11 April 1956 when an Irish student, making a point about the pictures of the Hugh Lane Bequest being in London rather than in Dublin, stole a Berthe Morisot painting called *Jour d'été* (*c.*1879) off the walls of the Tate without anyone apart from a passing photographer noticing. The press noticed, however, and John must have feared a few more broadsides from the Cooper gang; but they did not come. Somehow the incident resolved itself without too much focus on the Director, partly because the police decided not to prosecute anybody for fear of highlighting the Tate's woeful level of security. The picture was returned safely a few days later and no harm was done.[67] John kept his head down and, on this occasion, got away with it. The absence from the Gallery of anyone with a motivation to stir up trouble for him undoubtedly helped.[68]

With the publication of volume two of *Modern English Painters* (*Lewis to Moore*) in 1956, plenty of controversy emerged through the newspaper reviews (to be covered in Chapter 14). Nevertheless, the last entry in John's diary for 1956 reads: 'year was happiest and most fruitful perhaps ever'.[69] His later years at the Gallery slowly petered out without too many other anxieties. He noted Lord Jowitt's death with 'relief', saying that he had never 'met a man who so lacked moral sense'.[70] By 1958 much of his spare time was spent writing his autobiography, between other writing commitments and the endless stream of social engagements, and preparing for his daughter's wedding; Gallery matters got fewer and fewer mentions in the diary. Occasional opportunities were taken to winkle out stories about Le Roux, Sutherland or Cooper (and even Fincham).[71] On 16 January 1959 he had lunch with Lucian Freud and lured him onto the topic of Sutherland. Freud said that Sutherland was 'mesmerised' by Cooper and had been very jealous in the old days, hysterically suspicious that Freud and Bacon were getting higher prices for their pictures than he was. John followed up this theme over dinner with Bacon on 13 May. Bacon said he was no longer on speaking terms with Sutherland, who 'puts all his trust in Douglas Cooper in belief that he can somehow establish him in the European tradition'. John told Bacon that he would like to write a book about him.[72] Whatever Bacon said at the time by way of encouragement, he had sobered up enough by 16 May to tell John that he would prefer John not to write a book on him.[73]

John's long relationship with Bacon culminated in the artist's first major retrospective, at the Tate in 1962. The initiation of the show seems to have been John's doing,[74] although since 1959 the great Bacon collector Robert Sainsbury (1906–2000)[75] had been on the Board and was also closely involved. At the Board meeting in November 1961, Sainsbury said he had been discussing a Bacon retrospective

with Harry Fischer of the Marlborough Gallery. As the artist's dealer, he was independently organising a large Bacon show, which the gallery intended to take round several European capitals. Fischer knew that a formal retrospective at the Tate would add much to Bacon's stature and had offered to let the show come to the Tate free of charge. To the cash-strapped Tate, this seemed like a golden opportunity, although haggling and grumbling among the Trustees then ensued about how they could allow a commercial gallery to use the Tate for an event which would generate great publicity for the Marlborough. The Degas bronze incident in 1952 may also have been recollected, when the machinations had caused the Board agonies (as remarked in Chapter 10). They were particularly concerned that many of the pictures would be gallery stock and therefore for sale. The Marlborough also wanted to control the catalogue, suggesting (probably under the influence of Bacon) that it be prepared by Ronald Alley and Robert Melville, with an introduction by John.[76] By early 1962 the issues had been resolved. Instead of simply accepting the Marlborough show, the pictures for the Tate were selected by John and Robert Sainsbury. Of the approximately hundred works chosen, only thirteen were in the possession of the Marlborough.

John put much effort into the show to make it a success. At the beginning of 1962 he gathered material for his introduction to the catalogue and, as the year went on, met Bacon several times to discuss his work. In John's account, he came to understand the artist and his work pretty well. Visiting him, John found Bacon 'quite touchingly appreciative of what I have done to bring about the TG exhibition. Have never before known him interested in anything affecting his reputation'.[77]

Many other meetings followed with Bacon and others who could provide information about him. John met the formidable dealer Erica Brausen from the Hanover Gallery, who brought her 'invaluable' records about the artist to lunch.[78] She had been Bacon's first and most loyal gallery supporter and John found her unsurprisingly resentful towards Fischer, who had stolen Bacon away from her over 1959–60.[79] He lunched with Hecht to talk about Bacon, had several dinners with Bacon's early supporter, Roy de Maistre, for the same purpose and talked to David Sylvester about the artist.[80] His meetings with the artist included an entire afternoon with him on 7 February and dinner at Wheeler's on 21 March, when he found that Bacon spoke in a 'more forthcoming' way than ever before about his life, and at the Athenaeum on 27 February, when John boldly took Bacon and Freud to dinner. Herbert Read, dining at another table, must have been bemused to find this unusual grouping in the staid atmosphere of the Athenaeum. John suggested that the artists might like to become members, but Freud felt that he could not join somewhere which had no women in it.[81]

At last, after all his fact-gathering, John began to write his introduction on 9 April 1962, showing Bacon the draft on 27 April. It is a suave piece of writing and shows signs of Bacon's influence, inevitable after John's conversations with him.[82] Far from the array of comments which John was expecting from the artist on his

draft, the effect was to make Bacon cry. He 'said it was by far the best thing ever written on him – only one to treat his art in a matter-of-fact way'. With that imprimatur, the rest of the process went swimmingly. Bacon approved the catalogue entries on 2 May, had another dinner with John on 7 May, came to the launch party for John's *British Art since 1900* on 15 May, visited the Gallery to approve John's hanging of the pictures on 18 May and turned up at 11 o'clock in the morning on 23 May for the press view and later for the private view.[83] The reception for the show was stunning. It was a high point of John's career as Director and Bacon wrote him a charming letter thanking him for everything he had done.[84] He had got to know Bacon many years earlier, made friends with him and supported his career in a practical way.[85] He has been described as Bacon's 'early patron and most sympathetic critic' and as his 'champion'.[86] John developed his 1962 introduction for his chapter on Bacon in volume three of *Modern English Painters* (*Wood to Hockney*, 1974). By this time the Bacon industry was developing and John was able to draw on John Russell's book on Bacon and on the interviews which David Sylvester had published.[87] John was also involved in securing other Bacon pictures for the Gallery. The *Study for a Portrait of Van Gogh IV* (1957, Tate, 00226) was presented by the CAS in 1958, *Reclining Woman* (1959, Tate, 00453) was bought in 1961 and *Seated Man with Turkey Rug* (now called *Seated Figure*, 1961, Tate, 00459) was presented by J. Sainsbury Limited in 1961 as well. Bearing in mind Bacon's stature now in twentieth-century British art, John's support made a significant early contribution.

While he was in the middle of his Bacon preparations, John had been hit with another unforeseen blow at the hands of the Trustees. On 15 March 1962, when the Board met it excluded the staff who normally attended and began in private session. John and Reid pondered what they could be discussing: John did not have to wait long to find out. On 16 April he received a letter from Colin Anderson saying that he had been advised that it was customary Civil Service procedure to review the employment of those reaching the age of sixty to decide if they should continue in office and, if so, for how long. The Board had decided that John was to stay on for just two more years as Director.[88]

John was by this time sixty-one. To be given two years' notice at that age cannot have been either a complete surprise or regarded as unduly hostile. It left him with plenty of time to prepare himself for whatever he might do next and the Board probably thought they were being generous. Yet his spirits could be easily crushed and he reacted badly, the 'world suddenly a dark, cold place'. His first instinct in such a situation was to scuttle off to the Treasury and complain. Two days later he met them and was disappointed to find that they neither knew anything about the Trustees' decision nor cared to act on it.[89] In truth, Anderson had not warmed to his Director. He had inherited from Proctor an attitude towards John, after the Tate Affair, in which his role was treated by the Board with disdain as regards what art should join the Gallery's permanent collection. John had seen his influence over the Board declining. When the meeting on 15 March let the staff join them, John's

diary reported: 'since CA became chairman, have never known own influence less'. After a Board meeting on 17 May 1962 his comment was: 'CA tends not to seek my opinion on works put forward by Trustees'.[90]

Whatever his anger about the Board's plans for him, John knew that, as a Civil Servant, it would not be easy to force him to retire before he was sixty-five unless he committed acts of gross negligence. He perhaps underestimated how unpleasant they could make his life. As it happened, he was particularly busy in 1962. Apart from the Bacon work, he was distressing himself by having to write about the Tate Affair in his autobiography and also enduring the mixed reactions in the press to *British Art since 1900*. He managed to fit in dinner with the King and Queen of Greece (8 February) and with Princess Margaret (1 March) and a visit to the Astors at Cliveden (7 April), so not everything was a problem.[91] John's pleasure in representing the Gallery in the outside world would continue until his last day as Director. Bacon, whom he saw on 14 June, was delighted with the Retrospective and its reception; the artist told him that he was going to paint a special picture for him (which of course he did not). John held his first dinner party at his house in Tryon Street, Chelsea, which he had bought after leaving the flat in the Tate, and assembled a group of guests who might feature in some people's perfect world: Francis Bacon, Roy de Maistre, Robin Ironside, Bryan Robertson and Alfred Hecht.[92]

By 1963 Anderson's intolerance of John was coming to a head. He wanted to replace him as quickly as he could and it led to an uncomfortable year for John internally as he clung on in the face of the Board's hostility. On 21 March the Board rejected John's proposed purchase of a picture by his old friend Albert Houthuesen, and even John admitted that he had given a poor showing in front of the Board because he had not produced enough pictures as possible Chantrey purchases. Anderson had reacted by sending the Board round the London art galleries in taxis to see what was available and they had reconvened a few hours later with plenty of suggestions. This failure by John played into Anderson's hands. It triggered a hostile letter dated 29 March from him, with grumbles about John's performance and the request to come to the next Board meeting with his retirement plans. After John discussed this letter with Anderson, another similar letter came the next day, 'insisting on my discussing "future" at next Board meeting'. Anderson was now hounding John towards the exit. A lunch between them followed a week later to re-inforce the message in the letters; at the Board meeting on 18 April 1963, John duly read out a statement about his retirement, which was received by the Trustees in silence, then by a vigorous attack over various issues by Adrian Stokes and Lawrence Gowing.[93]

With nothing triggering his departure, however, John simply remained in post, noting the snubs from the Board as they occurred. At their meeting on 20 June 1963, Lawrence Gowing 'reacted with contempt' to John's suggestion that Michael Ayrton be considered as a Trustee.[94] This cannot have been a comfortable situation for John. Nominally he was still the Director, with no doubt some pride

derived from his long experience but with little or no influence on the Board. By late November 1963 Anderson was telling him that the Board wanted him to stand down sooner rather than later because they had decided to take the unprecedented step of promoting one of their own number, Gowing, to the job of Director. No sooner had this been reported to John than the Civil Service Commission blocked Gowing's appointment without an open competition for the position.[95] John hung on into the new year, but it was only a question of time.

The year 1964 opened ominously for John. The Government grant had been increased and when the news was received Anderson had immediately discussed it over lunch with Reid without even mentioning it to John, whose views on the subject were no longer of interest to the Board.[96] In response to what should have been an innocuous article in *Time* magazine about the Gallery by John on 9 January, two days later he received a 'most unpleasant letter' from Anderson, telling him that the piece was 'really rather offensively misleading where the Arts Council are concerned. They are not mentioned at all and all the credit for the shows they have given us has been "scooped" (the reader may well believe) by us – or even by you'. Anderson had felt it necessary to write a grovelling letter to Lord Cottesloe and Gabriel White at the Arts Council to apologise.[97] John sheepishly wrote to *Time* asking them to print a clarification.

As part of his remorseless campaign Anderson required John to draft the advertisement for his successor. By as early as 13 January, John was 'speculating about Colin Anderson's motives for continuous attempt to force me out and to undermine me'. Whatever the motivations, even John realised that the turning point had been reached; he at last began preparations to leave. At dinner on 27 February with Bryan Robertson he was sounded out about the succession to his position and in March he was offered a job for three years as art adviser to the publishing division of the British Printing Corporation.[98] This was the excuse for which John had been waiting to leave, with some dignity intact as he could move straight into another position.

The decision to go having been taken, aspects of the process played to John's tastes. The diary records him debating with himself the 'technique' for announcing his retirement. John loved this kind of publicity issue, at which he regarded himself as an expert, and on 25 March he briefed various friends in the press.[99] Anderson, ironically, having spent so long urging John to retire, was not keen that he should announce it when the Board's replacement plans had been thrown up in the air by the need to hold an open 'competition'.[100] He wanted to give the impression that the Board was in control by announcing John's replacement at the same time as his retirement, but the timing was against him and John's diary suggests, in a faint echo of Leeds years earlier, that he was enjoying manipulating the situation with the press to antagonise his Chairman.

The retirement was eventually announced on 2 April 1964. John gave interview after interview, to press, radio and television, exhausting himself in the process.

In contrast, as if to remind himself that he retained the affection of the artists themselves, he spent that evening carousing with Bacon and Freud. The next day, John was 'overwhelmed by the press acclaim', noting that Reid was annoyed with him because the *Daily Telegraph* carried a photograph of him in the Conservation Department, which Reid regarded 'as his special preserve'.[101] This was still rankling with Reid forty years later when he was interviewed about his life. When discussing his relationship with John, whom he described as 'not an easy man', he highlighted this photograph as typifying John's attitude of taking credit for things happening at the Gallery, which particularly annoyed Reid.[102] It shows some similarity with the trouble in January over the article in *Time* magazine.

Although John was delighted with the favourable press, at the next Board meeting, on 16 April, Anderson did not mention John's position and pointedly asked Alley rather than John to choose a picture to lend to Melbourne. The staff were unsettled as they waited to see who their next Director would be. Gowing was unhelpfully behaving as if he were already the Director and it was also rumoured that Robertson was a candidate. It was assumed that, of the two, Robertson was John's preferred choice, and this led to another squabble with Reid, who in front of other staff accused John of writing to the Board to support Robertson. Reid now had an eye on getting the job himself as the compromise candidate and, again, the tape forty years later makes it clear that he was horrified to find that, having asked Rothenstein for his support, he did not have it, after all the support he had loyally given him during the Tate Affair. John had even written Norman a pompous letter asking for a 'clear explanation' as to why Norman had accused John of supporting Robertson.[103]

The confusion around the appointment of his successor amused John no end; he perversely described the summer of 1964 as 'one of the happiest times of our lives'. On 28 July he told Colin Anderson and the Treasury that he intended to leave on 30 September and a few days later he heard that Reid had been appointed.[104] In these last months of his time at the Tate, John's attitude to Reid does not put him in a good light. He described with relish a *Sunday Times* interview with Reid on 2 August as being 'contemptuous' of him and his qualifications for the job; there was no hint that John took Reid's side. He then recorded in his diary that Reid had 'a very mean side' and, showing the gulf of understanding between them, expressed astonishment that Reid had 'said no syllable of appreciation about what I have done for him to me, still less in public or at all'.[105] John was unable to see what Reid might have been thinking about John's lack of support for him.

At the staff leaving party at the Tate on 29 September, John recorded that Reid was distinctly frosty to him.[106] At the final event to mark his retirement, a Trustees' dinner, Anderson had the last laugh, making a speech about John which John said contained no mention of his achievements at the Tate. It was a shabby ending to a turbulent and controversial twenty-six years.[107]

PART 4
Writing History

CHAPTER 13
The Autobiography

Those who write about the past always have an agenda which may or may not be apparent; the writer of an autobiography has multiple agendas and the facts can be manipulated to accommodate them. Some part of every autobiography is intended to settle a point, to create a version of the historical truth which suits the author's purpose. In John's case there were, by the mid-1960s, many points he wanted to settle. The three volumes were not an honest attempt to write the story of his life up to the end of his time at the Tate: they were the case for the defence.

The first volume, *Summer's Lease*, came out in 1965.[1] He had finished at the Tate the previous year and, since he was no longer constrained by being a Civil Servant, there was no time to waste before publishing the story of his life as seen from his point of view. In particular, it was essential for John that he got his version of his life at the Tate published before anyone else did. According to statements made towards the end of his third volume, published in 1970, (p. 204) he had begun writing an autobiography in the mid-1950s, that is, just when the Tate Affair was finished, even if the writing had not been completed until after he had left the Tate.[2] The timing suggests that the primary motive for writing an autobiography had been to set down his account of the Tate Affair. He had the precedent of his father before him and may have wanted to match the three volumes of *Men and Memories*.[3] If so, it was the final act in the long saga of competition with his father and his father's achievements; John balanced admiration and emulation of him against wanting to be seen to have been more successful.

The trouble with the first thirty-seven years of his life covered in *Summer's Lease* was that not much happened of any interest. That volume was merely preparatory for what followed in *Brave Day, Hideous Night*, which was heavily focused on the Tate Affair. Much of what John had to say in the first volume was reflective of his father's life – all those famous people he had known, in Paris and in London, and all his many connections with the British art world. John padded along in the background, a relatively shadowy and insubstantial figure, meeting some of the artists his father knew and getting to know them. The other category of artists John makes a point of noting were the young British ones who came into his world through being students at the RCA when his father was its Principal from 1920 onwards. These were indeed to be vital to John's later reputation as the writer of *Modern English Painters*.

John's account of his schooldays is perfunctory; it is a vehicle to carry the momentous event of his conversion to Roman Catholicism. This explained to the

world two things which were fundamental to the way John wished to be perceived: he was not the same as his father, and he was not Jewish. John's account of his Oxford life splutters along. He can hardly use his career there to burnish his academic credentials against later allegations that he was unsuited to become Director of the Tate, as he finished with only a third class degree. He does meet people who later became important, such as Evelyn Waugh, but he was not a significant member of that gilded undergraduate generation. His experience at Oxford combined with a characteristic inherited from his father to turn John into the voracious socialite that he became when Director of the Tate, as reflected in the diaries. The ever perceptive Max Beerbohm caught the effect of Oxford on John succinctly: 'I think he is one of the people for whom Oxford is no great good. He loves it dearly, but I don't think it enriched him with much beyond some expensive friends and habits'.[4]

Volume one falters in trying to maintain momentum through the obvious doldrums of the post-Oxford period of 1923–32. The dreary years when he was hanging around in London doing little of interest were followed by the relatively pointless American interlude, in which he wasted his time lecturing in insignificant history of art departments on trite subjects to bored undergraduates. Not surprisingly, John found it difficult to give any vigour to his account of those listless years.

One activity which filled quite a lot of John's spare time at many stages of his life after Oxford was writing books. Unfortunately, from the point of view of enhancing his later academic reputation, as even he acknowledged, his earlier books were poor. His self-criticism in *Summer's Lease* of *The Artists of the 1890's* does him credit:

> The book, published in 1928, was vitiated by many and serious faults:
> the historical introduction was too long and appropriate to a study of far
> wider scope; a number of obvious subjects, William Nicholson and James
> Pryde, for instance, were omitted for no valid reason; opportunities of
> recording illuminating facts, now irrecoverable, were missed; it was without a
> bibliography – in fact, it was a very amateurish affair [p. 139].

Then came Leeds and Sheffield. The account of these years in *Summer's Lease* gave him his first opportunity to prepare the ground for negating the allegations against him during the Tate Affair. It suited his agenda to show himself triumphing over powerful individuals closely involved in the galleries for which he was responsible. Both Alderman Leigh and Alderman Graves were subjected to heavy caricature, bordering on ridicule. They were, in John's tendentious account, ignorant of what was required to run a modern art gallery and, whatever their civic status in the local community, they were portrayed as being no match for him. Instead of sensibly leaving him to his own devices, they foolishly intervened to make his life difficult. The North is presented as a strange, alien world, full of ignorant people dabbling in an art world of which they knew nothing. Some passages make for painful reading. John was capable of writing caustically about people he sought to demean.[5] Here he is, for example, on Leigh's way of speaking:

Reporting the arrival of the Stubbs to Alderman Leigh, I must have spoken
in a tone too low to be clearly heard, for he exclaimed, 'What! Stoobs in town?
You ought to have told me; I'd like to have given him a little loonch at Queens.'

'No, I meant Stubbs' picture', I explained.

'But where's Stoobs himself?'

'As a matter of fact, he's dead.'

'Stoobs dead!' he exclaimed, striking his forehead in affected grief, 'when
did he die?'

'Oh, time passes, Mr. Alderman.'

'I want to know joost when he did die.'

'1806, Mr. Alderman.'

'Oh', he said. [p. 195]

And on Alderman Graves's house and art collection in Sheffield:

On this occasion we had stayed at his big gloomy house in Ranmoor Road,
where he showed us his collection. It was an eerie experience. The pictures,
almost all of them English and predominantly Victorian, and mostly of
mediocre quality, were hung from floor to ceiling in a series of rooms,
originally servants' bedrooms, at the top of the house. The windows had been
boarded up and there was total darkness except for the fierce beam from
the electric lamp carried by our host, which he directed upon each picture
successively, at which visitors were compelled to look for as long as it suited
the wielder of the lamp, which was often disproportionately long. 'Watson,
Weekes, both fine artists; just look at that splendid Henrietta Robertson; my
first Stanley Wood, a great painter', he would say, holding the works of these
nonentities long and lovingly in the beam of light. [p. 200]

Leigh had died in 1938 and Graves in 1945, so they could be defamed with
impunity. Given that John owed his appointment in each case to the benevolence
and encouragement of these men, and that his experience at Leeds and Sheffield
led him to the Tate, his freely expressed criticisms of them do not show John's most
attractive side.

His treatment of Yorkshire, whether as a place to live or to work, was dismissive.
The connection with his father's family was played down, but it also did not suit
his desired sophisticated and metropolitan image to emphasise that his father's
origins were in Bradford. Whatever the reason, Yorkshire was not acknowledged
so far as John personally was concerned as Rothenstein home territory; the reader
was under no circumstance to think that a posting to Leeds or Sheffield was, in any
sense, 'going home' for John.

In his eagerness to demonstrate his superiority to these leaden-footed northern-
ers, John trips himself up. He pays great attention, in recounting his resignation
from Leeds, to the use he made of the press. As has been seen in Chapter 4, he used

it but not to his advantage; he tried but failed. Where he made a mistake in using the autobiography to prepare the reader for his handling of the Tate Directorship was in making no secret of how he himself was happy to use the press. When it suited him, it was a legitimate tactic, in other words; it was only not acceptable when others used the press in the same way. Had he reflected on this, he might have realised that an account of the Leeds resignation would not help him later to criticise the tactics of those, such as Sutherland and Le Roux, who used the press effectively during the Tate Affair, whether to attack him or to publicise their own resignations.

When describing his time at Leeds and Sheffield, John is on surer ground, in terms of pre-empting later criticisms, when he praises the sturdy support he got from senior members of staff in both places. At Leeds, the key figure was Ernest Musgrave: 'a reassuring figure, resourceful, imperturbable, conscientious, courteous, and above all dedicated' (p. 194). That is, the reader is intended to register that he was the exact opposite of David Fincham and Le Roux Smith Le Roux and that John was happy to give generous acknowledgement to loyal subordinates. Similarly, at Sheffield he found George Constantine and Betty Dunster. Again, without spelling it out, the implication is that they were saints by comparison with other staff later. Constantine, for example, 'combined an exacting standard of personal conduct with a charitable and amused understanding of human weakness, a directness of thought and speech rarely met with' (p. 222). Betty, meanwhile, was 'intelligent' and 'wholly trustworthy' (p. 223). John records no difficulties with these compliant subordinates. His sublimated message is loud and clear: he was an excellent manager of staff as long as they were loyal and knew how to behave.

John was not pleased to find that the *New Statesman* had given the book to John Richardson to review. Richardson's review of John's introduction to Bacon's catalogue raisonné in the *New York Review of Books* on 25 March 1965 had not been gentle or appreciative of John's thoughts on Bacon. The review of *Summer's Lease*, on 3 December 1965, also began ominously: 'Catholic converts, like wartime collaborators, are usually scorned as much by those they side with as by those they side against', not a flattering comparison. Even more alarming for John was the warning shot fired at the end of the review about what to expect in the next volume, covering the Tate Affair: 'The reader cannot help wondering as he finishes the first volume how Sir John is going to acquit himself. Since it shows little interest in the major artistic developments of this century, and either denigrates modern art or sees it as a provincial London Groupish affair, one can't be particularly sanguine.' John was not happy, particularly if this was an indication that Richardson might be given the next, far more controversial, volume to review. He promptly wrote to the former editor of the *New Statesman*, Kingsley Martin, complaining and saying it was not fair that known critics should review his books, as they would not be impartial.[6]

Other reviews were either blandly amiable or mildly bored. It was quite difficult to get excited about the book. *The Times* said on 14 October 1965: 'There are times when *Summer's Lease* is less than compelling'. It preferred the accounts of

Leeds and Sheffield, when at least the subject of the book actually did something, rather than just observing what his father was doing. Christopher White in the *Times Literary Supplement* of 30 December noted that 'the over-awing personality of his father runs as a leitmotif throughout this book'. Anthony Curtis in the *Sunday Telegraph* on 17 October was impressed that, having inherited a well-known name, John had managed to make it well-known all over again in his own right. Patrick Anderson in *The Spectator* on 19 November thought it beautifully written. Malcolm Eaton in *Apollo* in May 1966 perceptively commented that 'to cultivate a view-point of his own, it was necessary [after Oxford] to put as great a distance as possible between himself and the celebrity-haunted household in which he had grown up'.[7] T. G. Rosenthal in *The Listener* on 4 November 1965 thought that the book showed 'the classic father and son problem'. He was also mildly deflating: 'One cannot pretend that as autobiography it goes very deep. There is little of the penetrating psychological awareness that runs through the great English autobiographies of this century'.

The second volume, *Brave Day, Hideous Night*, was published soon after the first, in 1966. Writing this part, whose story began in 1938 with John's arrival at the Tate, John was able to draw on the detailed diary which he had started to keep in August 1939 when war was imminent. Facts and anecdotes recorded in the diary often found their way verbatim into this volume; the problem came, in terms of historical accuracy, with the linking passages between the facts. These had to be created in the 1960s and were the method whereby John's agenda was achieved.

An excellent example of John's method when he wanted to twist the facts to suit his purpose is his description of his time in America in 1939–40. This, as has been seen, had turned into a public relations disaster for John, its flimsy purpose stretched to breaking point by his refusal to return to England. His account does its best to build up a considerable case as to why John was encouraged by the American Division of the Ministry of Information to travel to America and Canada in the first place: he was to foster goodwill with the American people and to secure information about trends in American public opinion about the European war. This may have been the visit's origin and initial external justification, but no one could have imagined that John would need to take seven months to achieve it.

The daily record of the trip in the diary, written at the time and unaffected by any later agenda, is without material reference to its alleged purpose: as noted before, it resembles nothing so much as John's later diary of social events. Travelling gaily around the cities of America and Canada, as Hitler made preparations for the complete destruction of Western democracy by the invasion of Western Europe and the Russians did their bit with the invasion of Finland, John appeared in the diary not to have a care in the world. In *Brave Day, Hideous Night*, he describes the 'anxieties that afflicted [him] without cease about [his] own country' (p. 74), no trace of which was recorded in his diary. He was, in the autobiography, desperate to return; in reality, he was reluctant.

Reprising how well he got on with loyal subordinates and how they were to be contrasted sharply with disloyal ones, he emphasised how well he got on with Robin Ironside, who could do no wrong, as compared to David Fincham, who had no redeeming features. One reason for favouring Ironside was that he had the quirky, disordered character of an artist, which John found amenable and which he could respect, whereas Fincham was just a drunken bore in John's eyes. The internal event which John could not bring himself to write about at all was the trouble involving Humphrey Brooke, Honor Frost and the affair of the Publications Department. For a start, those involved were still alive and potentially litigious and Brooke had made it clear during the Tate Affair whose side he was on. It would have been difficult for John to have described the disruptions without veering into dangerous legal territory; somebody other than the Director would have to have been blamed. Secondly, it would not have been easy to write in an accurate way which, without impugning Brooke or Frost, to avoid a writ for libel, yet put the Director in a good light. So he simply omitted the whole episode, which had caused him great trouble and sleepless nights at the time.

The scene was set, post-war, for John's account of life at the Tate to gear up for the big event which the book had been anticipating. To make a contrast with what followed, he chose to present the years between 1945 and 1952 as a golden period. It has been seen that they were not. He wants the reader to form the impression that, with the right sort of Chairman (Charteris or Ridley) who knew how to handle a clever Director and with unity between Chairman and Director against outside threats (the Chantrey business, for example, and demands for picture transfers to the National Gallery), all could be well in the life and administration of the Gallery under John. But if the relationship faltered (Jowitt, Proctor) in the face of rebellious elements inside and outside the Gallery, trouble ensued which no normal Director could be expected to withstand. John does not want the reader to get the slightest sense that any of the problems which in the 1950s almost overwhelmed him were his fault. The Director's only possible fault was a charming naivety in the face of ruthlessness and there was no helping that.

At some point in the description of events from the later 1940s to the end of 1954 the book departs from reality. The Tate was not always a happy place between 1945 and 1952; the sorry litany of events which triggered the different phases of the Tate Affair were neither unfortunate, immaterial lapses nor irrational assaults from inside and outside the Gallery by those with their own wicked agendas, although there were elements of both. The events of 1952–54 were caused by the Director's failings, whichever way one looks at them. Other parties took advantage of the failings and magnified them for their own reasons, but their chance to do so came because the Director made a series of avoidable mistakes.

Areas of Gallery life abound on which John's account in the autobiography is misleading. The hiring and retention of Le Roux is a good place to start, given how fundamental a cause this was for what was to follow.[8] John does not attempt

to deny that all responsibility for hiring Le Roux lay at his feet; once Le Roux arrived at the Gallery in March 1950, he immediately began to work his mischief. In order to demonstrate close attention to the administration of the Gallery, John cannot say that he was unaware of what Le Roux was doing: he has to assert that he quickly realised Le Roux's shortcomings, even though this is not apparent from John's contemporary diaries. Having set himself up to be challenged on why he did nothing about Le Roux in the early days, if he was aware of his failings, John has to come up with a reason which puts him in a good light.

In the middle of describing two whole years (1950–52) of increasing unhappiness over Le Roux's behaviour and performance, John justifies not doing anything by noting that he felt 'a serious obligation' to make Le Roux's appointment work, 'misgivings or no misgivings'. John 'hoped that his performance of his duties would improve'. In what can barely be read without incredulity, he even says about Le Roux's obsession with perusing Gallery files: 'Reading the files was an apprenticeship of sorts, and a time would come, I thought, when, curiosity satisfied, he would take up his share of our day-to-day correspondence and administrative routine' (pp. 237–8).

John 'persisted in the obstinate conviction that with proper guidance he could become a valuable member of the staff' (p. 238). One knows where that story ended. Far from becoming a valuable member of staff, Le Roux almost succeeded in destroying John's Directorship. Alternative explanations – either that it took John a long time to notice Le Roux's seriously untoward behaviour because he was not interested in the detailed administration of the Gallery, or that he buried his head in the sand and hoped that all would somehow be resolved without confrontation involving him (rather like when he passed the Dawson matter to Jowitt) – are not countenanced. Cooper's friend, Richardson, had this to say about John's account of his dealings with Le Roux: 'Brave Day, Hideous Night … includes 150 pages of exculpatory whining about the Tate affair. Granted, the memoir establishes Le Roux's villainy; it also establishes the author's innate silliness and lack of authority in allowing his deputy to spend months in the archives digging up evidence of his boss's lapses.'[9] The extensive evidence of John's weakness as a manager is fully displayed to the reader, but not acknowledged or accepted as such.

This seems to have been John's way of dealing with evidence of his own shortcomings. The next thing to go wrong was the Zsa Zsa Gabor episode. In John's account this was 'trivial'; the offending photograph was taken when he was temporarily not present; the transparencies of the photographs which arrived in advance of publication for his approval were too small and numerous for him to bother looking at; and, of course, no proof of the text of the offensive article was ever submitted to him. Nothing in relation to this incident was his fault; the reaction was an over-reaction, all Le Roux's doing (pp. 247–9).

The film to be partly made at the Gallery was definitely not his fault either. John's involvement with such a venture was motivated by the highest feelings:

'Ever since my first years as a gallery director in Yorkshire it had been my prime ambition that the mass of the population should learn to use art galleries'. So he had promoted the film as a way of advertising the Gallery; no mention of the fact that, as script writer, he stood to make money from it personally, until the Treasury pointed out that it would not look ideal as a senior Civil Servant to be making some money on the side by using his own work premises. Admittedly, in negotiations between himself and the film production company as to the terms on which they could use the Gallery, he made what he passes off as 'a verbal slip' which led to an awkward misunderstanding, but the ensuing farrago was out of proportion to the substance of the matter. Again, it was all Le Roux's fault for raising it and Jowitt's for listening to him. In reality it was an 'entirely absurd matter' (pp. 249–51).

John had to work a bit harder to write his way round the saga of the Degas bronze. The episode merits a twenty-page chapter (pp. 260–281) of excruciating boredom, the length suggesting that John felt he was on the back foot in this case and had to pay it full attention if its dangerous implications were going to be retrospectively neutralised. There was no serious suggestion, apart from by Le Roux and the Cooper claque, that John had sought to make money from the purchase and all investigations (by Jowitt and by the Treasury) exonerated him from this charge. But still there was no doubt that his processes when negotiating its acquisition and getting Board clearance had been slipshod and inadequate and had given his enemies the ammunition they needed to challenge him. This is not apparent from John's account. In these twenty pages there is no self-criticism.

The method John was using to create history and to defend himself – admitting no fault – reached its apogee in the case of the maladministration of the trust funds. A reader of the autobiography who had no access to the underlying documentation or the accounts of others involved, such as those of the Tate Trustees in their many meetings, would be forgiven for wondering what all the fuss was about. There was hardly any maladministration in John's account; just a few small errors of allocation, of a type which any public body operating with a small staff could make and which disadvantaged nobody. There was certainly nothing which the Director had done, or omitted to do, which suggested any fault on his part (pp. 302–26). If anybody was to blame, it was Norman Reid, 'the Deputy Keeper in charge, among other things, of Trust Fund affairs' (p. 303). How Reid took this little aside in 1966 is not recorded. He might have been surprised to find that the trouble over the trust funds was somehow his fault, loyal as he had been at the time and throughout his long employment at the Tate in support of his Director. Could it be that by 1966 John had forgotten what he had written on 30 January 1954, when the Board was reeling from its investigations into the trust funds? 'May I express to the Board my most deeply felt dismay and regrets about all that has come to pass? … I do wish to express to the Trustees my profound contrition and my sincere and earnest sorrow for the errors that have occurred under my administration.'[10]

What John took away from Reid's reputation with his little aside, he made up for with a glowing encomium earlier in the book:

> Over the years of my directorship there was none whom I took so fully into my confidence; I can recall no problem that I did not discuss with him in what eventually became our daily meetings. To his happy combination of initiative and caution I owe much. These meetings I found as enjoyable as they were fruitful, for Norman is a genial companion with a lively sense of the comedy of the human situation, in particular as it is to be encountered in the dangerous little art world of London. [p. 226]

The press started to pick up on *Brave Day, Hideous Night* in August 1966. The Atticus column of the *Sunday Times* on 7 August had a piece about it which was significant, because the unnamed journalist rang Sutherland and Cooper and managed to get their unrehearsed reactions. Faced with unexpected questions on the telephone, Sutherland made the incredible comment: 'I was never in any collusion with Cooper or Le Roux', and Cooper 'practically exploded on the telephone at the mention of Rothenstein's name. "It's all lies, lies, lies! Rothenstein lies from morning to night." He then went on to call him an imbecile, unscrupulous, dishonest and other names, but calmed down a bit at the mention of the fight. He didn't want to discuss that'.

The *Daily Express* reported, on 4 October, that Cooper, while confirming that he had not deigned to read the book, had heard that John had quoted from his letters. This infringed his copyright and he was going to sue John. He did not, of course.[11] It would be interesting to know if he ever actually sued anyone or ever appeared in court to support his claims. On 5 October next day the *Evening Standard* quoted Humphrey Brooke saying the book was 'mainly a work of the imagination'. The *Spectator* on 7 October remarked on the art world which John had to deal with: 'The community was disturbed, in the late forties and early fifties, by a degree of bitching and feuding rare even by its own standards'. *Brave Day, Hideous Night* was widely reviewed in the Sunday papers on 9 October. There was considerable sympathy for John. Raymond Mortimer, for example, concluded in the *Sunday Times* that he regarded John 'as the victim of shameful injustice'. There was also puzzlement over what the whole Affair had been about. Anthony Curtis in the *Sunday Telegraph* wondered: 'The social historian of the future may perhaps see it all as a strange off-shoot of the post-war art boom in Britain: rival groupings in mortal combat over who should be the final arbiter of public taste'.

Not everyone was so understanding. The *Observer*'s art critic, Nigel Gosling, thought: 'Even from his own account Sir John emerges as abnormally egocentric, self-deceptive, disingenuous, tactless and a bit naïve'. One day, he wrote, someone should make a film about it all 'and it will be a comedy'. 'As in some nightmare version of the nursery-tale, the little piggies Huffed and Puffed but the Big Bad Wolf just wouldn't budge. After all, his house stood on stout Treasury foundations.'

Norbert Lynton in *The Guardian* on 7 October thought the account of the Tate Affair 'an ugly but fascinating story, oddly lacking in heroes or ultimate benefit'. He also thought: 'Sir John himself appears as a rather careless, enormously credulous, but altogether well-intentioned director'. In contrast, Kingsley Martin, the former editor of the *New Statesman*, a journal always regarded by John as an enemy of the Rothenstein family, had his own letter published sweetly apologising for having hounded John at the time of the Affair, but saying in his defence that he had relied on what he thought was good evidence at the time. The actual review in the *New Statesman* (on 17 October), by Robert Melville, was reasonable and remarkably cheeky about Cooper.[12] John was so surprised to get a decent review from the *New Statesman*, after Richardson's review of *Summer's Lease*, that he wrote to the editor to thank him. The editor wrote back to say that the great litigant had, of course, threatened to sue them about Melville's comments.[13] John's friend Iain Hamilton, writing in the *Illustrated London News* on 15 October summed it all up nicely: 'London's art world, and especially the contemporary art world, is a small dense jungle abounding in venomous reptiles and malicious contagions'.

John received all sorts of letters after the publication of this second volume but among the most welcome must have been separate handwritten letters from Kenneth and Jane Clark of 24 October.[14] Kenneth's said that he was horrified by what he had read of the Tate Affair, which he, surprisingly, said he had not known much about at the time. He knew nothing of Le Roux and disliked Cooper, whom he avoided. He thought Jowitt came out of the story almost worse than anyone else. Since Clark would have known all the participants apart from Le Roux, was a former Trustee of the Tate, a close friend of Colin Anderson and at the centre of the British art world at the time, the chances that his claim of lack of knowledge is true are not high. He would have known if only from the publicity what was happening to John and the Tate and perhaps was feeling guilty, after reading John's account of what it felt like to be on the receiving end, that he had not said a public or private word in John's defence at the time.

For the third and final volume, *Time's Thievish Progress*, which appeared in 1970, John reverted to a style which his father had adopted in the course of his *Men and Memories*. In the absence of much in terms of events, there was little point to the book other than to recount stories about painters and people whom John had known and which he had not squeezed into the first two volumes. The British artists mentioned had often been covered in earlier books and there was not much new to say about them. A few modern foreign artists who had not featured heavily elsewhere in John's writings – Giacometti, Chagall, Rouault – were mentioned so as to balance any impression that John was only interested in British art, and Churchill got a chapter to himself.

When bringing matters at the Tate up to date after the conclusion of the Tate Affair, John found little to say; it is telling that one short chapter was sufficient to cover the final ten years (1954–64). After the drama and excitement of the

previous ten years, there was little to compare, only a certain amount of bathos. The number of art reference books in the Tate library increased as the function slowly became more professional; the administration of the Gallery was made to run more smoothly once Norman Reid was properly in charge; and John's secretary, Corinne Bellow, was a helpful and efficient person. There were Directorial achievements, of course. John's account has him setting up a new Conservation Department, soon to be 'recognised as one of the best anywhere and something of a show place for foreign and other professional visits' (p. 148). Reid would have had views on that characterisation insofar as it might suggest that John had created it. The catering in the Restaurant was improved; the Friends of the Tate were established; the Irish theft came and went; somebody smashed the winning maquette for the *Unknown Political Prisoner* competition (back in March 1953). The feeling of the writing is of diminuendo; the space is filled, but the passion has been spent.

Towards the end of the book, the old combatant John comes back into focus. He decides to set down his thoughts on the trustee governance structure. Needless to say, in the light of his own long experience of government by trustees, he is not entirely favourably disposed towards them as a form of governing body. They are too independent; they are, in fact, 'dictators'. They can as such only be controlled by a good chairman: 'The efficacy of the trustee system of government is dependent, then, upon the chairman's being a man of preternatural endowments'. When he began at the Tate, he found the more aristocratic Trustees to have a more appropriate idea of their role than the later 'artist-Trustees and … knowledgeable men belonging to the same sort of world as the Director and his staff'. The latter did not understand how to be good Trustees: they brought forward work, for the Board to consider for purchase, without necessarily discussing the work with the Director or his staff (pp. 192–9). John does not acknowledge that this tendency, post the Tate Affair, was exacerbated by Proctor's attitude to John, which encouraged the Trustees to behave in this way. It was not so much a feature of a modern style of trusteeship as a specific response to what the Chairmen (Anderson as well as Proctor) regarded as a necessary foil to John's weakened authority.

The penultimate chapter of the book, 'The Daimon of Progress', has an elegiac feel, its title reminding the reader of Wyndham Lewis's 1954 book called *The Demon of Progress in the Arts*. After many interventions over the years in his books in the public debate about the meaning of art, and modern art in particular, this chapter has the feeling of a threnody, a drawing together of thoughts previously expressed in different places. It also has the feeling of someone speaking with authority and experience. John was a serious historian of twentieth-century art, particularly British art, in among the vicissitudes of his working career.

He begins with a simple description of what he calls the 'progressive enfeeblement' during the century of 'the once widely inspiring Western European tradition' based on the imagery of the natural world. The challenges to the traditional way of painting introduced by artists such as van Gogh, Gauguin and Cézanne

could be accommodated as startling developments of, rather than breaks with, the tradition; not so Cubist works by Picasso or Braque, or work by Kandinsky or Duchamp. They had broken with all traditions. The Second World War saw the transformation of the art world and the post-war world saw artistic traditions totally replaced by 'a variety of movements' (pp. 222–40). Pushing against a defensive attitude of those representing the academic artistic establishment, by which John must have meant the Royal Academy in this context, newness in art became something revered in itself, which was a mistake, the concept of progress in art being misunderstood: 'the general assumption that prevails is that innovation is desirable in itself and likely to be an improvement on what has gone before' (p. 226). Allied to the destruction of regard for traditional artistic forms and training came the influence of abstraction. Here John took the position that abstraction could not be as important as the best representative work and gave cogent arguments for his belief (arguments which would have found favour with other academic commentators on the art world at the time, such as Kenneth Clark). The qualities of traditional, realistic art can be accurately gauged; there are yardsticks to measure the achievement of the artist. The product of purely abstract artists cannot be objectively tested: they are a 'class apart' (p. 229).

Another change in John's lifetime in the art world was that: 'Artists came to regard themselves not as a modest élite with wide-ranging sensibilities and responsibilities but rather as unique individuals capable of producing a primary self-expression of spirit through pure emotion' (p. 232). John noted, rightly, the power of the network of important dealers, with their "stable" of artists being promoted in all ways, sometimes creating reputations higher than those not so well-represented. He also saw the economic pressure which had driven the creation of the print market, and its vast size compared to the tiny production (and purchase) of original, highly priced works of art by an elite few (pp. 234–5).

Writing in the late 1960s, as he looked out over the artistic activity all around him in London John could see little which offered any hope of traditional art being restored to its historic primacy. All he could see was a multiplicity of short-lived experiments by people calling themselves artists, with barely any traditional artistic skills of drawing or painting and with no understanding at all of the profound traditions of Western European painting. It was impossible to make any rational, objective sense of the contemporary art world: 'We have our individual intuitions – the basis on which judgments must be formed – but they are increasingly difficult to bring to bear in the prevailing flux' (p. 239).

This book got a good response from Michael Holroyd in *The Times*, on 29 August 1970, saying that it was 'a rich and rewarding work that will delight all those interested in the artists of our day'. An unnamed reviewer in *The Observer* of 30 August thought that not much of it was memorable and that it was 'in the nature of a dish of petits fours after two substantial and spicy courses'. The old Tate attaché, John Russell in the *Sunday Times* the same day thought that a strong

theme emerged of 'an ever-increasing discontent with the state of art itself. It is as if no one worth naming had emerged in English art since 1945'. Patrick Marnham in that day's *Sunday Telegraph* said that 'an unexpected aspect of the book is the way in which the author presents his professional and his social life as one mixture'. Tom Driberg in *The Listener* of 24 September thought that the book, 'written with the most exquisite care, stops on the correct side of indiscretion, and is almost too kind and respectful to most of the people he writes about'.

Taken as a whole, the autobiography was a misshapen thing. Cantering along at a sedate and normal pace, it was suddenly brutally disrupted by the long and anxious account of the Tate Affair.[15] It may be that John saw his life like that, but a more accurate account would have seen battles cropping up throughout his public career, of which the Tate Affair was a culmination. Once it was finally over, there was not much else to say. John retired from his public life in 1964 in relatively good order and went on to produce more books on artists he liked, such as Stanley Spencer and John Nash.[16] In his later years he was much in demand to write introductions to exhibition catalogues, often for artists who were old friends.[17] He had a long writing career and a long life, living for more than twenty years after the publication of the final volume of the autobiography. Sadly for him, the huge emphasis he placed on the Tate Affair, rekindled in many of the reviews of the second volume, meant that the public perception of John's career was dominated by those terrible years, occluding the variety of achievements for which he was responsible at the Tate and elsewhere over many years.

CHAPTER 14
Modern English Painters

The three volumes of *Modern English Painters* were the outstanding achievement of John's life as a writer.[1] They survive as a monument to his long apprenticeship in studying contemporary British[2] artists and their work; they encapsulate what he was best suited to achieve as a commentator on twentieth-century British art. They demonstrate how his critical approach to that art did not follow a Modernist theoretical path: it did not follow any theoretical path, being developed from what he liked and what he thought to be good work, based upon his vast experience. John therefore made no deliberate contribution to the debate about what art should seek to achieve, as he considered each picture pragmatically. This meant that his chosen artists cut across all theoretical boundaries and he happily wrote about, for example, religious art.

The first volume, published in 1952, was dedicated to John's favourite Chairman, Jasper Ridley, who had died in October 1951. The book had been a long time in the making.[3] Throughout his life, John had been meeting artists. He came to know them socially and he learnt for himself, through conversations and visits to their studios, what they were trying to do with their art. Nevertheless, when he wrote about them, he regarded their work critically, rather than sycophantically, learning to grade each artist's work within the artist's own production and as against other artists'. He had no fear in recording weaker periods of an artist's production, even if his critical acumen was diminished when appraising the work of his particular favourites, such as Matthew Smith, Wyndham Lewis and Stanley Spencer. By the time the third volume (*Wood to Hockney*) was published in 1974, this series was, cumulatively, a considerable achievement.

What was the genesis of this work? From an early date he made notes of his visits to artists' studios, such as one to see Edward Burra at his studio in Rye in 1942, in preparation for his book on the artist in the Penguin Modern Painters series.[4] He was forming impressions which he wanted to record before they were lost. One of the original triggers for this approach was his interaction with his father. John learnt to analyse the work of an artist by studying his father's work and by talking to him about it. When he was living at home, especially after Oxford and before he went to America, he spent long periods talking to William about art and artists,[5] learning about the artists of his father's generation. The scene was set for the pre-war books.

After the slight volumes on his father's portraits and on Eric Gill, the first to set the scene for *Modern English Painters* was *The Artists of the 1890's* (1928). The

limitations of John's early theorising about the artist's place in society, gleaned from talking to his father and to Gill, were noted earlier (see Chapter 4). Where possible, though, he based his accounts on meetings with the artists themselves. His selection may have been guided by his father, but he learned that the immediacy and validity of his impressions, and therefore of the quality of what he could write, would be improved if he met the artists himself.

A good illustration of John's early deployment of the technique which later shone out of *Modern English Painters* was his treatment of Walter Greaves. Born in 1846, he was eighty when John first went to see him to talk about his life and work: 'I went down to his little room in the Charterhouse to find one of the most delightful old men I have ever met: enthusiastic, serene, utterly without guile or ill-will'.[6] What followed in *Artists of the 1890's* were the rudiments of what developed into John's mature writing about living artists. It was rudimentary because the largest part of the Greaves entry appeared to be an unmediated transcript of what he had said to John at their meeting.[7] John was so pleased with having captured the artist's views that, nearly forty years later, he reproduced the passage verbatim in *Summer's Lease*.[8] In a further consolidation of what became his method, John interviewed the other artists to be discussed in the book who were still alive in 1927 (Wilson Steer, Charles Ricketts and Charles Shannon). He hardly needed to interview his own father.[9]

Thereafter, notes survive from the 1930s of his thoughts on artists such as Cyril Mahoney, Edward Ardizzone, Geoffrey Hamilton Rhoades, Edward Bawden, Albert Houthuesen, Percy Horton and Evelyn Dunbar.[10] Not all were included in *Modern English Painters*. Over the years he also occasionally published articles on individual artists (such as one on Henry Moore, *Yorkshire Telegraph*, 5 May 1934). Notebooks with notes on more artists (such as Gwen John) survive from the later 1940s onwards.[11] Slowly, the ground was being prepared for work to begin on *Modern English Painters*. The first volume covered Sickert to Smith, chronologically by date of birth, which involved a tweak to art historians who preferred to group artists, as Cubists or Surrealists, for example.[12] John felt that, particularly with British artists, categorising individuals cut across their differing personalities and was difficult to sustain with artists who were impossible to classify.[13]

John had begun writing the book when he was forty-seven, some time in 1948–49. He soon realised that he was going to have to split the work into two volumes. The Preface to the first was the final piece to be drafted and was dated June 1951. These writing years were busy ones at the Tate but before the disruptions of the Tate Affair. Writing for the second volume later became a therapeutic way of escaping from the stresses of the Tate Affair. John's approach to the book is clear from the Introduction. Readers had learned to be wary of his introductions, with his tendency to use them as platforms for airing his theories of art. This introduction was no exception.

Its first sentence contained a strong statement of the unlikelihood that the twentieth century would be 'accounted one of the great periods of painting' (p. 17). This was a bold battle cry. Writing mid-century, he might have wanted a caveat for such a powerful, possibly foolhardy statement, to allow for anything interesting happening in the next fifty years. It is also impossible to grasp to which period he was comparing the century. The sixteenth century had been decisive in European art, but the seventeenth century and so on? Why was such a strong statement needed? The answer is that it was part of John's long battle against critics like Roger Fry, Clive Bell, Herbert Read, Douglas Cooper, Benedict Nicolson and, probably (if he had troubled to contemplate them), Roland Penrose and David Sylvester – art critics who saw in the artistic developments of the first part of the twentieth century something fundamentally different from, and more important than, what had come before in art. Whether it was worship for Cézanne, the Cubists, Picasso, Mondrian or abstract art generally, there was, as John saw it, a war on foot in the art world. On the one hand, he and others refused to accept any intrinsic superiority of non-British artists or of modern artists generally; they saw art as evolutionary and rooted in traditional skills of representation, and they preferred not to put artists into artificial groups which validated critical theories. On the other hand were critics who sought to identify and embrace the artistic revolutions of the century, sometimes generated by a group of artists aware of each other's work, such as the early Cubists.

The result of this focus on artistic progress and revolution was that, in the hands of many critics, British art had been subordinated to European art during the twentieth century in a way that John did not want to accept. Those who had connived to achieve this unwelcome outcome by prioritising the importance of artists working in France needed to be challenged and their assertions put into the context of all the developments in the art world of the period. The first aggressive swipe at a critic comes on the third page of the Introduction, when Thomas Bodkin is ticked off for being too harsh on Post-Impressionism. John later had trouble with Bodkin over the commission for the mosaics in the Baptistry of Westminster Cathedral, when Bodkin vigorously opposed John's proposal that Henry Moore should do them.[14] Herbert Read, a more substantive opponent,[15] soon follows, attacked for his dislike of representational art: 'This writer, more interested, perhaps, in the philosophical ideas which may be supposed to underlie works of art than in the aesthetic or representational content of works of art themselves, has treated the principal revolutionary artistic movements of our time with a serious objectivity' (p. 19). Read is more fully dealt with in the chapter on Ben Nicholson in *Lewis to Moore*.

Then comes a major attack on Cubism and on the suggestion that it had in some way returned modern art to classicism (pp. 27–30). John did not like or accept that idea. He was putting his head into the mouth of Douglas Cooper in saying so. Cooper did not like what he read in *Modern English Painters* and the first phase of the Tate Affair began only months after the publication of the book.

The Introduction ends with a passionate defence of English art against French art: 'I am conscious of the national prejudice, the parochialism, the personal affections that may have gone to the formation of my opinion, but I am conscious also of the obligation to place on record my conviction that no such gulf in fact exists, and that the English school shows no less excellence than the French and considerably more interest' (p. 39). The Introduction had begun with a battle-cry and it ended with one. Anyone seeking to criticise the purchasing policy of the Tate under John Rothenstein, as focusing on English art at the expense of European art of the period, had been handed their ammunition by the Director. If he wanted to persuade the art world that the Tate under his leadership would have been only too happy to buy modern foreign work as well as British art, if only sufficient funds had been available, this Introduction cut across that idea. It is ironic that John's own taste in art was broad and not limited to figurative British art. On the walls of his home in Chelsea there were, for example, works by the Russian artists Natalia Goncharova (two early Constructivist pieces), and Mikhail Larionov, an abstract by the Spanish artist Antonio Saura, two semi-abstract pictures by the Australian Roy de Maistre and works by Alan Reynolds.[16]

Amongst the taunts to critics, John explained how he had selected the artists for the book (by instinct) and the way in which he had chosen to write about them. He was making an important point. In the great cultural debate which threaded its way across the analysis of twentieth-century painting and literature, about whether the personality of the artist or writer mattered compared to the work, he was on the side of those who thought it did. Therefore, in writing about his chosen artists, he wrote of their personalities: 'But are we not moved yet more deeply by the works of art which we are able to see in relation to the personalities of the artists who made them, or against the background of the society from which they came? It is my conviction that we are' (p. 21).

The essential attribute which John brought to bear on his work, where he knew the artists (increasingly the case for the second and third volumes), is his often acute psychological insight. Most other art historians could not, or did not, do this, either because they did not know the artists in the same way or because they did not accept that artists' personalities mattered. There was nothing contrived about John's approach. He talked or wrote to most of the artists to get their biographical details accurate[17] and to hear from them directly what they hoped to achieve in their art and how they were going about it.

Although there were many serious writers publishing commentaries on living artists' work in newspapers and journals (for example, in the years after the war, Alan Clutton-Brock in *The Times*, Eric Newton in the *Sunday Times*, Maurice Collis in *The Observer* and Patrick Heron in the *New Statesman*),[18] no one else regularly wrote about modern artists like this. The art criticism of several of these writers could be collected and compared to *Modern English Painters*. Apart from the fact that they approached their subjects objectively (not usually based on personal

knowledge of the artists), their commentaries were mostly of the moment, commenting on particular shows. John's pieces, by contrast, were neither journalistic nor academic; illustrating no critical theory, they were compressed biographies, of which there were few in print, certainly at the time of publication of the first two volumes. When *Sickert to Smith* was published in 1952, few of the seventeen artists had been the subject of a biography or monograph. In the case of *Lewis to Moore*, published in 1956, one artist had been (out of sixteen) and by the time of *Wood to Hockney* in 1974, eight (out of sixteen). Writing in detail about individual artists was becoming more common. John's way of writing *Modern English Painters* was likely to appeal more to a general reader interested in learning about the art world than to the academic concerned to approach art theoretically. The books were biographical rather than art historical.

Moreover, by the late 1940s John had matured into a good writer. The style, free from its pre-war characteristics, was able to align itself with the book's objectives. It was ten years since he had last written a sustained book (on Conder) and the format of *Modern English Painters* suited his style better than a full-length biography. He wrote best in a series of pithy vignettes, in sharp and revealing aperçus about the artist's foibles and characteristics. In the short format of a chapter, those pearls shone out more clearly and with greater effect than they could in a full book. The concision of the format forced him to avoid padding; few words were wasted and theorising was kept to a minimum. Several of the more important or favoured artists received pieces like full essays. In the first volume Sickert was given the most pages, 17, and Matthew Smith (a close friend of the author's) 16.[19] Many others were covered in 8 or 9 pages. John knew that some artists deserved more words than others, and he also wanted to fill in missing public information about artists who had not been widely covered.

Given the standing of some of the other artists, this emphasis was fair. Several might not feature in a survey written now. Whereas it would include Sickert and Smith, would it Ethel Walker, Henry Tonks, James Pryde, Harold Gilman, or Ambrose McEvoy? Not much has been written about some of those artists, even now. Where was Charles Conder, born in 1868 so within the book's dates for consideration, who had been included in *Artists of the 1890's* and merited his own biography only ten years earlier? Where was Aubrey Beardsley, born in 1872, again one of only ten artists to merit a chapter in *Artists of the 1890's*? The answer to both questions – would they be included now and why were some omitted – is that artists' reputations change. John's tastes had changed over ten or twenty years and modern taste has changed again. Conder was borderline as a suitable subject in 1938; by 1952 he was out of the question. There is little to criticise about the choices made for *Sickert to Smith*, written in the late 1940s. It would become more meaningful to criticise the selection as the years passed and later editions of *Modern English Painters* emerged.

The first volume attracted widespread press attention. The review in *The Times* (18 June 1952) was straightforward: 'The criticism expresses the point of view of

a writer who was brought up among the artists of his father's generation and is still loyal to some among them who are no longer regarded with admiration'. This theme was picked up by Derek Hudson in the *Spectator* on 20 June. He thought the author might have been too indulgent to the artists he preferred and he was 'over-chivalrous' to the three women covered (Frances Hodgkins, Ethel Walker and Gwen John). For modern taste he was too generous to Ginner and Gore and had got himself in a muddle trying to analyse Pryde. The reviewer in *The Listener* on 3 July thought the author's presence was 'overpowering', but that was to misunder-stand the type of book John was writing, where his personal connections and views lay at the heart of the structure. Generally, for example in the case of John's old friend Allan Gwynne-Jones, in the *Sunday Times* on 29 June, reviews were encour-aging, with occasional teases (such as Pierre Jeannerat in the *Daily Mail* on 6 June asking where Sir Alfred Munnings was).

One of the more thoughtful reviews appeared in the *Daily Telegraph* on 6 June. Written by the competent landscape artist Stephen Bone, the son of the well-known Scottish artist Sir Muirhead Bone, it engaged in a mature way with the omissions and inclusions. Bone wondered why his own father had been omitted, together with Sargent, Charles Shannon and George Clausen. He also queried the justification for Charles Ginner and thought John had over-estimated Hodgkins. However, he found the studies of William Orpen, Gwen John and Ethel Walker excellent, and overall thought it a fascinating book, accepting that the author proceeded on the basis that pictures were produced by human beings rather than by movements and that a study of the artists' personalities was thereby justified.

By the time these reviews were appearing, John was already beavering away at the next volume, accumulating stories and notes, and sprucing up those written earlier, as he embarked on artists more central to his own life's experience than many of those in the first volume. When *Lewis to Moore* appeared in 1956, it was dedicated to Vincent Turner[20] with a quotation from Montaigne.[21] With its preface dated October 1955, it had largely been written during the years of the Tate Affair. A few decisions on inclusion or not were noted by John: no Ivon Hitchens, Allan Gwynne-Jones or Henry Lamb (p. ix and pp. 119–120). John had started on the last, who had been a Trustee representing the RA from 1944 to 1951, but Lamb had refused to co-operate (perhaps because of the Tate Affair, as he had recently called for an inquiry into the Tate). The absence of Hitchens and Gwynne-Jones was explained, oddly enough, in the chapter on Nevinson (whose own inclusion had been borderline, apparently; pp. 119–20): John pleaded that his 'mind [was] insufficiently attuned to be able to appraise the elusive iridescence of the art of Ivon Hitchens' (p. 119). This was strange, as the artist himself pointed out to John when he wrote to him following publication, offering to help him attune himself. John was well able to tackle the work of the more challenging British artists and Hitchens hardly falls into that category. Maybe John was concerned about causing offence. In Gwynne-Jones's case, John's note that he 'works with serene consistency in the

finest academic tradition' does not explain his exclusion (p. 119); the implication is that John thought the work too dull. This book covered more living artists than the first (in which only two were alive at the time of publication). Given that both were published when he was Director of the Tate Gallery, with considerable power over its purchasing policy, they could affect the reputations of those artists, especially when most of them had not yet been widely covered in print. As an example of John's alleged influence on an artist who was dead by the time of writing – Edward Wadsworth – it is said that, even in 1990 some found it difficult to look at Wadsworth's work without thinking about John's estimation of him and his work as being rather cold, callous, impersonal and inhuman.[22]

John never shrank from publishing his opinions, even when he knew they would cause controversy. On the second page of the first chapter, on one of John's favourite artists, Wyndham Lewis, he lashed out at people he associated with 'Bloomsbury' who had shown hostility to Lewis. Without naming these critics, apart from Roger Fry, who was dead (his other main target being Clive Bell, who was still alive), John described their 'ruthless and businesslike' methods; the extreme lengths they were prepared to go to 'in order to ruin, utterly, not only the "reactionary" figures whom they publicly denounced, but young painters and writers who showed themselves too independent to come to terms with the canons observed by "Bloomsbury"[23] … I rarely knew hatreds pursued with so much malevolence over so many years; against them neither age nor misfortune offered the slightest protection' (p. 14). It is curious that this criticism comes in the chapter on Lewis, whose own capacity for savage criticism of other artists was notorious. John's position was simply the latest phase in the long antipathy between the Rothensteins and Bloomsbury, originating in the exclusion of William from the Post-Impressionist show in 1910.

The next chapter, in an odd juxtaposition, was on Duncan Grant, definitely a Bloomsbury artist, It gave John an opportunity to develop his theme about Bloomsbury to include Fry's attacks on his father and, 'one way or another', on John himself (in the *New Statesman*, a Bloomsbury vehicle at one time and later of the attacks on John's Directorship, as noted earlier). Despite excluding Grant from his criticisms, he got a long letter from Grant strongly objecting to the Bloomsbury passages and denying that Fry had any sort of vendetta against either of the Rothensteins.[24] John attempted to pacify Grant by saying that he would look to adjust his comments in later editions, but this did not prevent Grant from writing further letters whose substance remained unanswered. In 1957 John was pleased to record that he had had a long and amicable meeting with Grant in which the Bloomsbury debate had been avoided.[25]

At the same time John was subjected to a barrage of letters from Bell's son Quentin. The latter had published a measured review in *The Listener* on 11 October 1956, for example making the fair point that the author 'finds most, I think, in the paintings of those artists in whose work and life he can see the effect of spiritual passion' (referring to John's treatment of Stanley Spencer and David Jones).

Quentin Bell was only mildly critical in print on the Bloomsbury passages, about which he grew increasingly heated in private. Similarly, from another name linked to the Bloomsbury past, Raymond Mortimer, came a review in the *Sunday Times* on 30 September 1956, which thought the book 'lively, biased and thoughtful'; in private he had written to John strongly complaining of the Bloomsbury passages.

The other main controversial feature of *Lewis to Moore* was the relatively short chapter on William Roberts. He was difficult to please and took offence at John's account of his relationship with Wyndham Lewis. What led John to be personally rude in his case is unknown, but Roberts was thoroughly traduced: he had 'shown little inclination for intellectual discussion and indeed little interest in the operations of the intellect'; he was 'temperamentally tough, rigid, unsubtle, sardonic, joyless and unresponsive'; he had 'a rather charmless combination of qualities'; his work consisted of 'representations of puppets neither noble nor endearing but rather absurd in their brutality and mirthlessness' (pp. 285, 286, 287). Given that Roberts was still making a living as a painter and thus his reputation was vital to him, this public obloquy from the Director of the Tate Gallery was highly provocative. Roberts's reaction was to publish in February 1957 a pamphlet attacking John's account, called 'A Reply to my Biographer Sir John Rothenstein'. He had already published three pamphlets commenting on the *Wyndham Lewis and Vorticism* exhibition at the Tate in 1956 (particularly on the catalogue essay, which had been written by John with input from Lewis), so he was spoiling for a fight.[26] Roberts's pamphlet, described by John in his diary as 'snarling and untruthful',[27] is rather entertaining. He wonders why John was so rude about him and why he had not checked his biographical facts beforehand, as a number were wrong, based on only a few minutes' old conversation.[28] His main grumble was that, after long friendship with Lewis and wholesale adoption of aspects of his version of art history, John could not be objective about other artists whose careers had overlapped with that of Lewis. This was perhaps a fair charge. Roberts believed that the consequence was an unfairly biased and hostile account of his work and achievements. John published a reply in the *Times Literary Supplement* on 29 November and ultimately the matter petered out.

That chapter illustrates John's method when the artist concerned was neither one of his particular friends nor one whose work he knew well. Roberts realised that John must have got some of his material on him from Lewis but had not acknowledged that; the text, consistent with others, appeared to be written from John's personal knowledge of the artist and his work. Moreover, in later editions John did not trouble to accommodate any of Roberts's remarks, even the factual corrections. What he did do was subtly to adjust Roberts's position in *British Art since 1900* (1962), which was written in 1957 after Roberts's reaction had emerged. In a list of those regarded as 'members' of Lewis's Rebel Art Centre, all editions of *Modern English Painters* included Roberts; in the later book his name was omitted, it having been one of Roberts's points in his pamphlet that he was not a 'member'.

In the chapter on Ben Nicholson, John violently attacked Sir Herbert Read and his interpretation of abstract art. Treatment of Nicholson's work was deferred for many pages whilst John set about Read's aesthetics. He saw Read as the high priest of writing about abstract art which made incomprehensible claims for its superiority to representational art. 'The philosophy of abstract art, in all the inflation of its currency and the high-flown and tense seriousness of its diction, is unsound from top to bottom.' Deducing that Read's approach to 'reality' was drawn from Plato, John gave his own analysis of what Plato meant for the study of art, disagreeing with Read and not resisting several snide comments about Read's qualities as a philosopher (pp. 270–78). One would assume that, if he were not one before, Read would have become an enemy of John's after reading this chapter. In fact, John had worked with him as recently as 1955 when the Tate had held its Nicholson exhibition, for which Read had contributed to the catalogue. John had written him a fulsome letter thanking him and looking forward to lunch the next day.[29] When he bumped into Read in February 1957 at one of Derek Hill's parties, he noted, with a hint of relief and surprise, that Read 'seemed in no way offended by my book'.[30] It is more likely that Read had not read it or did not in any event care what John said. Read's interests in modern British artists overlapped with Rothenstein's; he edited or introduced a series of monographs on the work of Moore (1944), Nicholson (1948), Paul Nash (1948) and Hepworth (1952), all of whom he knew personally. The degree of attention which John gave to refuting Read's position on Nicholson may indicate a wish to damage a rival.[31]

In contrast, the chapter on Lowry is a good illustration of John's ability to be objective. He is inclined to be favourable towards Lowry, whom he knew and liked as an individual and as an artist, but not too favourable. This objectivity is not retained by many writers wishing to champion Lowry. John says that he sought to do justice to Lowry's work but that required him to suggest that Lowry's reputation should be reduced from the level accorded it by others. He thought that Eric Newton was right to say that Lowry was not an artist 'of the first rank' but wrong to place him as high as 'among the first of the artists of the second rank … I know of no standard of values according to which Lowry could be placed among the first in a class which would include Goya, Degas, Botticelli, Poussin, Dürer, Brueghel or Constable. Or of any according to which he would stand in relation to such masters otherwise than as a domestic cat to tigers' (p. 85).

Most of the artists in this second volume were covered without controversy. They included such favourites of John's as Lewis, Paul Nash, Stanley Spencer and Moore, who got long chapters, with Spencer's the longest at thirty-six pages. John had known these artists and their work for a long time and thoroughly; what he had to say was relevant and important. In 1956, these chapters were in some cases the most substantive pieces of writing yet published about their work. It may be that the emphasis placed on them helped to encourage a continued focus on them in British art criticism, for all the main artists have now been covered repeatedly in

book form. Whether John's objectivity remained intact when he was dealing with one of his favourites is a different question. The essay on Spencer (pp. 164–199) was written against the trend of much contemporary (and subsequent) criticism of his unique and not universally loved work, as John himself acknowledged. Even here he accepted that, at a certain point in the artist's career, the quality of the work had declined.

The chapter on Paul Nash is a subtle piece of writing. Nash presents difficulties for the art critic. His style had varied influences and it is not easy to capture his artistic essence or exactly what were his motivations. John has as good an attempt as many others. He reacts to a recent description of Nash simply as imaginative with several pages of analysis, concluding: 'The mind of an artist is a complex instrument, and in attempting to describe the creative operations of the mind of Paul Nash I am aware of having over simplified, but I believe that my description is a little less remote from the unattainable truth than the declaration that he was a great imaginative artist' (p. 116).

This book probably marks the high point of the volumes of *Modern English Painters*. John was still near enough to the heart of the contemporary British art world to write with assurance about the artists' careers and work, which he was constantly seeing in their studios and galleries; he was attuned with his subjects. By the time later volumes and editions came out he was getting old; he had left the Tate (and the centre of the London art world) in 1964 and his understanding of and sympathy with contemporary British art was less sure.

Press reaction to *Lewis to Moore*, with the sour exception of Benedict Nicolson[32] and setting aside the Bloomsbury comments, was fairly good.[33] Several critics thought his long history with Stanley Spencer meant that John was particularly insightful on him. Anthony Bertram's review in *The Month* in December 1956 can stand for others. As the author of *A Century of British Painting 1851–1951*, Bertram was well placed to comment:

> Sir John is not directly concerned in these books with aesthetic theory nor with giving an overall account of the period he has covered. These things are incidental but in a short review it is not possible to discuss the individual studies. Obviously they are of unequal value. Sir John is an autobiographical critic: his judgments are personal and he records them with disarming honesty. He does not set up to be a dogmatic adjudicator. That is a great relief. It is what makes the book so much more readable than criticism based on a rigid and systematised theory of aesthetics. On the other hand, as a Catholic, he judges from a position of established values outside aesthetics which is an immense advantage. It compels him to escape the common heresy of treating art as an isolated activity. His whole treatment, indeed, is enormously refreshing because it reintegrates the elements which modern specialisation has divorced. He uses biography and autobiography, art-history, criticism,

theory and documentation – indeed, whatever means he likes – to get at the characters of his painters and of their works. The result is a rare humanism set in a pattern of even rarer superhuman values.

No sooner had that volume been published than John began on a book commissioned by Phaidon covering similar ground. *British Art since 1900*, published in 1962, had been written in 1957.[34] It had the significant subtitle *An Anthology* and was composed of an introduction of thirty-four pages followed by 155 pages of mostly black and white illustrations. Its scope overlapped with *Modern English Painters* and attempted to provide a coherent account of British art's evolution. This involved much discursive writing about nineteenth-century artistic trends, reopening territory familiar to readers of John's pre-war books.

Ultimately, John knew that it was difficult to summarise in all their diversity artists such as Stanley Spencer, Wyndham Lewis and Paul Nash and his narrative of the post-war period lost its will to do so. Some reviewers debated whether he had included the right artists. Terence Mullaly in the *Daily Telegraph* of 17 May 1962 thought the book was good but missed out candidates such as William MacTaggart, Anne Redpath and Sheila Fell. Eric Newton in *The Guardian* of 22 October thought that everyone would choose about sixty per cent of those chosen by the author. Other reviewers (such as Denys Sutton in the *Sunday Telegraph* for 20 May) correctly thought that the book was stronger on the art of the first two decades of the century and the anonymous reviewer in the *Times Literary Supplement* of 7 December thought the book should have stopped in 1940 or 1945. John's old friend and supporter John Russell was particularly unimpressed, telling John that the book was 'unworthy' of him.[35] Russell's review in the *Sunday Times* for 20 May said that John revealed his lack of knowledge of recent artists working in England, providing a long list of those who were not mentioned. He made the barbed comment that John 'deserves our respect for his courage in upholding a whole fistful of unpopular points of view'. Russell was so critical of the book that Elizabeth Rothenstein wondered to her husband whether he was in cahoots with Douglas Cooper (he was not).[36] The truth was that John's ability to keep up with developing British art was diminishing; like most critics, his tastes had been formed in earlier times; it is fairer to him to say that he had done well to accommodate Freud and Bacon, rather than criticising him for failing to encompass younger artists in the contemporary art world.

Twelve years later, in 1974, John at the age of seventy-three belatedly published the third volume of *Modern English Painters*, covering Wood to Hockney.[37] This had a terse preface of less than a page, reiterating the basis on which all three volumes had been prepared and including a sharp dig at Fry and Clive Bell, the latter having died since the publication of the second volume: 'No doctrine was more false than the view of Roger Fry and Clive Bell that to the contemplation of a work of art we need not and should not bring any of the emotions of everyday life.'

John noted that he had known all the artists represented except Christopher Wood, who had died young in 1930. Many readers will have turned first to the chapter on Graham Sutherland to see how John had managed to navigate between fairness to Sutherland and revenge for his behaviour over the Tate Affair. The monograph on Sutherland by Cooper had been published in the meantime (in 1961), making sensational claims for the high status of the artist's work. By contrast, John's treatment of Sutherland was nuanced. He praised aspects of his work and noted its occasional 'temporary loss of direction' and 'disparate quality' (pp. 63, 64). In effect, it damned Sutherland with faint praise. Far from the Titan portrayed in Cooper's study, here he was cut down, no more (or less) important than other artists featured.

John's preferred artists – Piper, Burra, Hillier, Bacon – got favourable treatment, although not all were brought up to date in any detail. Piper's extraordinarily wide range of productions could not realistically be covered in a single chapter. Compared to the earlier volumes, there was more now to criticise in terms of the artists selected. Houthuesen was a rogue inclusion, based on friendship rather than objective assessment. Hayter was also a surprising choice in this company. Quirky omissions were those artists sometimes bracketed as Neo-Romantics – John Craxton, Vaughan and John Minton, all now darlings of the saleroom but less prominent in the early 1970s. Nor did most of the artists working in Cornwall, many tending towards abstraction, get a mention: Terry Frost, Heron, Hilton, Lanyon or Bryan Wynter. Ayrton, Coldstream, William Gear, Josef Herman, Kenneth Rowntree, William Scott and Weight might also have been considered. Cecil Collins was an odd choice amid these omissions, reinforcing the idea that John liked to include artists with a foot in the spiritual world, even if they were in no sense mainstream. He made a telling comment about how some of his preferred artists had been treated: 'Like Roy de Maistre, Edward Burra and Albert Houthuesen, Cecil was never favoured by the establishment. When I brought examples of their work before the Tate Trustees they invariably treated my admiration for it as a symptom of personal idiosyncrasy, to be treated sometimes with tolerance, at others with tight-lipped reserve' (p. 140). History suggests that the establishment and the Trustees were right, except for Burra.

The chapters on Pasmore and Bridget Riley gave John another opportunity to wrestle with abstract art, all the more difficult in Pasmore's case because the artist had suddenly changed mid-career from representation to abstraction. John, like everyone else at the time, struggled to explain it and decided that this was an aberration on Pasmore's part, rather than a development constituting artistic progress (pp. 145–6). The chapter on Riley was, considering his starting point, generous. John saw her as one of those rare artists 'whose essential self is expressed in the language of abstraction' (p.212). On that basis he could respect her work.

It is mildly fitting that the last artist to appear in the long series, David Hockney, had, like John's father, been born in Bradford and had attended the same school as William. With John no longer in the public eye, the volume was not widely

reviewed. In the *Sunday Times* of 3 March 1974 William Feaver found its occasional irrelevant details a trying distraction.[38] He felt that the coverage was best on Ceri Richards, Burra and Collins. By 1974 the *New Statesman* and *The Spectator* had lost interest in John Rothenstein and did not publish reviews.

John's last consolidation of *Modern English Painters* came in 1984, when they were republished, again in three volumes. By this time John was eighty-three. There were various changes to the artists included, albeit no exclusions from first publication, but little change to the original judgements. Limited factual updating was made, with references to deaths, later exhibitions and so on, but none of John's opinions were changed, which gave the books an outmoded feel. It is doubtful if he had reviewed in any detail the work the artists had been doing for the previous thirty years. Several choices of additional artists were peculiar. To make room for these additions, the format required re-ordering who was in which volume.

Volume one now covered Sickert to Lowry with no new artists. Volume two now stretched from Nash to Bawden with five new artists: John Armstrong, Edward Bawden, David Bomberg, Barnett Freedman and Percy Horton. Of these the odd choice was Horton, whose status was below that of the other artists. Freedman was a borderline choice in 1984 but he and John had been friendly for years and it could be said that he was an excellent artist who had by that time simply become unfashionable. In any event, his inclusion is another example of the loyalty which John showed his old artist friends.

The new third volume covered Hennell to Hockney and the newcomers were Catherine Dean, Elizabeth Frink,[39] Thomas Hennell, Eric Ravilious, Alan Reynolds, Michael Rothenstein and Euan Uglow. Apart from Dean, who was Houthuesen's wife and another old friend of John's, this was a respectable list of additions.[40]

Richard Calvocoressi, who was then a curator at the Tate, and only just born when the Tate Affair started, reviewed the new edition in *The Spectator* of 17 November 1984 (again, there was no review in the *New Statesman*). He said that John had always disliked Bloomsbury and that his 'Scepticism is extended to groups and movements in general, most foreigners and, with one or two exceptions – Bridget Riley, late Pasmore – all abstract painters. The ideal Rothenstein artist is therefore British, realist or figurative, and "an individual"'. This represents the view of a commentator who had not experienced the books as they originally emerged or the Tate Affair at first hand and indicates how John's tastes as a writer on twentieth century British artists were coming to be characterised by a younger generation.

Conclusion

John Rothenstein had a long and rich career in the British art world of the twentieth century, as a writer and as the director of three public institutions, but it is his career at the Tate Gallery which dominates his reputation. The case for saying that he was one of the most successful Directors of the Tate requires a definition of what constitutes 'success' in Tate Directors, predecessors and successors, each of whom faced different challenges. It could be argued that he was more successful than his predecessors, at least. To do him justice one needs to view his active career in the round, beyond his years at the Tate, to record his considerable achievements at Leeds and Sheffield, as a writer and as a vigorous and effective supporter of many artists. At the provincial galleries he fought against local prejudice to establish the interests of twentieth-century British art. In the job at the Tate for twenty-six years, he had to deal with a difficult inheritance from Manson, no Government grant, a shocking relationship with the other main London institutions and little public or critical respect for the Gallery and its ramshackle collections. No sooner had he arrived than he had to start planning for the Second World War, which brought an evacuation of the collection and massive physical damage to the building in Millbank, such that the immediate post-war years were spent performing heroics of administration to reinstall the pictures in a building fit to contain them. Other Directors inherited different problems; apart from Sir Nicholas Serota, none has had to wrestle with them for as many years.

Bryan Robertson, sympathetically observing John from the smaller and less controversial environment of the Whitechapel Gallery, noted in a panegyric given after John's death in 1992 that he had been unorthodox in his views on artists, with what he called 'a soft spot for the awkward ones'.[1] By this he meant John's loyal and sometimes significant support for Francis Bacon, Edward Burra, David Jones, Wyndham Lewis and Stanley Spencer, all of whom were outside the mainstream of twentieth-century British art and whose careers benefitted from John's actions, not all of which concerned the Tate Gallery. Robertson also saw John as a 'serious and gifted writer' and a 'great stylist', which he was. As the director of an art gallery which had a trustee structure, Robertson could see what had happened to John's career at the Tate: he had stayed too long in the job. Robertson observed that such directors tend to go through three phases: a honeymoon period when they can do no wrong; a middle period when some trustees like them and others start to find fault; and a final phase when the director is regarded as a 'monster, a villain, totally

'incompetent' and the trustees cannot wait to get rid of him. This may have been Robertson's own experience at the Whitechapel, and is not true of all institutions at all times; but there was a grain of truth in what he said when applied to John's Tate career. It is surely significant that amongst those most sympathetic to John were people like Bryan Robertson and Philip Hendy, who had occupied analogous positions.

Robertson was right to highlight John's achievements as an author. Once he had purged himself of the theories of his youth, he moved on to a rich vein of accomplished writing about artists and their lives. His subjective and personal approach to writing about them as people did not mean that he was incapable of assessing them as artists: with few exceptions, he did this with objectivity, skill and insight.

Throughout his years at the Tate, the art world was changing out of all recognition, which is why twenty-six years at that time was too long for anyone to stay in that job and remain effective. The relatively traditional forms of art and the ways of gauging artistic achievement with which John had grown up had dissolved into myriad forms and styles by the time he finished at the Tate in 1964. Due to the Tate's haphazard history, the purpose of its collection was stretched irreconcilably between modern foreign art and the entirety of British art, including sculpture. With little money, conservative Trustees, rising art prices in the international art market and an array of challenges about where to focus the few resources, which would have thwarted and discouraged many in his position, John battled as best he could to promote the Gallery in those areas where he was able to make a difference.

In this he largely succeeded. The Government eventually gave the Gallery an annual grant; relations with the Royal Academy regarding the Chantrey Bequest were greatly improved; those with the National Gallery were regularised and formalised by Act of Parliament; good relations were established with the Arts Council, which arranged a succession of important exhibitions at the Tate as a result, and with the Contemporary Art Society, which provided the Tate with many gifts. One major area where John deserves particular credit is in the encouragement he gave to the appreciation of American art in this country. He had good relations with his counterparts in America which he used to promote exhibitions at the Tate of art which may not always have been to his taste.

Behind the furore often surrounding the Gallery and its Director in the 1950s, the Tate gradually acquired a seriousness of purpose which changed its public status. John's role as lightning rod for criticism enabled those working under him to pursue their scholarly ambitions relatively undisturbed and with his direct encouragement. Twice John had to build up a staff which he found demoralised (in 1938 and in 1945). With one or two mistakes, he achieved this brilliantly and by the mid-1950s, it is easy to forget amidst the chaos of the Tate Affair, he and Norman Reid had hired and brought on many excellent members of staff. The curatorial staff by then included Reid, Ronald Alley, Mary Chamot, Dennis Farr and Martin Butlin, who made a formidable team. Despite allegations that John was a bad manager, he

was able to ensure that working conditions at the Gallery encouraged these people to flourish.

As the art world changed around him, John also had to adapt to six different Chairmen of the Trustees, with their differing characters, styles, priorities and effectiveness, and to an evolution of types of Trustees, from the relatively hands-off ones of 1938, who acted as Trustees out of a sense of duty and looked to the Director to run the Gallery for them, to the much more engaged and intrusive Trustees, including some untrustworthy artist ones, of the 1950s. John learnt the hard way that the fact that a Trustee was an artist did not guarantee loyalty and support to him.

By the time he finished, the administration of the Tate was on a footing which was unrecognisable to those who had dealt with the Gallery in 1938. If John had not singlehandedly caused all the changes, he had been the Gallery's external representative and figurehead whilst changes happened around him and so personified to the outside world what the Tate became during his time as its Director. By 1964 there was a successful Publications Department, a Conservation Department, scholarly catalogues of the collection and a professional library of art reference books; the Friends of the Tate was a well-organised entity providing valuable support to the Gallery (including from America); there were underlying processes which delivered a fully functioning national art gallery. Furthermore, the collections had changed for the better under John's Directorship. Most of the gaps in the British collections had been filled, at his direct and skilful instigation. It was John's particular achievement that the Tate also acquired work by all the great contemporary British artists.

On developing the foreign collection he had done his best in circumstances in which his hands were tied. The Trustees had often let him down (when, for example, he had put before them works by de Stäel). Those wishing to find fault with the Gallery and its administration could point to the flourishing art market and ask why, compared with say MOMA, the Tate had not snapped up works by great modern foreign 'masters' on the London art market. The answer was that the Tate never had enough money to match its multitude of priorities. It was not a significant buyer in either the British or the international art markets as post-war prices escalated. If the art world criticised John and the Tate for not acquiring major Cubist works, for example, their criticisms would carry greater weight if they focused more on John's predecessors and pre-war Trustees, on the absence of material Government or private funding, than on John himself. Of the Cubist works from the first twenty years of the century, many were by the end of the war in American institutions or in the possession of the prodigiously wealthy collectors who had seized on them as symbols of their status. Picasso's work had been shown in London at both the Post-Impressionist shows put on by Roger Fry, in 1910 and 1912; the Leicester Galleries held a show of his work for sale in 1921, as did Reid and Lefevre ten years later. In November 1919 the Leicester had held a show to sell

the work of Matisse. The fundamental damage to the ability of the Tate to build up fully representative collections of twentieth-century foreign art was done long before John arrived.

Yet, if John was so successful, why is history not kinder to his memory? Here John was his own worst enemy. Untrained in the administration of a large art gallery or in how the commercial world operated and unsuited to the rigours of either a traditional Civil Service or business approach, and with occasionally wayward instincts when relying on his own judgement when taking decisions and managing people, he made self-inflicted mistakes as Director of the Tate. Failure to check the conditions attached to the trust funds was a shocking piece of amateur management; a manager in the commercial world would not have been surprised to have been sacked for it. John had the misfortune to make mistakes when there were people around him waiting to pounce on any error, for their own disparate reasons and latterly when he could no longer rely on the support of his Trustees. The decision to stay in America in 1940 was a lapse of judgement; the hiring and retention of Le Roux were poor decisions; the treatment of Humphrey Brooke was clumsy and unnecessarily created an enemy; yet the experience of reacting to Douglas Cooper and his friends was not one John caused or chose: nobody in his position would have known how to cope with it.

John's way of dealing with issues exacerbated some of his problems. He tended always to think that he was right. He was aggressive when attacking the reputations of those who seemed to be competing with him, such as Clive Bell and Herbert Read, but thin-skinned in the face of criticism, as repeated entries in his diaries show. When he retired from the Tate, George Whittet, the editor of *The Studio*, perceptively noted in the June 1964 issue, amidst a favourable review of John's career, that 'Journalists have been known to wilt from the sensitivity of the Director of the Tate Gallery towards any slight, real or imagined, that they have committed to print'. John invariably pushed back aggressively against criticism of what he wrote. In the case of criticism of his time at the Tate, he denied that anything was his fault and obstinately assumed the *mala fides* of those criticising him. His obituary in the *Guardian* of 28 February 1992 was headed 'Rothenstein pugnacious art director, dies at 90'. It did not help the later perception of his career that his autobiography was so heavily skewed towards his explanation of the Tate Affair, whose saga has tended to dominate consideration of John Rothenstein's career.

Somehow, through sheer stubbornness and good luck, and the hard carapace of his Civil Service status, together with the sympathy he received in response to Cooper's personal criticisms, John just about survived the Tate Affair. He sailed through the storm and on into the calmer waters of his last decade, the Gallery growing stronger and more effective as each year passed, with John as a figurehead representing the Gallery in the wider world while Reid and the Trustees ran everything in the background. But the Director in his last ten years was a much weakened figure and his decline in authority in front of the Trustees must have

been hard for him to stomach. Perhaps in 1955 he should have taken Proctor's advice and moved to America to take up a senior position there rather than staying on at the Tate. Meeting him towards the end of his career as Director, Anthony Lousada had this to say about him: 'John Rothenstein had been Director for far too long, was a very complicated character, could tie himself into inextricable knots and had been permanently damaged by his upset with Douglas Cooper'.[2] When the end came, it was brutally forced upon him by angry Trustees. Looking back on his twenty-six years, John may not have wanted them to have been so fraught and he did his best to diminish the significance of his problems in his carefully crafted autobiography. He always had the solid achievement of *Modern English Painters* to regard with pride.

John's tastes as Director had in fact been well-suited to the practical task of gently developing the expectations of the public who visited the Tate. He was not by any means a reactionary custodian of the national collection. Those who had relished the pictures in the Chantrey exhibition at the RA in 1949 would have found little favour with John and his taste would not have met with their approval. He cherished the best of British art across its range, right up to and including an artist whose work was widely disliked in his early years, Francis Bacon. Nor was John too progressive, not letting his tastes get too far ahead of those of the public. He resisted examples of contemporary art which he regarded as unproven or ephemeral. There is a telling letter which he wrote in April 1960 to Lord Cottesloe, then the Chairman of the Tate. The Board had agreed to buy a picture by the Russian artist Serge Poliakoff, called *Composition Abstraite* (1954, Tate, 00404). Although the decision had been taken, John was appalled and was writing to give his views, as the Director, on 'a painting with nothing to recommend it … This picture seems to me to be a conspicuously trivial manifestation of current fashion which, in a few years' time, will look no better than the litters of kittens in baskets and the like that were its equivalents in later 19th century England'.[3]

He never thought that the principal duty of the Tate was to espouse the latest artistic trends; nor did he believe that art endlessly progresses and gets better and better and that public galleries should therefore prioritise the most recent productions. He preferred to back his judgement to pick out what he thought was the best work produced at any given time. If his remit had been restricted to British art, he would have been a resounding success.

Did he ever wonder whether he might have made things easier for himself? He surely did. He knew he had shortcomings but he also knew that, fundamentally, he had done a good job for the Tate Gallery, however the role of Director should be defined or tested. What he passed on to his successors was unquestionably significantly better than what he inherited. Most people managing a large public institution in the twentieth-century British art world would have been more than satisfied with such a legacy.

Notes

Preface

1 Only resolved in 2000 with the split of the Tate into Tate Britain and Tate Modern.

2 The 19th-century British sculptor Sir Francis Chantrey had left a large sum of money to be administered by the RA for the purpose of acquiring British art. The problem was that the representatives of the RA decided which pictures were acquired and they then had the right to pass them on to the Tate, where many of them were consigned straight to storage and were never displayed. Since this represented one of the few sources of money which the Tate might have been able to use for acquisitions, the Tate Directors and Trustees found this an increasingly irritating situation.

3 By means of The National Gallery and Tate Gallery Act 1954, which came into effect in 1955.

4 A minor artist, Manson was the Director in 1930–38.

5 Munnings's speech at the RA was also made in the presence of such luminaries as Viscount Montgomery of Alamein and the Archbishop of Canterbury, not to mention the many people listening live on the wireless.

6 Ashton, educated at Winchester and Balliol College, Oxford, was Director of the V&A in 1945–55. He had been Kenneth Clark's best man at his wedding and had been a candidate for the Directorship of the Tate in 1938 when Rothenstein was appointed, at a time when Clark was a Trustee. The interconnectedness of the higher echelons of the British art world in mid-century will become apparent.

7 Clark, educated at Winchester and Trinity College, Oxford, was Director of the National Gallery in 1933–46. He became the greatest and most powerful man in the English art world for many years. See James Stourton, *Kenneth Clark: Life, Art & Civilisation* (London: William Collins, 2016).

8 The Previtali pictures are entitled *Scenes from Tebaldeo's Eclogues* (NG 4884.1).

9 Hendy, educated at Westminster and Christ Church, Oxford, was Director of the National Gallery in 1946–67. Rothenstein knew him at Oxford.

10 8 April 1954, as part of the debate on the National Gallery and Tate Gallery Bill.

11 Gulbenkian, a rich businessman, had assembled an enormous collection of high-quality art, much of which is now in the eponymous museum in Lisbon.

12 Cooper, a knowledgeable collector of Cubist art, was a determined controversialist. Wealthy enough from inherited money that he never had to earn a living, he had worked in the Mayor Gallery before the war. He was violently against British art of all periods.

13 Le Roux, a South African artist and art administrator, director of the Pretoria Art Centre 1940–9, was rashly appointed Deputy Keeper of the Tate by Rothenstein in 1950; sacked in 1954 as a result of the Tate Affair.

14 Reid joined the Tate in 1946, became Deputy Director in 1954, Keeper in 1959 and Director in 1964–79.

15 It ran to three volumes, published over 1952–74; see Sources.

Chapter 1. William Rothenstein's Influence on his Son

1 The correspondence between John and his mother also showed the great love that must have existed between them. This correspondence is not covered simply because there was either less of it or John retained less of it in his archives.

2 John Rothenstein, *Summer's Lease: Being Volume One of an Autobiography, 1901–1938* (London: Hamish Hamilton), p. 252.

3 John Rothenstein, *The Portrait Drawings of William Rothenstein, 1889–1925: An Iconography* (London: Chapman & Hall), 1926.

4 J. Rothenstein, *Summer's Lease* (1965), *Brave Day, Hideous Night: Autobiography, 1939–1965* (London: Hamish Hamilton, 1966) and *Time's Thievish Progress: Autobiography III* (London: Cassell, 1970).

5 However, both William and John actively disliked most music. John's choice of music for the BBC's Desert Island Discs on 1 November 1965, available on BBC iplayer, was peculiar.

6 Charles changed his surname to Rutherston in 1916, as did his younger brother, Albert.

7 There had been inconclusive discussions between Charles Rutherston and Charles Aitken,

then Director of the Tate, about the collection coming to London.

8 Michael Rothenstein's first name was William and much family correspondence with and about him refers to him as Bill.

9 However, William did retain links to Germany, visiting throughout his life.

10 One of the first people William met at the Slade was Charles Holroyd, who was from Leeds and was teaching at the Slade. He later became the first Director of the newly formed Tate Gallery in 1897. William's extensive connections with all the Directors of the Tate prior to John's appointment will be discussed later.

11 The Académie Julian had been founded in 1868 as a private school of art. Both Bonnard and Vuillard were there around the time that Rothenstein arrived.

12 John Rothenstein, *Modern English Painters: Sickert to Smith* (London: Eyre & Spottiswoode, 1952), pp. 121–36.

13 Fry, educated at Clifton College and King's College, Cambridge, was a core member of the Bloomsbury Group, founding the Omega Workshops. Painter and art critic, taught at the Slade, helped to found the *Burlington Magazine* in 1903, later Curator of Paintings at the Metropolitan Museum of Art, New York. Fry studied at the Académie Julian from 1892. Published collected essays, *Vision and Design* (1920), *The Artist and Psychoanalysis* (1924) and *Cézanne: A Study of his Development* (1927).

14 William also knew Robbie Ross (1869–1918), one of Oscar Wilde's closest and most loyal friends. Ross was one of John Rothenstein's godparents, a fact which is absent from the autobiography but which is mentioned by Robert Speaight, *William Rothenstein* (London: Eyre & Spottiswoode, 1962), p. 151. John collaborated closely with Speaight and it is unlikely that such a fact would have been provided without John's knowledge. John does not attach any significance to the fact in his own account of his conversion to Catholicism (see *Summer's Lease* passim), but Ross was also a Roman Catholic.

15 John Rothenstein, *The Life and Death of Conder* (London: Dent, 1938).

16 MacColl became the second Director of the Tate in 1906.

17 By the time Michael was born in 1908, there were four children. There were two girls in between John and Michael, Rachel and Betty.

18 The artist Randolph Schwabe moved to 20 Church Row in 1928.

19 Augustus John describes the method of entertaining people in less than glowing terms in his autobiography, *Finishing Touches* (London: Jonathan Cape, 1964), noting how he found that he needed to fortify himself with a few drinks in the pub on the way up to Church Row. (p. 25).

20 Legendary American art connoisseur, especially of Old Masters.

21 Visiting at I Tatti was a rite of passage for many serious people in the art world of the time, notably Kenneth Clark.

22 In *Modern English Painters: Sickert to Smith*, p. 127, John had this to say about his father: 'In the course of the early nineteen-hundreds he became increasingly marked by an extraordinary earnestness and intensity, an almost fanatical industry and an increasing severity with himself'.

23 William Rothenstein, *Jews mourning in a Synagogue* (1906, Tate, 2116).

24 Tagore became the first non-European to win the Nobel Prize for Literature in 1913.

25 Clive Bell, educated at Marlborough and Trinity College, Cambridge, was an art critic and key member of the Bloomsbury Group, particularly supporting the work of Duncan Grant. Originated the concept of 'significant form' in his book *Art* (1914). Married to Vanessa Stephen, sister of Virginia Woolf. Also published *Landmarks in Nineteenth Century Painting* (1927).

26 Eric Gill, letter to William Rothenstein, 4 May 1932, quoted in Speaight, *William Rothenstein*, p. 362.

27 Michael Holroyd, *Augustus John. Volume 1: The Years of Innocence* (London: Heinemann, 1974), p. 185.

28 J Rothenstein, *Augustus John: Reproductions of his Paintings and Drawings* (introduction). (London: Phaidon Press, 1944).

29 The situation behind such friendships perhaps worked the other way round as well. Those who had actively fallen out with the father may have deliberately or subconsciously sought to sustain friendships with the son, either through guilt at their destruction of the relationship with the father or as some sort of obscure punishment of the father.

30 Stephen Gardiner, *Epstein: Artist against the Establishment* (New York: Viking, 1993), p. 52.

31 Ibid., p. 86; Gardiner refers to this letter of 20 June 1911 but does not provide any reference for its whereabouts.

32 Henry Moore, in *Sir William Rothenstein 1872–1945: A Centenary Exhibition*, exh. cat. (Bradford: Bradford City Art Gallery and Museums, 1972).

33 Gwynne-Jones taught at the RCA from 1919 to 1930, as Professor of Painting from 1923.

34 Sorrell was Senior Assistant Instructor of Drawing at the RCA in 1931–39 and 1946–48.

35 Allan Gwynne-Jones, letter to Lady Rothenstein, 15 February 1945; Alan Sorrell, letter to Lady Rothenstein, 19 February 1945, both TGA 8726/4/43.

36 Particularly insightful into William Rothenstein's appetite for influencing people is Samuel

Shaw's PhD thesis, '"Equivocal Positions": The Influence of William Rothenstein, c.1890–1910', University of York, 2010.

37 Prior to this John had been at King Alfred's School in Hampstead, which had what he described as a 'slightly cranky progressivism'; J. Rothenstein, *Summer's Lease*, p. 5.

38 John Rothenstein, letter to Lady Rothenstein, n.d., TGA 8726/4/5.

39 J. Rothenstein, *Summer's Lease*, p. 23.

40 On Rodmarton see also the beginning of Chapter 4.

41 J. Rothenstein, *Summer's Lease*, p. 22.

42 His grandfather, Moritz, had died in 1915 which may have helped John to decide that he could openly step away from the family's historically Jewish faith.

43 William Rothenstein, letter to John, 2 January 1911, TGA 8726/4/2.

44 How John came to choose Worcester is not known. William knew Dean Inge at St Paul's and he may have lent a hand, as his father had been Provost of Worcester. William later achieved the status of 'member of the Senior Common Room' of the college; John became an Honorary Fellow some years later.

45 William Rothenstein, letter to Max Beerbohm, 5 August 1920, in Mary Lago and Karl Beckson (eds), *Max and Will: Max Beerbohm and William Rothenstein, their Friendship and Letters 1893–1948* (Cambridge, Mass: Harvard University Press, 1975), pp. 112–14.

46 J. Rothenstein, *Summer's Lease*, p. 96.

47 Stokes, educated at Rugby and Magdalen College, Oxford, was an artistic philosopher and a Tate Trustee in 1960–67.

48 Hughes, educated at Charterhouse and Oriel College, Oxford, became famous as a novelist for writing *A High Wind in Jamaica* (1929).

49 J. Rothenstein, *Summer's Lease*, p. 89.

50 John was part of that fortunate generation who were just too young to get sucked into the First World War and just too old to be risked on active service in the Second.

51 Elizabeth, daughter of Lord Ponsonby of Shulbrede, was thought to be the model for Agatha Runcible in Evelyn Waugh's *Vile Bodies* (1930).

52 Elizabeth Ponsonby, letters to John Rothenstein, TGA 8726/5/1.

53 J. Rothenstein, *Summer's Lease*, pp. 82–3.

54 Howard was educated at Eton and Christ Church, Oxford.

55 J. Rothenstein, *Summer's Lease*, chapter 3.

56 John had occasionally trespassed into the artistic milieu that was inevitable in any such account of a certain Oxford at this period, at Garsington Manor. There, from 1914 to 1928, Lady Ottoline Morrell held court and many intellectual figures and artists were to be found for the amusement

of chosen undergraduates invited from nearby Oxford.

57 J. Rothenstein, *Summer's Lease*, p. 90.

Chapter 2. London and America, 1923–32

1 The Savile Club was at 107 Piccadilly until 1927.

2 Alec Waugh, educated at Sherborne, was notorious for his novel about his schooldays, *The Loom of Youth* (1917).

3 Evelyn Waugh, diary entry, 6 April 1925, in *Diaries of Evelyn Waugh*, ed. Michael Davie (London: Weidenfeld & Nicolson, 1976). Olivia Plunket Greene (1907–1955).

4 J. Rothenstein, *Summer's Lease*, p. 97. When the Speaight biography of William came out in 1962, Waugh, whose capacity for caustic reviews is well known, wrote a favourable one (in *Month*, January 1963), with great admiration for the book's subject.

5 Such as Martin Green, *Children of the Sun: Narrative of Decadence in England after 1918* (London: Constable, 1977) or D. J. Taylor, *Bright Young People: The Rise and Fall of a Generation 1918–1940* (London: Chatto & Windus, 2007).

6 J. Rothenstein, *Summer's Lease*, p. 112.

7 Philip Ziegler, *Osbert Sitwell* (London: Chatto & Windus, 1998), p. 112.

8 Ibid.

9 Jean Goodman, *What a Go! The Life of Alfred Munnings* (London: Collins, 1988), p. 239. The Jewishness of Chagall was also noted by the artist Frank Brangwyn, who grumbled in a letter to Elinor Pugh on 1 March 1948 that Rothenstein had bought a picture by Chagall, 'the Russian Jew'; Libby Horner, *Frank Brangwyn: A Mission to decorate Life* (London: Fine Art Society, 2006), p. 256. This would have been Chagall's "Bouquet aux amoureux volants" of c.1934–1947, bought by the Tate in 1948 (Tate, 5804).

10 Sir Lionel Lindsay, letter to Hal Missingham, 10 December 1945, Art Gallery of New South Wales Archive, Sydney.

11 Lousada, educated at Westminster and New College, Oxford, was a solicitor and Trustee of the Tate in 1962–69 and Chairman in 1967–69, Chairman of the Friends of the Tate Gallery in 1971–77, Chairman of the RCA in 1972–79 and Vice-Chairman of the Contemporary Art Society in 1961–71.

12 J. Rothenstein, diary entry, 1 July 1960, TGA 8726/1/31.

13 The *Jewish Chronicle* had treated William Rothenstein as a Jewish artist. See e.g. 'Mr Will. Rothenstein: A Great Artist and his Work', 15 June 1906.

14 J. Rothenstein, letter to the editor, *Jewish Chronicle*, 25 May 1933, not published.

15 It is important to point out that John's daughter, Lucy Carter, does not agree with this supposition.

16 Lucy Carter has pointed out, email to me, 10 February 2017, that John was horrified to hear that two of his Jewish cousins had been murdered by the Nazis during the war.

17 David Pryce-Jones, *Fault Lines* (London: Criterion Books, 2015), p. 239.

18 The question of the Jewish identity of the Rothenstein family at the level of John's father's generation would come up again early in the Second World War, when the fear of invasion became widespread after Dunkirk. Randolph Schwabe's diaries record for 17 June 1940 that the Rutherstons, as Jews, were considering getting their children away to Canada for fear of what might happen to them in the event of a German occupation. The way in which the Nuremberg laws of 1935 defined Jewishness would indeed have meant that William Rothenstein and his surviving siblings would have been categorised as Jewish, whatever their religious faith (which the Germans regarded as irrelevant), because they had four Jewish grandparents. John (and his siblings), with two Jewish grandparents, would not have been so characterised but would have suffered from the consequences.

19 The context of this quote is: "Rothenstein ever after [the Tate Affair] thought that the intellectual homosexual set were victimising him. This and the constant struggle … etc". Anthony Lousada, transcript of interview with Corinne Bellow, TGA 891/38.

20 J. Rothenstein, *Summer's Lease*, p. 119.

21 Ibid., p. 131.

22 Elizabeth Rothenstein wrote a book on the artist: *Stanley Spencer's Paintings and Drawings* (London: Phaidon, 1945). John edited *Stanley Spencer. The Man: correspondence and reminiscences* (Ohio: Ohio University Press, 1979).

23 J. Rothenstein, *Summer's Lease*, p. 97.

24 Ibid., pp. 144, 145.

25 Professor Sax (University of Kentucky), letter to William Rothenstein, 18 August 1927, TGA 8726/5/1.

26 Sax, letter to W. Rothenstein, 5 October 1927, ibid.

27 English-Speaking Union, Kentucky Branch, notice of annual meeting, 29 March [1928], TGA 933.

28 For example, 'Great Britain's Foreign Policy', given to the class of International Relations at Kentucky University, [1927/8] TGA 933/1.

29 John Rothenstein, letter to D. S. MacColl, 12 January 1929, D. S. MacColl Special Collection, University of Glasgow Library, MS MacColl R166.

30 Unidentified Kentucky newspaper cutting, 'Authority on art will teach here this year', [1927], TGA 933/2.

31 John Rothenstein, letter to Mrs Rothenstein, 11 October 1927, TGA 8726/4/5.

32 Mrs Rothenstein, letter to John Rothenstein, 25 May 1929, TGA 8726/4/1.

33 William Rothenstein's portrait drawings first went to the Art Institute of Chicago in April 1928 and then went on to Lexington.

34 J. Rothenstein, *Summer's Lease*, p. 166.

35 Rothenstein, letter to MacColl, 12 January 1929, MacColl R166.

36 See John's article, 'The Spread of Ugliness: The City's Part', *The Listener*, 30 October 1929, pp. 579–80.

37 John Rothenstein, 'The Development of Colour and Design in 19th Century Painting: With Special Reference to the Conflict between the Academic and Revolutionary Traditions'. PhD thesis, University College London, 1931.

38 Bernard Berenson, 3 December 1928, TGA 8726/5/1.

39 Randolph Schwabe, diary entry of 2 May 1930, in *The Diaries of Randolph Schwabe: British Art 1930–1948*, ed. Gill Clarke (Bristol: Sansom & Co, 2016).

40 Constable, educated at Derby School and St John's College, Cambridge, was Assistant Director of the National Gallery in 1929–31, Director of the Courtauld Institute in 1931–37 and Slade Professor of Fine Arts at Cambridge in 1935–37.

41 J. Rothenstein, *Summer's Lease*, pp. 176, 177.

42 He probably meant Keeper of the Department of Fine Art, as the senior position of Keeper did not change at this time.

43 William may have encouraged John to apply for this position in the light of his long association with the NEAC.

44 Schwabe, diary entry of 20 July 1931, *Diaries*.

45 George Clausen, letter to John Rothenstein, 4 February 1932, TGA 8726/3/2.

46 W. G. Constable, letter to John Rothenstein, 6 October 1931, TGA 8726/5/1, had encouraged John to apply to Leeds.

Chapter 3. Leeds and Sheffield, 1932–38

1 J. Rothenstein, *Summer's Lease*, p. 192.

2 *Leeds Mercury*, 20 September 1932.

3 For details of all acquisitions at Leeds and Sheffield, I have relied heavily on David McCann's excellent thesis "Sir John Rothenstein and the Advocacy of British Art between the Wars", PhD thesis, Nottingham Trent University and Southampton Solent University, 2006.

4 J. Rothenstein, letter to Tancred Borenius, 7 November 1932, TGA 8726/3/3. Finnish-born

Borenius became the first professor of the history of art at UCL in 1922; co-founded *Apollo* in 1925; managing editor of *The Burlington Magazine* in 1940–45; wrote numerous books.

5 J. Rothenstein, letter to D. S. MacColl, 28 July [1932?], University of Glasgow Library, MS MacColl R167.

6 J. Rothenstein, letter to Lady Rothenstein, 27 July 1932, TGA 8726/4/5. One artist who lived in the city whom he did get to know was Jacob Kramer. David Manson describes aspects of their friendship in *Jacob Kramer, Creativity and Loss.* (Bristol: Sansom & Co, 2006).

7 John Rothenstein, letter to William Rothenstein, 7 October 1932, TGA 8726/4/6.

8 William Rothenstein, letter to Max Beerbohm, 31 December 1932. Mary Lago and Karl Beckson (eds), *Max and Will: Max Beerbohm and William Rothenstein, their Friendship and Letters 1893–1948* (Cambridge, Mass: Harvard University Press, 1975), pp. 145–6.

9 William Rothenstein, letter to Elizabeth Rothenstein, 31 March 1932, TGA 8726/4/4.

10 Speaight, *William Rothenstein*, p. 290.

11 Ede studied at Newlyn Art School and the Slade, worked at the Tate in 1921–36, founded Kettle's Yard, Cambridge, in 1966 and later donated it to the University.

12 Jim Ede, letter to John Rothenstein, 4 April 1932, TGA 8726/3/2.

13 On the last page of *Summer's Lease*, p. 253, after many critical passages on Leeds and Sheffield and their people, John surprisingly commented that he had formed a 'deep attachment' to Yorkshire.

14 Kramer did a fine pastel portrait of Musgrave in 1932.

15 J. Rothenstein, *Summer's Lease*, p. 194.

16 Percival Leigh (*c.*1865–1938), Lord Mayor of Leeds in 1935.

17 J. Rothenstein, *Summer's Lease*, p. 196.

18 Ibid.

19 *Catholic Herald*, 21 October 1933.

20 A few weeks' earlier John had published a review in a local paper of Herbert Read's controversial new book, *Art Now* (1933).

21 J. Rothenstein, *Summer's Lease*, p. 199.

22 Head of Sculpture at Leeds since December 1927. He popped up again in the periphery of John's life on 29 January 1954 during the Tate Affair. Described as 'Acting Hon. Secretary, Chelsea Arts Club', he had a letter published in *The Times* objecting to giving trustees a power of sale as per the Bill before Parliament at the time. A portrait of him by none other than the one-time Director of the Tate, J. B. Manson, was sold in London in 2016.

23 Giving a lecture on modern art at the Sheffield Arts Club on 19 January 1933, John had been introduced by Alderman John Graves

(1866–1945), Lord Mayor of Sheffield in 1926; Graves set up one of Britain's first mail order businesses and was a great benefactor to the City of Sheffield.

24 W. Rothenstein, letters to J. Rothenstein, August and September 1933, TGA 8726/4/3.

25 In 1964 too John took considerable trouble over his resignation strategy from the Tate.

26 William Rothenstein, letters to Lord d'Abernon, Chairman of Trustees, 20 June and 4 July 1933, TG 1/6/6.

27 W. Rothenstein, letter to J. Rothenstein, 18 March 1936, TGA 8726/4/3.

28 J. Rothenstein, *Summer's Lease*, pp. 250–51.

29 Ibid., p. 200.

30 John was replaced at Leeds by Philip Hendy, who became director of the National Gallery in 1945 after Clark's resignation. This meant that, after the war, two of the leading art galleries in the country were run by men who had previously worked in Leeds.

31 John also found time to write 'In Defence of English Painting', *The Bookman* (January 1934) and a piece on Henry Moore, *Sheffield Telegraph*, 5 May 1934.

32 Constantine, a landscape artist trained at Sheffield College of Art, studied picture restoration at the Courtauld and worked with William Rothenstein at some point in the 1930s.

33 J. Rothenstein, *Summer's Lease*, p. 223. Dunster's life dates are unknown.

34 W. G. Constable, letter to J. Rothenstein, 9 July 1934, TGA 8726/3/4.

35 W. Rothenstein, letter to J. Rothenstein, 16 October 1934, TGA 8726/4/2.

36 Sir Thomas Bodkin was Director of the Barber Institute, 1935–52 and Director of the National Gallery of Ireland, 1927–35. Obituary in the *Times* 25 April 1961.

37 If he did apply for the post and was beaten to it by Bodkin, this may explain the later antagonism between the two men, which occasionally surfaced thereafter.

38 Honeyman later became Director of Glasgow Art Gallery.

39 Picasso, *La Vie*, Cleveland Museum of Art, Ohio. John suggested to Sheffield that it might wish to buy the picture for £4000, but it did not.

40 Another show had arrived from the Seligmann Galleries in Paris in March entitled *Drawings and Watercolours by 19th Century French Artists*.

41 J. Rothenstein, *Summer's Lease*, p. 225.

42 William wrote to John on 18 March 1936 to say that he had seen Clark just after his return from a visit to Sheffield 'and he spoke warmly of you and of what you are doing'; TGA 8726/4/3.

Chapter 4. The Books, 1926–38

1 David McCann gives a thorough analysis of John's writing before he went to the Tate in 'Sir John Rothenstein and the Advocacy of British Art between the Wars', PhD thesis, Nottingham Trent University and Southampton Solent University, 2006.

2 Rodmarton Manor, designed by Ernest Barnsley, was built in 1909–26.

3 J. Rothenstein, *Summer's Lease*, p. 51.

4 John retained a connection with Mrs Biddulph: among the letters he received when he was appointed to the Tate is one from her dated 5 May 1938, TGA 8726/3/6.

5 Between the first two books, John published three articles on living artists: on Eric Kennington, *Apollo*, III (June 1926), pp. 316–19; on Richard Wyndham, *Apollo*, IV (August 1926), pp. 81–3; and on Stanley Spencer, *Apollo*, V (April 1927), pp. 162–6.

6 Eric Gill, letter to J. Rothenstein, 1 May 1927, TGA 8726/5/1.

7 J. Rothenstein, *Summer's Lease*, p. 128.

8 Ibid., pp. 7, 8.

9 Ibid., pp. 11, 26.

10 Eric Gill, *Autobiography* (London: Jonathan Cape, 1940).

11 Ibid., p. 138.

12 Ibid., pp. 172–3.

13 A portrait of John by Blanche is the frontispiece to *Summer's Lease*, painted shortly before publication in 1965. Blanche was well-regarded as a portraitist, having painted Conder and also a well-known image of Marcel Proust.

14 In a lecture given while William was Professor of Civic Art at Sheffield University, he had 'looked back fondly to the days of State and Church sponsored art, complaining that contemporary patronage of the arts was "almost entirely in the hands of the individual patron".' See Shaw, '"Equivocal Positions"', p. 69.

15 Review of John Rothenstein's *Artists of the 1890's* (London: G. Routledge & Son, 1928), *Apollo*, VIII (September 1928).

16 Three of the artists covered in *Artists of the 1890's* made it through to *Modern English Painters: Sickert to Smith* (1952): Steer, Sickert and W. Rothenstein.

17 Max Beerbohm, letter to Florence Beerbohm, 25 September 1924, cited in Lago and Beckson, *Max and Will*, p. 117 n. 1.

18 Rothenstein, *Artists of the 1890's*, p. 5.

19 Ibid., p. 7.

20 Ibid., pp. 19, 43.

21 Ibid., pp. 7, 18.

22 Wyndham Lewis, *The Demon of Progress in the Arts* (London: Methuen & Co, 1954).

23 J. Rothenstein, *Summer's Lease*, pp. 139, 169, 141.

24 Ibid., p. 139.

25 J. Rothenstein, *Artists of the 1890's*, p. 123.

26 J. Rothenstein, *Artists of the 1890's*, p. 175.

27 Ibid., p. 176.

28 John Rothenstein, *British Artists and the War* (London: P. Davies, 1931). His solitary work of fiction, *Morning Sorrow*, will be ignored, as will another book which drew on his father's legacy, *Sixteen Letters from Oscar Wilde* (both 1930).

29 J. Rothenstein, *British Artists and the War*, p. 8.

30 Ibid., p. 10.

31 Ibid., p. 11.

32 Ibid., p. 12.

33 Ibid., p. 13.

34 Quoted in Brian Foss. *War paint, Art, War, State and Identity in Britain 1939–1945.* (New Haven and London: Yale University Press, 2007). Foss took the quote from an article by John Rothenstein, *European Paintings 1893–1943*; Studio 125, (April–May 1943).

35 John Rothenstein, *Nineteenth Century Painting: A Study in Conflict* (London: John Lane, 1932), p. 10.

36 D. S. MacColl, *Nineteenth Century Art* (Glasgow: James MacLehose, 1902).

37 J. Rothenstein, *Nineteenth Century Art*, p. 15.

38 Ibid., pp. 178 and 180.

39 John Rothenstein, *An Introduction to English Painting* (London: Cassell & Co., 1933), p. 142.

40 Ibid., p. 162.

41 Ibid., pp. 162–163.

42 John had also been continuing his study of individual living artists: 'The Art of Victor Hammer', *The Studio*, 7 (February 1934), pp. 80–84; 'Barnett Freedman', *The Studio*, 9 (February 1935), pp. 90–93 and 'Donald Towner: A Painter of London', *The Studio*, 10 (July 1935), pp. 22–7.

43 William Rothenstein, *Men and Memories: Recollections of William Rothenstein 1900–1922* (London: Faber & Faber, 1931).

44 W. Rothenstein, letter to J. Rothenstein, 18 February 1938, TGA 8726/4/3.

45 In a review in *Parnassus*, 13, no. 3 (March 1941), S. A. Callisen and H. W. Janson found that, despite the author's best efforts, 'Conder's artistic stature is not greatly increased' and the book could 'not be considered of first importance'.

46 Indeed, the National Gallery's *Australia's Impressionists* in 2016–17 included Charles Conder.

47 This may have been Bell joking about William's lack of height.

48 J. Rothenstein, diary entry, 18 September 1951, TGA 8726/1/20.

Chapter 5. The Status of the Tate

1 In the pages which follow I owe a heavy debt to the seminal work done by Frances Spalding, *The Tate: A History* (London: Tate Gallery Publishing, 1998). Her excellent book has supplied me with the framework of what follows.

2 The Sheepshanks gift in 1857 of 233 British paintings also went to the South Kensington Museum.

3 Five further galleries were built in the early 20th century.

4 Smith had designed a series of libraries for Tate, in South Lambeth, Streatham and Brixton. After his patron died, Smith's final commission was for Tate's mausoleum in West Norwood Cemetery.

5 John Rothenstein, *The Tate Gallery: The National Collection of British Painting and of Modern Foreign Art* (London: Tate Gallery, 1947), p. 6, no source given but quoted as in a letter from Edward Martin (the MP?) to the Speaker of the House of Commons.

6 Ibid. John was referring here to the Musée du Luxembourg in Paris, which at this time was used as a home for French contemporary art.

7 All such numbers after titles of works are the Tate's reference/acquisition numbers.

8 The baronetcy and barony both became extinct on his death in 1939.

9 Kenneth Clark, letter to John Rothenstein, 7 May 1938, TGA 8726/3/6.

10 Spalding, *The Tate*, p. 27.

11 Ibid., p. 27.

12 Some years later, during the Tate Affair, John might have come to rue this decision after experiencing the behaviour of the artist Trustee Graham Sutherland.

13 The initial members of the fund committee were Courtauld himself, Lord Henry Bentinck, Sir Michael Sadler, Sir Charles Holmes (Director of the National Gallery) and Charles Aitken.

14 For the details of the saga, see Robert O'Byrne, *Hugh Lane: 1875–1915* (Dublin: Lilliput Press, 2000), ch. 18.

15 Clark had prepared a memorandum in 1936 on how he saw the relationship working between the two galleries. See TGA 8812/1/4/244.

16 Robin Ironside, a painter of extraordinary Romantic pictures, was Assistant Keeper in 1937–46.

17 Robin Ironside, letter to John Rothenstein, 15 April 1964, TGA 8726/4/29.

18 Harold Stanley Ede, always known as Jim, letter to John Rothenstein, 4 April 1964, TGA 8726/4/29.

Chapter 6. The Four Previous Directors and Keepers

1 Manson e.g. had published 'The Paintings of Mr. William Rothenstein', *The Studio*, 50 (1910), cited in Shaw, '"Equivocal Positions", bibliography.

2 E.g. by John in *The Tate Gallery* (London: Thames & Hudson, 1962), pp. 21–2. See also Spalding, *The Tate*, p. 30.

3 D. S. MacColl, 'The Maladministration of the Chantrey Bequest' and 'Parliament and the Chantrey Bequest', *Saturday Review*, 25 April and 6 June 1903.

4 Maureen Borland, *D. S. MacColl: Painter, Poet, Art Critic* (Harpenden: Lennard Publishing, 1995), p. 129.

5 Borland, *D.S. MacColl*. W. S. Meadmore wrote the unkindly called 'The Crowing of the Cock: A Biography of James Bolivar Manson', 1957, TGA 806/7/2, never published. Manson's daughters may have felt that a book with such a title was not going to emphasise their father's better features.

6 MacColl's first article for the *Spectator* appeared on 15 February 1890.

7 D. S. MacColl, *Saturday Review*, 31 July 1897. Borland, *D.S. MacColl*, p. 100. He was also editor of the *Architectural Review* in 1901–5.

8 Borland, *D. S. MacColl*, p. 165.

9 MacColl wrote *Twenty-Five Years of the National Art Collections Fund 1903–1928* (London, 1928).

10 There had been some controversy in 1905 when the NACF had refused to help buy an Impressionist picture for the National Gallery.

11 CAS Annual Report, 1911, www.contemporaryartsociety.org, accessed 3 July 2017. A William Rothenstein oil and a drawing were also donated to the CAS.

12 Borland, *D.S. MacColl*, p. 179.

13 Spalding, *The Tate*, p. 32.

14 John Rothenstein later claimed that physical fitness was a prerequisite for working at the Tate, at least in the early years he was there; John Rothenstein, *Brave Day, Hideous Night: Autobiography, 1939–1965* (London: Hamish Hamilton, 1966), p. 234. Le Roux's appearance of good health was one of the reasons John chose him.

15 D. S. MacColl, *Confessions of a Keeper and Other Papers* (London: Alexander MacLehose, 1931).

16 *The Whitechapel Art Gallery Centenary Review* (London: Whitechapel Art Gallery, 2001).

17 For example, Aitken had been one of the founders in 1909 of the Modern Art Association, the predecessor of the CAS.

18 Gwendoline and Margaret Davies had extensive collections of twentieth century art at Gregynog, their house in Wales. See Oliver Fairclough (ed), "*Things of Beauty*". *What two sisters did for Wales* (Cardiff: National Museum of Wales, 2007).

19 Editorial, Vol 38, 21 May 1921, p. 209.,
 Burlington Magazine.

20 The arbitrary way in which modern art was
 chosen by the Tate at this time is well-illustrated
 here. See Pamela Fletcher and Anne Helmreich
 (eds). *The rise of the modern art market in London,
 1850–1939.* (Manchester: Manchester University
 Press, 2011) pp. 197–199. (Chapter by Alexandra
 MacGilp).

21 J. Rothenstein, *Brave Day, Hideous Night*,
 pp. 10–11.

22 Meadmore, 'Crowing of the Cock', p. 101.

23 The Trustees promoted an insider again after
 Rothenstein – Norman Reid in 1964.

24 Presented to the Tate by David Fincham in 1938.

25 J. B. Manson, *Rembrandt, 1607–1669* (London:
 Cassell and Co., 1923); *The Life and Work of
 Edgar Degas* (London: The Studio, 1927); *The
 Work of John S. Sargent, R.A.*, intros by Manson
 and Mrs Meynell (London: William Heinemann,
 1927); *Dutch Painting* (London: Avalon Press,
 1945); *Hours in the Tate Gallery* (London:
 Duckworth, 1926).

26 Museum of Modern Art, New York, letter to
 Lord Duveen, 13 March 1936, TG 92/55.

27 Kenneth Clark, *Another Part of the Wood: A
 Self-Portrait* (1974; London: Hamish Hamilton,
 1985), p. 233.

28 As reported in J. Rothenstein, *Brave Day,
 Hideous Night*, p. 26. Years later Fincham told
 John that the comment on Utrillo had been
 published with Manson's specific approval; John
 Rothenstein, diary entry, 13 November 1963,
 TGA 8726/1/36.

29 Frances, Lady Phipps (1893–1988) was the
 daughter of the sculptor Herbert Ward.

30 Sir Eric Phipps (1875–1945); his papers in
 Churchill College, Cambridge, might reveal
 more about the incident.

31 Clark, *Another Part of the Wood*, p. 234.

32 Clive Bell, letter to Vanessa Bell, 6 March 1938,
 Charleston Papers, TGA 8010/5/371. With
 permission of The Society of Authors as the
 literary representatives of the Estate of Clive
 Bell.

33 Schwabe, *Diaries of Randolph Schwabe*, entry for
 26 March 1938, p. 270.

34 The Hon. Sir Evan Charteris (1864–1940),
 educated at Eton and Balliol College, Oxford,
 son of the 10th Earl of Wemyss, was a barrister,
 Chairman of the Trustees of the National
 Portrait Gallery, Trustee of the Wallace
 Collection and the National Gallery and
 Chairman of the Tate Trustees in 1934–40.

35 J. B. Manson, letter [1938], TGA 806/2/3.

36 HM Treasury, Minutes [Tate Gallery], 4 May
 1938.

37 Charteris, letter to J. B. Manson, n.d. [1938],
 TGA 806/1/167.

38 Charteris, letter to Manson, 22 March 1938,
 TGA 806/1/168. Manson had been at the Tate
 for nearly 26 years, in different capacities, the
 same number as Rothenstein was to serve.

39 J. Rothenstein, *Summer's Lease*, pp. 250, 251.

40 John Rothenstein, application to Tate Board of
 Trustees, 4 April 1938, TGA 8726/3/7.

41 Charteris, letter to the Earl of Sandwich, 13 April
 1938, TGA 707/60.

42 The Prime Minister at the time was Neville
 Chamberlain. The order of the names perhaps
 suggests that the Trustees preferred Rothenstein.

43 Leigh Ashton, letter to John Rothenstein, n.d.
 [April 1938], TGA 8726/3/6.

44 As seen in Ch. 3, when John was considering
 applying for a position at the Ashmolean in 1933.

45 Sir William Rothenstein, letter to John
 Rothenstein, 25 March 1938, TGA 8726/4/3.

46 Alderman Graves, letter to John Rothenstein,
 5 May 1938, TGA 8726/3/6; W. Rothenstein,
 letter to John Rothenstein, 5 May 1938, TGA
 8726/3/4.

Chapter 7. Early Days and North American Tour, 1938–40

1 Clark, *Another Part of the Wood*, p. 233.

2 J. Rothenstein, *Brave Day, Hideous Night*, p. 12.

3 J. Rothenstein, diary entry, 1 January 1942, TGA
 8726/1/7.

4 J. Rothenstein, *Brave Day, Hideous Night*, p. 7.

5 Ibid., p. 19.

6 John Rothenstein, *Time's Thievish Progress:
 Autobiography III* (London: Cassell, 1970),
 p. 196.

7 The Hon. Sir Evan Charteris, letter to John
 Rothenstein, 24 May 1939, TG 1/6/5.

8 J. Rothenstein, *Brave Day, Hideous Night*, ch. 1.

9 Ibid., p. 4.

10 Ibid.

11 Ibid., p. 15, citing Herbert Read's approval of the
 rehang.

12 For Cooper, see John Richardson, *The Sorcerer's
 Apprentice: Picasso, Provence and Douglas Cooper*
 (London: Jonathan Cape, 1999), ch. 2.

13 Museum of Modern Art, New York, letter to
 John Rothenstein, 2 June 1938, TG 92/55.

14 Paul Nash, *Landscape at Iden* (1929, Tate, 5047)
 and *Blue House on the Shore* (1930–31, Tate,
 5048).

15 J. Rothenstein, *Brave Day, Hideous Night*, p. 30.

16 Sir John Ramsden, letter to David Fincham,
 6 January 1939, www2.tate.org.uk/
 archivejourneys/historyhtml/war.htm, accessed
 28 June 2017.

17 1892–1947. Educated at Eton and Trinity
 College, Oxford. Primarily a portrait painter.
 The Lowinsky family were friendly with the
 Rothensteins but the diary records, without
 proper explanation, that they fell out. John

terminated the friendship by letter and received a "vile letter" in return. Diary 12 May 1943. TGA 8726/1/8. Lowinsky got no mention in the autobiography or in *Modern English Painters*.

18 The National Gallery closed on the evening of 23 August and by 2 September had evacuated approximately 1800 pictures. See Suzanne Bosman, *The National Gallery in Wartime* (London: National Gallery Co., 2008), p. 17. For detail of the Tate evacuation, see Nicholas McCamley, *Saving Britain's Art Treasures* (Barnsley: Leo Cooper, 2003), pp. 115–122. This notes that a small number of very large pictures were left in place, bricked up.

19 John Rothenstein, letter to the Hon. Sir Evan Charteris, 26 July 1940, TG 1/6/5.

20 Once in America, John wrote a detailed account of the August–September period in two handwritten memos, autumn 1939, TGA 8726/2/44 and 8726/2/45.

21 J. Rothenstein, diary, 22 August–15 September 1939, TGA 8726/1/1.

22 J. Rothenstein, *Brave Day, Hideous Night*, pp. 58–9.

23 HM Treasury, letter to John Rothenstein, 22 September 1939, TGA 8726/3/9.

24 John did report back to the Government several times and was paid £150 towards the costs of the trip by the Treasury.

25 This book is indebted to John's diaries but he largely used them to cover social events, rather than to record in detail his thoughts on any given subject, so they may in that sense be misleading.

26 See CAS Annual Report 1940–41, www.contemporaryartsociety.org, accessed 28 June 2017.

27 This Rothenstein–Ironside–Fincham correspondence is in TGA 15/5/2.

28 E.g., David Fincham, letter to John Rothenstein, 19 October 1939, about staff upsets.

29 J. Rothenstein, letter to Tommy Lowinsky, 2 March 1940; Lowinsky, letter to Rothenstein, 25 March 1940, both TGA 8726/3/10.

30 J. Rothenstein, diary, 4 May 1940, TGA 8726/1/2.

31 Clive Bell, book review, *New Statesman and Nation*, 18, no. 462 (30 December 1939).

32 J. Rothenstein, diary, 5 May 1940, TGA 8726/1/2.

33 HM Treasury, letter to Sir Edward Marsh, 10 April 1940, TGA 8726/3/9.

34 W. Rothenstein, letter to J. Rothenstein, 2 January 1940, TGA 8726/4/2.

35 J. Rothenstein, Memorandum on the Tate Gallery and the outbreak of the Second World War, 11 September 1939, TGA 8726/2/45.

36 Bosman, *National Gallery in Wartime*, ch. 3.

37 See Adrian Clark, 'The Royal Academy of Arts in World War II', 2011, paper prepared for the RA, Royal Academy Library, London.

38 W. Rothenstein, letter to J. Rothenstein, 19 January 1940, TGA 8726/4/3.

39 Hansard, House of Commons, 23 January 1940.

40 HM Treasury, letter to John Rothenstein, 21 February 1940, TGA 8726/3/9. On 2 March, John was still writing to the Treasury saying that he did not think it was time to come back.

41 W. Rothenstein, letter to J. Rothenstein, 21 March 1940, TGA 8726/4/3.

42 See John Rothenstein, letter to Sir Edward Marsh, 6 December 1940, National Archives, Kew, Treasury file, T162/869/8, and in TGA 15/5/2: 'As soon as I had fulfilled my immediate obligations, I cabled to Hale at the Treasury asking permission to return without delay'. He also complains about Fincham.

Chapter 8. War and Post-War, 1940–46

1 See J. Rothenstein, *Brave Day, Hideous Night*, ch. 7. As an indication of unhappiness in the art world about John's appointment, his diary records on 14 June 1940 that Tommy Lowinsky had told Elizabeth 'how many people resent "influence" of R's [Rothenstein's]', TGA 8726/1/3.

2 It was even not appreciated that all the art treasures stored deep in the Underground tunnels would have been susceptible to a direct hit from a large German bomb.

3 At some point in the Autumn of 1940 the Tate allocated to the Contemporary Art Society what it hoped would be a secure basement room for the storage of CAS pictures. There were apparently still some Tate pictures stored "in a special underground storeroom". A CAS picture by Wyndham Lewis was duly damaged when the Tate was bombed. CAS Annual Report 1940–1, p. 8.

4 John Rothenstein, 'Painting in America', *Horizon*, Vol III, no. 18 (June 1941), pp. 406–17 (2 illustrations).

5 The USA's Public Works of Art Project, followed in 1935 by the Federal Art Project of the Works Progress Administration.

6 E.g., John Rothenstein, 'American Art Today', *The Listener*, 4 September 1941; 'State Patronage of Wall Painting in America', *The Studio* (July 1943).

7 Alfred Barr (1902–1981), art historian, was the first Director of MOMA, New York. For discussions with Walker and Barr, see TG 92/55.

8 For discussions with Walker, see TG 92/77.

9 E.g., in *The Studio* (September 1941), *Connoisseur* (September 1941); *The Listener*, 9 April 1942, *Magazine of Art* (October 1942) and *The Studio* (May 1944).

10 Tate Board of Trustees minutes, 17 December 1940, TG 1/3/4.

11 Ibid.; see also Spalding, *The Tate*, p. 87. Old Quarries had previously been storing some of the most important pictures belonging to the National Gallery. See Nicholas McCamley, *Saving Britain's Art Treasures*, pp. 83–4.

12 See Ch. 7 n. 42 for Rothenstein to Marsh, 6 December 1940; National Archives, HM Treasury, T218/298, July 1941.

13 The Hon. Sir Jasper Ridley, son of 1st Viscount Ridley, educated at Eton and Balliol College, Oxford, Trustee of the National Gallery and the British Museum, was the Chairman of the Tate Trustees in 1941–51.

14 National Archives, HM Treasury, T218/298, October 1941.

15 Ibid., April 1942.

16 J. Rothenstein, *Brave Day, Hideous Night*, p. 244.

17 Ibid., p. 169.

18 I should like to acknowledge the assistance of Sir Adam Ridley, Jasper Ridley's grandson, discussion with me, February 2017.

19 J. Rothenstein, diary entry, 18 December, 1941, TGA 8726/1/6.

20 E.g., ibid., 14 May 1942, TGA 8726/1/7, noting that Fincham had disposed of all the Tate's press cuttings about John's appointment and for the whole of his first year as Director.

21 Ibid., 31 October 1946, 5 November 1946 (TGA 8726/1/12) and 20 June 1947 (TGA 8726/1/14). When John talked to Manson's biographer in 1963, he was told that at some point Fincham had been in prison; diary entry 24 January 1963, TGA 8726/1/36.

22 Ibid., 22 September 1947, TGA 8726/1/14.

23 Ibid., 15 September 1948, TGA 8726/1/15. Whenever John met someone who had dealt with Fincham, he asked them for their views. In 1949 he was told by General Paget that in 1938 Fincham had gone down to Camberley, got drunk, behaved badly and tried to make up for it by sending Paget a picture by Edward Lear as a gift, claiming that it was owned by the Tate but no longer required; ibid., 23 August 1949, TGA 8726/1/19.

24 Ibid., 5 November 1942, TGA 8726/1/7. The Massey Report: *The Report of the Committee on the Functions of the National Gallery and Tate Gallery and, in respect of Paintings, of the Victoria & Albert Museum, together with a Memorandum thereon by the Standing Committee on Museums and Galleries* (London: HMSO, 1946, Cmnd. 6827).

25 Ibid., 14 January 1943, TGA 8726/1/8.

26 J. Rothenstein, *Brave Day, Hideous Night*, p. 209.

27 John gives a hilarious anecdote of Lutyens, whose sense of humour was legendary, in ibid., p. 34.

28 J. Rothenstein, diary entry, 19 January 1943, TGA 8726/1/8.

29 Ibid., 18 September 1947, TGA 8726/1/14.

30 Pope-Hennessy, educated at Downside and Balliol College, Oxford, was the older brother of the more flamboyant James.

31 J. Rothenstein, diary entry, 9 June 1943, TGA 8726/1/8.

32 For a list of the artists whose pictures were bought, see my *British and Irish Art 1945–1951: From War to Festival* (London: Hogarth Press, 2010), p. 42.

33 See Adrian Clark, *British and Irish Art 1945–1951*, p. 38.

34 J. Rothenstein, diary entry, 6 February and Boxing Day 1947, TGA 8726/1/14.

35 The exhibition later toured Britain, also with mixed reception although for different reasons. In Bournemouth, for example, visitors found the pictures too modern; see director of the art gallery, letter to John Rothenstein, 2 April 1948, TG 92/58.

36 Read, educated at Leeds University, worked at the V&A, then became Professor of Fine Arts at Edinburgh University. He published *The Meaning of Art* (1931), *Art Now* (1933), *Art and Industry* (1934), *Art and Society* (1937), *Education through Art* (1943), *Anarchy and Order* (1945) and *Contemporary British Art* (1951). Read was also the editor of the *Burlington Magazine* in 1933–39 and with Roland Penrose and Peter Watson helped found the Institute of Contemporary Art in 1946.

37 Herbert Read, letter to Douglas Cooper, 7 August 1945, Douglas Cooper Papers, Getty Research Institute, Los Angeles, Accession no. 860161, Box 1.

38 J. Rothenstein, *Modern English Painters: Nash to Bawden* (London: Macdonald, 1984), p. 183.

39 Schwabe, *Diaries*, entry for 24 November 1946, p. 499.

40 Similarly, John was the London buyer in 1940–41 with a budget of £100 for the National Museum of Wales in Cardiff, whose director was Cyril Fox.

41 Dean was Albert Houthuesen's wife and later featured in *Modern English Painters: Hennell to Hockney*, p. 81. Grunspan got himself arrested and sent to prison in 1945 when he pretended to be a high-ranking officer and stayed at expensive hotels without paying his bills; John's encouragement had been insufficient.

42 In 1943 John was appointed sole buyer for the CAS and again bought a wide selection of pictures, including work by Paul Nash (*Sunflower and Sun*, at £125 the most expensive picture on the list) and by Robin Ironside. CAS Annual Report 1942/3, p. 9.

43 Russell's *High Tide, Blakeney* (1938, Tate, 4961) and *Carting Sand* (1910, Tate, 5105).One could continue this analysis: e.g., how did the Tate come to purchase work by Albert Rutherston in 1941 and by William Rothenstein in 1943?

44 He is recorded as buying pictures in 1946 and 1947 and had definitely been replaced by 1950. The precise date is unclear. I am grateful for information about this appointment to Steven Miller, Head of Library Services at the Art Gallery of New South Wales.

45 William Rothenstein, asked to recommend an artist for these murals, had suggested Stanley Spencer, whom Campion Hall did not like. After consulting his father, John then suggested Mahoney.

46 Father d'Arcy was educated at Stonyhurst and Campion Hall, Oxford; J. Rothenstein, *Brave Day, Hideous Night*, p. 84, reproduces a portrait of him by Augustus John (1939, Campion Hall).

47 J. Rothenstein, diary entry, 8 June 1943, TGA 8726/1/8.

48 American wife of Lord Walston.

49 Information from John's daughter, Lucy Carter, in conversation with me, 25 August 2016.

50 E.g., J. Rothenstein, diary entries, July 1943, TGA 8726/1/8.

51 Ibid., 23 June, 5 July, 10 November 1943, TGA 8726/1/8; 14 March 1944, TGA 8726/1/9.

52 See e.g. my 'The Art Collection of Peter Watson', *British Art Journal*, Vol XVI, no. 2 [Autumn 2015], pp. 101–7, exploring what happened to his collection in Paris during the war and the involvement of French art dealers in art theft.

53 J. Rothenstein, *Brave Day, Hideous Night*, ch. 9.

54 Max Beerbohm, *The Poet's Corner*, intro. John Rothenstein (London: Penguin Books, 1943).

55 *Manet*, intro. John Rothenstein and notes by R. H. Wilenski (London: Faber and Faber, 1945).

56 John Rothenstein (introduction), *Augustus John: Reproductions of his Paintings and Drawings* (London: Phaidon, [1944] 1946).

57 J. Rothenstein–Augustus John correspondence, TGA 8726/3/10 (e.g. letter from John to Augustus, 5 April 1943, grumbling that it seems to be impossible to satisfy the artist on the choice of illustrations).

58 J. Rothenstein, *Augustus John*, pp. 5–20.

59 Ibid., p. 20; J. Rothenstein, *Modern English Painters: Sickert to Smith*, p. 187.

60 John Rothenstein: *Edward Burra* (London: Penguin Books, 1945).

61 See Carol Peaker, *The Penguin Modern Painters: A History* (London: Penguin Collectors Society, 2001).

62 Before then, Michael Rothenstein had got to know Burra at the RCA in 1921–3.

63 John Rothenstein, *Edward Burra* (London: Tate Gallery, 1973); John Rothenstein, *Modern English Painters: Wood to Hockney* (London: Macdonald, 1974), pp. 100–16. He bought Burra's *The Torturers* (1935) and *On the Shore* (1934), as well as other drawings. Burra wrote to William Chappell on 23 June 1971 to say that he had deliberately over-priced a recent picture

of Ebbw Vale which John wanted to buy from him to prevent him doing so; William Chappell (ed.), *Well Dearie! The Letters of Edward Burra* (London: Gordon Fraser, 1985), p. 186. Jane Stevenson, *Edward Burra: Twentieth-Century Eye* (London: Jonathan Cape, 2007), pp. 135–6, queries whether John really understood the artist at all; he might have been hoodwinked by Burra's sense of humour.

64 Burra's *Wake I* (Tate, 5165), *Wake II* (both 1940, 5166) and *Mexican Church* (1938, 5167).

65 Burra's *Skeleton Party* (1952–54, Tate, T00013).

66 See *The Tate Gallery Report 1953–54: Review 1938–53* (London: HMSO, 1954).

67 Utrillo, *Vase de Fleurs* (1938–9, Tate, 5020); Max Ernst, *The Entire City* (1934, 5289); Marc Chagall, *Le Poète Allongé* (1915, 5390).

68 J. Rothenstein, diary entry, 17 January 1945, TGA 8726/1/11.

69 *Tate Gallery Report 1953–54*, p. 69.

70 John had even been to see his father on one occasion with Vincent Turner, in what may have been an attempt to secure a late conversion of William; diary entry, 9 August 1942, TGA 8726/1/7.

71 Ibid., 14 February 1945, TGA 8726/1/11.

72 J. Rothenstein, *Brave Day, Hideous Night*, ch. 11.

73 W. Rothenstein, letter to J. Rothenstein, 11 July 1942, TGA 8726/4/3.

74 Ibid., 12 April 1943 and May 1944, TGA 8726/4/2.

75 J. Rothenstein, diary entries, 4 and 12 February 1946, TGA 8726/1/12.

76 Honor Frost (1917–2010) later became a pioneering and notable underwater archaeologist.

77 Spalding, *The Tate*, p.91. J. Rothenstein, diary entries, 20 May and 13 June 1946, TGA 8726/1/12.

78 J. Rothenstein, *Brave Day, Hideous Night*, ch. VII.

79 Yet John wrote warmly of dining with the Reids at their house in Beckenham.

80 J. Rothenstein, diary entry, 22 October 1946, TGA 8726/1/12.

81 Massey Report.

Chapter 9. Straws in the Wind, 1947–51

1 John Rothenstein, *Brave Day, Hideous Night*, p. 231.

2 Margaret Nash, letter to John Rothenstein, 23 September 1946, TG 92/65.

3 Mary Chamot compiled the Tate's *British School* concise catalogue (1953) and, with Martin Butlin and Dennis Farr, the *Modern British School* catalogue (2 vols, 1964). She collaborated with John on *The Tate Gallery: A Brief History and Guide* in 1951, and retired from the Tate in 1965.

4 Ronald Alley worked at the Tate for 35 years, becoming Keeper of the Modern Collection in 1965 and retiring in 1986.

5 National Archives, HM Treasury files T222/487 and T222/652 respectively.

6 Treasury, Organisation and Methods Division, 'Tate Gallery: Review of the Organisation and Work of the Gallery', 13 September 1950, T222/487.

7 Picasso, *Femme nue assise* (1909–10, Tate, 5904) and *Buste de Femme* (1909, 5915); Matisse, *Notre Dame* (*c.*1900, 5905); Rouault, *L'Italienne* (1938, 5906); Léger, *Feuilles et Coquillage* (1927, 5907); Giacometti, *Intérieur* (1949, 5908) and *Homme assis* (1949, 5909).

8 The main example always given is that of Matisse's *Red Studio*, previously in the Gargoyle Club and sold by the Redfern Gallery in the 1940s to an American buyer for less than £1000 and now in MOMA, New York, number 8.1949. Patrick Heron reports a story, indirectly from Matthew Smith, in which the picture was said to have been offered to the Tate for £400 but had been turned down by John. See *Painter as Critic. Patrick Heron: Selected Writings* (Mel Gooding editor), (London: Tate Publishing, 1998), p. 200.

9 See e.g. Spalding, *The Tate*, p. 102 (Derain's *Two Sisters*).

10 16 November 1948. Referred to in Spalding, *The Tate*, note 11 on chapter 7.

11 Soutine, *La Route de la colline*, *c.*1924, bequeathed 1959 (Tate, 00315).

12 J. Rothenstein, diary entry, 20 April 1950, TGA 8726/1/21. The Gallery already owned work by Dufy.

13 Ibid., 19 October 1950, TGA 8726/1/21.

14 Editorial, *Burlington Magazine*, 89, no. 534 (September 1947), p. 235.

15 Benedict Nicolson, educated at Eton and Balliol College, Oxford, was editor of the *Burlington Magazine* in 1947–78. His relationship with Cooper was difficult, as he recorded in his diaries; I am grateful to Vanessa Nicolson for sharing relevant excerpts with me by email dated 21 September 2016.

16 Educated at Marlborough and New College, Oxford. Had been on the Fine Arts Advisory Committee of the British Council and was by 1954 Director of the Barber Institute, Birmingham. Described in his *Times* obituary, 9 September 1985, as 'perhaps the most distinguished art historian of his generation'.

17 Denis Mahon, educated at Eton and Christ Church, Oxford, was a collector and art historian. Trustee of the National Gallery 1957–64 and 1966–73. Knighted in 1986. His archive, at the National Gallery of Ireland, Dublin, is uncatalogued and cannot be accessed: email from Killian Downing, Assistant Archivist, Sir Denis Mahon Collection, 5 October 2016.

18 John Russell, letter, *Burlington Magazine*, 89, no. 536 (November 1947), p. 320.

19 Richardson, *Sorcerer's Apprentice*, p. 161.

20 Bryan Robertson, in his address at the memorial party on 8 June 1992 following John's death (TGA, tape, TAV 1007A), said that Cooper was a brilliant art scholar who was in all other ways a nightmare, totally irresponsible and ruthless. Roy de Maistre had a theory to explain Cooper. He told John on 27 January 1954 that Cooper's "turning point" came after an incident in Malta, when Cooper was arrested and threatened with a court martial in connection with a sexual assault on a boy. "He wished to make others suffer what he had feared suffering himself". Diary entry, TGA 8726/1/24.

21 John Pope-Hennessy, also difficult with people, noted in his autobiography, *Learning to Look* (London: Heinemann, 1991), pp. 136–7, how much he liked Cooper because of his knowledge of art and desire for accuracy but that he was 'mendacious' and 'embarrassingly unpredictable'.

22 Douglas Cooper, letter, *Burlington Magazine*, 90, no. 538 (January 1948), pp. 28–9.

23 J. Rothenstein, diary entry, 1 January 1948, TGA 8726/1/15.

24 John Rothenstein, letter, *Burlington Magazine*, 90, no. 540 (March 1948), pp. 83–4. There was also a private exchange of letters between John and Cooper, with John's of 23 February surviving in Cooper's archives; Douglas Cooper Papers, Getty Research Institute, Series 1 Correspondence 1939–1984, Box 1, folder 75.

25 Douglas Cooper, letter to John Rothenstein, 23 January 1948, TG 92/67.

26 The *Samuel Courtauld Memorial Exhibition* opened at the Tate on 13 May 1948.

27 J. Rothenstein, diary entry, 26 January 1948, TGA 8726/1/15.

28 As an indication of the casual mischief-making popular amongst leading figures in the art world, Blunt told Rothenstein over lunch that Cooper had been asked on four separate occasions to resign his membership of the Reform; ibid.

29 Ibid., 2 and 11 February 1948, TGA 8726/1/15.

30 Ibid., 17 February 1948, TGA 8726/1/15.

31 Ibid., 4 March, 18 May, TGA 8726/1/15. Moore had his own show at the Tate in May 1951.

32 Ibid., 12 July 1948, TGA 8726/1/15.

33 Cooper, letter to J. Rothenstein, 6 November 1949, TG 92/76.

34 Ibid., 22 October 1950; J. Rothenstein, [reply, ?October 1950], TG 92/76.

35 J. Rothenstein, diary entry, 5 July 1949, TGA 8726/1/19.

36 J. Rothenstein, letter to Cooper, 19 October 1949, Douglas Cooper Papers, Box 2, folder 58.

37 Humphrey Brooke, educated at Wellington and Magdalen College, Oxford, was a 'Monuments

Man' during the war, Deputy Keeper at the Tate in 1948–9 and Secretary of the Royal Academy in 1952–68.

38 J. Rothenstein, diary entry, 22 November 1949, TGA 8726/1/19.

39 Ibid., 5 January 1950, TGA 8726/1/21.

40 Cooper, letter to J. Rothenstein, 10 January 1950, TG 5/3/11.

41 J. Rothenstein, letter to Cooper, 19 May 1950, TG 5/3/11.

42 J. Rothenstein and Cooper discussions, May 1950, and Rothenstein, letter to Cooper 21 June 1950, Douglas Cooper Papers, Box 2, folder 58; Rothenstein, diary entry, 23 May 1950, TGA 8726/1/21.

43 John recorded on 30 January that Philip James had told him that Cooper had written to him to say that the Tate had given 'belated and meagre recognition to Léger'; TGA 8726/1/21. As if Cooper wanted as many antagonisms at the same time as possible, Norman Reid mentioned to John on 2 February (diary entry, ibid.) that he had heard Cooper on the wireless giving a 'clever but vitriolic review' of Kenneth Clark's *Landscape into Art*. Reid said he 'expected to see poison drip from the loudspeaker'.

44 Ibid., 15 February 1950, TGA 8726/1/21.

45 J. Rothenstein, letter to Cooper, 16 May 1950, TG 5/3/11.

46 J. Rothenstein, diary entry, 1 March 1948, TGA 8726/1/15.

47 See further my *British and Irish Art*, p. 78.

48 For Brooke's criticisms of Frost, see TG 15/5/3.

49 J. Rothenstein, diary entry, 7 May 1948, TGA 8726/1/15; 4 January, 18 February 1949, 19 March 1949, TGA 8726/1/19; for letters and Board meeting minutes, see TGA 15/5/3.

50 J. Rothenstein, statement to the Chairman, [February 1950], TG 15/5/3.

51 TG 15/5/3.

52 J. Rothenstein, diary entry, 28 April 1949, TGA 8726/1/19.

53 E.g. Honor Frost, letter to Jasper Ridley, 23 February 1949, TG 15/5/3.

54 Treasury, Organisation and Methods Division, 'Tate Gallery: Review', 1949–1955. T222/652. For Frost's resignation, see J. Rothenstein, diary entry, 17 November 1949, TGA 8726/1/19.

55 Humphrey Brooke's letter of acceptance, 4 October 1951, Royal Academy Archives/SEC/8/65/1.

56 J. Rothenstein, diary entries, 15 and 16 April 1948, TGA 8726/1/15.

57 John Rothenstein–Le Roux Smith Le Roux early correspondence, TGA 8726/3/22.

58 J. Rothenstein, diary entry, 15 December 1949, TGA 8726/1/19.

59 J. Rothenstein, *Brave Day, Hideous Night*, pp. 231–43.

60 Ibid., p. 236.

61 Dennis Proctor, comments on ibid., n.d., TG 1/6/40. Proctor, educated at Harrow and King's College, Cambridge, was a Treasury official before becoming Tate Chairman.

62 J. Rothenstein, *Brave Day, Hideous Night*, p. 237.

63 Ibid., p. 238.

64 John Rothenstein, 'Why the Tate does not show its Chantrey Pictures', *Daily Telegraph*, 20 January 1949, leader page.

65 Eric Newton, review, *Sunday Times*, 9 and 16 January 1949.

66 Wyndham Lewis, review, *The Listener*, 13 January 1949.

67 Raymond Mortimer, review, *New Statesman and Nation*, 15 January 1949.

68 Charles Wheeler, article, *The Times*, 29 June 1949. Wheeler's judiciousness had deserted him by the time he came to write his autobiography, *High Relief: The Autobiography of Sir Charles Wheeler Sculptor* (London: Country Life Books, 1968): 'Under the Directorship of Sir John Rothenstein, many monstrous, cumbersome and incompetent works have been shown in the galleries of Millbank', p. 139.

69 John Rothenstein, review of the Summer Exhibition, *The Tablet*, 7 May 1949.

70 Sir Gerald Kelly, educated at Eton and Trinity Hall, Cambridge, was PRA in 1949–54.

71 J. Rothenstein, diary entry, 19 January 1950, TGA 8726/1/21.

72 Ibid., 30 April and 4 July 1951, TGA 8726/1/20.

73 J. Rothenstein, *Brave Day, Hideous Night*, p. 226.

74 J. Rothenstein, diary entries, 4 and 30 July 1950, TGA 8726/1/21; 19 January 1951, TGA 8726/1/20.

75 Ibid., 28 February 1951, TGA 8726/1/20.

76 Le Roux Smith Le Roux, review, BBC Third Programme, in *The Listener*, 5 July 1951.

77 See my *British and Irish Art*, p. 180 for more detail.

78 J. Rothenstein, diary entry, 22 November 1951, TGA 8726/1/20.

79 On Paul Hulton see *The Independent*, 27 January 1990, obituary. Tate Board meeting minutes, 15 March 1951, TG 1/3/7.

80 Earl Jowitt, educated at Marlborough and New College, Oxford, was Lord Chancellor in 1945–51. Diary, 2 November 1951, TGA 8726/1/20.

81 Sir Colin Anderson, educated at Eton and Trinity College, Oxford, was a businessman and a great supporter of various artists, including Robert Colquhoun, Robert Macbryde, Ceri Richards and so on. He had lived on the same staircase as Kenneth Clark at Oxford and they remained close friends. Unpublished memoirs, n.d., Colin Anderson Collection, Sainsbury Centre for Visual Arts, University of East Anglia, Norwich.

Chapter 10. Tate War: First Phase, 1952–53

1 Dennis Proctor in his letter said that John was the best director of any gallery he had ever known. John said that a letter from Sir Alfred Munnings was the only rude one he received; J. Rothenstein, diary entry, 7 January 1952, TGA 8726/1/22.

2 Ibid., 29 February 1952, TGA 8726/1/22.

3 Ibid., 17 and 18 July 1952, TGA 8726/1/22.

4 Ibid., 21 August 1952, TGA 8726/1/22.

5 Le Roux Smith Le Roux, letter to John Rothenstein, 20 August, replied to by J. Rothenstein, 24 September 1952, TGA 8726/3/23. Le Roux certainly explored the possibility of leaving, writing on 17 October 1952 to Philip Hendy asking him for a reference for a job he called the 'Natal Professorship'. By 13 November he was writing to Hendy to say that he had withdrawn his application; Philip Hendy Papers, National Gallery Archives, NG 16/409/1.

6 Le Roux, statement to the Board (referring to his 20 August letter to the Director), 8 October 1952, National Archives, HM Treasury papers, 'Tate Gallery enquiry into activities of Sir John Rothenstein and Mr Le Roux', T 273/14–16; all further references to Treasury reports, memoranda and notes are from this source.

7 Is it possible that, following the failure of his attempt to encourage Le Roux to leave by his own volition, John had put Mr Dawson up to this and the initiative for getting Dawson to raise the matter came from John? Readers may recall that one of John's methods of attacking Fincham had been to challenge his expenses claims. If Le Roux knew or suspected that Dawson was just being used as cover and that John was behind the challenge to his claim, it might explain the ferocity of his attack on John at the Board meeting.

8 Le Roux Smith Le Roux, letter to Mr Hockaday-Dawson, 30 June 1952, 'Papers handed to Sir Edward Ritson at the beginning of his enquiry December 1952', in 'Tate Gallery enquiry', Treasury, T273/14–15.

9 J. Rothenstein, diary entry, 4 September 1952, TGA 8726/1/22; *Brave Day, Hideous Night*, p. 238; John's account of the Tate Affair covers pp. 231–376.

10 *Brave Day, Hideous Night*, p. 239.

11 Ibid.

12 Le Roux to Hendy, 30 September 1952, Philip Hendy Papers, NG 16/409/1.

13 J. Rothenstein, diary entry, 7 October 1952, TGA 8726/1/22.

14 Lord Jowitt, Chairman's Report, copy in 'Papers handed to Ritson', Treasury, T273/14–15.

15 *Brave Day, Hideous Night*, pp. 240–43; other sources include William Coldstream, journal entries, TGA 8922/1/11, and Jowitt, Chairman's Report, Treasury, T273/14–15.

16 William Coldstream, journal entry, 8 October 1952, TGA 8922/1/11; further references to Coldstream are all from this TGA file. Copyright the Estate of Sir William Coldstream / Bridgeman Images.

17 J. Rothenstein, diary entry, 8 October 1952, TGA 8726/1/22.

18 Le Roux, statement to Board, 8 October 1952, copy in 'Papers handed to Ritson', Treasury, T273/14–15; Coldstream, journal, TGA 8922/1/11.

19 J. Rothenstein and Treasury meeting, 6 November 1952. A year later, John saw the film at the cinema; diary entry, 3 September 1953, TGA 8726/1/23.

20 Writer Percy Lubbock quoted in Bruce Arnold, *Derek Hill* (London: Quartet Books, 2010), p. 109.

21 John took illusory comfort from the fact that the sculptor himself did not seem concerned about the incident; *Brave Day, Hideous Night*, p. 248.

22 Viscountess Davidson, question, 11 November 1952; the Chancellor of the Exchequer, R. A. Butler, answered that the article had not been submitted to the Director beforehand; *Hansard*, *HC Debates*, vol. 507, cols 30–31W; Maurice Edelman, question, 13 November 1952, ibid., col. 73W.

23 *Brave Day, Hideous Night*, p. 248; diary entry, 28 October 1952, TGA 8726/1/22.

24 Diary entry, 12 February 1952, TGA 8726/1/22.

25 Directed by Godfrey Grayson, *The Fake* came out in 1953, starring Dennis O'Keefe, Coleen Gray and Hugh Williams (John was not credited with the script). Internet amateur reviews of the 80-minute film are mixed, several noting the use of the real location. One ends with: 'If the Tate Museum had such lax security … people crawling through windows in the boiler room – million dollar paintings with no alarms – ALL of their artwork would have been stolen'.

26 J. Rothenstein and Treasury meeting, 6 November 1952; *Brave Day, Hideous Night*, p. 250.

27 An article in the *Daily Mail* of 1 November used words guaranteed to alarm the Chairman: 'Before the cameras invade the gallery in mid-November'; copy, TGA 8726/3/23.

28 See sarcastic internal Treasury memo, 12 November 1952. Edward Playfair to Robert Armstrong. T273/14–16.

29 *Brave Day, Hideous Night*, pp. 250–51; diary entry, 7 November 1952, TGA 8726/1/22.

30 Douglas Cooper, postcard to J. Rothenstein, November 1952, Douglas Cooper Papers, Series 1, Correspondence, 1939–1984, Box 2, folder 58.

31 See Le Roux; letters to Lord Jowitt, 27 October, 7 November and 11 November, in 'Papers

handed to Ritson'. Around this time, Le Roux was also meeting Sutherland to tell him what was going on.

32 Chairman's report, 20 November 1952, in 'Papers handed to Ritson'.

33 *Brave Day, Hideous Night*, p. 255.

34 It is impossible to gauge the extent of the connection between Hendy and Le Roux, which is reflected in their intermittent letters. From their tone, Le Roux did not regard Hendy as an enemy, asking him for references as required. Yet Hendy was undoubtedly supportive of John. An undated letter (to which Hendy replied on 28 November 1952) from Elizabeth Rothenstein thanks him 'for being the one person to resist this barrage of evil which has almost blown us to bits'. In the complex interplay of relationships in the British art world, it is notable that Hendy was also receiving letters at this time from Humphrey Brooke, e.g. of 28 November 1952 in which Brooke grumbles about his treatment at the hands of John in 1949. Philip Hendy Papers, NG 16/409/1.

35 *Brave Day, Hideous Night*, p. 296.

36 Edward Playfair, educated at Eton and King's College, Cambridge, KCB 1957, was Chairman of the National Gallery in 1972–74.

37 *Brave Day, Hideous Night*, p. 252.

38 Edward Playfair, comment in 'Tate Gallery enquiry'.

39 Although Anderson's comments at this meeting were not recorded, he certainly disliked John. In his unpublished memoirs, p.697, he says, in racist terms: 'John Rothenstein was a complex little man, hampered sadly by an unattractive Nibelung-like appearance and a tendency to flatter and cringe, a possible heritage from his Jewish ancestry, though he was only half-Jewish', and that, as regards the staff, John 'lacked frankness and gave no acceptable form of leadership'; memoirs, extract courtesy of Anderson's daughter, Mrs Catriona Williams.

40 Sir Thomas Padmore, educated at Sheffield Central School and Queens' College, Cambridge, was Permanent Secretary to the Treasury and Second Secretary in 1952–62.

41 *Brave Day, Hideous Night*, p. 278. Years later, on 18 October 1957, John's diary recorded a telephone call from Ritson, in which he said he had heard that Jowitt had never circulated the Report to the Trustees; he had just summarised it; TGA 8726/1/28.

42 J. Rothenstein, letter to Edward Playfair, 22 December 1952, Treasury, T 273/16.

43 Ritson Report, 30 December 1952, Treasury, T 273/16.

44 J. Rothenstein, note to Treasury, January 1953, T 273/16; *Brave Day, Hideous Night*, p. 278; diary entry, 6 January, TGA 8726/1/23.

45 See Tate Gallery annual reports, 1951 and 1952.

46 The Hon. John Fremantle, educated at Eton and Trinity College, Cambridge, became Lord Cottesloe in 1956, was Chairman of the Arts Council in 1960–65. Lionel Robbins, educated at Southall County School and University College London, was an economist, later Lord Robbins.

47 Sir Lawrence Gowing (knighted 1982) studied under Coldstream at the Euston Road School and became a prestigious writer on art and arts administrator, Tate Trustee in 1953–60 and 1961–64.

48 TG 92/121.

49 I am grateful for this information from Miriam Power, Westminster Cathedral Archives, email to me, 16 March 2017.

50 J. Rothenstein, diary entry, 19 January 1953; e.g. on 29 January John recorded that Le Roux was telling people that John had been rifling through his personal correspondence file, kept in his office; TGA 8726/1/23.

51 Ibid., 7 January 1953, TGA 8726/1/23.

52 Ibid., 15 January 1953, TGA 8726/1/23.

53 Douglas Cooper, letter to J. Rothenstein, 13 June 1953, TGA 8726/3/10.

54 J. Rothenstein, diary entry, 2 November 1953, TGA 8726/1/23.

55 Proctor seems to have regarded Blunt as a highly principled traitor, sticking to his beliefs; see Proctor, letter to Dadie Rylands at King's College, n.d. [1979], Papers of George Humphrey Wolferstan Rylands, King's College, Cambridge, GHWR/3/337. At the height of Blunt's public disgrace, Proctor even had a long letter defending Blunt published, in the *London Review of Books*, 2, no. 18 (18 September 1980), which concluded that he was proud to count him as one of his dearest friends. In contrast, David Pryce-Jones, reviewing Miranda Carter's biography of Blunt, *The Spectator*, 10 November 2001, p. 73, commented: 'Blunt was a shit through and through. By definition, such a character takes for granted that whatever he feels like doing is quite all right, and the consequences to other people are no concern of his.'

56 See Andrew Lownie, *Stalin's Englishman: The Lives of Guy Burgess* (London: Hodder & Stoughton, 2015), p. 131, reporting Blunt in an MI5 interview: 'Dennis was the best source Guy ever had for the Russians'. See also p. 33: 'of the thirty-one Apostles elected between 1927 and 1939, fifteen were communists or Marxists … [Burgess] and Blunt brought in fellow supporters as part of a strategy to infiltrate communists into important university societies'; 'The first Marxian generation of Apostles are regarded as Dennis Proctor, Alister Watson, Hugh Sykes-Davies and Richard Llewellyn-Davies,' p. 339, n. 26.

57 Ibid.

58 Proctor, letter to J. Rothenstein, 11 February
 1953, TG 1/6/39, asks on behalf of a friend
 knowledgeable about pictures, detailed questions
 about the whereabouts of various pictures. The
 'friend' may well have been Cooper.

59 It became the National Gallery and the Tate
 Gallery Bill, and was in gestation a long time: see
 e.g. Tate Board Minutes, 18 September 1947, TG
 1/3/6, reporting that a Bill was in preparation.

60 J. Rothenstein, diary entries, 1953, TGA
 8726/1/23.

61 All reports from the *Hansard* website, hansard.
 millbanksystems.com/sittings/1950s, accessed
 2017.

62 J. Rothenstein, diary entries, 2 November, 2
 December, 29 September 1953, respectively,
 TGA 8726/1/23.

63 Ibid., 18 June 1953, TGA 8726/1/23.

64 Ibid., 13 July 1953, TGA 8726/1/23. There is
 great doubt that the artist wrote even the short
 piece which appeared under his name in the
 Smith catalogue. Bacon was not much of a writer.

65 The 12th Lord Kinnaird, educated at Eton and
 Trinity College, Cambridge, lived at Rossie
 Priory in Perthshire. His *Who's Who* entry for
 1948 states that he 'owns about 11,900 acres'.
 Photographs show him with a remarkably
 prominent hearing aid.

Chapter 11. Tate War: Second Phase, 1953–54

1 On 14 January 1954 the Director was told by Mary,
 Duchess of Roxburghe that Lord Kinnaird was not
 the type to have picked up on a technicality like the
 Knapping Fund affair 'without positive prompting';
 diary entry, TGA 8726/1/24. In the Kinnaird
 Collection, Perth & Kinross Council Archive,
 Perth, MS 100, the first item from Le Roux is
 the 27 November letter, with its accompanying 8
 handwritten pages. My particular thanks to Claire
 Devine, Senior Archive Assistant, for locating this
 information. See also *Brave Day, Hideous Night*,
 pp. 302–4.

2 *Brave Day, Hideous Night*, p. 303.

3 Ibid., p. 305.

4 John's diary entries for early December (TGA
 8726/1/23) are unperturbed: he was told that
 Kinnaird had followed up the information he
 received from Le Roux by visiting him at the
 Gallery on 30 November.

5 John found out about breaches of the terms of
 the Knapping Bequest on 27 and 28 November
 and of the Courtauld Bequest on 4 December,
 as he reported to the Board on 30 January 1954;
 diary entries, TGA 8726/1/23, 8726/3/25.

6 Ibid., 1 December 1953, TGA 8726/1/23.

7 Lord Amulree, educated at Lancing and Gonville
 and Caius College, Cambridge, was the 2nd
 and last Baron. He and Sutherland had been

at kindergarten together; Berthoud, *Graham
Sutherland*, p. 28.

8 House of Lords debate on Bill, 8 December 1953,
 Hansard, *HL Debates*, vol. 184, cols 1032–78.

9 There are no letters, e.g., from Le Roux in the
 Douglas Cooper Papers at the Getty. Yet, Le
 Roux had links with Humphrey Brooke and was
 close to Sutherland.

10 J. Rothenstein, diary entries, 8 and 19 December
 1953, TGA 8726/1/23.

11 *Brave Day, Hideous Night*, p. 304.

12 Cooper had sharpened his knowledge of the Tate
 collection through working in the Tate archives
 in connection with research for his publication
 of *The Courtauld Collection. A Catalogue and
 Introduction. With a Memoir of Samuel Courtauld
 by Anthony Blunt*. (London: the Athlone Press,
 1954).

13 *Brave Day, Hideous Night*, p. 306.

14 Humphrey Brooke, letter to Douglas Cooper, 21
 December 1953, Douglas Cooper Papers, Series
 1, Correspondence, 1939–1984, Box 9, folder
 2, from which come further references to the
 Brooke–Cooper correspondence.

15 Brooke was doing his best to accumulate evidence
 of the Tate's failings, having contacted Paul
 Hulton about his dismissal and even Roderic
 Thesiger; Brooke, letter to Cooper, 7 February
 1954, ibid.

16 J. Rothenstein, diary entry, 1 June 1950, TGA
 8726/1/21 (at the Athenaeum).

17 Denis Mahon, letters to Douglas Cooper, 22
 January–7 February 1954, Douglas Cooper
 Papers, Series 1, Correspondence, 1939–1984,
 Box 9, folder 2, from which further references to
 their correspondence come.

18 *Brave Day, Hideous Night*, p. 307.

19 Tate Board meeting minutes, 5 January, sent
 by Proctor to the Treasury, 23 February 1954,
 Treasury, T 227/362.

20 Dennis Proctor, 'Comments on *Brave Day,
 Hideous Night*', n.d., 66-page memorandum,
 n.p., Proctor papers, uncatalogued, TGA.

21 Tate Board meeting minutes, 22 January 1954,
 Treasury, T 227/362.

22 John Rothenstein, note to Board, 30 January
 1954, TGA 8726/3/25.

23 Proctor, 'Comments on *Brave Day, Hideous
 Night*'.

24 Graham Sutherland, letter to Dennis Proctor, 26
 January 1954, copy in Douglas Cooper Papers,
 Series 1, Correspondence, 1939–1984, Box 9,
 folder 2. For letters to Clark and Anderson, see
 e.g. Berthoud, *Graham Sutherland*, p. 175.

25 Berthoud, *Graham Sutherland*, p. 167, noted that
 the artist was not very good at thinking things
 through.

26 Denys Sutton, educated at Uppingham and
 Exeter College, Oxford, was an art critic.
 According to John, Sutton had applied for a post

at the Tate but had been rejected when found to have lied about the class of his degree; note, 2 February 1954, TGA 8726/3/25.

27 The *Sunday Times* and the *Observer* treated the resignation more neutrally. Mahon believed that they must have been 'got at' by Rothenstein; letter to Cooper, 31 January 1954.

28 Sutherland and Beaverbrook had been to the Tate for lunch with the Director on 27 May 1952, following which there had been a civilised exchange of letters between them; Beaverbrook Papers, University of Delaware Library, Special Collections, MSS502.

29 Lord Beaverbrook to Douglas Cooper, 3 May 1957, Douglas Cooper Papers, Series 1, Correspondence, 1939–1984, Box 2, folder 1; it is clear they were already friendly.

30 *Brave Day, Hideous Night*, p. 370.

31 Lawrence Gowing and Edward Bawden, letters to Sutherland, 30 January and 1 February 1954 respectively, Treasury, T 227/362.

32 See e.g. Proctor, letter to Sutherland, 29 January 1954, Treasury, T 227/362.

33 Berthoud, *Graham Sutherland*, p. 176.

34 Ibid., p. 177. Cooper had promised to write a monograph on Sutherland's work, which he kept: *Graham Sutherland* (London: Lund Humphries, 1961).

35 Sir Colin Anderson, unpublished memoirs, extract courtesy of Anderson's daughter, Mrs Catriona Williams.

36 Berthoud, *Graham Sutherland*, p. 177; Mahon and Brooke, letters to Cooper, 2 February 1954. Much of what follows comes from Treasury, T 227/362, unless otherwise specified.

37 It is not known if some of the conspirators had a connection with Butler. Letters from Mahon (4 February) and Brooke (7 February) mention him to Cooper.

38 Graham Sutherland, memorandum to R. A. Butler, 5 March 1954. Years later, in 1962, John recorded a comment on this encounter from Alfred Hecht (see Ch. 12 n. 20 below). He had been told by Sutherland that Butler had been 'menacing' when handed the envelope and had 'turned him out of No. 11 almost at once saying that unless left matter alone perhaps *he* should be investigated: G v. frightened'; diary entry, 31 May 1962, TGA 8726/1/35.

39 Charles Fletcher-Cooke, letter to Douglas Cooper, 13 February [1954], Douglas Cooper Papers, Series 1, Correspondence, 1939–1984, Box 9, folder 2.

40 Lawrence Gowing, letter to Dennis Proctor, February 1954, referred to in minutes of meeting of 18 February 1954.

41 Proctor sent all these Board meeting minutes to the Treasury, 23 February 1954, from which further references come; Proctor, 'Comments on *Brave Day, Hideous Night*'.

42 Mahon, letter to Cooper, 4 February 1954, wrote that Speaight's letter was 'obviously written by J.R.'

43 Ibid.

44 Mahon, letters to Cooper, 5 February (twice), n.d. [?6 February]1954.

45 Mahon, letter to Cooper, 7 February 1954. Brooke also urged Cooper to make Sutherland come back to England; letter, 7 February 1954.

46 Proctor, Fremantle and Le Roux, meeting, 5 March 1954, note, Treasury, T 227/362.

47 Ronald Alley, Jane Ryder (both 10 March), Betty Butcher, Mary Chamot (both 11 March) and Anne Crookshank (n.d.), copies in Philip Hendy Papers, NG 16/409/1.

48 Rothenstein, diary entry, 28 January 1954, TGA 8726/1/24.

49 J. Rothenstein, diary entry, 31 January 1954, TGA 8726/1/24; Mahon, letter to Cooper, [February 1954].

50 Copy in Philip Hendy Papers, NG 16/409/1.

51 *Brave Day, Hideous Night*, ch. 20.

52 "Tate Gallery: report by the Trustees Feb 1954" (London: HMSO, 1954).

53 J. Rothenstein, diary entry, 25 January 1954, TGA 8726/1/24.

54 J. Rothenstein, diary entry, 10 March 1954, TGA 8726/1/24.

55 Letter 26 March 1952. Copy in Philip Hendy Papers, NG 16/409/1.

56 Tate Board meetings, 1954, TG 1/3/9. At his last meeting, 30 May 1954, Le Roux presented a memorandum on Trustees' responsibilities, which must have amused all concerned.

57 Lord (Paul) Methuen (1886–1974), educated at Eton and New College, Oxford, was an artist, among other activities. He let part of his house, Corsham Court, as an art school.

58 Spalding, *The Tate*, p. 117.

59 My thanks for this information to Lucy Carter, 11 May 2017.

60 *Brave Day, Hideous Night*, p. 352.

61 J. Rothenstein, diary entry, 3 May 1954, TGA 8726/1/24; Le Roux had more luck with Philip Hendy, who did give him a reference, 24 May 1954, Philip Hendy Papers, NG 16/409/1.

62 J. Rothenstein, diary entry, 10 August 1963, TGA 8726/1/36.

63 *The Tate Gallery Report 1953–54: Review 1938–53* (London: HMSO, 1954).

64 J. Rothenstein, diary entries, 2 July (Le Roux's new job), 12 and 15 October 1954, TGA 8726/1/24.

65 Debate, 18 February 1954 , *Hansard, HC Debates*, vol. 523, cols 2125–6.

66 Debate, 30 March 1954, *Hansard, HL Debates*, vol. 186, cols 779–805.

67 Ibid., 8 April 1954, vol. 186, cols 1151–76.

68 G. R. Strauss (1901–1993), educated at Rugby School, was an exact contemporary of John's; he

was also from a Jewish family and his obituary in *The Independent*, 9 June 1993, records the 'rough treatment meted out to Jewish boys' there in his time.

69 Jo Grimond (1913–1993), educated at Eton and Balliol College, Oxford, was the leader of the Liberal Party in 1956–67.

70 Debate, 29 October 1954, *Hansard, HC Debates*, vol. 531, cols 2281–355.

71 Nigel Nicolson (1917–2004), educated at Eton and Balliol College, Oxford, MP 1952–59, was the son of Harold Nicolson and Vita Sackville-West.

72 Sir Kenneth Robinson (1911–1996), educated at Oundle, later became Chairman of the Arts Council, 1977–82.

73 Woodrow Wyatt (1918–1997), educated at Eastbourne and Worcester College, Oxford, was a journalist.

74 *Brave Day, Hideous Night*, p. 359.

75 Dennis Proctor, letter to Henry Brooke, 15 November 1954, Proctor papers, TGA.

76 Cooper had lunch that day with John Richardson at Sutherland's house in Kent. All three came up to London for the party, although Sutherland did not see the incident; Berthoud, *Graham Sutherland*, p. 181; J. Rothenstein, diary entry, 2 November 1954, TGA 8726/1/24; *Brave Day, Hideous Night*, p. 363; Richardson, *Sorcerer's Apprentice*, pp. 163–4.

77 *Brave Day, Hideous Night*, p. 363. John kept a file of letters and telegrams from people who approved of his action, including Graham Greene, Hendy and Ben Nicholson, TGA 8726/3/26. The incident was covered in the *Evening News, Evening Standard, Daily Mail, Guardian, Daily Express* and *Daily Sketch*.

78 Dennis Proctor, memo, 12 November 1954, correspondence file, Proctor papers, TGA.

79 Ibid.

80 Benedict Nicolson, letter to Douglas Cooper, 10 November [1954]; Denys Sutton, ibid., Sunday [probably 14 November 1954], Douglas Cooper Papers, Series 1, Correspondence, 1939–1984, Box 9, folder 2.

81 Proctor was also consulting Blunt about the situation with Cooper; letter to Cooper, 14 November 1954, Proctor papers, TGA.

82 Editorial [Benedict Nicolson], 'The Tate Controversy', *Burlington Magazine*, 96, no. 621 (December 1954).

83 J. Rothenstein, diary entry, 12 November 1954, TGA 8726/1/24.

Chapter 12. Last Years at the Tate, 1955–64

1 In his diary on 16 June 1955, TGA 8726/1/25, John noted an 'incredibly rude and spiteful article in the Evening Standard by Le Roux about [the Tate's] Ben Nicholson exhibition'.

2 Examples of Cooper's strangeness abound. Robert Medley, *Drawn from the Life: A Memoir* (London: Faber and Faber, 1983), p. 193, records a meeting with him in which Cooper chose to speak English only with a French accent. Bryan Robertson's speech at Sir John Rothenstein's Memorial Party, 8 June 1992, TGA, TAV 1007A, noted that Cooper employed a variety of accents, for no discernible reason, including 'camp Cockney, French, Deep South and German'. In 1976 Cooper wrote a savage review of Michael Holroyd's biography of Augustus John, 'How John got on', *New York Review of Books*, 4 March, dismissing the achievements of one of Rothenstein's favourite artists.

3 Who was this? There is a well-known Czech journalist called Egon Kisch, who had caused controversy while trying to enter Australia in the 1930s, but he had died in 1948; https://en.wikipedia.org/wiki/Egon_Kisch, accessed 24 July 2017. Was it his son?

4 J. Rothenstein, diary entry, 7 January 1955, TGA 8726/1/25.

5 Letter J. Rothenstein to D. Proctor, 14 December 1955, TGA 8726/3/25. John enjoyed hearing from others their low opinion of Cooper, e.g. from Alfred Barr, diary entry, 5 June 1956, TGA 8726/1/27.

6 John Rothenstein, letter to Colin Anderson, 21 September 1957, TGA 8726/3/10; diary entry, 20 September 1957, TGA 8726/1/28.

7 J. Rothenstein, diary entry, 25 September 1957; this led to an apology to John by Bill Williams of the Arts Council, ibid., 27 September 1957, TGA 8726/1/28.

8 See J. Rothenstein, diary entry, 20 January 1955, TGA 8726/1/25, when John had met the deputy editor of the *Evening Standard*: 'There had been some revision of views about situation at the Tate Gallery and I need anticipate no more attacks.'

9 Cooper also wrote to Proctor to explain himself (14 April 1956), pointing out also that the 12-month 'truce' had expired; Proctor papers, TGA.

10 J. Rothenstein, diary entry, 4 April 1956, TGA 8726/1/27.

11 John was also phoned to say that Denys Sutton had resigned from the same committee for the same reason and was then phoned two days later to say that Sutton had reconsidered.

12 John Rothenstein, 'Art in our Churches', *Picture Post*, 19 May 1956.

13 J. Rothenstein, diary entry, 15 June 1955, TGA 8726/1/25; *Picture Post* showed him a letter from Mrs Sutherland.

14 Ibid., 3 November 1955, TGA 8726/1/25; Philip Hendy told him.

15 Ibid., 19 March 1957, TGA 8726/1/28.

16 Dennis Proctor, letter to Douglas Cooper, 28 March 1957, Douglas Cooper Papers, Series 1, Correspondence, 1939–1984, Box 9, folder 5.

17 J. Rothenstein, diary entry, 23 December 1955, TGA 8726/1/25.

18 J. Rothenstein, diary entry, 26 October 1962, TGA 8726/1/35.

19 John Rothenstein, *The Moderns and their World* (London: Phoenix House, 1957).

20 Alfred Hecht (1907–1991), whose shop was in King's Road, Chelsea, dealt in pictures as well as framing them. He was the main framer for Sutherland, Bacon and the Marlborough Gallery.

21 J. Rothenstein, diary entry, 26 February 1957, TGA 8726/1/28.

22 Ibid., 19 December 1957, TGA 8726/1/28. John recorded that Blunt had told Proctor that he thought Cooper 'really evil' and his hatreds made him 'behave like a schoolgirl'.

23 John Richardson, letter to Anthony Blunt, 15 October 1957, copy in Proctor papers, TGA.

24 J. Rothenstein, diary entry, 5 July 1960, TGA 8726/1/31. Corinne Bellow, John's last assistant at the Tate, records that when in 1983 Cooper was working on the final preparations for *The Essential Cubism: Braque, Picasso and their Friends 1907–1920* (he was then suffering from the cancer which would kill him), John went to the show and, learning that Cooper was in the Gallery, asked if he could congratulate Cooper in person for such a good exhibition. Alan Bowness, then Director, asked Cooper but got the same old apoplectic reply, even after all those years; TGA, TAV 1696A. No reconciliation between John and Cooper ever occurred.

25 Proctor papers, TGA; Douglas Cooper Papers, Series 1, Correspondence, 1939–1984, Box 9, folders 2 and 5.

26 J. Rothenstein, diary entry, 10 October 1957, TGA 8726/1/28; Proctor, letter to Cooper, 13 June 1957, Douglas Cooper Papers, Series 1, Correspondence, 1939–1984, Box 9, folder 5.

27 Proctor, letters to J. Rothenstein, 1955 and 29 May 1959, TGA 8726/3/10.

28 Douglas Cooper, *Graham Sutherland* (London: Lund Humphries, 1961), pp. 1 to 64.

29 J. Rothenstein, diary entry, 24 January 1962, TGA 8726/1/35.

30 Ibid., 22 February 1962, TGA 8726/1/35.

31 Denis Mahon, 'Gallery Trusteeship: the re-establishment of confidence', *Burlington Magazine*, 622, (January 1955), pp. 20–22.

32 J. Rothenstein, diary entry, 26 February 1955, TGA 8726/1/25.

33 E.g., ibid., 17 October 1957, TGA 8726/1/28; Proctor said he had rung Cooper to ask him to apologise to John.

34 Cooper, letters to Proctor, 1954–56, Proctor papers, TGA.

35 These 'Research Days' had been introduced for senior staff in 1954; I am very grateful to Martin Butlin for describing aspects of life at the Tate as the staff saw it from 1955 to 1964; personal communications, 2016–17.

36 John Marin, *Downtown, New York* (1923, Tate, T0080).

37 J. Rothenstein, diary entry, 14 June 1955, TGA 8726/1/25.

38 Dennis Farr, educated at Luton Grammar School and the Courtauld Institute, Assistant Keeper at the Tate in 1954–64, was the Director of the Courtauld Institute in 1980–93. He wrote *English Art 1870–1940* (1978) in the Oxford History of English Art series.

39 Martin Butlin, educated at Rendcomb College and Trinity College, Cambridge, studied at the Courtauld Institute and was Assistant Keeper, Tate, in 1955–67, then Keeper of the Historic British Collection in 1967–89. He is an expert on Turner and William Blake.

40 J. Rothenstein, diary entries, 19 January, 15 June 1961, TGA 8726/1/34.

41 Tate Gallery, Annual Reports, 1954–1964, TGA, from which further information on acquisitions and references come.

42 Proctor briefed Cooper in 1957 on seeking Treasury grants; note, 9 May 1957, Douglas Cooper Papers, Series 1, Correspondence 1939–1984, Box 9, folder 5.

43 J. Rothenstein, diary entry, 1 December 1961, TGA 8726/1/34.

44 Ibid., 7 December 1961, TGA 8726/1/34.

45 John's diary, e.g. 4 January 1961, TGA 8726/1/34, also noted ongoing discussions with the Royal Academy, about the Chantrey Bequest, and with Philip Hendy at the National Gallery about picture transfers between the galleries.

46 Together with the Whitechapel's *Jackson Pollock* which Bryan Robertson put on in 1958.

47 In 1959 he started discussions with the American Ambassador in London, John Hay Whitney, to show his extensive art collection at the Tate; TG 92/158. The *John Hay Whitney Collection* opened in 1960, with an impressive catalogue for which John wrote the foreword.

48 Butlin, personal communications, 2016–17.

49 Jack Yeats, letter to John Rothenstein, 6 September 1948, TG 92/69. Rothenstein had visited the artist in Dublin in 1945, leading to the purchase of The Two Travellers (1942, Tate, 5660) and to an article 'Visits to Jack Yeats', New English Review, July 1946.

50 J. Rothenstein, diary entries, e.g. 5 August, 15 August, 17 August, 16 October, 14 November, 1 December, 2 December, 7 December 1961, TGA 8726/1/34.

51 J. Rothenstein, diary entry, 30 March 1955, TGA 8726/1/25.

52 Robert Adeane, educated at Eton and Trinity College, Cambridge, was knighted in 1961.

53 J. Rothenstein, diary entry, 14 May 1962, TGA 8726/1/35.

54 See Sophie Bowness and Clive Phillpot, eds, *Britain at the Venice Biennale 1895–1995* (London: British Council, 1995).

55 J. Rothenstein, diary entry, 4 March 1955, TGA 8726/1/25.

56 John was told a year later by Moore that Sutherland had become isolated from his old friends after the publicity around his resignation; ibid., 15 March 1956. The painter Carel Weight told John that he was ashamed as an artist by Sutherland's behaviour; ibid., 8 May 1956, TGA 8726/1/27.

57 Ibid., 5 May 1956, TGA 8726/1/27.

58 Ibid., 5 June 1956, TGA 8726/1/27.

59 Churchill Papers, Churchill College, Cambridge, Chur 1/25 A-B, 1/130, 2/154, 2/175, 2/182 A-B, 2/379, 2/404, 2/412, 2/533; J. Rothenstein file, TGA 8726/3/10.

60 *Time's Thievish Progress*, p. 138.

61 J. Rothenstein, diary entries, 12 and 13 July 1955, TGA 8726/1/25.

62 Ibid., 7 June 1956, TGA 8726/1/27.

63 Le Roux was found dead in 1963, possibly having committed suicide; see e.g. https://en.wikipedia.org/wiki/Le_Roux_Smith_Le_Roux, accessed 24 July 2017. After the publication of *Brave Day, Hideous Night,* John received letters from lawyers acting for Le Roux's widow, complaining about the suggestion that he had committed suicide. TGA 8726/2/109A.

64 Beaverbrook–J. Rothenstein correspondence 1958–60, Beaverbrook Papers, Parliamentary Archives, House of Lords, BBK.

65 *Brave Day, Hideous Night*, pp. 370–72.

66 Lord Beaverbrook, letter to John Rothenstein, 30 November 1960, Beaverbrook Papers.

67 *Time's Thievish Progress*, pp. 160–62. The Morisot later left the Gallery anyway when it was transferred to the National Gallery with other Hugh Lane pictures.

68 Similarly, there was little fuss when the Tate announced, on 14 May 1957, that a work by Rodin had gone missing from the collection. John mused in his diary whether Le Roux might have stolen it; 14 May 1957, TGA 8726/1/28.

69 Ibid., 31 December 1956, TGA 8726/1/27.

70 Ibid., 17 August 1957, TGA 8726/1/28.

71 On 21 May 1964 John heard about Fincham's death, ibid., TGA 8726/1/37.

72 Ibid., 16 January and 13 May 1959, TGA 8726/1/30.

73 Francis Bacon, letter to John Rothenstein, 16 May 1959, TGA 8726/3/10.

74 Board meeting minutes, 21 September 1961, mentioned as John's proposal, TG 1/3/14.

75 Robert Sainsbury, educated at Haileybury and Pembroke College, Cambridge, was a Trustee in 1959–73 and Chairman 1969–73.

76 Robert Melville may have been particularly welcome to Bacon as a commentator because he had written the first ever substantive critique of Bacon's work, in *Horizon* (December 1949).

77 J. Rothenstein, diary entry, 24 January 1962, TGA 8726/1/35.

78 Ibid., 30 January 1962, TGA 8726/1/35.

79 Erica Brausen (1908–1992) was also hostile towards Robert Melville, who had worked with her at the Hanover Gallery and had then also moved to the Marlborough.

80 Ibid., 21 February, 20 and 23 March 1962, TGA 8726/1/35. David Sylvester (1924–2001), educated at University College School, London, was an important art critic, closely associated with promoting Bacon's work.

81 Ibid., 7 February, 21 March and 27 February, respectively, 1962, TGA 8726/1/35.

82 E.g., the phrase 'make an assault on our nervous system', as if John rather than Bacon is saying it; *Francis Bacon* (London: Tate Gallery, 1962), n.p; on the next page, John quotes the 1953 Matthew Smith catalogue in which Bacon uses exactly the same phrase.

83 J. Rothenstein, diary entries, 27 April–23 May 1962, TGA 8726/1/35. Corinne Bellow has described how she was told by Bacon to do her best to keep the press away from him at the press view; TGA, TAV 1696A.

84 Bacon, letter to J. Rothenstein, 4 July 1962, TGA 8726/3/10.

85 John included Bacon in *British Art since 1900* and in 1963 published a short book on Bacon in the British Printing Corporation's *Masters* series. In 1964 the *Catalogue Raisonné* was published: *Francis Bacon*, intro. John Rothenstein, cat. raisonné and documentation Ronald Alley (London: Thames & Hudson). Alley did all the hard work, with John's 1962 catalogue introduction adjusted for it; also published in the UK edition of *Vogue* (May 1964), pp. 108–11.

86 Andrew Sinclair, *Francis Bacon: His Life and Violent Times* (London: Sinclair-Stevenson, 1993), pp. 72, 142.

87 John Russell, *Francis Bacon* (London: Methuen, 1964); David Sylvester wrote numerous books on Bacon, which went into many editions.

88 J. Rothenstein, diary entries, 15 March and 16 April 1962, TGA 8726/1/35.

89 Ibid., 16 and 18 April, TGA 8726/1/35.

90 Ibid., 15 March and 17 May 1962, TGA 8726/1/35.

91 Ibid., 17 March, 8 February, 1 March and 7 April 1962, respectively, TGA 8726/1/35.

92 Ibid., 14 and 22 June 1962, TGA 8726/1/35.

93 Ibid., 21 March, 1 and 2 April, 9 and 18 April 1963, TGA 8726/1/36; Colin Anderson, letter

to John Rothenstein, 29 March 1963, TGA
8726/3/10. Stokes had been a friend of John's at
Oxford.

94 J. Rothenstein, diary entry, 20 June 1963, TGA
8726/1/36.

95 Ibid., 14 and 27 November 1963, TGA
8726/1/36.

96 Ibid., 3 January 1964, TGA 8726/1/37.

97 Anderson, letter to J. Rothenstein, 10 January
1964, TGA 8726/3/10.

98 J. Rothenstein, diary entries, 13 January, 27
February, 13 March 1964, TGA 8726/1/37.
He soon found himself editing a series called
'*The Masters*', which published 100 titles up to
September 1967.

99 Ibid., 24 and 25 March 1964, TGA 8726/1/37.

100 Ibid., 25 March 1964, TGA 8726/1/37.

101 Ibid., 2 and 3 April 1964, TGA 8726/1/37.

102 Norman Reid, interview with Cathy Courtney,
2000, British Library recording, C466/97,
Vol 3.

103 Ibid.

104 J. Rothenstein, diary entries, 29 June and 28
July 1964, TGA 8726/1/37.

105 Ibid., 2 and 27 August 1964, TGA 8726/1/37.

106 Ibid., 29 September, TGA 8726/1/37. In fact,
Reid and John had a long and reasonably close
relationship. It is misleading to suggest that
they were regularly antagonistic to each other;
my thanks to Lucy Carter for this information;
see also *Brave Day, Hideous Night*, passim.

107 J. Rothenstein, diary entry, 12 October 1964,
TGA 8726/1/37. Tidying up his office after he
had left, Corinne Bellow wrote him a touching
letter on 1 October: 'You have left a very sad
atmosphere indeed in your wake – and I can't
imagine how on earth we are ever to get used
to the idea of referring to anyone else as "The
Director"', TGA 8726/3/10.

Chapter 13. The Autobiography

1 *Summer's Lease* and *Brave Day, Hideous Night*
had been written as one very long volume
which the publishers chose to split into two; J.
Rothenstein, diary entry, 1 June 1964. John's
wife chose the title for *Summer's Lease*; ibid., 1
November 1964, TGA 8726/1/37. The book was
dedicated to her. Page references for all further
quotations from John's books will follow in
brackets in the text.

2 John's diary records him finishing the first draft
of the period of his life which became *Summer's
Lease* on 3 September 1960 and starting on the
phase which became *Brave Day, Hideous Night*
on 10 October; TGA 8726/1/31.

3 In *Modern English Painters: Sickert to Smith*,
p. 134, John says that he had urged his father to
write his memoirs in the first place.

4 Max to Florence Beerbohm, letter, 25
September/19 October 1924, cited in Lago and
Beckson *Max and Will* p. 117 n. 1.

5 Ch. 14 will cover the treatment of William
Roberts in *Modern English Painters*.

6 John Rothenstein, letter to Kingsley Martin,
former *New Statesman* editor, 4 December
1965, TGA 8726/2/108. This may have had the
desired effect, because when *Brave Day, Hideous
Night* came out in 1966, the *New Statesman*'s
reviewer was the more objective Robert Melville.

7 Malcolm Eaton, review of *Summer's Lease*, *Apollo*
(May 1966), p. 397.

8 By 1966 when *Brave Day, Hideous Night* came
out, Le Roux was dead and John had no concerns
about libel. All the other main participants in
the Tate Affair were alive and capable of being
litigious if defamed.

9 Richardson, *Sorcerer's Apprentice*, p. 160.

10 J. Rothenstein, note to Board, 30 January 1954,
TGA 8726/3/25.

11 Although John's publishers did pay Cooper
£75 to get rid of him; Hamish Hamilton, letter
to John Rothenstein, 18 October 1966, TGA
8726/2/109A.

12 Melville was upset because he had worked hard
alongside Cooper on the Sutherland book (1961),
but his contribution had been deliberately
downplayed to emphasise Cooper's role. John
recorded in his diary, 24 July 1961, TGA
8726/1/34, that Alfred Hecht was also indignant
that this should have happened to Melville.

13 John Rothenstein, letter to the editor, *New
Statesman*, 17 October; reply, 25 October 1966,
TGA 8726/2/109A.

14 Kenneth and Jane Clark, letters to J. Rothenstein,
24 October 1966, TGA 8726/2/109A.

15 In his diary John recorded how he hated having
to dredge up the whole business in order to write
about it. It had taken him the best part of three
months, from 17 March to 4 June 1962, TGA
8726/1/35, to write that section of *Brave Day,
Hideous Night*.

16 In his archive, TGA 8726/2/89B, is an
annotated proof of a collection of essays on
artists which was never published: 'Fourteen
Artists' is dated 1982 and covered Spencer,
Blanche, Eakins, Hammer, Churchill, Ironside,
Sickert, Underwood, Alvara Guevara, Minton,
Mahoney, Weight, Buhler and Roberts-Jones.

17 E.g., for Robin Ironside (New Art Centre, 1966),
Edward Burra (Tate, 1973), Alvaro Guevara
(Colnaghi, 1974), Charles Mahoney (Michael
Parkin, 1975), Albert Houthuesen (Colnaghi,
1976) and Wyndham Lewis (City of Manchester
Art Galleries, 1980).

Chapter 14. Modern English Painters

1 The title was presumably a play upon Ruskin's *Modern Painters* of 1843–60 but there the resemblance ends. There was a passing reference to Ruskin's work in the introduction to the first volume of *Modern English Painters* (*Sickert to Smith*), which suggests it was on John's mind. A precedent structured more similarly to John's work would be Vasari's *Lives of the Most Excellent Painters, Sculptors and Architects* of 1550; see Professor Edward Chaney, 'The Vasari of British Art: Sir John Rothenstein', *Apollo*, 132 (November 1990), pp. 322–6. A relatively recent precedent was R. H. Wilenski's *Modern French Painters* (London: Faber and Faber, 1940).

2 The author explained, Preface p. xii, that he perversely chose to call the artists 'English' rather than 'British' because, apart from Gwen John, England was their home. Several artists were not English, being from other parts of the British Isles (the Johns, Orpen, Pryde) or foreign-born (Hodgkins, Pissarro, Sickert). An artist like Jack Yeats, whose work John liked, was born in London but mostly worked in Dublin, so was not included.

3 J. Rothenstein, diary entry, 16 April 1951, TGA 8726/1/20, records delivering most of the manuscript to the publishers, but the contract with Eyre and Spottiswoode was dated 13 February 1946. They had been remarkably patient.

4 J. Rothenstein, note on visit to Edward Burra, 1942, TGA 8726/2/47–48.

5 John's choice of artists for the first, *Sickert to Smith*, seems not to have been influenced by his father's friendships: of those covered, William had written only about Orpen, Sickert, Wilson Steer and Tonks in his autobiography.

6 *Summer's Lease*, p. 135.

7 *Artists of the 1890's*, pp. 125–30: although in quotation marks, John does not mention a tape recorder; he must have taken notes and pieced it together afterwards.

8 *Summer's Lease*, pp. 136–9.

9 Curiously, John did not interview Walter Sickert, who was still alive. He had been a close friend of his father's but John seems not to have known him. Had there been a family falling-out?

10 For 1930s notes on artists, see sub-files in TGA 8726/2.

11 For late 1940s notes, see e.g. TGA 8726/2/102.

12 The artists allocated to the different volumes changed over the years with different editions (not because the artists changed). In *Sickert to Smith*, the first edition, the order went Sickert, Wilson Steer, Walker, Tonks, Pissarro, Pryde, Hodgkins, Rothenstein, Ben Nicholson, Gilman, G. John, A. John, Ginner, Gore, McEvoy, Orpen and Smith.

13 A number of the artists in *Sickert to Smith* had been associated with groups around the turn of the century, such as the New English Art Club. John's point throughout his introduction about modern artists not being suited to grouping is more relevant in the second, *Lewis to Moore* (Spencer, Lowry and so on).

14 See *Time's Thievish Progress*, p. 78.

15 According to Norman Reid, John blocked Read becoming a Trustee while he was Director; interview with Cathy Courtney, 2000, British Library recording, C466/97, Part 7, Tape 4. Read promptly became a Trustee after Reid took over as Director.

16 Many thanks to Lucy Carter for this information.

17 In many cases little had been published about the artists concerned, so there was a basic need to establish a biographical framework. For some, such as William Roberts, there was less effort to verify the facts.

18 Other regular and serious commentators were Michael Ayrton, Nigel Gosling, James Laver, Robert Melville, M. H. Middleton, John Russell, and Wyndham Lewis.

19 Matthew Smith reacted oddly when he read the chapter on him (*Sickert to Smith*, pp. 228–44). He had co-operated fully with John in preparing it and provided most of the information but *Brave Day, Hideous Night*, p. 13, records in understandable puzzlement his negative reaction.

20 *Brave Day, Hideous Night*, ten years later, was also dedicated to Turner (and to John's daughter Lucy).

21 The artists covered are Lewis, Grant, Innes, Lowry, P. Nash, Nevinson, Wadsworth, S. Spencer, Gertler, G. Spencer, J. Nash, de Maistre, Nicholson, Roberts, Jones and Moore. No women artists were included.

22 Jonathan Black, *Edward Wadsworth: Form, Feeling and Calculation* (London: Philip Wilson, 2005), p. 149.

23 John singled out *The Nation* (from 1931 the *New Statesman and Nation*) for publishing these people's opinions (Fry having been its art critic).

24 For all the J. Rothenstein–Bloomsbury correspondence see TGA 8726/2/106.

25 J. Rothenstein, diary entry, 19 July 1957, TGA 8726/1/28. That there was a Tate retrospective for Grant in 1959 may have been influenced by John's wish to placate him.

26 William Roberts, 'The Resurrection of Vorticism and the Apotheosis of Wyndham Lewis at the Tate'; 'Cometism and Vorticism: A Tate Gallery Catalogue Revised'; 'A Press View at the Tate Gallery'; 'A Reply to my Biographer Sir John Rothenstein', *Vortex*, 1–4 (privately published, September 1956–February 1957).

27 J. Rothenstein, diary entry, 22 March 1957, TGA 8726/1/28.

28 In fact, John's diary recorded on 10 July 1951 a meeting with Roberts at The Tate where John gathered biographical information from him. He described Roberts as "pathologically suspicious, flushing scarlet as remarks of mine (v.gentle) called up memories, touched chords, but he was perfectly amicable". TGA 8726/1/20.

29 J. Rothenstein, letter to Sir Herbert Read, 14 June 1955, TG 92/117.

30 J. Rothenstein, diary entry, 5 February 1957, TGA 8726/1/28.

31 For a summary of Read's position on contemporary British art, see Andrew Causey, 'Herbert Read and Contemporary Art', in David Goodway (ed.), *Herbert Read Reassessed* (Liverpool: Liverpool University Press, 1998), pp. 123–44.

32 Benedict Nicolson, review, *New Statesman*, 6 October 1956: the book contained a 'succession of disconnected scraps' and, 'by isolating the individual contribution of minor painters such as these, the author presents an exaggerated impression of their uniqueness, of their preciousness'.

33 E.g. Stephen Bone in *The Guardian*, 5 October, and Nevile Wallis in *The Observer*, 7 October 1956.

34 John noted in his diary the artists at the launch party, including Francis Bacon, Ceri Richards, Keith Vaughan, Victor Pasmore, William Coldstream and Albert Houthuesen; 15 May 1962, TGA 8726/1/35.

35 Ibid., 17 May 1962, TGA 8726/1/35.

36 Ibid., 19 May 1962, TGA 8726/1/35.

37 The full list of artists is Wood, Hayter, Richards, Sutherland, Houthuesen, Piper, Burra, Hillier, Collins, Pasmore, Bacon, Colquhoun, Freud, Andrews, Riley and Hockney.

38 William Feaver, review, *Sunday Times*, 3 March 1974, with the cruel example of the needlessly full treatment given to Elizabeth Collins's background (*Wood to Hockney*, p. 131) in the entry on Cecil Collins.

39 John had come across Frink in 1953 when she had entered the competition for the *Unknown Political Prisoner* sculpture, getting to the last 12 out of 3500 applicants. Stephen Gardiner, *Frink: The Official Biography of Elizabeth Frink* (London: HarperCollins, 1998), p.57. That year the Tate bought a bronze *Bird* (1952, Tate, 6140) by Frink.

40 There is an undated note by John in TGA 8726/2/93 in which he reproaches himself for not having covered Eric Kennington or Robin Ironside.

Conclusion

1 Bryan Robertson, speech at Sir John Rothenstein's Memorial Party, 8 June 1992, Tate Gallery, TGA, TAV 1007A.

2 Anthony Lousada, transcript of conversation with Corinne Bellow, 27 November 1989, TGA 891/38.

3 John Rothenstein, letter to Lord Cottesloe, 27 April 1960, TG 1/6/41.

Sources

Archives

Colin Anderson Collection, Sainsbury Centre for Visual Arts, University of East Anglia, Norwich. Extract courtesy of Mrs Catriona Williams.

Art Gallery of New South Wales Archives, Sydney.

Beaverbrook Papers, Parliamentary Archives, House of Lords, London.

Beaverbrook Papers, University of Delaware Library, Special Collections.

Max Beerbohm Collection, Merton College, Oxford.

Bernard Berenson Archive, Villa I Tatti, Harvard University Center for Italian Renaissance Studies, Florence.

British Library recordings, London.

Campion Hall Archives, Oxford.

Churchill Archive, Churchill College, Cambridge.

Douglas Cooper Papers, 1900–1985, Getty Research Institute, Los Angeles, Accession no. 860161.

Guardian News & Media Archive, www.theguardian.com/gnm-archive.

Philip Hendy Papers, National Gallery Archives, London.

HM Treasury Papers, National Archives, Kew.

Kinnaird Collection, Perth & Kinross Council Archive, Perth.

James Bolivar Manson Papers, TGA.

D. S. MacColl Special Collection, University of Glasgow Library.

Henry Moore Foundation, Perry Green, Hertfordshire.

National Archives, Kew.

Benedict Nicolson Archives (private collection).

Dennis Proctor Papers, TGA.

Dennis Proctor Papers, King's College, Cambridge.

Sir William Rothenstein Collection, Houghton Library, Harvard University.

William and John Rothenstein Collection, TGA.

Royal Academy Archives and Library, London.

George Humphrey Wolferston Rylands Papers, King's College, Cambridge.

Denys Sutton Collection, University of Glasgow.

TGA Tate Gallery Archive, London.

Treasury, *see* HM Treasury

Worcester College Archives, Oxford.

Unpublished Sources

McCann, David. 'Sir John Rothenstein and the Advocacy of British Art between the Wars'. PhD thesis, Nottingham Trent University and Southampton Solent University, 2006.

Meadmore, W. S. 'The Crowing of the Cock: A Biography of James Bolivar Manson', 1957, TGA 806/7/2.

Rothenstein, John. 'The Development of Colour and Design in 19th Century Painting: With Special Reference to the Conflict between the Academic and Revolutionary Traditions'. PhD thesis, University College London, 1931.

Shaw, Samuel. '"Equivocal Positions": The Influence of William Rothenstein c. 1890–1910'. PhD thesis, University of York, 2010.

Published Sources

Anderson, William. *Cecil Collins. The quest for the great happiness*. Barrie & Jenkins, London, 1988.

Arnold, Bruce. *Jack Yeats*. Yale University Press, New Haven & London. 1998.

—. *Derek Hill*. Quartet Books, London, 2010.

Berthoud, Roger. *Graham Sutherland: A Biography*. Faber & Faber, London, 1987.

Black, Jonathan. *Edward Wadsworth: Form, Feeling and Calculation*. Philip Wilson, London, 2005.

Borland, Maureen. *D. S. MacColl: Painter, Poet, Art Critic*. Lennard Publishing, Harpenden, 1995.

Bosman, Suzanne. *The National Gallery in Wartime*. National Gallery Publications, London, 2008.

Boughton, Peter, Virginia Ironside and Simon Martin. *Robin Ironside: Neo-Romantic Visionary*. Pallant House Gallery, Chichester, 2012.

Bowness, Sophie, and Clive Phillpot (eds). *Britain at the Venice Biennale 1895–1995*. British Council, London, 1995.

Buckman, David. *James Bolivar Manson 1879–1945*. Maltzahn Gallery, London, 1973.

Carter, Miranda. *Anthony Blunt: His Lives*. Macmillan, London, 2001.

Chappell, William (ed). *Well, Dearie! The Letters of Edward Burra*. Gordon Fraser, London, 1985.

Clark, Adrian. *British and Irish Art 1945–1951: From War to Festival*. Hogarth Press, London, 2010.

—. 'The Art Collection of Peter Watson', *British Art Journal*, XVI, no. 2 [Autumn 2015], pp. 101–7.

Clark, Kenneth. *Another Part of the Wood: A Self-Portrait*. 1974; Hamish Hamilton, London, 1985.

Clarke, Gill (ed). *The Diaries of Randolph Schwabe: British Art 1930–1948*. Sansom, Bristol, 2016.

Cooper, Douglas. *Graham Sutherland*. Lund Humphries, London, 1961.

Farr, Dennis. *English Art 1870–1940*. Oxford University Press, Oxford, 1978.

Fletcher, Pamela and Helmreich, Anne (eds). *The rise of the modern art market in London, 1850–1939*. Manchester University Press, Manchester, 2011.

Foss, Brian. *War Paint. Art, War, State and Identity in Britain 1939–1945*. Yale University Press, New Haven & London, 2007.

Gardiner, Stephen. *Epstein: Artist against the Establishment*. Viking, New York, 1993.

—. *Frink: The Official Biography of Elizabeth Frink*. HarperCollins, London, 1998.

Garlake, Margaret. *New Art New World: British Art in Postwar Society*. Yale University Press, New Haven and London, 1998.

Gerhardie, William. *Memoirs of a Polyglot*. Duckworth, London, 1931.

Gill, Eric. *Autobiography*. Jonathan Cape, London, 1940.

Gooding, Mel (ed). *Painter as Critic. Patrick Heron: Selected Writings*. Tate Publishing, London, 1988.

Goodman, Jean. *What a Go! The Life of Alfred Munnings*. Collins, London, 1988.

Goodway, David (ed). *Herbert Read Reassessed*. Liverpool University Press, Liverpool, 1998.

Green, Martin. *Children of the Sun: Narrative of Decadence in England after 1918*. Constable, London, 1977.

Hamlyn, Robin. *Henry Tate's Gift: A Centenary Celebration*. Tate Gallery, London, 1997.

Hansard. Parliamentary Debates (Lords and Commons), 1952–54.

Holroyd, Michael. *Augustus John. Volume 1: The Years of Innocence*. Heinemann, London, 1974.

—. *Augustus John. Volume 2: The Years of Experience*. Heinemann, London, 1975.

Horner, Libby. *Frank Brangwyn: A Mission to decorate Life*. Fine Art Society, London, 2006.

Hudson, Derek. *For Love of Painting: The Life of Sir Gerald Kelly, KCVO, PRA*. Peter Davies, London, 1975.

John, Augustus. *Chiaroscuro*. Jonathan Cape, London, 1954.

—. *Finishing Touches*. Jonathan Cape, London, 1964.

King, James. *The Last Modern: A Life of Herbert Read*. Weidenfeld & Nicolson, London, 1990.

Lago, Mary, and Karl Beckson (eds). *Max and Will: Max Beerbohm and William Rothenstein, their Friendship and Letters 1893–1948*. Harvard University Press, Cambridge, Mass., 1975.

Laughton, Bruce. *William Coldstream*. Yale University Press, New Haven and London, 2004.

Wyndham Lewis on Art: Collected Writings 1913–1956. Ed. Walter Michel and C. J. Fox. Thames & Hudson, London, 1969.

Lownie, Andrew. *Stalin's Englishman: The Lives of Guy Burgess*. Hodder & Stoughton, London, 2015.

MacColl, D. S. *The Administration of the Chantrey Bequest*. Grant and Richards, London, 1904.

—. *Twenty-Five Years of the National Art Collections Fund 1903–1928*. Alexander MacLehose, Glasgow, 1928.

—. *Confessions of A Keeper and Other Papers*. Alexander MacLehose, London, 1931.

Manson, David. *Jacob Kramer. Creativity and Loss*. Sansom & Co, Bristol, 2006.

Massey Report. *The Report of the Committee on the Functions of the National Gallery and Tate Gallery and, in respect of Paintings, of the Victoria & Albert Museum, together with a Memorandum thereon by the Standing Committee on Museums and Galleries*. HMSO, London, 1946.

McCamley, Nicholas. *Saving Britain's Art Treasures*. Leo Cooper, Barnsley, 2003.

Medley, Robert. *Drawn from the Life: A Memoir*. Faber and Faber, London, 1983.

Peaker, Carol. *The Penguin Modern Painters: A History*. Penguin Collectors Society, 2001.

Penrose, Antony. *Roland Penrose: The Friendly Surrealist*. Prestel, London, 2001.

Peppiatt, Michael. *Francis Bacon: Anatomy of an Enigma*. Weidenfeld and Nicolson, London, 1996.

Pery, Jenny. *Painter Pilgrim: The Art and Life of Tristram Hillier*. Royal Academy Publications, London, 2008.

Pope-Hennessy, John. *Learning to Look*. Heinemann, London, 1991.

Pryce-Jones, David. *Fault Lines*. Criterion Books, London, 2015.

Richardson, John. *The Sorcerer's Apprentice: Picasso, Provence and Douglas Cooper*. Jonathan Cape, London, 1999.

Roberts, William. *A Reply to my Biographer Sir John Rothenstein*. Privately printed, London, 1957.

Rothenstein, John, *The Portrait Drawings of William Rothenstein, 1889–1925: An Iconography*, preface by Max Beerbohm. Chapman & Hall, London, 1926.

—. *Eric Gill*. Ernest Benn, London, 1927.

—. *The Artists of the 1890's*. G. Routledge & Son, London, 1928.

—. *Morning Sorrow*. Constable & Co, London, 1930.

—. *Sixteen Letters from Oscar Wilde*. Faber & Faber, London, 1930.

—. *British Artists and the War*. P. Davies, London, 1931.

—. *Nineteenth Century Painting: A Study in Conflict*. John Lane, London, 1932.

—. *An Introduction to English Painting*. Cassell & Co, London, 1933.

—. *The Life and Death of Conder*. Dent, London, 1938.

—. *Edward Burra*. Penguin Books, London, 1945.

—. *American Painting from the 18th Century to the Present Day* (introduction). Tate Gallery, London, 1946.

—. *Augustus John: Reproductions of his Paintings and Drawings* (introduction). Phaidon Press, London, (1944) 1946.

—. *Tableaux Britanniques modernes appartenant à la Tate Gallery* (introduction). Tate Gallery, London, 1946.

—. *Modern Foreign Pictures in the Tate Gallery* (introduction). Tate Gallery, London, 1947.

—. *The Tate Gallery: The National Collection of British Painting and of Modern Foreign Art*. Tate Gallery, London, 1947.

—. *Modern English Painters: Sickert to Smith*. Eyre & Spottiswoode, London, 1952.

—. *Auguste Renoir* (introduction). Tate Gallery, London, 1953.

—. *Matthew Smith* (introduction). Preface by Francis Bacon, foreword by Henry Green. Tate Gallery, London, 1953.

—. *Modern English Painters: Lewis to Moore*. Eyre & Spottiswoode, London, 1956.

—. *The Moderns and their World*. Phoenix House, London, 1957.

—. *John Hay Whitney Collection* (foreword). Tate Gallery, London, 1960.

—. *Francis Bacon* (introduction). Tate Gallery, London, 1962.

—. *British Art since 1900: An Anthology*. Phaidon Press, London, 1962.

—. *The Tate Gallery*. Thames & Hudson, London, 1962.

—. *Summer's Lease: Being Volume One of an Autobiography, 1901–1938*. Hamish Hamilton, London, 1965.

—. *Brave Day, Hideous Night: Autobiography, 1939–1965*. Hamish Hamilton, London, 1966.

—. *Time's Thievish Progress: Autobiography III*. Cassell, London, 1970.

—. *Modern English Painters: Wood to Hockney*. Macdonald, London, 1974.

—. *Modern English Painters: Sickert to Lowry*. Macdonald, London, 1984.

—. *Modern English Painters: Nash to Bawden*. Macdonald, London, 1984.

—. *Modern English Painters: Hennell to Hockney*. Macdonald, London, 1984.

—. 'Painting in America', *Horizon*, 8, no. 18 (June 1941), pp. 406–17 (2 illustrations).

—. 'Church Decoration in England: The Coming Opportunity', *The Tablet*, 26 July 1941.

—. 'American Art Today', *The Listener*, 4 September 1941.

—. 'State Patronage of Wall Painting in America', *The Studio* (July 1943).

—. 'Art in our Churches', *Picture Post*, 19 May 1956.

— and Mary Chamot. *The Tate Gallery: A Brief History and Guide*. Tate Gallery, London, 1951.

Rothenstein, J., and Ronald Alley. *Francis Bacon* (introduction). Catalogue raisonné and documentation by Ronald Alley. Thames & Hudson, London, 1964.

Rothenstein, William. *Men and Memories: Recollections of William Rothenstein 1872–1900*. Faber and Faber, London, 1931.

—. *Men and Memories: Recollections of William Rothenstein 1900–1922*. Faber and Faber, London, 1932.

—. *Since Fifty: Men and Memories, 1922–1938*. Faber and Faber, London, 1939.

Rutherston, Max. *Albert Rutherston, 1881–1953*. Privately printed, London, 1988.

Saumarez Smith, Charles. *The National Gallery: A Short History*. Frances Lincoln, London, 2009.

Schwabe, Randolph. *The Diaries of Randolph Schwabe: British Art 1930–1948*. Ed. Gill Clarke. Sansom, Bristol, 2016.

Sinclair, Andrew. *Francis Bacon: His Life and Violent Times*. Sinclair-Stevenson, London, 1993.

Spalding, Frances. *The Tate: A History*. Tate Gallery Publishing, London, 1998.

Speaight, Robert. *William Rothenstein*. Eyre & Spottiswoode, London 1962.

—. *The Life of Eric Gill*. Methuen, London, 1966.

Stevenson, Jane. *Edward Burra: Twentieth-Century Eye*. Jonathan Cape, London, 2007.

Stourton, James. *Kenneth Clark: Life, Art & Civilisation*. William Collins, London, 2016.

Tate Gallery Report 1953–54, The. Review 1938–53. HMSO, London, 1954.

Taylor, D. J. *Bright Young People: The Rise and Fall of a Generation 1918–1940*. Chatto & Windus, London, 2007.

Thuilliér, Rosalind. *Graham Sutherland: Life, Work and Ideas*. Luttterworth Press, Cambridge, 2015.

Waugh, Evelyn. *The Diaries of Evelyn Waugh*, ed. Michael Davie. Weidenfeld & Nicolson, London, 1976.

Wheeler, Sir Charles. *High Relief: The Autobiography of Sir Charles Wheeler Sculptor*. Country Life Books, London, 1968.

Whitechapel Art Gallery Centenary Review, The. London, 2001.

Williams, Andrew Gibbon. *William Roberts: An English Cubist*. Lund Humphries, Aldershot, 2004.

Yorke, Malcolm. *Matthew Smith: His Life and Reputation*. Faber and Faber, London, 1997.

Ziegler, Philip. *Osbert Sitwell*. Chatto and Windus, London, 1998.

Websites

https://en.wikipedia.org

www.contemporaryartsociety.org

www.theguardian.com

www2.tate.org.uk

hansard.millbanksystems.com

Picture Credits

Jacket and title page, © Estate of Archie Parker / Private collection; page 13, Private collection; page 14, Private collection; page 15, Image © Tate London 2018; page 18, © National Portrait Gallery, London; page 24, © National Portrait Gallery, London; page 26, © National Portrait Gallery, London; page 29, © National Portrait Gallery, London; page 31, © National Portrait Gallery, London; page 33, © National Portrait Gallery, London; page 34, Private collection; page 37, Photo © Musée La Piscine (Roubaix), Dist. RMN-Grand Palais / Alain Leprince; page 42, Leeds Civic Collection; page 47, © National Portrait Gallery, London; page 50, © The artist's estate. Photo credit: Museums Sheffield; page 53, © The Estate of Sylvia Baker / Private Collection; page 55, Private collection; page 59, © Estate of Max Beerbohm / Private collection; page 61, © National Portrait Gallery, London; page 65, Private collection; page 83, © National Portrait Gallery, London; page 84, Image © Tate London 2018; page 87, Image © Tate London 2018; page 90, Image © Tate London 2018; page 95, © National Portrait Gallery, London; page 98, Private collection; page 99, Harold White / © The Illustrated London News Picture Library; page 111, Image © Tate London 2018; page 113, © National Portrait Gallery, London; page 115, © National Portrait Gallery, London; page 118, © National Portrait Gallery, London; page 122 (left), © National Portrait Gallery, London; page 122 (right), © Neil Libbert; page 124, Photo by Kurt Hutton / Getty Images; page 125, Photo by Chris Ware / Keystone / Getty Images; page 128, Image © Tate London 2018 / (Picture Post); page 129, © reserved, collection National Portrait Gallery, London; page 130, Photo by Robert DOISNEAU / Gamma-Rapho via Getty Images; page 132, © National Portrait Gallery, London; page 134, Private collection; page 137, © National Portrait Gallery, London; page 139, © National Portrait Gallery, London; page 140, © National Portrait Gallery, London; page 141, Image © Tate London 2018; page 147, © National Portrait Gallery, London; page 148, © National Portrait Gallery, London; page 152, © National Portrait Gallery, London; page 155, Clayton Photos Ltd / Private collection; page 160, © National Portrait Gallery, London; page 166, © National Portrait Gallery, London; page 168, (b/w photo), Lewinski, Jorge (1921–2008) / Private Collection / © The Lewinski Archive at Chatsworth / Bridgeman Images; page 171, Private collection; page 173, Osbert Lancaster / Daily Express / N&S Syndication; page 174, Osbert Lancaster / Daily Express / N&S Syndication; page 179, Private collection; page 182, © National Portrait Gallery, London; page 184, Image © Tate London 2018.

Index

'JR' in this index refers to John Rothenstein. Page numbers in italic refer to illustrations. Page numbers ending in 'n' refer to endnotes.

abstract art 31, 54, 55, 62, 63–64, 67, 91, 123, 176, 203, 207, 208, 213, 217
Abstract Expressionism 181
Académie Julian, Paris 14, 89
Adeane, Sir Robert 181, 182, *182*
Air Ministry 116
Aitken, Charles 16, 49, 76, 77, 80, 82, 86–89, *87*, 91–92, 223n, 229n
Alhambra Theatre, London 27
Alley, Ronald 128, 167, 179, 186, 190, 219
American Art 1609–1938 (exhibition) 91, 102
American Painting, from the 18th Century to the Present Day (exhibition) 112
Amulree, Basil Mackenzie, 2nd Baron 160, *160*, 166, 169, 173, 175
Anderson, Sir Colin 144, *148*
 as Chairman of Tate 175
 and Kenneth Clark 201
 on Jowitt 144
 on JR 144
 and JR's retirement as Director of Tate 187–189
 and Spencer 181
 support of Sutherland 163, 164, 166–167
 and Tate Affair 146, 150, 153
Anderson, Patrick 196
Andrews, Michael 245n
Anrep, Helen *24*
Anthologies (British Painting 1925–1950) (exhibition) 143
anti-Semitism 28–29, 31, 176
 see also Jews, Judaism

apartheid policy 138
Apollo 35, 58, 196
Apostles (Cambridge club) 157
Appelbee, Leonard 119
Ardizzone, Edward 23, 206
Armstrong, John 122, 129, 217
Arp, Jean 180
Art Gallery of New South Wales, Sydney 119
Art Institute of Chicago 104
Art Workers' Guild 82, 83
Artists in the British Isles at the Beginning of the Century (exhibition) 87
Arts and Crafts Exhibition Society 82–83
Arts and Crafts Movement 20, 82–83
Arts Council 92, 116–117, 119, 125, 127, 136, 143, 155, 175, 180, 189, 219
Art Panel 116, 117
Ashmolean Museum, Oxford 38, 131
 Department of Fine Art 48
Ashton, Sir (Arthur) Leigh 9, 94–95, *95*, 181
Association Française d'Action Artistique 127
Astor family 188
Atticus 200
Avery, Milton 112
Ayrton, Michael 188, 216, 244n

Bacon, Francis *129*
 catalogue raisonné 195
 collection in Tate 129
 on Cooper's book on Sutherland 178
 exhibition at Tate 180
 relationship with JR 10, 129, 143, 157–158, 185–188, 190, 195, 218, 222, 245n
 and Matthew Smith exhibition 156, 157

and Sutherland 185
and Venice Biennale 183
Figure in the Landscape 129
Reclining Woman 187
Seated Man with Turkey Rug (later *Seated Figure*) 187
Study of a Dog 129
Study for a Portrait of Van Gogh IV 187
Three Studies for Figures at the Base of a Crucifixion 129, 158
Baker, Sylvia, *John Rothenstein* 53
Balniel, Lord 23, 100
Balthus (Balthasar Klossowski de Rola) 180
Baltimore 104
Barnsley, Ernest and Sidney 20
Barr, Alfred 112, 183
Bawden, Edward 23, 122, 129, 146, 150, 153, 164, 206, 217
BBC
 Desert Island Discs 223n
 Third Programme 143
Beardsley, Aubrey 16, 61, 67, 88, 209
Bearsted, Walter Samuel, 2nd Viscount 101
Beaverbrook, Max Aitken, 1st Baron 163, 164, 167, 169, 170, 175, 183–185
Beaverbrook Art Gallery, Fredericton, New Brunswick 170, 184
Bedales Chronicle 112
Bedales School, Steep, Hampshire 19–21, 22, 35
 Lupton Hall 20
Beerbohm, Sir Max 16, 22, 36, 40, 56, 58, 119, 120, 193
 'On the Threshold of Life' *59*
Behrend Collection 181
Bell, Clive 17, 60, *61*, 63, 68, 92–93, 106, 207, 211, 215, 221
 Landmarks in Nineteenth Century Painting 63

Bell, Graham 122
Bell, Quentin 211–212
Bell (née Stephen), Vanessa 17, 86, 224n
Bellow, Corinne 202, 243n
Bennett, Arnold 36
Bentinck, Lord Henry 229n
Berenson, Bernard 16, 30, 32–33, 33, 38, 58, 75, 131
Beresford, George Charles 31, 83
Bertram, Anthony 214–215
A Century of British Painting 1851–1951 214
Betjeman, Sir John 120
Bevan, Robert 91
Bevin, Ernest 125
Biddulph, Margaret 56
Bird, Walter 166
Birmingham, University of, Barber Institute 52
Blake, William 88, 127, 133
illustrations to Dante's Divine Comedy 79
Blanche, Jacques-Émile 58, 243n
portrait of Sickert 39
The Saville Clark Girls 39
Bloomsbury Group 17, 23, 31, 211–212, 214, 217, 224n
Blunt, Anthony 66–67, 131, 133–134, 157, 162, 173, 176–177
Bodkin, Thomas 52, 92, 156, 207
Bomberg, David 90, 217
Bone, Sir Muirhead 77, 210
Bone, Stephen 20, 210
Bonnard, Pierre 224n
Borenius, Tancred 39, 66
Boston, Massachusetts 104
Botticelli, Sandro 213
Boucher, François 67
Boudin, Eugène 51
Bowness, Sir Alan 181, 241n
Bradford 13, 14, 40, 194, 216
City Art Gallery and Museum 19
Bradford Telegraph 44
Brangwyn, Sir Frank 225n
Braque (exhibition) 180
Braque, Georges 78, 91, 102, 124, 125, 130, 143, 177, 180, 203
Guitare et pichet 91
Brausen, Erica 186
Brazil 117
Bright Young Things 23, 27
Brighton 103

British Council 117, 119, 125
Fine Arts Advisory Committee 117, 123
British Museum, London 75, 116
Department of Prints and Drawings 143
British Narrative Paintings from the Tate Gallery 116
British Printing Corporation 189
Brooke, Henry (later Lord Brooke) 170, 172
Brooke, Humphrey 135, 136–138, 137, 139, 148, 157, 161, 167, 173, 197, 200, 221, 237n
Brown, Frederick 85
Browse, Lilian 120
Brueghel, Pieter 213
Buffalo, New York 104
Buffet, Bernard 180
Burgess, Guy 157
Burlington Magazine 88, 131–134, 171, 173, 178, 224n
Burne-Jones, Sir Edward 16, 91
Burra, Edward 101, 119, 121, 122, 122, 179, 205, 216, 217, 218, 245n
Dancing Skeletons 121
Harlem 121
Soldiers at Rye 121
Butcher, Betty 167
Butler, Reg 155
Butler, Richard Austen (later Lord Butler of Saffron Walden) 165, 169
Butler, Sydney Elizabeth (née Courtauld) 165
Butlin, Martin 179, 219

Calvocoressi, Richard 217
Cambridge 89
King's College 157
Camden Town Group (later London Group) 89, 90, 114, 195
Cameron, Sir David 77
Canada 104, 117, 125, 129, 178
Canadian High Commission 181
Canaletto 39
La Capponcina, Cap d'Ail, France 164
Carr (or Kerr) Fund 170
Carter, Miranda, Anthony Blunt: His Lives 237n
Castle Howard, North Yorkshire 103

Catholicism 18, 19, 21–22, 27, 30–31, 42–43, 56–62, 65, 66, 112, 119, 192, 195, 214, 224n
Cecil, Lord David 23
A Century of Canadian Art (exhibition) 102, 103
Cézanne, Paul 17, 23, 51, 52, 67, 78, 88, 91, 125, 170, 202, 207
Card Players 51
Chagall, Madame 134
Chagall, Marc 122, 128, 129–130, 155, 201
exhibition at Tate 29, 117, 127, 134
Chamberlain, Neville 102, 230n
Chamot, Mary 128, 167, 179, 219
catalogue of the English School 128
English Medieval Enamels 128
Modern Painting in England 128
Painting in England from Hogarth to Whistler 128
Chantrey, Sir Francis 116
Chantrey, Lady 72
Chantrey Bequest 9, 72–85, 101, 116, 118–119, 122, 126, 127, 132, 140–142, 155, 170, 188, 197, 219, 222, 241n
Chantrey Recommending Committee 85, 140, 142
The Charterhouse, City of London 206
Charteris, Hon. Sir Evan 93, 94, 95, 100, 103, 105, 114, 197
Château de Castille, Argilliers 143
Chatham 115
Chequers, Buckinghamshire 113
Chicago 104
Chile 117
Chinnery, George 91
Chirico, Giorgio de 130, 132
Church of England 20, 21, 22, 84
Churchill, Lady (Clementine) 183
Churchill, Sir Winston 9, 142, 162, 164–165, 169, 179, 183, 243n
Civil Service Commission 140, 143, 189
Clark, Jane 201
Clark, Kenneth (later Lord Clark) 47
and abstract art 123, 203
and Anderson 235n
and Ashton 94
on Brave Day, Hideous Night 201

as Director of National Gallery 9, 80, 115–116
and Giorgione scandal 9
leaves Ashmolean post for National Gallery 47–48
on Manson and Fincham 99
on Manson's behaviour 92–93
offices held 9, 80, 100, 106, 115–116, 131
and 'Penguin Modern Painters' series 121
relationship with JR 76, 82, 106, 108, 115, 133
resigns from National Gallery 123
and South American exhibition 117
and Sutherland 163
trip to Paris with JR 120
visits I Tatti 224n
visits Sheffield 53
and War Artists Advisory Committee 107
Landscape into Art 235n
Clarke, Francis 79
Clarke Fund 102
classical and romantic movements 64–65
Clausen, Sir George 38, 210
Cleveland 104
Cliveden House, Buckinghamshire 188
Clutton-Brock, Alan 68, 208
Coldstream, Sir William 146, 147, 148, 153, 216, 245n
Collins, Cecil 27, 216, 217, 245n
Collins, Elizabeth 245n
Collis, Maurice 208
Colquhoun, Robert 235n, 245n
Conder, Charles 15, 67–68, 88, 120, 209, 228n
Connolly, Cyril 112
Conrad, Joseph 16, 36
Constable, John 51, 65, 66, 67, 74, 127, 178, 213
Constable, W. G. 38, 42, 48, 52, 113
Constantine, George 51, 195
Constructivism 208
Contemporary Art Society (CAS) 79, 86, 104, 118, 119, 122, 170, 182, 219, 231n
Contemporary British Artists (exhibition) 87
Contemporary British Painting (exhibition) 54

Contemporary English Watercolours (exhibition) 117
Contemporary South African Paintings, Drawings and Sculpture (exhibition) 138
Cookham, Berkshire 54
Cooper, Douglas *130*
accused of anti-Semitism 176
and acquisition of modern foreign art 130–131, 135–136
and Brooke 138, 157
buys château in France 143
and Kenneth Clark 201
and Cubism 102
enmity with and personal attacks on JR 9, 132–136, 142, 149, 150, 156, 172, 175–178, 185, 199, 200, 207, 221, 222
and Fletcher-Cooke 170
mentioned in JR's diary 185
punched in face by JR 172, *173*
Herbert Read and 117
and John Russell 215
and Slade Professorship 176
and Sutherland 136, 173
and Tate Affair 160–174
Graham Sutherland 177–178, 216
Copies of English Mediaeval Mural Paintings by E. W. Tristram (exhibition) 42
Cotman, John Sell 39, 88
Cottesloe, John Fremantle, 4th Baron (earlier Hon. John Fremantle) 156, 167, 189, 222
Council for the Encouragement of Music and the Arts 116
Courtauld, Samuel 78, 133–134, 165, 179
Courtauld Fund 78, 79, 161, 165
Courtauld Institute, London 38, 51, 94, 113, 124, 128, 131, 133–134, 135
Coxon, Raymond 23
Crawford and Balcarres, David Lindsay, Earl of (earlier Lord Balniel) 23, 100
Craxton, John 216
Crewe, Robert Milnes, Earl of 76
Crookshank, Anne 167
Cubism 90, 102, 136, 176, 177, 203, 206, 207, 220
Curtis, Anthony 196, 200
Curzon of Kedleston, George Curzon, 1st Marquess 77

Curzon Report 77, 80
d'Abernon, Edgar Vincent, 1st Viscount 49, 99
Dadd, Richard 114
Daily Express 26, 35, 45, 164, 166, 200
cartoons *173*, *174*
Daily Mail 166, 167, 210
Daily Telegraph 62, 66, 68, 141, 163, 166, 167, 168, 172, 190, 210, 215
Dante Alighieri, *Divine Comedy* 79
d'Arcy, Father Martin 119
Daumier, Honoré 79
Davidson, Frances Davidson, Viscountess 149
Davies, Alderman 46
Davies, Gwendolen and Margaret 88
Dawson *see* Hockaday-Dawson
de Maistre, Roy 27, 179, 180, 186, 188, 208, 216, 244n
Dean, Catherine 118, 217
Degas, Edgar 15, 51, 52, 78, 79, 85, 91, 155, 213
The Little Dancer 150, 152–153, 175, 186, 199
Delacroix, Eugène 52, 65
Delaunay, Robert 143
Delvaux, Paul 180
Derain, André 91, 174
Detroit 104
Diaghilev, Sergei 172
Dick, Sir William Reid 100
Disney, Walt 54, 127
Dobson, Frank 80
Douglas, Lord Alfred 62
Dowson, Ernest 61
Drawings by Contemporary Artists (exhibition) 52
Driberg, Tom 204
Dublin 79
Dubuffet, Jean 180
Dufy, Raoul 91, 130, 131, 170
Dunbar, Evelyn 206
Dunkirk evacuation 110, 226n
Dunlop, Roland Ossory 119
Dunster, Betty 51, 195
Dürer, Albrecht 213
Dutch painting 65, 90
Duveen, Joseph, Jr. 75
Duveen, Sir Joseph (later Lord Duveen) 75, 79, 80, 88
Duveen Brothers 75

Eakins, Thomas 243n
Earp, T. W. 54
Eastington Hall, Worcestershire 102, 113
Eaton, Malcolm 196
Ecole de Paris (exhibition) 181
The Economist 167
Ede, Jim 40, 80
Edelman, Maurice 149, 165
Eden, Anthony (later Lord Avon) 23
Edinburgh College of Art 94
Edwards, Ralph 93
Eliot, T. S. 120
Elizabeth II, HM Queen 157
Elizabeth, Queen (later Queen Mother) 120, 143
English-Speaking Union, Kentucky branch 34
Ensor, James 91
Epstein, Sir Jacob 16, 19, 80, 155
Ernst, Max 122, 180
ESTA code 151
Eurich, Richard 129
Evening Standard 163, 164, 167, 175, 183, 185, 200
Evill, Wilfrid 124
Exposicion de Arte Britanico Contemporaneo (exhibition) 117

The Fake (film) 149–150, 198–199, 236n
Fantin-Latour, Henri 51, 74
Farr, Dennis 179, 219
Fauvism 177
Feaver, William 217
Fell, Sheila 215
Festival of Britain 143
Field, Michael (Katharine Bradley and Edith Cooper) 62
Fincham, David 49, 89, 92, 98–100, 101, 104, 105–107, 111–115, 148, 185, 195, 197
Finland 196
First World War 64
Fischer, Harry 186
Fitzroy Street Group 90
Fletcher-Cooke, Sir Charles 165, *166*, 170
Fould-Springer, Mary (Mitzi) 30
Fox, Cyril 232n
Fragonard, Jean-Honoré 67
Frampton, Meredith 141
France, art of 208
Francis, Sam, *Painting* 181

Frederica of Hanover, Queen of Greece 188
Freedman, Barnett 23, 40, 217
Sicilian Puppets 39
Fremantle, Hon. John (later 4th Baron Cottesloe) 156, 167, 189, 222
French and Contemporary British Painting and Sculpture (exhibition) 87
French School 17
Freud, Lucian 186, 190, 215, 245n
portrait of Francis Bacon 155
on Sutherland 185
Girl with a White Dog 155
Frink, Elizabeth 217
Frost, Honor 124, 137–138, 161, 197
Frost, Sir Terry 216
Fry, Roger 15, 17, 23, 31, 63, 68, 78, 87, 207, 211, 215, 220
Clive Bell 61
Futurism 90, 177

Gabor, Zsa Zsa 148–149, 150, 151, 198
Gainsborough, Thomas 39, 51, 129
Garsington Manor, Oxfordshire *24*, 225n
Gauguin, Paul 17, 86, 180, 202
Gauguin (exhibition) 180
Gear, William 216
George VI, King 125, 157
Gerhardie, William 23
Géricault, Théodore 52, 244n
Germany 28
non-aggression pact with Russia 103
Gertler, Mark 16, 101, 122, 179, 244n
Giacometti, Alberto 130, 180, 201
Homme assis 234n
Intérieur 234n
Gibson, William 94
Gill, Eric *26*
and Catholicism 22, 30–31, 57, 119
death 119
friendship with JR 30–31, 38, 60, 206
friendship with William Rothenstein 16
JR's book on 26, 32, 35, 56–58, 60, 69, 120, 205
JR's changing view of 68–69

rift with William Rothenstein 17–18
on science, industry, art and religion 57
Stations of the Cross 35
Gilman, Harold 119, 209, 244n
Gimpel Fils, London 181
Gimson, Ernest 20
Ginner, Charles 170, 210, 244n
Giorgione 9
Girtin, Thomas 39
Glasgow 84, 103
Goncharova, Natalia 208
Gore, Spencer 210, 244n
Standing Nude 39
Gosling, Nigel 200, 244n
Gothenburg 92
Gowing, Sir Lawrence *155*, 156, 164, 166, 174, 181, 188, 189, 190
Goya, Francisco 76, 213
Grafton Galleries, London 17
Grant, Duncan 86, 91, 122, 155, 180, 211, 244n
Graves, John George 49–50, *50*, 51–55, 95, 193–194, 227n
Gray, Coleen 236n
Gray, John 61
Grayson, Godfrey 236n
Greaves, Walter 32, 60–61, 179, 206
Green, Henry 156
Greene, Graham 21, 119, 240n
Greene, Vivien 119
Gregynog 88
Grigson, Geoffrey 121
Grimond, Jo 171, 172
Gris, Juan 102, 129, 130, 132
Gross, Anthony 119
Grunspan, C. E. 118
The Guardian 167, 168, 201, 215, 221
Guevara, Alvaro 243n
Gulbenkian, Calouste, collection 9
Gustaf VI Adolf, King of Sweden 157
Guston, Philip 180
Gwynne-Jones, Allan 19, 20, 41, 114, 119, 179, 210–211
The Mantelpiece 118

Hailsham of Marylebone, Quintin Hogg, Baron *184*
Hall, Eric 129
Hamilton, Iain 201

Hammer, Victor 243n
Hanover Gallery, London 129, 186, 242n
Harewood, George Lascelles, 7th Earl of 172
Harlech, David Ormsby-Gore, 5th Baron 138–139, 143–144, 146, 148, 150, 151, 153, 169
Harmsworth History of the World 35
Hartley, Leslie *24*
Hartung, Hans 143
Harvard University 33
Hayter, Stanley 216, 245n
Hecht, Alfred 176, 186, 188, 243n
Hellens, Herefordshire 102, 112–113
Helsinki 178
Hendy, Sir Philip 9, 23, 76, 116, 146–147, 150, 151, 157, 219, 227n, 236n, 240n, 241n
Hennell, Thomas 122, 129, 217
Henry VIII, King 22
Hepworth, Barbara 123, 213
Herman, Josef 216
Heron, Patrick 208, 216, 234n
Hess, Myra 108
Hill, Derek 213
Hillier, Tristram 27, 119, 141, 216, 245n
Hilton, Roger 216
Hitchens, Ivon 20, 122, 210
Hitler, Adolf 196
Hockaday-Dawson, E. 145–146, 147, 148, 151
Hockney, David 180, 216–217, 245n
Hodgkin, Howard 91
Hodgkins, Frances 119, 122, 179, 210, 244n
Enchanted Garden 52
Hogarth, William 127
Holme, Geoffrey 33
Holmes, Sir Charles 76, 229n
Holroyd, Sir Charles 82–84, *83*, 85, 89, 224n
Holroyd, Michael 203
Honeyman, Tom 52
Horizon 112, 120
Horton, Percy 23, 40, 206, 217
House of Commons 149
House of Lords 9, 159–160, 162
 Select Committee on Chantrey Trust 76
Housman, A. E. 16

Houthuesen, Albert 23, 188, 206, 216, 217, 232n, 243n, 245n
Howard, Brian 23
Howard de Walden, Thomas Scott-Ellis, 8th Baron 100–101, 118
Hudson, Derek 210
Hudson, W. H. 36
Hugh Lane Bequest 78, 79, 185
Hughes, Richard 23
Hulton, Paul 143, 148, 238n
Hunt, William Holman 16
Huston, John 148
Hutton, Kurt *124*

Illustrated 149
Illustrated London News 201
Impressionism 65, 75, 85, 89, 90, 91, 134
An Index of American Design (exhibition) 112
India 17
Industrial Revolution 64, 66
Information, Ministry of 104
 American Division 196
Inge, Rev. William (Dean Inge) 225n
Inland Revenue 152
Innes, James Dickson 244n
Institute of Contemporary Art, London (ICA) 133, 155, 232n
International Sculpture Competition: The Unknown Political Prisoner 155, 202
Ireland, independence 79
Ironside, Robin 80, 89, 98, 99–100, *99*, 101, 105, 112, 118, 125, 188, 197, 232n, 243n, 245n
Italy 178

Jackson Pollock (exhibition) 241n
James, Henry 15
James, Philip 117, 127, 135, 143, 149, 181, 235n
Jeannerat, Pierre 210
Jesuits 119
Jeu de Paume, Paris 91
Jewish Chronicle 29–30
Jews, Judaism 13, 15, 17, 28–30, 86, 193
John, Augustus 16, 18, *18*, 39, 51, 86, 91, 100, 101, 120–121, 123, 179, 224n, 244n
 'Fragments of an Autobiography' 120
Madame Suggia 75

John, Gwen 39, 101, 206, 210, 244n
John Hay Whitney Collection (exhibition) 241n
John Moores Exhibition *155*
Johns, Jasper 180
Johnson, Lionel 61
Johnston, Sir Alexander 164–165
Jones, David 27, 101, 104, 122, 170, 211, 218, 244n
Jowitt, William Allen Jowitt, 1st Earl 114, 144–159, *147*, 163, 169, 170, 185, 197, 199

Kahnweiler, Daniel-Henry 176
Kandinsky, Wassily 203
Kandinsky (exhibition) 180
Karsavina, Tamara 35
Kelly, Sir Gerald 142, 181
Kennington, Eric 228n, 245n
Kentucky, University of, Lexington 33, 35, 36, 38
Kettle's Yard, Cambridge 227n
King's Pictures 131
Kinnaird, Kenneth Kinnaird, 12th Lord 158, 159–160, 169, 170
Kisch, Egon 241n
Kisch (journalist) 175
Klee, Paul 116, 129, 132, 134, 180
Knapping Bequest/Fund 79, 102, 121, 129, 158, 159–160, 163, 170
Knewstub, Emily (née Renshaw) 35
Knewstub, Walter 16, 35
Knewstub family 29
Knight, Dame Laura 141
Kramer, Jacob 227n

Labour, Ministry of 114
Lake District 111
Lam, Wifredo 130
Lamb, Henry 86, 115, 210
Lamb, Sir Walter 115–116, 142
Lancaster, Sir Osbert, cartoons *173*, *174*
Landseer, Sir Edwin 74
Lane, Sir Hugh 79
Lanyon, Peter 216
Larionov, Mikhail 208
Laurencin, Marie 91
Laver, James 244n
Lawrence, T. E. (Lawrence of Arabia) 23
Layton and Johnstone 27

le Bas, Edward 119
Le Roux, Le Roux Smith 138–161,
 139
 Cooper and 172–174
 death 169, 242n
 dismissal of 167, 169
 employed by Beaverbrook 170,
 175, 184–185
 hired by JR 221
 JR on 198–199
 mentioned in JR's diary 185
 and Reid 180
 relationship with JR 9, 138–140,
 195
 review of Arts Council
 exhibition 143
 and Sutherland letter to R. A.
 Butler 165
 Sutherland on 200
 and Tate Affair 145–148, 150–161
 unknown to Kenneth Clark 201
Lear, Edward 232n
Lee of Fareham, Arthur Lee, 1st
 Viscount 113
Lee, John 100
Leeds 27, 37, 82
 Art Collection Fund 39
Leeds City Art Gallery 9, 22, 30,
 38, 39–51, 52, 54, 64, 101, 163,
 189, 193–195, 195–196, 218
Leeds City Council, Art Gallery
 Sub-Committee 41, 44, 45
Leeds College of Art 44
Lefevre Gallery, London 119, 129
Léger, Fernand 127, 130, 135, 136,
 143, 177, 180
 Feuilles et Coquillage 234n
Leger Galleries, London 119
Legros, Alphonse 51, 82
Leicester Galleries, London 52, 54,
 119, 181, 220–221
Leigh, Mrs 45
Leigh, Percival 41, *42*, 43–47, 50,
 193
Leonardo da Vinci 149
Lewis, Wyndham *31*
 and anti-Semitism 28
 on Chantrey Bequest 141
 as commentator on living artists
 244n
 Cooper on 177
 friendship with JR 16, 19, 31–32,
 60
 JR essay on 243n

JR's support of 19, 54, 101, 102,
 122, 129, 179–180, 205, 211,
 213, 215, 218
Manson and 90
painting damaged in Tate
 bombing 231n
portrait of Ezra Pound 32, 102
portrait of Wing Commander
 Orlebar 39
and William Roberts 212
The Demon of Progress in the Arts
 202
Surrender of Barcelona 32
Lexington 30, 104
Linnell, John 129
The Listener 196, 204, 210, 211–212
Liverpool 38, 106
Llewellyn-Davies, Richard 237n
London
 Arlington House 183
 Athenaeum 110, 157–158, 186
 Battersea Park 135
 Blitz 110
 Brick Lane 17
 Buck's Club 115
 Café Royal 110
 Chelsea 208
 City Club 29
 Embankment 73
 Forbes House 172
 French Embassy 134
 Garrick Club 28
 Hampstead 16
 Kensington 22
 King Alfred's School, Hampstead
 225n
 Marlborough House 72
 Notting Hill Gate 27
 Pimlico 73
 Primrose Hill 110
 Reform Club 134, 169, 172
 Ritz Hotel 110
 St Paul's Cathedral 225n
 Wellington Monument 83
 Savage Club 114
 Savile Club 26, 32
 Soho 143
 Somerset House 162
 Tryon Street 188
 Underground 102, 108
Longden, Major Alfred 117–118
Lousada, Sir Anthony 29, 30, 181,
 222
Louvre Museum, Paris 92

Low, Sir David, cartoons *141*, *184*
Lowinsky, Tommy 103, 106, 107
Lowry, L. S. 101, 122, 213, 217,
 244n
Lusitania 79
Lutyens, Sir Edwin 108, 116
Lynton, Norbert 201

Macbryde, Robert 235n
MacColl, D. S. 16, 35, 37, 39–40,
 54, 65, 67, 82, 84–87, *84*, 88,
 89, 182
 Crock and Cottage Loaf 85
McEvoy, Ambrose 209, 244n
MacLaren, Andrew 108
Maclaren, Donald, portrait of D. S.
 MacColl *84*
Maclean, Donald 157
MacTaggart, William 215
McTaggart, Sir William (the elder)
 91
McWilliam, F. E. 149
Madrid 178
Maersk 157
Mahon, Sir Denis 131, 161–168,
 169, 173–174, 178
Mahoney, Charles 23, 206, 243n
 murals for Campion Hall Lady
 Chapel 119
Maillol, Aristide 80
Mallarmé, Stéphane 15
Manchester 35
Manet, Edouard 52, 78, 120, 170
Manet and the Post-Impressionists
 (exhibition) 17
Manson, James Bolivar
 Kenneth Clark and 76
 conservatism 78
 and Contemporary Art Society 118
 death 123
 as Director of Tate 89–93, 101, 218
 dismissed as Director of Tate 8,
 49, 93, 102
 drunken behaviour 8, 55, 92–93,
 99
 and Jim Ede 80–81
 exhibitions planned by 103
 and Fincham 89, 99, 114–115
 JR's relationship with 114–115
 and Knapping Fund 159
 and London Group 90
 William Rothenstein and 49, 82
 Hours in the Tate Gallery 90
 self-portrait *90*

Manzù, Giacomo 131, 156
Margaret, Princess 188
Maria of Yugoslavia, Queen 120
Marin, John 178
Marini, Marino 131
Marlborough Gallery, London 150,
　152, 176, 186
Marnham, Patrick 204
Marsh, Sir Edward 51, 100, 107,
　113, *113*, 118, 155
Martin, Edward 229n
Martin, John 125, 133
Martin, Kingsley 195, 201
Massey, Vincent 103, 125, 184
Massey Report 115, 126, 157
Masson, André 132
Matisse, Henri 17, 52, 78, 91, 130,
　174, 180, 220–221
　Notre Dame 234n
　Reading Woman with Parasol 88
　Red Studio 234n
　Snail 181–182
Max Ernst (exhibition) 180
Meadmore, W. S. 93
　'The Crowing of the Cock:
　　A Biography of James Bolivar
　　Manson' 229n
Melbourne 190
Melville, Robert 186, 201, 243n,
　244n
Methuen, Paul Methuen, 4th
　Baron 169, 170
Metropolitan Museum, New York
　116
Meynell, Alice 62
Michelangelo Buonarroti 83
Middleton, M. H. 244n
Millais, Sir John, *The Boyhood of
　Raleigh* 74
Millbank, London 73
Minton, John 216, 243n
Miró, Joan 130, 132
Missingham, Hal 119
Modern Art Association 229n
Modern Art in the United States
　(exhibition) 156, 180
Modern Italian Art (exhibition)
　127, 135, 180
*Modern Paintings and Drawings by
　British Artists* (exhibition) 117
Modern Spanish Painting
　(exhibition) 180
Modernism 20, 40, 64, 89, 131,
　165, 178, 205

Modigliani, Amedeo 91
Modigliani (exhibition) 181
Mondrian, Piet 207
Monet, Claude 17, 79, 80, 85
Monet (exhibition) 175, 180
Montacute House, Somerset 108
Montaigne, Michel de 210
Montgomery of Alamein, Field
　Marshal Bernard Law
　Montgomery, 1st Viscount 223n
The Month 214
Montreal 104
Moore, Henry *134*
　attacked by Cooper 135
　Bacon on 158
　on Cooper 178
　critical of JR as manager 153
　and Lord Harlech 143–144
　included in Penguin Modern
　　Painters series 121, 244n
　JR's article on 206
　Manson and 91
　Read and 213
　relationship with JR 51, 102, 156
　and William Rothenstein 19
　at Venice Biennale 149
　and Westminster Cathedral
　　mosaics 207
　wins International Sculpture
　　Prize 183
　works acquired by Tate 122, 123,
　　129, 180
　King and Queen 181
Morisot, Berthe 79
　Jour d'été 185, 202
Morland, George 39, 170
Morrell, Lady Ottoline *113*, 225n
Morris, Sir Cedric 51
Morris, William 20, 82
Mortimer, Raymond 141, 200, 212
Moulin Rouge 148–149
Moynihan, Rodrigo 155
Mullaly, Terence 215
Muncaster Castle, Cumberland
　102, 103, 111
Munch, Edvard 155
Munich Agreement 102
Munnings, Sir Alfred 8–9, 28–29,
　29, 116, 133, 142, 210, 236n
*Mural Painting in Great Britain,
　1919–1939* (exhibition) 103
Museum of Modern Art, New York
　(MOMA) 91, 104, 133, 135,
　220, 234n

Musgrave, Ernest 41, 195

Nash, John 51, 122, 204, 244n
Nash, Margaret 127
Nash, Paul 16, 19, 51, 54, 101, 102,
　117, 122, 129, 177, 213, 215,
　217, 244n
　Sunflower and Sun 232n
Nation and Athenaeum 60
National Art Collections Bill 157,
　159–161, 162, 170–172, 173
National Art Collections Fund
　(later Art Fund) 54, 79, 85–86,
　157, 170, 182, 219
National Gallery of Art,
　Washington 112
National Gallery of Canada 103,
　104, 108
National Gallery of Ireland 79
National Gallery, London
　Mary Chamot at 128
　Clarke Fund 79
　Clark's Directorship of 9, 48, 92,
　　100, 107–108, 115
　collections moved to Wales 102
　Hendy's Directorship of 23, 116
　Holroyd's Directorship of 83
　JR considers applying for position
　　at 38
　JR's Tate-inspired exhibitions at
　　120
　and Knapping Bequest 158,
　　159, 162
　and Viscount Lee of Fareham
　　113
　loans from 51
　Massey and 125
　relations between NG and Tate
　　72–80, 219
　and Tate Board 100–101
　Tate Gallery opened as annexe of
　　73
　Trustees 86, 88, 146, 150
　Hubert Wellington at 94
　see also National Art Collections
　　Fund
National Gallery and Tate Gallery
　Act (1954) 76, 126, 219
National Museum of Wales 232n
National Portrait Gallery, London
　75, 76
Neo-Romantics 216
Nevinson, Christopher 91, 177,
　210, 244n

The New American Painting
 (exhibition) 180
New English Art Club 38, 85, 89,
 177
New South Wales, Art Gallery 29
New Statesman (from 1931 to 1964
 New Statesman and Nation) 66,
 68, 106, 167, 168, 171, 172, 195,
 201, 208, 217
New Year's Honours List 145
New York 104, 106, 178
 World Fair 108
New York Review of Books 195
Newark Museum of Art 104
Newdigate Prize 85
Newton, Eric 54, 94, 141, *155*, 208,
 213, 215
Nicholson, Ben 102, 117, 122, 178,
 207, 240n, 244n
 exhibition at Tate 179, 213
 JR on 213
Nicholson, Sir William 86, 100,
 101, 193
Nicholson, Winifred 119
Nicolson, Benedict 131–132, *132*,
 161, 162, 167, 171, 173, 207,
 214
 'The Tate Controversy' 173–174
Nicolson, Sir Harold 68, 240n
Nicolson, Nigel 171
Nolde, Emil 132

The Observer 62, 66, 167, 168, 200,
 203, 208
O'Keefe, Dennis 236n
O'Keeffe, Georgia 112
Old Quarries, Gloucestershire 113
Omega Workshops 224n
Operation Pied Piper 104
Orlebar, Wing Commander
 Augustus 39
Orpen, Grace (née Knewstub) 16
Orpen, Sir William 16, 35, 39, 210,
 244n
 Augustus John 18
Ottawa 104
Oxford 16, 26, 27, 34, 37, 38, 48,
 56, 76, 85, 100, 111, 158, 193
 All Souls College 23
 Balliol College 23
 Campion Hall 111, 119
 Christ Church 23, 94
 Lincoln College 84
 Magdalen College 23

New College 23, 48
Worcester College 22, 23, 35
Oxford Fortnight 35
Oxford Magazine 85

Padmore, Sir Thomas 153–154
Paget, General Sir Bernard 232n
Paris 14–15, 16, 17, 67, 89, 92, 110,
 112, 120, 130, 178
 Hôtel George V 92
 Musée du Luxembourg 229n
Pasmore, Victor 122, 216, 217, 245n
Pattison, Mark 84
Paul, King of Greece 188
Pavlova, Anna 35
Penguin Modern Painters series
 121, 205
Penrose, Sir Roland 133, 177, 207,
 232n
Peru 117
Philpot, Glyn 91, 103, 122
Phipps, Sir Eric 92
Phipps, Frances, Lady 92, 93
Picasso, Pablo 9, 17, 78, 91, 102,
 120, 130, 134, 176, 177, 180,
 203, 207, 220
 Buste de femme 234n
 Femme nue assise 234n
 La Vie 52
 Picasso (exhibition) 180
Picture Post 176
Pictures for Schools (exhibition) 127
Piper, John 118, 119, 122, 129, 130,
 143, 146, 148, 150, 153, 156,
 166, 216, 245n
Pissarro, Camille 15, 51, 79, 244n
Pissarro, Lucien 15
Pissarro family 115
Pitblado, David (later Sir David)
 165
Pittsburgh, University of 33–34,
 36–38
Plato 213
Playfair, Sir Edward 151, 152, *152*,
 153–154, 156, 165
*Pleydell-Bouverie Collection of
 Impressionist and Other Paintings*
 (exhibition) 170
Poliakoff, Serge, *Composition
 Abstraite* 222
Pollock, Jackson 180
Ponsonby, Hon. Elizabeth 23
Poor Brothers 60
Pope-Hennessy, James 232n

Pope-Hennessy, Sir John 66, 116,
 119, 131, 234n
Post-Impressionism 207
 exhibitions 17, 87, 211, 220
Pound, Ezra 32
Poussin, Nicolas 213
Pre-Raphaelites 35, 88, 89, 116
Pretoria 138–139
Previtali, Andrea 9
Prime Minister's Appointment
 Office 94
Proctor, Sir Dennis 134, 140, *140*,
 146, 150, 156–169, 172–178,
 187, 197, 202, 222
 as Apostle 237n
Proust, Marcel 228n
Pryce-Jones, David 30, 237n
Pryde, James 119, 193, 209, 210,
 244n

Quakers 21
Queen's Quarterly 104
Queen's Speech 157
Quennell, Peter 23

Raffalovitch, André 62
Ramsden, Sir John 103
Ravilious, Eric 23, 40, 122, 217
Read, Sir Herbert 117, *118*, 131,
 133, 186, 207, 213, 221
 Art Now 227n
Realism 112
Rebel Art Centre 212
The Recorder 166
Redfern Gallery, London 119, 121,
 234n
Redon, Odilon 132
Redpath, Anne 215
Reformation 16, 22, 43, 59, 64, 66
Reid, Sir Norman *125*
 and day-to-day running of Tate
 179–181
 distrust of Le Roux 139–140
 and filming at Tate 150–151
 JR on 199–200
 and JR's retirement from Tate
 189–190
 and Le Roux 145, 146, 180
 praised by Cooper 136
 succeeds JR as Director of Tate
 Gallery 9, *125*, 190, 202,
 230n
 and Tate trust funds 162, 199
Reid and Lefevre Ltd 52, 220

Rembrandt van Rijn 90
Renaissance 64, 72
Renoir, Auguste 78, 79, 80, 130, 156, 161
Reunited National Party (South Africa) 138
Rey, Loris 44, 46
Reynolds, Alan 208, 217
Reynolds, Sir Joshua 51
Rhoades, Geoffrey Hamilton 206
Richards, Ceri 217, 235n, 245n
Richardson, John 132, 143, 173, 175, 177, 178, 195, 198, 201
Ricketts, Charles 32, 206
Ridley, Hon. Sir Jasper 100, 113–114, *113*, 118, 127, 138, 143, 144, 197, 205
Riley, Bridget 216, 217, 245n
Ritson, Sir Edward 152–155
Ritson Report 154–155, 165
Robbins, Lionel (later Lord Robbins) 156
Roberts, William 51, 104, 122, 212, 244n
'A Reply to my Biographer Sir John Rothenstein' 212
Robertson, Bryan 188, 189, 190, 218–219, 234n, 241n
Robertson, Henrietta 194
Robinson, Sir Kenneth 171–172
Rodin, Auguste 16, 80
Rodmarton Manor, Gloucestershire 20, 56
Rolfe, Frederick (Baron Corvo) 62
Romantic movement 64–65, 67, 125
Rosenthal, T. G. 196
Ross, Robbie 224n
Rossetti, Dante Gabriel 35, 39
Rothenstein, Bertha (JR's grandmother) 13, 29, 40
Rothenstein, Betty (JR's sister, later Mrs Ensor Holiday) 14, 30, 224n
Rothenstein, Sir John
autobiography 192–204
see also Brave Day, Hideous Night; *Summer's Lease*; *Time's Thievish Progress* (under WORKS, below)
birth 8, 16
and Catholicism 27–28, 30, 43, 56–58, 59–60, 61–62, 65, 66, 112, 117, 119, 192, 214, 224n

diary 103–104, 109, 145, 147, 148, 158, 178–179, 185, 188, 196
as Director of Leeds City Art Gallery 38, 39–51, 64, 95, 98, 101, 163, 193, 194–195, 196, 218
as Director of Graves Art Gallery, Sheffield 51–55, 91, 93, 95, 98, 101, 193–195, 196, 218
as Director of Tate Gallery 12, 17, 25, 38, 50, 51, 67–68, 72, 80–81, 92, 93–95, 98–190, 193–201, 218–222
doctorate in art history 38
as guest on BBC Desert Island Discs 223n
and Jewish heritage 13, 15, 17, 28–30, 193
knighthood 145
as lecturer 33–36
in London after graduation from Oxford 22–23, 26–27
marriage to Elizabeth Smith 36, 38
overseas trips on Tate business 178, 182
at Oxford 35–38, 45, 56, 76, 100, 193, 196, 205
portraits and photographs frontispiece *13*, *24*, *34*, *37*, *53*, *55*, *59*, *65*, *98*, *111*, *124*, *128*, *129*, *134*, *155*, *168*, *171*, *179*
retirement from Tate 187–190, 192, 221
and Slade Professorship 176
in South Africa 138
in USA 32–38, 64, 103–109, 110, 112, 178, 193, 196, 221, 222
and Venice Biennale 143, 182–183
as writer 112, 120–121, 193, 219
see also titles of works below
writes script for film to be made at Tate 149–150, 198–199, 236n
WORKS
'The Architecture of the Italian Renaissance' 36
The Artists of the 1890's 32, 58–62, 64, 65, 67, 193, 205–206, 209
Augustus John 123

Brave Day, Hideous Night 88–89, 100, 101, 104, 123, 192, 196–201
British Art since 1900 187, 188, 212, 215
British Artists and the War 62–64, 68
'British Painting' 117
'British Painting Today' 104
'Church Decoration in England: The Coming Opportunity' 112
Edward Burra 205
Eric Gill 26, 32, 35, 56–58, 60, 69, 120, 205
'The Evacuation of the Tate' 104
'Fourteen Artists' (unpublished) 243n
'Great Britain's World Policy and the United States' 34
An Introduction to English Painting 66–67, 68
The Life and Death of Conder 67–68, 120, 209
'Modern Art' 36
Modern English Painters 10, 22, 32, 60, 61, 64, 68–69, 117, 121, 178, 192, 205, 205–217, 206–210, 217, 222
republished (1984) 217
vol. 1 (Sickert to Lowry) 9, 143, 205, 207–215, 217
vol. 2 (Lewis to Moore) 185, 192, 207, 209, 210–215, 217
vol. 3 (Wood to Hockney) 187, 192, 205, 209, 215–217
The Moderns and Their World 176
Nineteenth Century Painting: A Study in Conflict 64–65
'A Note on American Painting' 112
'Painting in America' 112
The Portrait Drawings of William Rothenstein, 1889–1925 35, 36, 58, 205
Summer's Lease 20, 40, 192–196, 201, 206
Time's Thievish Progress 201–204

'Why the Tate does not show its Chantrey Pictures' 141

Rothenstein, Lady (née Alice Knewstub, JR's mother) 16, 19, 21, *26*, 35, 36, 40

Rothenstein, Lady (née Elizabeth Smith, JR's wife) 30, 32, 36, *37*, 38, 40, 50, 54, *55*, 95, 102, 103, 104, 109, 110, 120, 123, *171*, 215

Rothenstein, Lucy (JR's daughter, later Carter) 10, *55*, 104, 109, 226n, 244n

Rothenstein, Michael (JR's brother) 14, 106, 123, 217, 233n

Rothenstein, Moritz (JR's grandfather) 13, 29, 40, 225n

Rothenstein, Rachel (JR's sister, later Ward) 54, 56, 224n

Rothenstein, Sir William *13*, *26*, *98*
 as artist 14, 54, 86, 119, 244n
 background 12–14, 216
 and Bloomsbury Group 211
 and Charles Conder 67, 120
 Cooper on 177
 death 109, 123
 as figure on London cultural scene 14–15
 and Eric Gill 57, 120
 influence on JR 12–25, 28, 35, 46–49, 52, 58, 62, 120, 121, 128, 192, 205–206
 and Jewish heritage 13, 15, 17, 29
 and JR's conversion to Catholicism 28
 and Keepers/Directors of Tate Gallery 82–95
 knighthood 123
 marriage to Alice Knewstub 16
 in Paris 14–16
 relationship with JR 26–27, 31, 33, 40, 56, 67, 95, 107, 108–109, 123, 131, 194, 196
 relationships and friendships 15–19, 28
 at Slade School of Fine Art 14
 PAINTINGS
 Eric Gill and Alice, Lady Rothenstein *26*
 Jews mourning in a Synagogue 17, 86
 John Rothenstein and Elizabeth 37
 The Princess Badroulbadour 15

WRITINGS
 Men and Memories: Recollections of William Rothenstein, 1872–1900 12, 30, 192
 Men and Memories: Recollections of William Rothenstein, 1900–1922 12, 17, 192
 Since Fifty: Men and Memories, 1922–1938 12, 192

Rothko, Mark 180

Rouault, Georges 125, 130, 201

Rousseau, Henri (Douanier) 91

Rowlandson, Thomas 88

Rowntree, Kenneth 216

Royal Academy of Arts, London
 Brooke and 138
 and Chantrey collection 141, 142, 219, 222, 241n
 exhibits bronze head of Elizabeth Rothenstein 30
 formerly housed with National Gallery 72
 MacColl and 84, 85
 Munnings's drunken behaviour at 9
 RA members on Tate board 77, 100, 101
 relations with Tate 115–116
 as representative of artistic establishment 203
 Schools 101
 Summer Exhibition 82, 108, 142, 183
 work of Academicians 73, 74
 see also Chantrey Bequest

Royal College of Art, London 19, 22, 27, 35, 94, 123

Royal Society of Painter-Etchers 82

Ruskin, John, *Modern Painters* 244n

Russell, John 124, *132*, 133, 187, 203–204, 215, 244n

Russell, Sir Walter 101, 118

Russia 103, 157, 196

Rutherston, Albert (JR's uncle, earlier Rothenstein) 14, *14*, 16, 26, 35, 48, 54, 223n

Rutherston, Charles (JR's uncle, earlier Rothenstein) 13, 35, 40

Rutter, Frank 54

Ryder, Jane 167

Rye, East Sussex 205

Sackville-West, Edward (later Lord Sackville) 23, *24*, 121, 183

Sackville-West, Hon. Vita 240n

Sadler, Sir Michael 54, 229n

Sainsbury, J., Limited 187

Sainsbury, Sir Robert 185–186

St Matthew's, Northampton 176

Sandwich, George Charles Montagu, 9th Earl of 94, 101

Sargent, John Singer 90, 210
 Study of Mme Gautreau 75

Saturday Review 62, 84, 85

Saura, Antonio 208

Sax, Professor 33, 34

Schwabe, Randolph 38, 93, 117–118, 224n, 226n

Schwarz, Bernard Lee ('Bern') *132*

Schwitters, Kurt 180

Scotland, national collections 159

Scott, William 216

Scrutton, Hugh *155*

Sculpture of a Decade, '54–'64 (exhibition) 181

Second Post-Impressionist Exhibition 17

Second World War 28, 41, 64, 102–120, 123, 203, 218
 bombing 110, *111*, 112–113

Selkirk, George Douglas-Hamilton, 10th Earl of 157, 170

Serota, Sir Nicholas 218

Settignano, I Tatti 16

Seurat, Georges 17, 52, 78

Shahn, Ben 112
 Lute and Molecules 181

Shannon, Charles 32, 206, 210

Shaw, George Bernard 16

Sheffield 27, 37, 39, 40, 46, 51, 68, 182
 Graves Art Gallery 46, 48, 50–53, 55, 91, 101, 113, 127, 193–195, 196, 218
 Mappin Art Gallery 50, 53
 Ranmoor Road 194
 University of 40

Sheffield Art Collections Fund 54

Sheffield Telegraph 54

Sickert (exhibition) 180

Sickert, Walter 15, 39, 51, 86, 90, 91, 101, 119, 120, 122, 209, 217, 243n, 244n

Sims, Charles 77

Sitwell, Dame Edith 26, 31

Sitwell, Sir Osbert 26, 28, 31, 146, 150

Sitwell, Sir Sacheverell 26, 31

The Sketch 166
Slade School of Fine Art, London
 14, 82, 89, 91, 128
Smith, Sir Matthew 39, 51, 54, 88,
 91, 101, 119, 122, 129, 143, 155,
 156, 157–158, 177, 183, 205,
 209, 234n, 244n
Smith, Sidney 73
Society for Education in Art 127
Sorrell, Alan 19, 23
South Africa 138–139
South America 117
South Kensington Museum *see*
 Victoria and Albert Museum
Soutine, Chaim 131, 180
Soutine (exhibition) 181
Speaight, Robert 166–167
The Spectator 35, 66–67, 85, 162,
 167, 196, 200, 210, 217
Spencer, Gilbert 51, 91, 244n
 Girls gathering Flowers 39
Spencer, Sir Stanley *179*
 and Campion Hall murals 233n
 friendship with JR 10, 54, 102,
 204
 included in JR's *Modern English
 Painters* 205, 213
 JR's essay on 243n
 JR's support for 39, 101, 104,
 118, 211, 215, 218, 228n
 JR's writings on 244n
 Manson and 91
 The Resurrection, Cookham 75
 Rickett's Farm, Cookham Dene
 102
 Separating fighting Swans 42
 spiritual leanings 27, 32
 Swan Upping at Cookham 181
 works acquired by Tate 91, 101,
 122, 129, 155, 179, 180
Squire, Sir John 66
Stäel, Nicolas de 175–176, 177,
 180, 220
The Star 166
Stead, William *24*
Steer, Philip Wilson 32, 51, 88, 91,
 116, 120, 133, 206, 244n
Stevens, Alfred 66, 77, 80, 83, 85
 Wellington Monument 83
Stoke-on-Trent 108
Stokes, Adrian 23, 188
Stoneman, Walter *95*
Stoop Bequest 91
Stoop Collection 78

Stoop, Frank 91
Strachey, Barbara *33*
Strachey, John *24*
Strauss, G. R. 170–171
The Studio 33, 35, 221
Sudeley Castle, Gloucestershire
 113
Sunday Express 163, 164, 167
Sunday Telegraph 196, 200, 204,
 215
Sunday Times 54, 66, 141, 167, 168,
 190, 200, 203–204, 208, 210,
 212, 215
Surrealism 177, 206
Sutherland, Graham *122, 184*
 ambitious nature 136–137
 attacks on JR 9
 and Brooke 138
 and Churchill 183
 and Cooper 136, 173
 Cooper on 178
 exhibition at Tate 155
 Lucian Freud on 185
 included in JR's *Modern English
 Painters* 245n
 included in Penguin Modern
 Painters series 121
 on JR's autobiography 200
 JR's support of 143
 and Le Roux 184–185
 mentioned in JR's diary 185
 relationship with JR 195, 216,
 229n
 resignation from Tate Board 163–
 168, 170–171, 178
 seeks to promote modern foreign
 art 130, 131
 and Tate Affair 146, 148, 150,
 156, 168–173, 175–176
 as Trustee of Tate 136
 and Venice Biennale 183
 works acquired by Tate 119,
 122, 129
 Crucifixion 176
Sutton, Denys 163, 165, 167, 169,
 173–174, 176, 215, 240n
Sweden 117
Sykes-Davies, Hugh 237n
Sylvester, David 186, 187, 207

*Tableaux Britanniques modernes
 appartenant à la Tate Gallery*
 (exhibition) 117
The Tablet 112, 142

Tagore, Rabindranath 17
Tate Affair
 aftermath 175, 178, 179, 183,
 184, 187, 188, 190, 192, 201,
 216, 219
 Blunt's discretion regarding 134
 and Chantrey Bequest 140
 criticisms of JR during 67, 78, 82
 first phase 145–158, 207, 217
 Hendy's support of JR during
 116
 JR's account of 197–198, 200–
 204, 221
 JR's lack of perception of 131
 JR's survival of 9, 206, 210
 and personal insults to JR 28
 second phase 159–170
 Treasury and 129
 and use of press 195
Tate Gallery, London
 administration of trust funds 76,
 161–169, 199, 221
 American Friends of 182
 Annual Reports 180
 Board meeting of 8 October 1952
 146–148
 bombed 110, *111*
 building and location 73
 Chairmen 220
 closed during Second World War
 103
 Conservation Department 202,
 220
 Ede at 40
 flood (1928) 88
 Friends of 32, 181–182, 202,
 220
 funding 78–80
 see also Treasury
 Keepers and Directors before, *see
 also* Aitken, Charles; Holroyd,
 Sir Charles; MacColl, D. S.;
 Manson, James Bolivar
 Keepers and Directors before JR
 49, 82–95
 library 202, 220
 opened as National Gallery of
 British Art 73
 Publications Department 128,
 137–138, 139, 161, 197, 220
 relations with National Gallery
 72–80, 219
 reopening after end of Second
 World War 41, 123–125, 127

Report 1953–54: Review 1938–53 169–170
restaurant 175, 202
William Rothenstein and 48–49, 82
Sargent Gallery 79
split into Tate Britain and Tate Modern 223n
theft of Morisot painting 185, 202
Trustees 23, 41, 75–80, 83, 87, 88, 91, 95, 98–101, 105–106, 136, 138, 162–174, 202, 220
Turner Wing 75, 87
see also Chantrey Bequest; National Gallery, London; Rothenstein, Sir John, as Director of Tate Gallery
Tate, Sir Henry 73–74
Tate, Lady 74
Tatlock, Robert 88
Temple, William, Archbishop of Canterbury 223n
Thérèse of Lisieux, St 156
Thesiger, Roderic 124, 238n
Thesiger, Wilfred 124
Thompson, Francis 61
Time magazine 189, 190
Time and Tide 117, 167
The Times 42, 54, 62, 94, 142, 161, 162, 164, 166–167, 167, 172, 195, 203, 208, 209–210
Times Literary Supplement 35, 68, 149, 176, 196, 212, 215
Tobey, Mark 112
Tonks, Henry 91, 209, 244n
Toronto 52, 104
Toulouse-Lautrec (exhibition) 180
Toulouse-Lautrec, Henri de 15, 52, 148–149
Treasury
 Brooke and 170
 and hiring of staff 126
 and JR's travels 104, 113–114
 offers JR directorship of Tate 95
 Organisation and Methods Division 128–129
 Sutherland and 164–165, 169
 and Tate finances 124, 150–159
 and Tate Publications Department 138
 and Tate purchase grant 126, 177, 180, 189, 219

and Tate Trustees' plans for JR 187
see also National Art Collections Bill
Trevelyan, Julian 20
Tunnard, John 119, 122
Turner, J. M. W. 51, 72, 74, 84, 88, 127, 178
Turner, Vincent 112, 119, 120, 210, 233n
Turner Bequest 85
Twentieth Century British Painting (exhibition) 54
Twentieth-Century Masterpieces (exhibition) 155
Twenty Years of British Art (exhibition) 87
Two Centuries of British Drawings from the Tate Gallery (exhibition) 116

Uffizi Society 23
Uglow, Euan 217
Underwood, Leon 243n
Unitarianism 30
United States of America 22, 32, 64, 103–109, 110, 112, 117, 178, 196, 221, 222
 Depression 112
The Universe 112
University College London 38, 84
Uruguay 117
Utrillo, Maurice 92, 122

Van Gogh, Vincent 17, 51, 78, 91, 117, 127, 174, 202
 La Haie 51
Vasari, Giorgio, *Lives of the Painters* 244n
Vaughan, Keith 216, 245n
Velázquez, Diego, *Rokeby Venus* 86
Venice Biennale 134, 149
 International Committee of Experts 182
 Selection Committee 143, 182
Verlaine, Paul 15
Vernon Bequest 72
Victoria and Albert Museum (earlier South Kensington Museum), London 9, 32, 51, 72, 80, 93, 94, 108, 116, 128
Villon, Jacques 143
Vinogradoff, Julian *24*
Vlaminck, Maurice de 130

Vuillard, Édouard 224n

Wadsworth, Edward 51, 54, 55, 101, 127, 211, 244n
Wakefield Art Gallery 41
Walker Art Gallery, Liverpool 38, *155*
Walker, Ethel 104, 119, 209, 210, 244n
Walker, John 112
Wallace Collection, London 75, 87, 94
Walpole, Hugh 51
Walston, Catherine 119, 121
Walston, Henry, Baron Walston 121
War Artists Advisory Committee 107, 129
Ward, Alan 54
Ward, Herbert 230n
Washington, DC 104
Waterhouse, Ellis 131, 167
Watson, Alister 237n
Watson, Diana 129
Watson, Harry 194
Watson, Peter 112, 133, 232n
Watteau, Antoine 67
Watts, G. F. 66, 73, 80, 170
Waugh, Alec 26
Waugh, Evelyn 21, 26–27, 119, 193
 Brideshead Revisited 23, 27
 Vile Bodies 225n
Webb, Aston 77
Weekes, Herbert William 194
Weight, Carel 216, 242n
Wellington, Hubert 94
West, Rebecca 66
Westminster Cathedral, London 35
 Art and Architecture Committee 156
 Baptistery 207
Westminster Gazette 85
Westminster School, London 94
Wheeler, Sir Charles 142
Wheeler's, London 186
Whistler, James McNeill 15, 88
 Nocturne in Blue and Gold 86
Whistler, Rex, *The Expedition in Pursuit of Rare Meats* 88, 103
White, Christopher 196
White, Gabriel 175, 189
Whitechapel Gallery, London 87, 88, 89, 175, 218–219, 241n
 exhibition of Jewish art 86
Whitney, John Hay 241n

Whittet, George 221
Wilde, Oscar 15, 67
Williams, Hugh 236n
Wilson, Richard 39, 88
Wishart, Michael 20
Wood, Christopher 216, 245n
Wood, Grant, *American Gothic* 112
Wood, Stanley 194
Woolf, Virginia 17
Wyatt, Woodrow 172
Wyndham Lewis and Vorticism
 (exhibition) 32, 180, 212
Wyndham, Richard 228n
Wynter, Bryan 216

Yeats, Jack 181, 244n
Yorkshire College of Science 82
Yorkshire Evening News 39, 45
Yorkshire Evening Post 39, 45
Yorkshire Post 44, 45
Yorkshire Telegraph 55, 206

Zay, Jean 92
Zwemmer Gallery, London 119